FRENCH DRAWINGS

FROM THE BRITISH MUSEUM

Clouet to Seurat

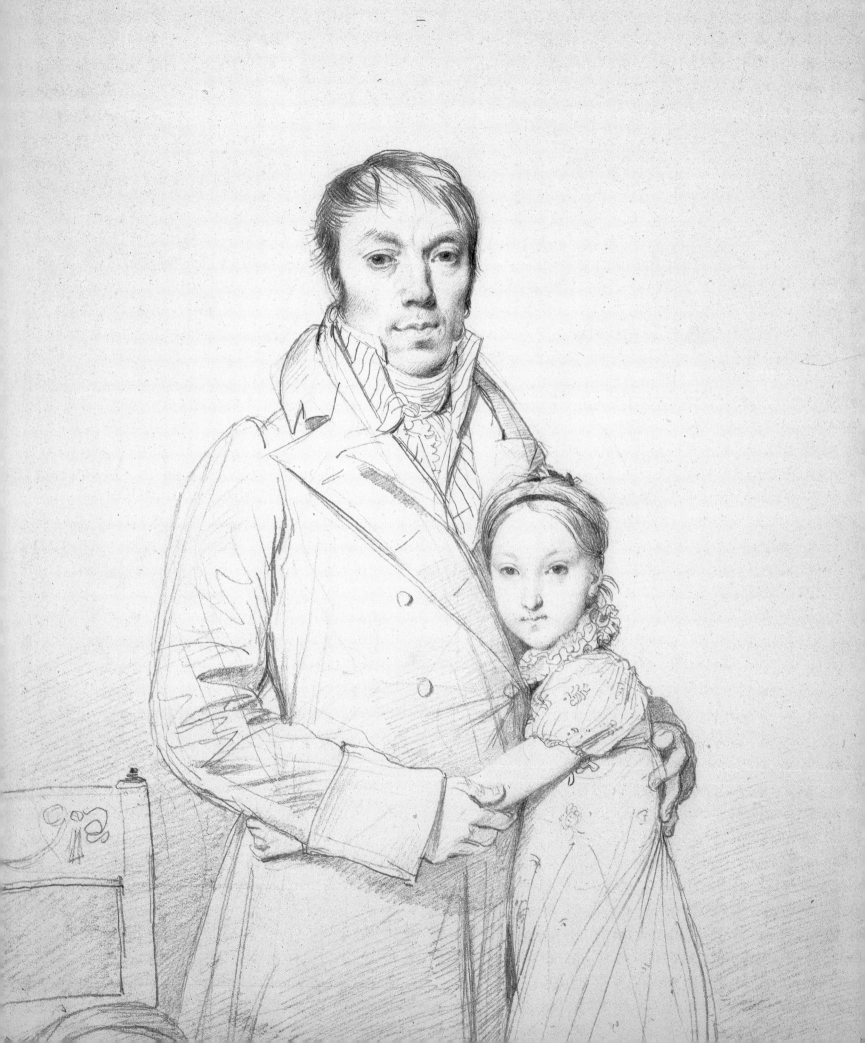

FRENCH DRAWINGS
FROM THE BRITISH MUSEUM
Clouet to Seurat

Perrin Stein

with a contribution by Martin Royalton-Kisch

THE BRITISH MUSEUM PRESS

AND

THE METROPOLITAN MUSEUM OF ART, NEW YORK

This catalogue is published to accompany an exhibition (*Clouet to Seurat: French Drawings from The British Museum*) shown at The Metropolitan Museum of Art, New York, from 8 November 2005 to 29 January 2006 and at the British Museum (*French Drawings: Clouet to Seurat*) from 29 June to 26 November 2006.

The exhibition at The Metropolitan Museum of Art is in memory of

William Slattery Lieberman

February 14, 1923 – June 1, 2005

The exhibition was organized by The Metropolitan Museum of Art, New York, and The British Museum.

The exhibition in New York is supported by an indemnity from the Federal Council on the Arts and the Humanities.

First published in 2005 by The British Museum Press
A division of The British Museum Company Ltd
38 Russell Square, London WC1B 3QQ

www.britishmuseum.co.uk

A catalogue record for this book is available from the British Library

ISBN-13: 978-0-7141-2640-1

ISBN-10: 0-7141-2640-3

Designed by Tim Harvey
Typeset in Rialto
Printed in Spain by Grafos SA, Barcelona

PHOTOGRAPHIC ACKNOWLEDGEMENTS
The majority of the illustrations are copyright © The Trustees of the British Museum. Others are copyright © the institutions named in the captions, and were provided by:
Berkeley Art Museum, University of California: no.43, fig.1; Boston, The Horvitz Collection, Courtesy of the Fogg Art Museum, Harvard University Art Museums: no.13, fig.1; Boston, Museum of Fine Arts: no.12, fig.1; Brussels, Musée Royal des Beaux-Arts: no.20, fig.1; Cambridge, Mass., Courtesy of the Fogg Art Museum, Harvard University Art Museums: no.19, fig.1 (photo: Rick Stafford), no.71, fig.1, bequest of Grenville L. Winthrop (photo: Katya Kallsen), no.72, fig.1 (photo: Katya Kallsen); Chantilly, Musée Condé: no.52, fig.1 (photo: Bridgeman Art Library International Ltd.); Chicago, The Art Institute of Chicago: no.91, fig.1, Helen Birch Bartlett Collection; Holkham, Viscount Coke and the Trustees of the Holkham Estate: no.24, fig.2, no.25, fig.1; Kansas City, Missouri, The Nelson-Atkins Museum of Art: no. 23, fig.1; London, Courtauld Institute Galleries: no.35, fig.1; New Orleans Museum of Art: no.46, fig.1, museum purchase through the bequest of Judge Charles F. Claiborne; New York, The Metropolitan Museum of Art: no.16, fig.1, no.16, fig.2, no.28, fig.1, no.29, fig.1, no.30, fig.1, no.34, fig.1, no.37, fig.2, no.85, fig.1, no.86, fig.1, no.92, fig.1; New York, private collection: no.40, fig.1; New York, private collection: no.58, fig.1; Paris, Bibliothèque Nationale de France: no.7, fig.1, no.8, fig.1; Paris, École nationale supérieure des Beaux-Arts: no.27, fig.1, no.34, fig.2; Paris, Musée des Arts décoratifs: no.5, fig.1 (photo: Laurent Sully Jaulmes); private collection: no.49, fig.1, no.49, fig.2, no.49, fig.3; private collection: no.55, fig.1; Réunion des Musées Nationaux / Art Resource, NY: no.2, fig.1 (photo: Harry Bréjat), no.3, fig.1 (photo: Michèle Bellot), no.19, fig.2 (photo: R.G. Ojeda), no.33, fig.1 (photo: Gérard Blot), no.64, fig.1 (photo: R.G. Ojeda), no.73, fig.1 (photo: R.G. Ojeda), no.75, fig.1 (photo: J.G. Berizzi), no.88, fig.1 (photo: Arnaudet); Rome, Musei Capitolini, Rome: no.65, fig.1 (photo: Scala / Art Resource, NY); Salt Lake City, Utah Museum of Fine Arts, University of Utah: no.54, fig.2; Windsor, Royal Library: no.18, fig.1, no.24, fig.1.

frontispiece
JEAN-AUGUSTE-DOMINIQUE INGRES (1780–1867).
Charles Hayard and his Daughter Marguerite, 1815, graphite (detail, enlarged).

Contents

FOREWORD

The British Museum and The Metropolitan Museum of Art have a long history of close and friendly collaboration. They have much in common. Both contain an enormous range of artefacts from every age and every culture. Both are in a very real sense museums of the world. The wealth of their collections of European works on paper is not the most widely known facet of their holdings because for conservation reasons they can be displayed only on a rotating basis. Yet they contain some of the greatest of all European drawings and these form the key to understanding the working practices of artists, many of whom are better known for their paintings and sculpture.

This is the third collaboration between the Department of Prints and Drawings at the British Museum in London and the Department of Drawings and Prints at The Metropolitan Museum of Art in New York: *Correggio and Parmigianino, Master Draughtsmen of the Renaissance* was shown in both institutions in 2000–2001; and *Samuel Palmer (1805–1881): Vision and Landscape*, to be shown at The Metropolitan Museum of Art from March 2006, opens at the British Museum two weeks before the present exhibition, *Clouet to Seurat: French Drawings from The British Museum*, opens in New York.

It is often through their drawn sketches that we can best judge the artistic calibre of these French artists, whether in preliminary ideas such as Jacques Callot's *Sheet of Studies with a Horse, after Tempesta* (no.14) or Philippe de Champaigne's study for the Infant Christ in his painting of the *Presentation in the Temple* (no.20), or in a rapid drawing made outdoors from nature, such as Claude Lorrain's *Study of a Stream* (no.21), or even in a finished work of art in its own right, such as Victor Hugo's *Landscape with a Castle on a Cliff* (no.77) or Gustave Courbet's *Self-Portrait* (no.80).

Influenced by turns by artists from Flanders, Italy and Holland, French artists reflected and instigated some of the major stylistic innovations in European art, which may be studied particularly well in their drawings. From the Renaissance, through the Baroque, Rococo and Neoclassic phases, to the Romantic, Realist and Impressionist movements of the nineteenth century, the Department of Prints and Drawings at the British Museum contains one of the more remarkable groups of French drawings outside France. Ranging from the fifteenth to the twenty-first century, the collection boasts more than 3,500 French drawings, ninety-five of which are shown here. The selection includes masterpieces by Clouet, Claude, Poussin, Watteau, Ingres, Degas and Seurat, covers the sixteenth to nineteenth centuries and reflects both the range and particular strengths of the British Museum's holdings of French art. Claude, for example, is particularly strongly represented here by five sheets (nos 21–25), which come from the extraordinary *richesses* of this artist's work in the British Museum, which owns some 500 drawings by him.

This is the first time such a wide-ranging selection from this part of the British Museum's collection has been exhibited and published and we feel sure that our visitors will relish the experience of seeing it. The choice was made by Perrin Stein, Curator of

Drawings and Prints at the Metropolitan, who has worked with Martin Royalton-Kisch at the British Museum. She has written all the catalogue entries, while he has provided the Introduction.

NEIL MACGREGOR
Director
The British Museum
London

PHILIPPE DE MONTEBELLO
Director
The Metropolitan Museum of Art
New York

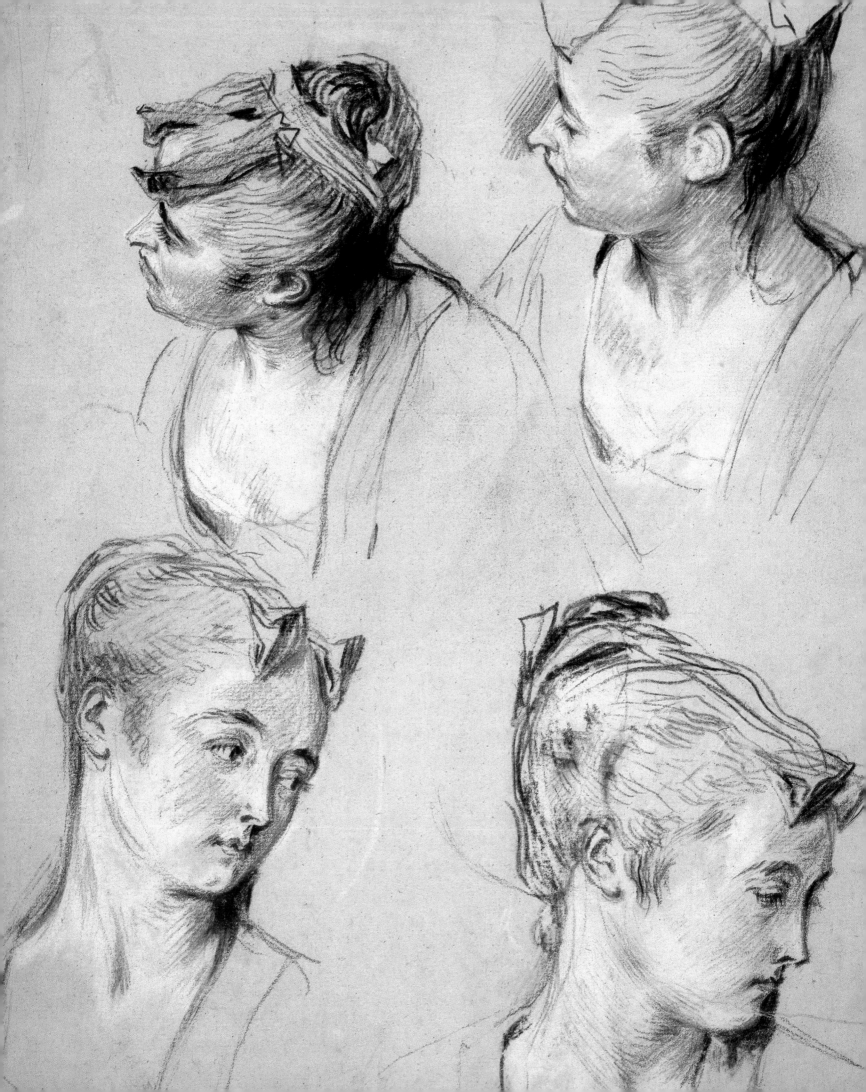

Preface and Acknowledgements

Among the earliest and finest cabinets of drawings in Europe, the Department of Prints and Drawings at the British Museum boasts an enviable collection, built up, for the most part, in earlier centuries when masterpieces were far more readily available than they are today. Because they are sensitive to light, drawings only become known to the general public through publications and exhibitions, and the illustrious holdings of the Department have benefited immensely from the attentions of several generations of curators whose permanent and exhibition catalogues have added to the renown of the collection. The French drawings, however, have generally stood in the shadow of the yet larger holdings of British, Italian and Northern drawings (the latter including Dutch, Flemish and German works), although exceptions are formed by certain artists, such as Claude and Watteau, who have been studied in monographic publications. But there is no permanent catalogue of the collection, and one motivation behind the present project has been to present an overview of the French holdings that would be useful to scholars and the general public alike. While a presentation of ninety-five works represents only a fraction of the approximately 3,500 French drawings in the collection, this exhibition and catalogue aim to provide the means to survey the strengths and the breadth of this fine collection.

Within the holdings of French drawings at the British Museum several core collections are rightly considered treasures. A group of royal court portraits from the sixteenth century by Jean Clouet and his son François Clouet (nos 1–2) contains rare and precious examples of the early use of different coloured chalks to produce naturalistic effects. At the time of Catherine de Médicis (1519–89), queen of France (1547–59), such portraits were collected and valued as independent works of art. Equally or even more prominent are the 500 or so drawings by Claude Lorrain, the French 'old master' artist most beloved of British collectors. He is particularly strongly represented here by five sheets (nos 21–25) which demonstrate the range of his production, from free *plein air* studies to the breathtakingly fresh copies he made after his paintings in his *Liber Veritatis*. The British Museum also has one of the world's finest collections of drawings by Antoine Watteau, the most original and influential of Rococo draughtsmen, represented here by four sheets which reveal the evolution of his sparkling use of red, black and white chalk in combination *à trois crayons* (nos 38–41). César Mange de Hauke's bequest of 1968 added a stellar group of nineteenth-century drawings to the collection (nos 71, 76, 78, 85–86 and 91–93). If this area had formerly lagged behind, this important bequest, in combination with judicious acquisitions, has enriched the collection with works of the highest calibre.

With sheets spanning such a broad chronological range, one inevitably looks for qualities that are quintessentially French. And indeed, certain conceptual and aesthetic strands can be traced over the course of generations, and even centuries. There are continuities between the portrait drawings in coloured chalks by the Clouets (nos 1–2) and the

ANTOINE WATTEAU
Five Studies of a Woman's Head, two shades of red, black and white chalk (detail, enlarged).

trois crayons studies of heads by Charles de La Fosse (nos 32–33) and Antoine Watteau (no.40); and between the twisting female nudes of Primaticcio (no.4) and those by Boucher (no.47); between the landscapes rendered in areas of wash by Callot (no.15) and those produced in conté crayon by Seurat (no.91). Surveying a broad period, one can also appreciate the cyclical nature of stylistic development, often conceived and expressed at any given time in terms of contrasts. For instance, the rivalries which came to the fore in the 1670s between proponents of *Rubénisme* (favoring colour and naturalism) and *Poussinisme* (advocating line and the study of antiquity) find an echo in the confrontation between the Classicism of Ingres (nos 71–72) and the Romanticism of Delacroix (nos 75–76) in the early nineteenth century. Even in the highly innovative work of the Impressionists and Post-Impressionists, qualities can be traced that are distinctly French as part of a tradition that continued to flourish amid foreign influences and through cycles of rebellion and revival. Pissarro's incisive sketches in pastel of a woman dressing (no.84), for instance, evoke Watteau's studies of a woman's head in 'trois crayons' (no.40), just as Cézanne's tendency to focus on a scene's underlying geometry (no.88) recalls Poussin's compositional studies (no.19).

The selection of works was inevitably a subjective process. The glories of the collection were not denied, but there is also a pleasure in putting before the public sheets such as Gillot's *Passion for Gaming* (no.37) or Greuze's *Return from the Wet Nurse* (no.55) which have not been on display for a generation or more. The 95 works, here generally arranged by the artists' dates of birth, were chosen with an eye towards creating a visually compelling picture of French draughtsmanship as it evolved from the Renaissance until the end of the nineteenth century. Whether the drawings were made as part of a working process or as independent works of art in their own right, they reveal the mastery and exquisite beauty of the French artistic tradition in the artists' most direct and immediate means of expression.

In producing this exhibition and catalogue we have incurred many debts that we gratefully acknowledge here. Critical to the project since the inception has been the support of Antony Griffiths, Keeper of the Department of Prints and Drawings at the British Museum, and George R. Goldner, Drue Heinz Chairman of the Department of Drawings and Prints at the Metropolitan Museum. Further assistance at the British Museum has been provided by Hugo Chapman, Mark McDonald, Angela Roche, Richard Perfitt and Alison Wright. All the new photography at the British Museum was created by Ivor Kerslake to his customarily high standards.

At the Metropolitan Museum, the following staff members have contributed their time and talents to the project: Dita Amory, Rosayn Anderson, Kit Basquin, Esther Bell, Susan Bresnan, Barbara Bridgers, Lisa Cain, Aileen Chuk, Roxanne Collins, Nina Diefenbach, Robyn Fleming, Patricia Gilkison, Claire Gylphé, Harold Koda, Michael

Langley, Carol Lekarew, Rebecca Noonan, Connie Norkin, Samantha Rippner, Marjorie Shelley, Linda Sylling, Evalyn Stone, and Mary Zuber. Special thanks are due to Katherine Holmgren who created the index and whose tireless research as a high school volunteer in 2003 greatly facilitated the writing of this catalogue.

Many colleagues in the field also provided critical assistance by answering queries and sharing their thoughts: Olivier Aaron, Colin Bailey, Joseph Baillio, Rhea Blok, Jean-Claude Boyer; Etienne Breton, Alvin L. Clark, Jr., Georgina Duits, François Fabius, Nicole Garnier, Margaret Morgan Grasselli, Mary-Elizabeth Hellyer, Mary Tavener Holmes, Stephane Houy-Towner, Eik Kahng, Edouard Kopp, Alastair Laing, Nicolas Lesur, Stéphane Loire, Patrice Marandel, Béatrice de Moustier, Jill Newhouse, William O'Reilly, Donald Posner, Richard Rand, Pierre Rosenberg, Alan Salz, Nicolas Schwed, Kristel Smentek, Martin Sonnabend, Laure Starcky, Jon Whiteley, Eunice Williams, Gloria Williams, Humphrey Wine, and Alexandra Zvereva.

At the British Museum Press we thank Isabel Andrews and Laura Brockbank, and the freelance copy-editor Colin Grant, and the designer Tim Harvey.

PERRIN STEIN
Curator
Department of Drawings and Prints
The Metropolitan Museum of Art
New York

MARTIN ROYALTON-KISCH
Senior Curator
Department of Prints and Drawings
The British Museum
London

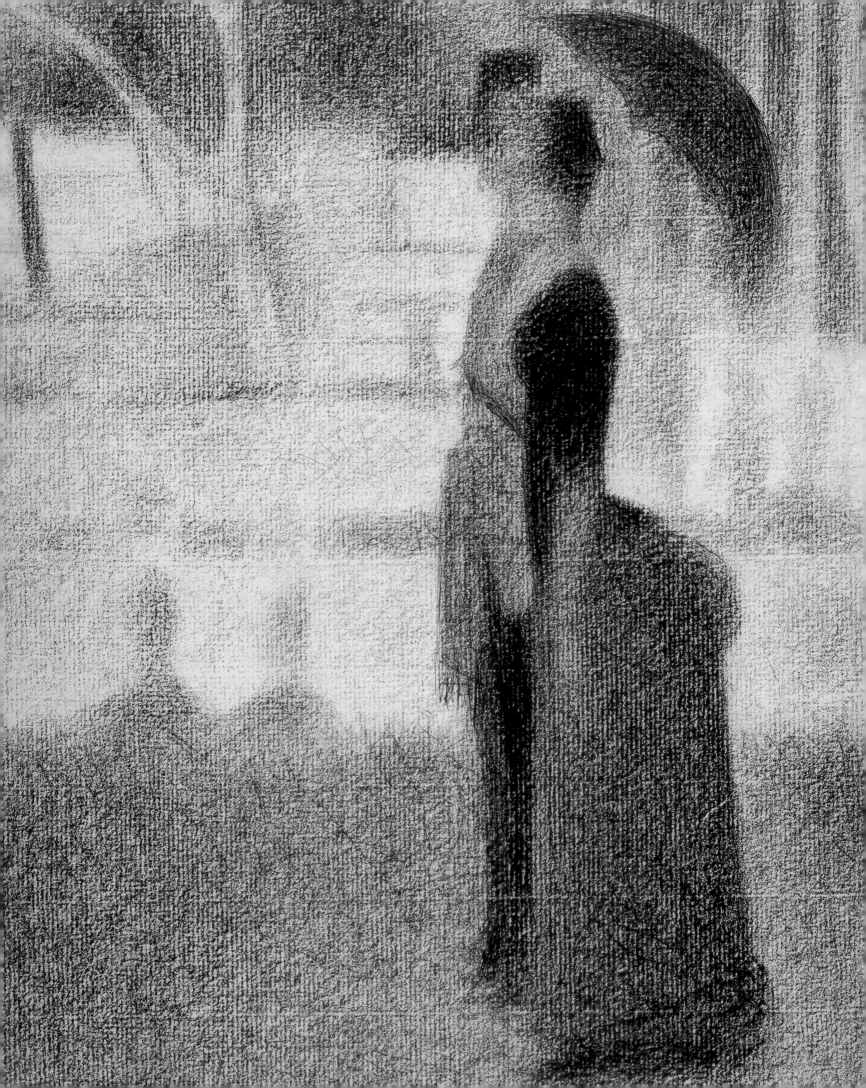

INTRODUCTION

Martin Royalton-Kisch

THE DRAWINGS IN CONTEXT: A BRIEF GUIDE

With some 3,500 sheets, the collection of French drawings in the British Museum is broad and deep enough to offer an extraordinary survey of French draughtsmanship. In the selection published here we cover the sixteenth to the nineteenth centuries, and in all but the last of these the collection boasts unrivalled numbers of drawings by a few major individual figures: the portrait painter François Clouet in the sixteenth (no.2), the landscapist Claude Lorrain in the seventeenth (nos 21–25), and Antoine Watteau at the dawn of the eighteenth century (nos 38–41). And although the nineteenth-century collection has no equivalent individual representation, it contains widely admired drawings by many of the most significant figures, including Ingres, Delacroix, Courbet, Degas and Seurat (nos 71–2, 75–6, 80, 85–6 and 91–2).

This essay surveys this material in two sections, the first being a very brief introduction to the development of French drawings based on the present selection; the second, a history of the growth of this part of the collection in the British Museum.

DRAWING IN FRANCE, FROM CLOUET TO SEURAT: AN OVERVIEW

In broad terms, French artists of the sixteenth century exhibit a strong allegiance to Flemish styles, as seen for example in the work of Jean and François Clouet (nos 1–2), into which an irruption of Italian influences took place under the patronage of the French crown, chiefly under François I and Henri II. To represent this facet of the period we have included works by two of the most gifted Italians who were employed at the royal residence, the Château de Fontainebleau: Francesco Primaticcio and Niccolò dell'Abbate (nos 3, 4 and 5). Their influence was exerted on many of their collaborators, although when examined alongside indigenous artists such as Jean Cousin the Elder and the Younger, Etienne Dupérac, and the botanical artist Jacques Lemoyne de Morgues (see nos 10–11), the great variety of their drawings reveals that there was little unity in French art of the period. Rather, it exposes the breadth of the foundations on which the art of France rose to such prominence in the centuries that followed.

By contrast, in the seventeenth century French art developed a considerably more unified national style. Given the exceptions formed by strongly individual personalities such as Jacques Bellange and Jacques Callot (respectively nos 12 and 14–16), who only qualify as French because their homeland, the Duchy of Lorraine, was much later subsumed into France (in 1766), there was a general consolidation of Italianate styles, conditioned by the study of the antique. The chief progenitor of this tendency was Nicolas Poussin (nos 18–19), and if the works of the artists he inspired, such as Eustache Le Sueur, Michel Dorigny and Charles Le Brun, can sometimes seem academic, a poetical sentiment usually inflects their ambitious compositions (nos 27, 28 and 29). The foundation of the French Royal Academy (the *Académie Royale de Peinture et de Sculpture*) in 1648

GEORGES SEURAT
The Couple: Study for 'La Grande Jatte', 1884, conté crayon (detail, enlarged).

assisted the process of stylistic unification, which mirrored the centralizing politics that came to characterize the French court under Louis XIV. On the other hand, the landscape painter Claude Lorrain stands apart from these developments, not least because he, like Bellange and Callot, came from Lorraine, and also because he spent almost his entire life in Rome, deriving inspiration from the Eternal City and its environs (nos 21–5).

Overall, of course, the situation was more complex, and styles were not rigidly fixed. Emulators of Rubens's painterly bravura, like Charles de La Fosse (nos 31–3), clashed with adherents of Poussin's cooler classicism. But the advent, early in the eighteenth century, of the more accessible style wrought by Antoine Watteau, the inventor of the idyllic scenes termed *fêtes galantes*, was sudden and barely anticipated (nos 38–41). Watteau melded the fascination that the theatre held for his teacher, Claude Gillot (no.37), with an idealized landscape style that was indebted to Venetian sixteenth-century art and to Claude Lorrain. The resulting compositions, strongly poetic and melancholic, stand apart from the academic mainstream. And while the latter remained a dominant force for artists such as François Lemoyne, Edme Bouchardon, Charles-Joseph Natoire, Jean-Baptiste-Marie Pierre and Jean-Baptiste Greuze (respectively nos 43–4, 45, 46, 49 and 55), the most successful official painter of all, François Boucher, assimilated many of Watteau's fluent, sensuous and decorative qualities early in his career (nos 47–8). For many other artists, including such original figures as Gabriel de Saint-Aubin and Jean-Honoré Fragonard (nos 54 and 56–8), whose art lay at the core of the decorative Rococo style, the chief inspiration came from Watteau's less formal approach, for all the old-style discipline instilled into them during their training at the *Académie Royale* (with which Saint-Aubin finally broke off his relationship, and from which Fragonard became increasingly detached).

The French Revolution of 1789 rapidly stifled these informal tendencies in French art. With Jacques-Louis David, himself a member of the new ruling Assembly, French art returned to a conservative classicism, albeit refreshed by his powerfully creative imagination (nos 64–5). Designed to reflect the aspirations of the new élite, subjects were introduced from ancient history to instruct the citizens of the new republic, which promoted the supremacy of the human intellect over spiritual or emotional considerations. The keen edge to the art that the Revolution inspired was soon compromised in the nineteenth century by a return to religious subject matter and the advent of sentimentality.

The resumption of more liberal tendencies in the art of the nineteenth century was neither rapid nor straightforward. For example, David's leading pupil, J.A.D. Ingres (nos 71–72), although chiefly remembered as a portrait painter and draughtsman, created numerous academic histories and allegories that do little to enhance his reputation today, despite their success in his own time. Indeed, a small army of painters, Jean-Léon Gérôme among them (no.83), continued to maintain the academic tradition. Yet, despite further alterations in subject matter and influences from the Orient, their efforts failed to rejuvenate French art. Nonetheless, Ingres, as a disciplined draughtsman and teacher, laid foundations on which a more powerfully poetic artistic personality like Edgar Degas (nos 85–6) could build (as did later Picasso). In Gustave Courbet (no.80) France finally produced a more truly revolutionary painter than David, one who succeeded in evolving a democratic vision, devoid of pomposity or sentimentality. Art was at last sufficiently liberated, in some circles, to develop its own momentum under the banner of art for art's

sake – *l'art pour l'art* – without depending on political or academic patronage. This new freedom, adumbrated in the works of the 'Romantics', Théodore Géricault, Eugène Delacroix and Victor Hugo (nos 73, 75–6 and 77), facilitated the flourishing, in the late nineteenth century, of Impressionism and Post-Impressionism. These were entirely liberal explorations of the formal possibilities of painting and drawing, explorations that were dependent on each artist finding an individual voice – in the process inevitably arousing the disquiet or even scorn of traditional, academic practitioners of painting. But the burgeoning avant-garde became unstoppable, and with works by Odilon Redon, Georges Seurat and Henri de Toulouse-Lautrec (nos 90–93), we bring our journey through French draughtsmanship to its astonishing and exhilarating conclusion; the contrast between their drawings and those by Ingres, let alone Clouet, could hardly be more stark.

THE COLLECTION OF FRENCH DRAWINGS IN THE BRITISH MUSEUM: A BRIEF HISTORY

The story of how these drawings came to the British Museum has never been told and holds a fascination of its own. It is a history of collecting and curatorial activity that combines tales of individual enthusiasms and eccentricities against the general background of government parsimony.

The database describing all the drawings in the Department of Prints and Drawings in the British Museum calculates that 3,536 of them are French. Although not entirely accurate, as the folios of some albums are counted individually, while others are not, the figure gives some idea of the extent of the collection. If the list is arranged chronologically according to the dates when the drawings were acquired, it begins with an undistinguished anonymous sheet depicting a *Cavalry Engagement* that came in 1753 with the founding bequest of Sir Hans Sloane (1660–1753). The drawing, thought to be seventeenth century, is somewhat ignominiously kept unmounted (in Sloane's day it would probably have been stuck into an album). The list of old masters currently ends with a group of three designs for medals by the sculptor Edme Bouchardon (1698–1762) that the Museum purchased at Christie's in Paris in 2004. French drawings continue to enter the collection, and many gaps and weaknesses remain, although the financial constraints imposed on the museum by successive governments, especially during the last ten years, have come near to stemming the flow. If it were not for a generous group of 'Patrons of Old Master Drawings', even the Bouchardon designs would have been beyond our reach, as official funds for acquisitions by the Department of Prints and Drawings are now restricted to a paltry £5,000 per annum.

Sir Hans Sloane's bequest of 1753, which led to the foundation of the British Museum, contained more than 200 French drawings, a few of them attributed to artists who have always figured on our list of desiderata, Jacques Bellange, Jean Cousin, Etienne Delaune, Jacques Callot (twelve drawings), Nicolas Poussin and Claude Gillot among them. Some uncertainties surround the accuracy of the first inventory of Sloane's collection, which was compiled more than eighty years later, in 1837. Yet we know that Sloane's main interest in drawings lay in those with a documentary value, because of what they represented, rather than in those with the potential to give aesthetic pleasure as works of art. Typically, his bequest contained albums of drawings of fauna and flora, primarily birds, plants, shells and insects, but in addition it featured depictions of 'curiosities' of the type

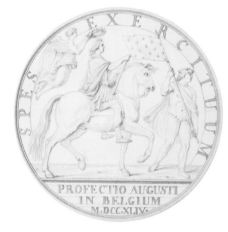

EDME BOUCHARDON (1698–1762)
Design for a Medal: the Departure of Louis XV for Flanders
Red chalk. 225 mm diameter.

A recent acquisition: this is one of 36 drawings sold together at Christie's in Paris in 2004. Three were acquired for the British Museum. The design was made into a medal by François Marteau.

Purchased with Funds provided by the Patrons of Old Master Drawings.
2004-4-29-3

that preoccupied the inquisitive during the Renaissance and Enlightenment periods, such as studies of bones, teeth and deformed animals.

More surprising is to find that Sloane may also have owned a drawing by his much younger contemporary, François Boucher (1703–70), and a somewhat erotic example at that (no.47). This study of a female nude, which was kept in one of Sloane's albums (one consisting mostly of Italian drawings), relates to a painting of 1731–2, so that he must have acquired it late in his life. But therein lies the difficulty caused by the inaccuracies in the earliest inventories: we cannot be entirely certain that the drawing was Sloane's. His albums were rearranged before any inventories had been drawn up, and it is likely that some drawings from other sources were mixed with Sloane's, although probably not very many. The broader picture is therefore less corrupted, and we can be sure that the French school accounted for less than 10 per cent of the drawings in Sloane's bequest. This modest percentage was not unusual, and characterizes the other three early bequests of drawings to the British Museum, those by William Fawkener (died 1769), Clayton Mordaunt Cracherode (1730–99) and – aside from his exceptional collection of Claude Lorrain – Richard Payne Knight (1751–1824).

For the first eighty years of the Museum's existence the acquisition of prints was given priority over drawings, and the few purchases that occurred were of prints. Drawings were never purchased until 1836, six years after the Trustees had felt unable to accept the offer of Sir Thomas Lawrence's collection in accordance with the terms of the artist's will. Yet by then, almost entirely thanks to the four donors we have named, there were already some 4,700 continental drawings in the collection. Sloane had supplied some 2,600 of them, of which 229 were French.[1]

Unlike Sloane, the interests or even passions of Fawkener, Cracherode and Payne Knight were focused above all on drawings as works of art, created by artists who had been singled out for their aesthetic appeal by high-minded connoisseurs – these very collectors among them. All three men belonged to the tradition of the 'gentleman amateur', the art lover whose tastes extended beyond merely decorative needs to the acquisition and even hoarding of large quantities of works of art. In the field of drawings the tradition gathered strength in England later than on the continent. It remained weak in the time of collectors such as Charles I and the Earl of Arundel, and gathered strength with figures such as Lord Somers (1651–1716) and William Cavendish, the second Duke of Devonshire (1672–1729). Although they were soon joined by other well-to-do, and often aristocratic, collectors, the drawings market was dominated, as it had already been in the later seventeenth century by Peter Lely (1618–80), by successful painters such as Jonathan Richardson (1665–1745) and his eponymous son (1694–1771), Thomas Hudson (1701–79) and Joshua Reynolds (1723–92). The combined wealth and enthusiasm of these two classes of collectors created a highly active market for drawings, and by the end of the eighteenth century, London had supplanted Amsterdam as the most important European location for auction sales and the art trade in general.[2]

French drawings, however, were never the chief priority. The gentlemen- as well as the artist-collectors, often inspired by journeys to Italy, above all sought out works by the great masters of the Italian Renaissance and Baroque periods. Raphael and Michelangelo headed their shopping lists, with later sixteenth- and seventeenth-century draughtsmen such as Annibale Carracci and Guercino not far below. It was therefore not unusual that

two-thirds of the Duke of Devonshire's collection consisted of Italian drawings, and many eighteenth-century collections had an even greater Italian bias. In the same way, of the 359 drawings bequeathed to the British Museum by William Fawkener in 1769, no less than 70 per cent were Italian. The French school was the next most important, but far behind, accounting for just 10 per cent. Of Fawkener's thirty-seven French drawings, twelve were by Jacques Callot (see nos 14–16), three by Raymond La Fage, two by Poussin (both since reattributed to his school) and two by François Chauveau.

The ratio of French drawings in Cracherode's bequest of 1799 was even lower. Of his 452 drawings, only 27 or 26 per cent were French. Nine of them were by Claude Lorrain, the first by this master to enter the British Museum, and five of them had been owned before Cracherode by the artist-collector, Jonathan Richardson the Elder. Richardson had assembled one of the most distinguished collections in England, following Lely's example in the seventeenth century. But once again, only about 1.5 per cent of Lely's and 4.5 per cent of Richardson's drawings were French,[3] while the Italians dominated with around 73 per cent of Richardson's collection and a staggering 89 per cent of Lely's. Although the availability of Italian drawings was greater, they were clearly also vastly more fashionable.

It is above all to Richard Payne Knight's bequest of 1824 that the British Museum owes its pre-eminent collection of drawings by Claude Lorrain. Of the 914 drawings in his collection, 290 – 32 per cent – were French, a high ratio. But of these, 270 – or 93 per cent – were by Claude! Claude was an inspiration to landscape designers, not least Payne Knight himself, who personally secured the residual contents of Claude's studio from the artist's heirs.[4] The small remainder of Payne Knight's French drawings included five by Poussin, two by Gaspard Dughet, two by Michel Corneille, two by Raymond La Fage and one by Antoine Watteau, the first of Watteau's drawings to arrive at the Museum (which now boasts a matchless collection of some fifty-two sheets).[5]

Since Payne Knight, with a few notable exceptions, the growth of the collection of French drawings has been sporadic. One such exception was the purchase in 1836 of 441 views of Egypt of antiquarian interest by Dominique Vivant Denon (1747–1825). Sloane would doubtless have approved of their documentary value. But in general, the rate of purchases was reduced to around three French drawings per annum, some of them distinctly odd choices, like the album of costume studies by an anonymous hand, purchased in 1841. Presumably their antiquarian interest was again the attraction. Through the 1840s and 1850s one dealer, named Rodd, sold the Museum a number of French and other drawings. Among them was a group, with three by Watteau, sold at Christie's in 1846 from the Vizconde de Castelruiz collection (whence came nos 20, 29, 50 and 55). In 1859 Rodd supplied a further fourteen drawings, two more by Watteau, the remainder by his emulator Nicolas Lancret (1690–1743). François Lemoyne's famous study of *Hebe* (no.44) arrived with five other French works purchased from Francis Duroveray's estate sale at Christie's in 1850 via another dealer who often acted for the Museum in these years, A.E. Evans (the drawing by Natoire, no.46, also came from this source). In 1857 it was again Evans who supplied the extraordinary album of the 'Cries of Paris' (*Cris de Paris*) by Edme Bouchardon (no.45). Two years later, in 1859, Walter Benjamin Tiffin, another member of the trade, who often acted for the Museum when securing Italian drawings, uncharacteristically supplied four works by Boucher.

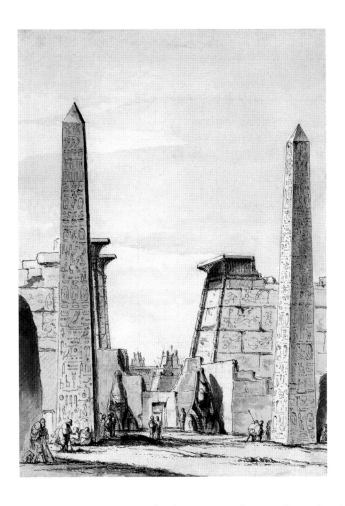

In the same year a further group of some forty drawings – some by non-French artists – was bought from the firm of Willis and Southeran. Most were portraits, with examples by Pierre Dumonstier II, François Clouet and Jacques Bellange. This spurt of purchases continued briefly in 1860–61 with the acquisition of eight drawings by Jacques Callot and two more by Watteau, and through the 1860s further, more modest groups of French acquisitions arrived, the name of Watteau featuring yet again, alongside Boucher and Fragonard. But it has to be said that vastly greater numbers of Italian and Netherlandish drawings entered the British Museum at this period. If anything, the French purchases became yet more haphazard, among the more intelligible being another Claude, acquired in 1866, that relates to his painting of the *Arrival of the Queen of Sheba* that had been acquired by the National Gallery in London in 1824.

This period, the second half of the nineteenth century, was marked by increasingly nationalistic attitudes on both sides of the English Channel, and the relative paucity of French acquisitions in these years reflects these rivalries. As a result, until 1895 there were few developments worthy of note. The arrival of Felix Slade's bequest in 1868 brought nine French drawings, not least another Watteau and four albums of designs by Jean-Michel Moreau le Jeune, made to illustrate a *History of France*. In 1872 some thirty-two French drawings were bought from various sources, but along with the eleven more acquired in 1874, and others later, the choice now seems inconsistent, including in 1874 a spectacular Watteau of an *Engraver Working at his Table* on the one hand, and a drawing by the indifferent François Boitard of the *Finding of Moses* on the other (both came from the

sale of Hugh Howard, Earl of Wicklow). During the 1880s some nineteenth-century drawings were collected, supplied by Alphonse Wyatt Thibaudeau, a prominent dealer who perhaps influenced this development; and in 1886 the architectural drawings of Jacques Androuet Du Cerceau from George III's library were transferred to the Department of Prints and Drawings from the British Museum Library, where they had been housed since 1828. Drawn on large sheets of vellum, they are fragile to transport and we have therefore reluctantly omitted them from the present selection.

The acquisition of the collection of John Malcolm of Poltalloch with a special government grant in 1895 brought the next – and much needed – injection of high quality drawings.[6] Although a mere sixty-five of his 968 drawings were French, he owned twenty-six by Claude, fourteen by Watteau (one of them being no.40) and seven by Poussin. Their arrival may have inspired some further French acquisitions of the same year, not least the purchase of twenty-four drawings by Callot, three by Charles Meryon and one by Jean-Baptiste Greuze. In 1900 six more Claudes and five more Watteaus arrived with Henry Vaughan's bequest, matched precisely in number by George Salting's bequest of 1910 (see no.2).

This was soon before the outbreak of the First World War in 1914, by which time the Museum had initiated a more active policy of acquiring nineteenth-century drawings, including examples by Théodore Géricault, Eugène Delacroix, Jean-François Millet (no.79), Théodore Rousseau, Constant Troyen, Henri Fantin-Latour (no.87) and Théophile-Alexandre Steinlen. The last came as a gift from Campbell Dodgson, who as a curator and later as Keeper of the Department amassed an extraordinary array of prints and drawings that he gave or bequeathed to the Museum. Among them were forty French drawings, six of them by Odilon Redon, who would otherwise remain poorly represented.[7] Other, more modern acquisitions from before the First World War came through the critic Claude Phillips, who in 1905, while employed as Keeper of the Wallace

JACQUES ANDROUET DU CERCEAU
(1550–1614)
The Château de Boulogne, called Madrid
Pen and black ink with grey wash on vellum.
518 × 749 mm.

The drawing is one of a series of 122 drawings of French châteaux, many of which were reproduced as etchings in the artist's book, Les plus excellents bastiments de France, 1576–79. They came to the British Museum in 1828 with the acquisition of the King's Library, and were transferred to the Department of Prints and Drawings in 1886. The Château de Boulogne was built for François Ier and demolished in the late eighteenth century.
1972.U.1351

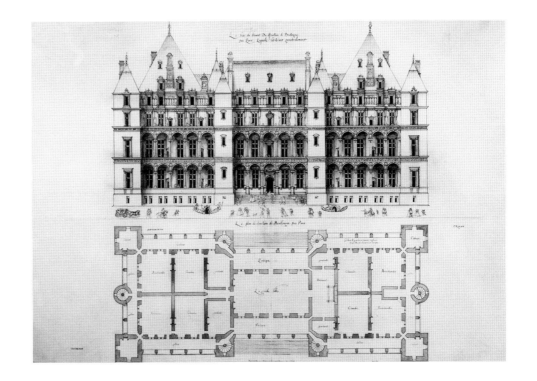

Collection, donated two sketches by Auguste Rodin, and through the artist Lucien Pissarro, who gave two drawings by his father Camille in 1912.

With some notable exceptions, the twentieth-century acquisitions gradually increased the scope of the collection of post-1850 French drawings. The chief exceptions, providing further works by old msters, were donations: Fragonard's sketchbook covering his Italian journey with the Abbé De Saint-Non in 1761, given by Mrs Spencer Whatley in 1936 (see nos 56–7); the bequest of Eric Rose in 1943, bringing ten French drawings, works by Nicolas Lancret and Charles-Joseph Natoire among them; and the Phillipps-Fenwick collection in 1946 (see nos 18, 36 and 62), mostly acquired by Sir Thomas Phillipps at the dispersals of Thomas Lawrence's collection in 1860, with seventy-seven French drawings by such artists as Poussin, Dughet, Le Brun, La Fage, Boucher and, intriguingly, eight drawings by Paul Delaroche. In 1957 Claude's *Liber Veritatis* or 'Book of Truth' was allocated to the Museum in lieu of inheritance tax by the Treasury (see no.25). This had come from the collections of the Dukes of Devonshire at Chatsworth. The acquisition in 1962 of Jacques Le Moyne de Morgue's album of fifty-one watercolours of flowers would have been impossible without special grants from the National Art-Collections Fund and the Pilgrim Trust (see nos 10–11); and the following year twenty-two French drawings were purchased from the collection of the late Bruce Ingram, who owned works by Callot, Dughet, Etienne Jeaurat, Boucher, Hubert Robert, Jean-Baptiste Pater, Gustave Doré and Philippe Auguste Hennequin (here no.69).

The National Art-Collections Fund (now known as The Art Fund) had already provided financial assistance towards some distinguished French acquisitions before: a Courbet in 1925 (no.80), an Ingres in 1938, two Bouchers in 1944 and a drawing attributed to Jacques Bellange in 1946. But in general, as we have seen, the Museum's already meagre finances were focused on the period after around 1850. Of particular interest, for a variety of reasons, were the three sketches by Eugène Boudin which came from the French critic and art-historian Claude-Roger Marx in 1928; the splendid Victor Hugo purchased in 1930 (no.77); the gift of drawings by Paul Helleu and Steinlen by the artist Frank Brangwyn in 1943; and the gift from Kenneth Clarke of a minor sketch by Paul Cézanne in 1952.

In recent years we have had to rely increasingly on gifts and bequests. Some money was allocated by the Trustees of the British Museum in the 1980s and 1990s to improve the nineteenth-century French collections, but recent cuts of 30 per cent in real terms in the government's grant to the Museum has halted this initiative. This is regrettable, as the funds had been applied to purchases that represented excellent value. Ten drawings in the present selection were acquired in the last twenty years, mostly for a modest financial outlay.[8]

This initiative had been largely inspired by the extraordinary bequest of César Mange de Hauke (1900–65), comprising sixteen items of the highest quality, thirteen of them French drawings of the nineteenth century.[9] As a youngster, Mange de Hauke was sent to a private preparatory school in England, which he apparently enjoyed. When a young man, his interest in art already kindled, he came to the Department of Prints and Drawings. He was made welcome and permitted to see whatever he wanted in a manner that he thought, later in life, would be difficult to replicate elsewhere. At his death, to the considerable chagrin of some institutions, he expressed his gratitude by bequeathing

the cream of his collection of drawings to the British Museum. No less than eight of them feature in this selection, masterpieces by Ingres, Delacroix, Daumier, Degas, Seurat and Toulouse-Lautrec (nos 71, 75, 78, 85–6 and 91–3). Mange de Hauke had simply been a beneficiary of the British Museum's traditional policy of open access. This has always formed a central plank of the Museum's *modus operandi*, and is threatened only by the retrenchment in the resources the government provides. But inspired by the continuing generosity of many donors, we hope to continue encouraging all-comers to enrich their lives through a knowledge of our collections and to improve our holdings through further acquisitions.

NOTES

1 The computer provides these figures, which includes the contents of some albums of drawings that were much later transferred from the British Museum Library (known as the Departments of Printed Books, Manuscripts and Maps), now the British Library.

2 For the Amsterdam collectors, see Michiel Plomp, *Collectionner, passionément: les collectionneurs hollandais de dessins au XVIIIe siècle*, Paris, 2001.

3 These figures are based on the samples of their collections now in the British Museum, which probably give an approximately correct picture.

4 For Payne Knight see Michael Clarke and Nicholas Penny (eds), *The Arrogant Connoiseur: Richard Payne Knight*, Manchester 1982.

5 Based on those still attributed to Watteau himself by P. Rosenberg and L.A. Prat, *Antoine Watteau 1684–1721: catalogue raisonné des dessins*, Milan, 1996.

6 For Malcolm, see M. Royalton-Kisch (ed.), *Old Master Drawings from the Malcolm Collection*, exh. cat., British Museum, London, 1996 (especially the introduction by Stephen Coppel).

7 See the essay on Dodgson by Frances Carey in Antony Griffiths (ed.), *Landmarks in Print Collecting*, exh. cat., Museum of Fine Arts, Houston; Huntingdon Library, San Marino; Museum of Art, Baltimore; and Institute of Fine Arts, Minneapolis, 1996–7, pp.211–24.

8 The push to improve the holdings of nineteenth-century drawings was initiated by Nicholas Turner, who was the curator responsible for the French school. He left the British Museum to work in America in 1994 when this responsibility passed to the present writer.

9 See P.H. Hulton, *The César Mange de Hauke Bequest*, exh. cat., British Museum, London, 1968. The other three items were a monotype by Gauguin, a watercolour by Johan Barthold Jongkind and a drawing by Van Gogh.

overleaf
LÉONARD THIRY
Christ on the Road to Calvary, pen and black ink, brush and grey wash, white gouache, on blue-green prepared paper (detail, enlarged).

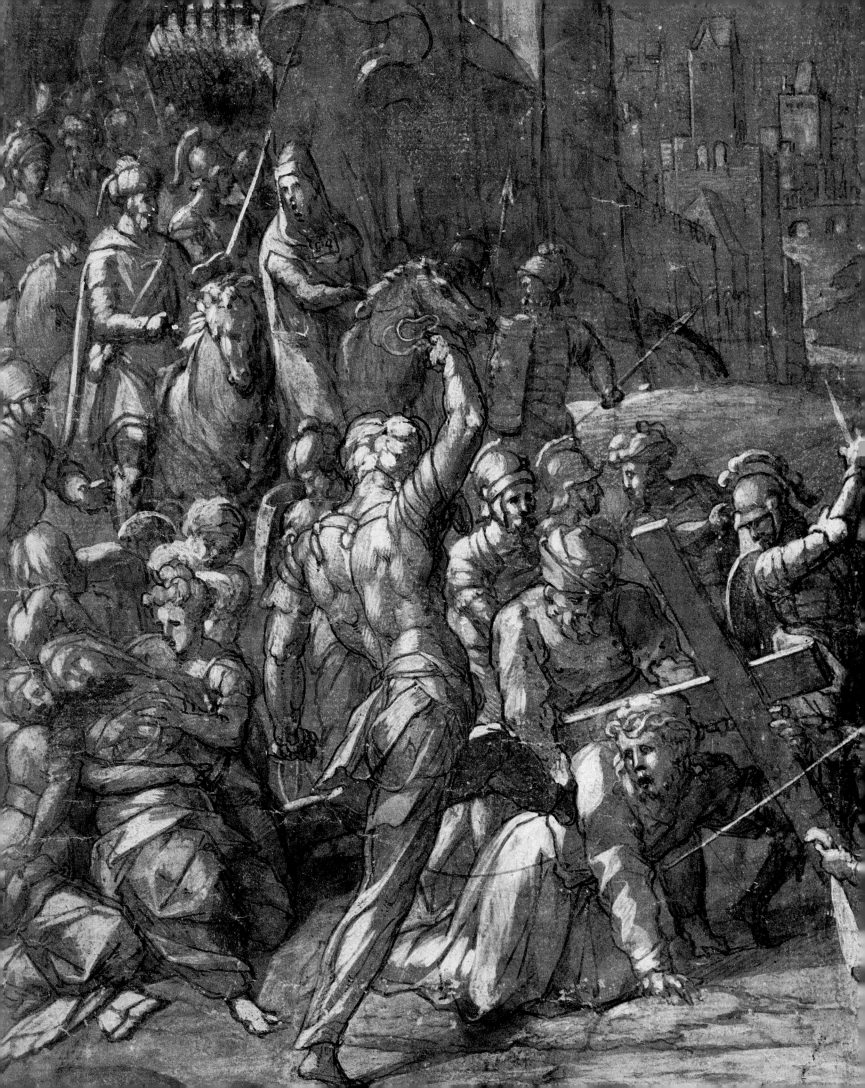

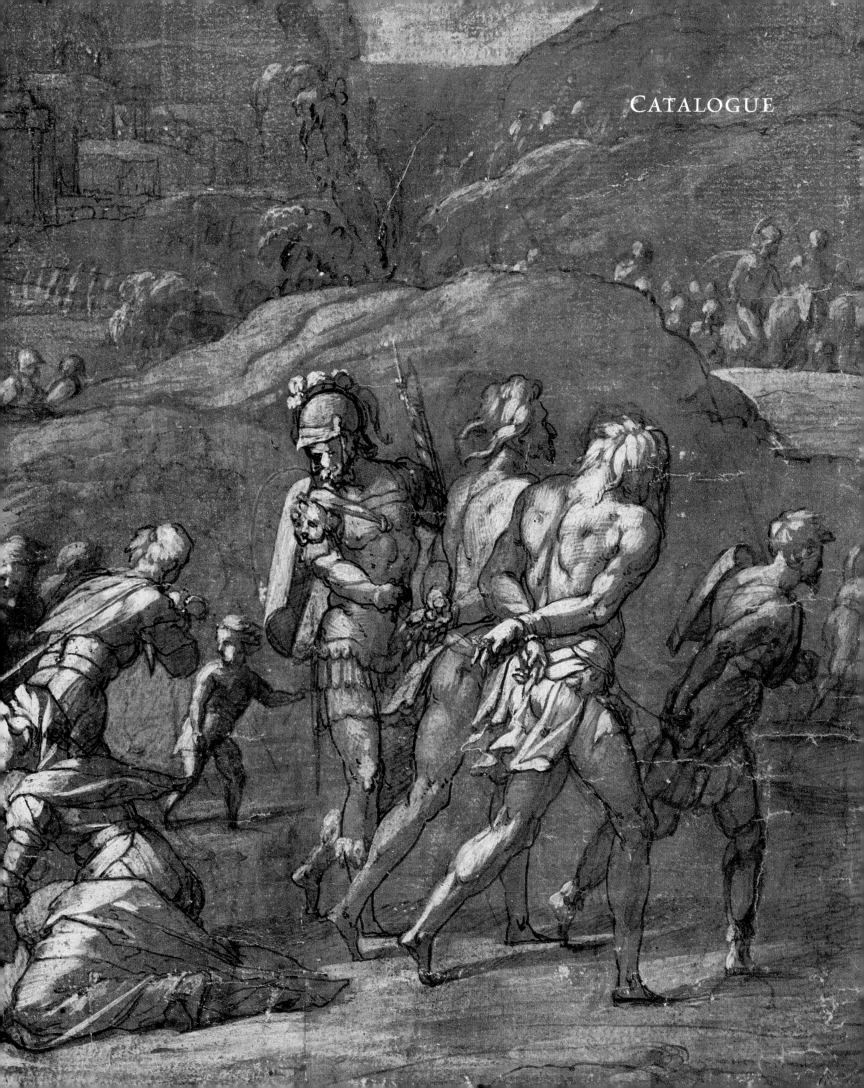

JEAN CLOUET

c.1475/1485 Brussels? – 1540 Paris

1 Portrait of a Young Woman

The drawing of portraits in colour, achieving a pictorial effect through the mixing of red and black chalk, seems to have been a French invention. The earliest extant example (*Guillaume Jouvenel des Ursins*, c.1460–65, Kupferstichkabinett, Berlin) is by Jean Fouquet (c.1420–c.1481), and it is probable that Jean Perréal (c.1455–1530) and Jean Bourdichon (c.1457–1521), court artists to François I (1494–1547) also made use of the process.[1] The first artist for whom there survives a large group of coloured drawings is Jean Clouet. Though he did not invent the technique, Clouet is credited with perfecting it.

Clouet is recorded in the employ of the French court in 1516, working principally as a portraitist. There is little reason to doubt that most, if not all, of his known drawings were preparatory to paintings. Often he drew the heads alone or indicated costume in the most rudimentary fashion. There is no attempt to hide alterations or pentimenti, and in a few cases colour notes for the clothing appear on the verso.[2] Clouet's style is characterized by a delicate handling of the chalk; the planes of the face are typically modelled in soft diagonal hatching, from upper right to lower left, blending black and red to produce naturalistic flesh tones, effects that have been compared to the *sfumato* of Leonardo. In addition, the British Museum drawing uses graining – a manner of shading with chalk that exploits the texture of the paper to create a half-tone – for the shadows beneath the jawline, the nostrils and the lips. The composition adheres to Clouet's favoured formula, showing the sitter bust length, in three-quarter view, her glance oblique. The artist's attention was focused on her luminous and untroubled countenance, with only minimal indications for her dress. It was, almost certainly, drawn from life.

Whether and to what degree Jean Clouet's preparatory drawings were appreciated as independent works of art during his lifetime is not known. Alexandra Zvereva has plausibly suggested that at least the majority would have remained in his studio and gone at his death to his son François, also a portraitist.[3] Presumably, at some point while Catherine de Médicis (1519–89) was building her collection of portrait drawings, François Clouet either gave or sold his father's drawings to her. Many of them were annotated decades after Jean Clouet's death by either Catherine or one of her secretaries. In a number of cases, including the present sheet, the drawings lack annotations, most probably indicating that the identity of the sitter was not known to Catherine.

Black and red chalk

Inscribed in black chalk on the verso, *An original drawing by Clouet / La Reine Marguerite de Navarre / Collection of Francis Godolphin*, and in pen and brown ink in another hand, *F. Godolphin / May 4. 1738*

289 × 196 mm

PROVENANCE: Probably, with the contents of the artist's studio, to François Clouet; Catherine de Médicis; by descent to her granddaughter Christine of Lorraine, Grand Duchess of Tuscany; by descent through the house of Médicis to grand duke Jean-Gaston de Médicis; Ignazio Enrico Hugford (who attributed the group to Holbein), Florence, by 1737; sold in 1738 to Lord Treasurer Francis Godolphin (1678–1766), 2nd Earl of Godolphin; probably to his cousin Francis Godolphin (c.1707–85), 2nd Baron Godolphin of Helston; probably to his widow Lady Anne Godolphin; possibly included in the sale of the collection of the late Francis Earl of Godolphin, Christie's, London, 6–7 June 1803 (possibly as part of lot 33, as Hans Holbein the Younger, 'A Man's Portrait, ditto a Lady's, small, and a study of a Boy's Head, Correggio', bought by Walton); Frank T. Sabin

1908-7-14-46

LITERATURE: Moreau-Nélaton, 1924, II, fig.315, III, p.127, no.34; Dimier, 1924–6, I, pl.4, II, p.14, no.39; Mellen, 1971, pp.216–17, no.24, pl.32; Chantilly, 2002, p.17 note 46

EXHIBITIONS: London 1984b, p.123, no.114; Nagoya and Tokyo, 2002, p.30, no.4

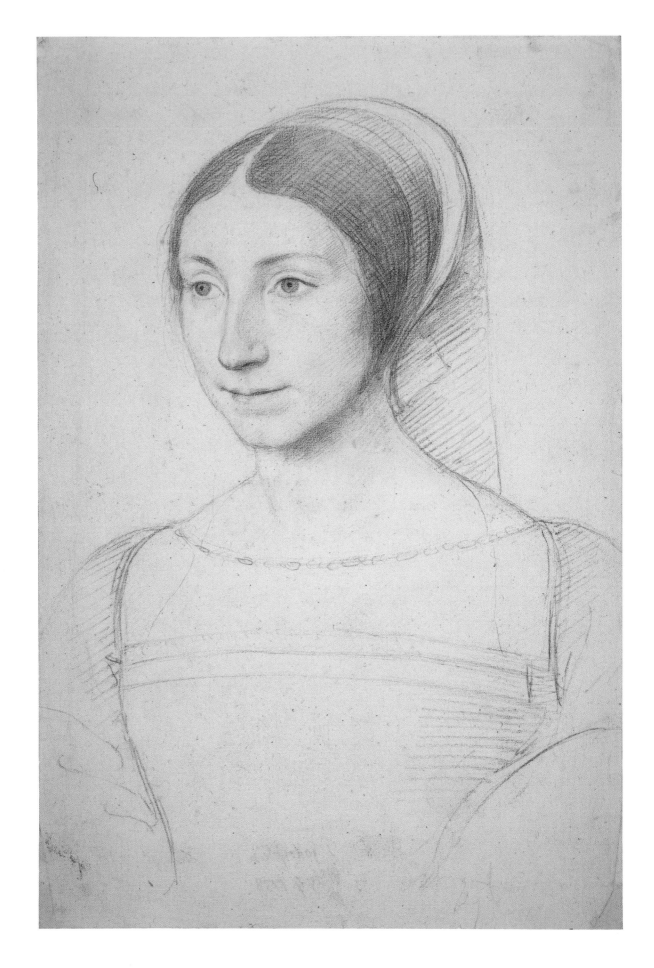

François Clouet (?)

c.1515 Tours – 1572 Paris

2 Portrait of King Charles IX as a Young Boy

On the death of his father Jean (see no.1) in 1540, François Clouet succeeded to his position at court and the salary that accompanied it. The French law dictating that the estate of a foreigner dying on French soil became the property of the crown was waived in this case by François I (1494–1547), who also granted letters of naturalization to François Clouet for 'ttrès bien imyté' his father.[3] Although formed in the style of his father, François Clouet's draughtsmanship can ultimately be distinguished by its more sculptural conception of the face, with less prominent diagonal hatching and greater detail in the treatment of the clothing. In part, these changes were a function of the interest of Catherine de Médicis (1519–89), Henry II's wife, in collecting portrait drawings and the attendant shifts in artistic style that brought about the rise of the portrait drawing as a finished autonomous work in France from around 1560.

As a collector, Catherine followed the model of François I, commissioning portraits of the royal family and members of the court, although her particular passion for drawings ultimately led her to amass 551 portraits on paper. François Clouet was a favoured portraitist, but Catherine also patronized a number of his contemporaries as well as acquiring the drawings of his father Jean. She was driven by personal, genealogical and artistic interests and spent much of the 1560s arranging, annotating and building her collection, which she kept unbound in special boxes in a private chamber.[4]

Annotations on the drawings, giving the name and title of the sitter, offer some evidence of Catherine's organization of the collection. Alexandra Zvereva has divided the annotated sheets into five groups, of which three seem arbitrary while two are much larger and present rational compilations of members of the royal family and the French court. The latter are termed 'group M' and 'group A', and each bears inscriptions by a single hand. For 'group M', to which the present sheet undoubtedly belongs, Zvereva hypothesized that the secretary making the annotations may have been Italian.[5]

From the apparent age of the sitter the British Museum portrait of Charles IX (1550–74) must have been part of a group of portraits that Catherine commissioned of her children around 1556. The inscription, however, would have been added years later, as it refers to Charles IX as king – therefore after his coronation in 1561 – but describes the sitter as 'when he was duc d'Orléans', a title he gained as a young child following the death of his elder brother Louis. The present drawing can be connected to two portraits of Charles IX's brothers, *Hercule-François* (fig.1) and *François II* (private collection, Switzerland), done at the same time, perhaps part of a larger commission for effigies of the royal children.[6] As half-length views, they are unusual among the Clouet portrait drawings both for their inclusion of the sitter's hands and for their detailed and pictorial treatment of the elaborate clothing. Zvereva catalogued *Hercule-François* as 'François Clouet?'. The high quality of the group and the importance the commission must have had for Catherine certainly support the possibility that they are autograph works.

Black and red chalk

Inscribed in pen and brown ink at upper right, *le roi Charles ix^e estamt / duc d'orleams*

327 × 225 mm

PROVENANCE: Catherine de Médicis; by descent to her granddaughter, Christine of Lorraine, Grand Duchess of Tuscany; by descent through the house of Médicis to Grand Duke Jean-Gaston de Médicis; Ignazio Enrico Hugford, Florence, by 1737 (who attributed the group to Holbein); acquired by John Bouverie in 1740 (as part of a collection of 32 portraits assembled by Hugford); probably by descent to Christopher Hervey; Elizabeth Bouverie; Sir Charles Middleton, later 1st Lord Barham; Sir Gerard Noel Noel;[1] bequeathed by George Salting (1835–1909)[2]

1910-2-12-58

LITERATURE: Moreau-Nélaton, 1908, p.15, pl.VI; Moreau-Nélaton, 1924, II, fig.319, III, p.127, no.40; Dimier, 1924–6, I, pl.4, II, p.135, no.10 (as 'le peintre de Luxembourg-Martigues'); Jollet, 1997, pp.73, 230 (as François Clouet); Chantilly, 2002, pp.17, 68 and 70 note 1

EXHIBITIONS: Nagoya and Tokyo, 2002, pp.31–2, no.6 (as François Clouet)

Fig.1 FRANÇOIS CLOUET (?), *Hercule-François, Duc d'Alençon*, c.1556, red and black chalk, 332 × 227 mm, Musée Condé, Chantilly (inv.MN 40).

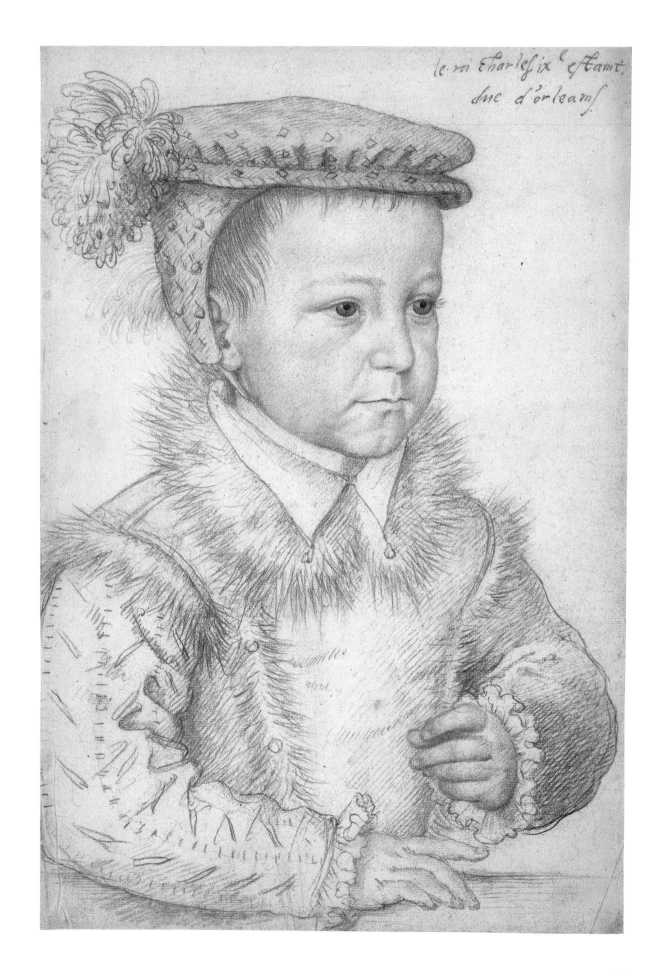

le roi Charles ix e estant
duc d'orleans

27

FRANCESCO PRIMATICCIO

1504 Bologna – 1570 Paris

3 A Seated River God with a Nymph, Two Dogs and the Banished Callisto

To rebuild and decorate a ruined medieval castle in the forest of Fontainebleau as his primary residence and the centre of court life, the French king François I sought the services of leading Italian artists. With the arrival of Rosso Fiorentino (1494–1540) in 1530 and Primaticcio in 1532, an international team of Italian, Flemish and French artists and craftsmen was assembled to execute a series of decorative ensembles. In this collaborative milieu a distinctive style, referred to as the School of Fontainebleau, was forged that set elegant Mannerist compositions within rich and dense compartmentalized schemes of high stucco relief and painted ornament, harnessing a classical vocabulary to a playful and erotic sensibility.

Primaticcio was born in Bologna and worked with Giulio Romano (?1499–1546) on the decoration of the Palazzo del Tè in Mantua, but spent his entire mature career in France working for a succession of French kings on various projects for the Château de Fontainebleau. While very few of these interiors survive, the innovative designs that influenced a generation of artists are recorded to some degree in the large body of extant drawings and reproductive prints. One of the most spectacular spaces must have been the Appartements des Bains on the ground floor below the Galerie François I, a series of richly decorated rooms devoted to bathing and relaxation, in which were displayed masterpieces from the royal collection, such as Leonardo da Vinci's *Virgin of the Rocks* (1483–6) and Andrea del Sarto's *Charity* (1518; both Louvre, Paris).

From descriptions it is known that the fifth room contained a small pool and was decorated with scenes from the story of Jupiter and Callisto.[1] The British Museum drawing was the design for the right half of a lunette depicting Diana banishing Callisto after discovering her pregnancy.[2] A study for the left half of the lunette is in the Louvre, Paris (fig.1).[3] The compositions of the two drawings overlap somewhat, whereby the seated nymph to the right in the Paris sheet is summarily repeated on the left of the London sheet. In a typical Mannerist inversion the central figure of the narrative, the outcast Callisto, is relegated to the background. Primaticcio's attention is focused on the figure of the river god anchoring the right corner of the lunette. Aged and muscular, he is embedded, almost imprisoned, in the rocky grotto that surrounds him, analogous to the figures of the grotto of the Jardins des Pins at Fontainebleau, a portion of whose façade survives today with rusticated atlantes supporting stone arches.[4]

Pen and brown ink, brush and brown wash, heightened with white gouache, over traces of black chalk on light brown prepared paper; squared in black chalk

240 × 353 mm

PROVENANCE: Pierre Crozat (1665–1740; his numbering at lower right, '7'); his estate sale, Paris, 10 April–13 May 1741 (possibly part of lot 403, 404 or 405); Pierre-Jean Mariette (1694–1774; Lugt 2097); his estate sale, Paris, 15 November 1775 and days following (possibly lot 623); Sir Thomas Lawrence (1769–1830; Lugt 2445); Samuel Woodburn (1780–1853); his sale (of drawings from Lawrence's collection), Christie, Manson & Woods, London, 6 June 1860, lot 644; John Malcolm of Poltalloch; Colonel John Wingfield Malcolm; acquired with the Malcolm Collection in 1895

1895-9-15-676

LITERATURE: Robinson, 1876, p.90, no.235; Dimier, 1900, pp.283, 426 and 455–6, no.164; Paris, 1972, p.147, under no.157; Béguin, 1992, pp.90–91 note 13; Eschenfelder, 1993, pp.46–7, fig.4; Los Angeles, New York and Paris, 1994, pp.254–6, under no.48

EXHIBITIONS: London, 1951, p.30, no.84; Paris, 2004, pp.189, 191, 195, 197, no.72

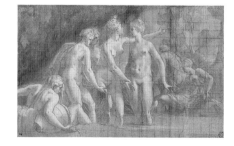

Fig.1 FRANCESCO PRIMATICCIO, *Diana and her Nymphs at the Bath*, pen and brown ink, brush and brown wash, heightened with white gouache on beige paper, squared in black chalk, 214 × 345 mm, Musée du Louvre, Paris (inv.8521).

FRANCESCO PRIMATICCIO

1504 Bologna – 1570 Paris

4 Minerva Carried to Heaven by the Graces

In four decades working for four successive French monarchs at the royal château of Fontainebleau, Primaticcio's most ambitious and most celebrated project was the decoration for the Galerie d'Ulysse (destroyed 1738). For this exceptionally long space occupying the entire south wing of the Cour du Cheval Blanc on the second floor, Primaticcio devised a complex decorative scheme. The space was divided into fourteen sections with smaller bays at each end; corresponding compartments on the barrel-vaulted ceiling were decorated with painted mythological and allegorical scenes set within a symmetrical framework of stucco work and grotesques. The walls of the gallery, by contrast, featured a narrative sequence of scenes drawn from Homer's *Odyssey*. The decoration of the gallery occurred over an extended period of time, with the schematic plan probably having been devised in the early 1540s, shortly after the death of Rosso, and a good portion of the ceiling was completed before the death of François I in 1547. The vault was largely complete by about 1550 when other projects diverted Primaticcio's energies for several years before he returned to oversee the completion of the walls between 1555 and 1560. From descriptions in eighteenth-century guidebooks *Minerva Carried to Heaven* has been identified as a study for the central image of the twelfth compartment of the ceiling of the Galerie d'Ulysse,[3] although any iconographic relationship between the principal and subsidiary scenes of each section of the vault, or between the imagery of the vault and the Ulysses cycle, has eluded scholars.[4]

Given the span of time over which the project occupied Primaticcio, it is not surprising that a stylistic evolution has been detected in his drawings for the project, with many of the pen and brown wash drawings associated with the earlier stages, and the red and white chalk studies seen as dating later in the process. In the British Museum *Minerva* Primaticcio's mastery of the chalk medium is evident in the convincing modelling of volume and the play of light. The detailed rendering of the drapery, sandals, sword and helmet suggests that the sheet represents a late stage in the compositional process, although the shaped surround is only sketchily indicated. The dense arrangement of muscular forms seen from below was one of Primaticcio's great skills, a facility in the invention of elegant and unconventional poses recalling his early study with Giulio Romano (?1499–1546) as well as his admiration for the work of Correggio (c.1489–1534) and Parmigianino (1503–40).

Red and white chalk on light brown prepared paper, squared in red chalk, red wash border

Inscribed at lower right in pen and red ink, *Bologne*, and in pen and black ink, 36

230 × 233 mm

PROVENANCE: Ercole Lelli? (1702–66; Lugt supplement 2852, his mark at lower left); Pierre-Jean Mariette, Paris (1694–1774; Lugt 2097, his mark at lower left); probably in his estate sale, Paris, 1775 (part of lot 628 or 632?); possibly Robert Udny (1722–1802);[1] his estate sale, 4–10 May 1803,[2] lot 328); Sir Thomas Lawrence (1769–1830; Lugt 2445, his blind stamp at lower left); John Malcolm of Poltalloch; Colonel John Wingfield Malcolm; acquired with the Malcolm Collection in 1895

1895-9-15-677

LITERATURE: Robinson, 1876, no.236; Dimier, 1900, p.456, no.165; Béguin, Guillaume and Roy, 1985, pp.182–6, fig.94; Paris, 2004, p.314, under no.153

EXHIBITIONS: London, 1951, p.30, no.82; Nagoya and Tokyo, 2002, pp.26–7, no.2

Bologne

36

Niccolò dell'Abbate

1509/12 Modena – 1571 Fontainebleau?

5 Charity

When dell'Abbate left his native Italy for France in 1552 at the invitation of the French king Henri II (1519–59), he was already a mature artist who had produced decorative cycles, landscapes and altarpieces in Modena and Bologna. He worked at Fontainebleau for Francesco Primaticcio (1504–70; see nos 3, 4) and proved an ideal collaborator; his skill at interpreting Primaticcio's drawings in fresco allowed Primaticcio to increasingly devote himself to design and conceptualization, while entrusting the execution to others. Dell'Abbate remained in France until his death in 1571 and was largely responsible for the completion of the Galerie d'Ulysse and the painting of the Salle de Bal. Although he was initially brought to Fontainebleau as Primaticcio's subordinate, the relationship soon became reciprocal. Dell'Abbate's style evolved in response to the richly ornamental manner of decoration that Rosso Fiorentino (1494–1540) and Primaticcio had formulated at Fontainebleau, while his own brand of Emilian Mannerism, based heavily on the model of Parmigianino (1508–40), would reinvigorate Primaticcio's style, formed in the same milieu.

In addition to his work at the Château de Fontainebleau, dell'Abbate was also engaged in the decoration of several private residences in Paris: the Hôtel de Guise, the Hôtel de Toulouse and the Hôtel du Faur, called Torpanne. The present sheet must be a study for such an independent commission. It was considered by early collectors to be by Primaticcio, until Frederick Antal recognized dell'Abbate's characteristic draughtsmanship, where forms are delineated with incisive outlines on light brown prepared paper and modelled in an elaborate mesh of parallel hatching, with brown ink and gouache hatching for the shadows and highlights.[1] Philip Pouncey identified a close variant of the composition in a painting sold at auction in 1981.[2] Bearing the signature of Pierre Scalberge (c.1592–1640) and dated 1631, it presumably records the composition of the lost painting for which the British Museum drawing is a study.

At the time it was in Jabach's collection, the present drawing was followed in the same portfolio by a drawing of Abundance described as a seated Flora with three putti (fig.1; Musée des Arts décoratifs, Paris) likewise considered by Jabach to be by Primaticcio and today attributed to dell'Abbate.[3] Comparable in format, technique and scale, the Paris *Abundance* and London *Charity* are also linked by similarities in their compositional strategies.[4]

Pen and brown ink, brush and brown wash, white gouache, over traces of a black chalk underdrawing, on light brown prepared paper, squared for transfer in black chalk

278 × 212 mm

PROVENANCE: Abbé Desneux de la Noue, Paris (died before 1657; Lugt 661, his paraph on verso); probably Everhard Jabach (1618–95; no.179 in the 1695–6 inventory, as by Primaticcio); to his widow Anne-Marie de Groote (died 1701); to their son Everhard Jabach (1658–1721); Gerhard Michael Jabach; his sale, Amsterdam, October 16, 1753 (lot 347); Brunet; Sir Thomas Lawrence (1769–1830; Lugt 2445, blind stamp at lower left); the executor of Lawrence's estate sold the drawings to Samuel Woodburn (1786–1853), London, in 1835; sale (of the Lawrence drawings from the Woodburn estate), Christie's, London, 4–16 June 1860 (part of lot 645); presented by Miss Kate Radford

1900-6-11-6

LITERATURE: Py, 2001, p.70, no.160

EXHIBITIONS: London, 1951, p.33, no.99; Tokyo and Nagoya, 1996, p.114, no.40, English supplement p.28; Modena, 2005, pp.431–2, no.217 (entry by Nicholas Turner)

Fig.1 NICCOLÒ DELL'ABBATE, *Abundance*, black chalk, pen and brown ink, heightened with white gouache on light brown prepared paper, squared in black chalk, 278 × 223 mm, Musée des Arts décoratifs, Paris (inv.16438).

33

LÉONARD THIRY

Active Fontainebleau 1536, died 1550 Antwerp

6 Christ on the Road to Calvary

From at least the time it was in Everhard Jabach's collection in the seventeenth century this powerful sheet was considered to be the work of Rosso Fiorentino (1494–1540), a Florentine Mannerist artist employed by François I to decorate the interiors of his château at Fontainebleau.[2] The suggestion that the author of the sheet was not Rosso but his talented assistant and collaborator from Antwerp, Léonard Thiry, was made by Frederick Antal in 1931 and quickly gained widespread acceptance.[3]

Thiry is listed on the payroll at Fontainebleau several times between 1536 and 1540: aiding Rosso in the decoration of the Galerie François I and the Cabinet du Roi, and assisting Primaticcio with the Chambre du Roi as well as the rooms below the Galerie François I. Thiry's activities at the French court also included several series of designs for prints engraved by René Boyvin, Léon Davent and Jacques Androuet du Cerceau and many ornamental designs for decorative luxury objects and masquerade costumes.[4] The British Museum drawing, however, cannot be associated with any known commission or project, nor are there any drawings of similar technique associated with Thiry's hand. Thiry's work for the French court at Fontainebleau is not known to have included religious subjects of this type.

In a pair of articles published in 1996 Nicole Dacos set forth a thesis linking Thiry to Bernard van Orley's studio and proposing an early trip to Italy based on visual borrowings from Roman artists.[5] For Dacos many visual elements of the drawing have their source in Thiry's Flemish training.[6] However, until further documents or evidence come to light, proposals for Thiry's activities or whereabouts before and after his recorded presence at Fontainebleau will remain speculative.

Pen and black ink, brush and grey wash, white gouache, on blue-green prepared paper

244 × 356 mm

PROVENANCE: Everhard Jabach (1618–95), traces of his gold border along bottom edge (described in the 1695–6 inventory as by Rosso Fiorentino); to his widow Anne-Marie de Groote (died 1701); to their son Everard Jabach (1658–1721); Anton Maria Zanetti (1680–1757); Zanetti family, Venice; sold in 1791 to Jean-Baptiste-Florentin-Gabriel de Meryan, Marquis de Lagoy (1764–1829; Lugt 1710, his mark at lower right);[1] Alphonse Wyatt Thibaudeau (c.1840–c.1892; Lugt 2473), from whom purchased in 1885

1885-7-11-267

LITERATURE: Popp, 1927, pp.50–51, pl.59 (as by Rosso Fiorentino); Kusenberg, 1931, pp.111–12 (here, and henceforth as Thiry); Kusenberg, 1931–2, p.89; Popham, 1939, p.29; Barocchi, 1950, p.107; Paris, 1972, p.316, under no.409 (entry by Henri Zerner); Carroll, 1976, II, pp.493–4, no.F.37; Lévêque, 1984, p.213, ill.; Dacos, 1996a, pp.209–10, figs 17, 19 and 21; Dacos, 1996b, p.22; Py, 2001, p.72, no.168

EXHIBITIONS: Paris, 1972, no.224, p.199 (entry by Sylvie Béguin); Nagoya and Tokyo, 2002, pp.38–9, no.11

JEAN COUSIN THE ELDER

c.1500 Souci?, near Sens – c.1560 Paris?

7 Putti Playing in a Landscape with Classical Ruins

An elusive, but much admired figure, Jean Cousin the Elder is recognized as a central artistic personality of the French Renaissance. A rather small corpus of generally accepted works demonstrates his fluent mastery of perspective and his assimilation of the style of the first School of Fontainebleau, manifest in his elegant, elongated figures and his inventive vocabulary of ornamental strapwork. An awareness of Northern painting may also be inferred from his extensive, detailed landscapes.

The construction of Cousin's graphic oeuvre has centred on a handful of documented works in other media, most notably his designs for the St Mamas tapestries for the cathedral in Langres[1] and the plates for his *Livre de Perspective* published in Paris in 1560. From these sources a set of characteristics can be associated with Cousin the Elder: deep, logically structured landscapes, often organized around a winding river, complex groupings of classical ruins, gnarled tree trunks with mossy, dripping foliage, and figures in twisting poses with elegantly folded or knotted drapery and springy, tightly curled hair. However, many of these attributes were carried forward by his son Jean Cousin the Younger and other followers, clouding to some degree many attributions in this area.

In the case of *Putti Playing in a Landscape with Classical Ruins*, the related print (fig.1) was known – and its attribution debated – long before the drawing was published.[2] In 1966 Geneviève Monnier suggested an attribution to Cousin the Younger for the print,[3] although not long afterwards Philippe de Montebello made the connection between the British Museum drawing and the print, concurring with the classification on the mount to Jean Cousin.[4] Indeed, the drawing is in reverse to the print, of virtually identical format and has been incised for transfer.

If the function of the sheet as preparatory for the print is now clear, its subject remains as enigmatic as it is charming. Putti frolic on the ragged bank of a fast-moving river, collecting water, gathering reeds, playing music. Their innocence and nudity are evocative of an earlier golden age, as is the splendid array of antique buildings drawing the eye into the distance. Ruins of arched bridges, arcades, obelisks and columns create a fantastic jumble balancing the equally complex craggy hillside of rocky outcroppings and bent trees to the right. Landscape was not yet an independent genre in sixteenth-century France, yet in a sheet like this one, and the related *Jeux d'enfants* in the Louvre,[5] Cousin demonstrates the growing potential of the subject for French artists. Moreover, the development of this type of imagery may well have constituted an important part of Cousin's contribution judging from a contemporary description of a series of paintings he created for the banquet room used as part of Henri II's official entry into Paris in 1549, which were praised in a published description of the event as 'particularly beautiful landscapes, representing nature as well as the onlookers, and also the gestures of several people playing at all the games to which so much importance was attached in the venerable time of antiquity, that people forgot to eat and drink'.[6]

Black chalk, pen and brown ink, brush and brown wash, indented for transfer

Inscribed in pen and brown ink at upper left, 15

159 × 234 mm

PROVENANCE: Purchased from Leo Schidlof in 1949

1949-8-12-7

LITERATURE: Zerner, 1969, p.22 note 1; Lévêque, 1984, p.31, ill.; Paris, 1989, fig.1, p.38, under no.1 (entry by Sylvie Béguin); Paris, Cambridge and New York, 1994, p.164, under no.52; Zerner, 1996, fig.271, pp.238, 240

EXHIBITIONS: Paris, 1972, pp.63–5, no.62 (entry by Sylvie Béguin); Nagoya and Tokyo, 2002, pp.33–4, no.7

Fig.1 ANONYMOUS, after JEAN COUSIN THE ELDER, *Putti Playing in a Landscape with Classical Ruins*, etching, 155 × 233 mm, Bibliothèque Nationale de France, Paris (Ed 8B rés).

JEAN COUSIN THE YOUNGER

c.1525 Sens? – c.1595 Paris?

8 Jupiter and Semele

If there are few universally accepted works around which an oeuvre can be constructed for Jean Cousin the Elder, the terrain is even more uncertain in the case of his son. In 1939 Otto Benesch proposed a modest corpus of drawings for Cousin the Younger, taking as a starting point his one accepted painting, The Last Judgement (Musée du Louvre, Paris), and a set of emblematic drawings known as the Livre de Fortune (Bibliothèque de l'Institut, Paris).[1] Since then confidence in the cohesiveness of the group has only eroded, with the division between the hand of the father and that of the son seen as ever more murky. This is hardly surprising as Cousin the Younger apparently continued a style and repertoire of forms developed by his father. He would have inherited his father's drawings along with the contents of his studio and seems to have been responsible for the publication in 1595 of Livre de pourtraicture, a drawing manual announced in his father's Livre de perspective of 1560.[2]

With a prominent early inscription on the base of the bed and what may be a signature at lower left, Jupiter and Semele has long been associated with the Cousins. The figural types and the whimsical ornamental quality of the bed both derive from the work of Jean Cousin the Elder. However, there are subtle differences in the quality of the line, the manner of the hatching and the treatment of the draperies that set it apart. Fabric, in the hands of Cousin the Elder, typically falls in large volumetric folds. Here, Semele's rumpled bedsheets are dimpled and irregular. The hatching also lacks the boldness associated with autograph sheets by the father. The allegorical drawings for the Livre de Fortune, despite their differences in scale, provide a closer analogy.[3]

Semele, a mortal girl, the daughter of Cadmus, king of Thebes, was one of the many loves of Jupiter. Her ensuing pregnancy came to the attention of Juno, Jupiter's wife, who disguised herself as the girl's nurse and convinced Semele to ask Jupiter to grant her wish and to visit her in his true form. Trapped into agreeing, Jupiter had no choice but to come undisguised, with bolts of lightning in hand. Semele was consumed in flames, but Jupiter was able to rescue the unborn child – Bacchus – who would eventually be born from Jupiter's own thigh.[4]

Although he is not recorded as having worked at the château de Fontainebleau, Cousin the Younger was probably aware of Francesco Primaticcio's two treatments of the subject. Known today through prints,[5] both contain elements of passion and regret as Jupiter twists an arm back in a futile attempt to keep the thunderbolts from harming Semele. One version (fig.1) may have inspired Cousin in his placement of Semele, aligned diagonally on a high pillow, with the frontal plane of her body turned towards the viewer, and her left arm hanging down and twisted back, and grasping the bow of the unusually prominent Cupid, still unaware of the danger Jupiter's arrival brings. In an essentially planar composition emphatic diagonal lines signal the force and light of Jupiter's arrival.

Pen and black and grey ink, with brush and pink wash, heightened with white gouache, over black chalk underdrawing, on grey-brown prepared paper

Signed or inscribed in pen and brown ink at lower left, IO CVSINS / SENON. INVENTOR, and on the bed at lower right in pen and brown ink, Jehan Cousin

160 × 242 mm

PROVENANCE: Sale, Sotheby's, London, 2 May 1928, lot 14 (as 'Jehan Cousin, Mythological Scene'); sale, Sotheby and Co., London, 27 February 1935, part of lot 27; purchased through Colnaghi, London

1935-3-9-1

LITERATURE: Paris and New York, 1993, under no.2; New York, 1998, p.174, under no.82

EXHIBITIONS: Nagoya and Tokyo, 2002, pp.34–5, no.8

Fig.1 LÉON DAVENT, after Francesco Primaticcio, Jupiter and Semele, etching, 237 × 276 mm, Bibliothèque Nationale de France, Paris (Da 67).

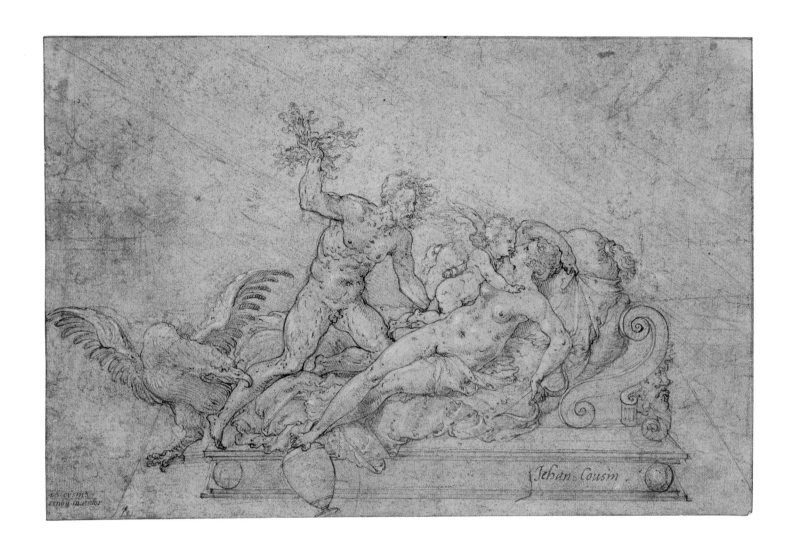

ETIENNE DUPÉRAC

c.1525 Bordeaux – 1601 Paris

9 View of Tivoli, 1568

Over the course of a career split between Rome and Fontainebleau, Etienne Dupérac worked as a painter, draughtsman, printmaker, architect and garden designer. Artistically, his most lasting contributions were the prints and maps that were the result of his twenty-year study of the topography of ancient and modern Rome, where he lived from 1550 to 1570. His designs for prints include both accurate views of ancient ruins as they appeared in the sixteenth century and projections of what ancient buildings would have looked like in their original state.

Although most of his Italian production depicts the historic centre of Rome, Dupérac recorded notable sites in its environs as well. Among his most ambitious prints was a large plate presenting a bird's-eye view of the palace and gardens of the Villa d'Este at Tivoli, recently constructed by Ippolito d'Este II, Cardinal of Ferrara and Governor of Tivoli. Published by Antoine Lafréry in 1573 with a dedication to the Italian-born French queen, Catherine de Médicis, the print bore a caption explaining that it was based on a drawing Dupérac made for the Emperor Maximilian II.[1] The artist's presence in Tivoli is further documented by the present sheet whose inscription very specifically states that it was done there on the 8 May 1568. Whether or not a print was planned from the London drawing, it is difficult to imagine a draughtsman of Dupérac's antiquarian bent passing by the picturesque ruins of the Temple of Vesta situated above the cascades of Tivoli without recording the view. The combination of the antique ruins, the powerful waterfall and the arched bridge proved attractive to many future generations of French artists visiting Italy, especially in the eighteenth and early nineteenth centuries.[2] The appearance of the spot would change in the early nineteenth century when the S. Rocco bridge was replaced.

Both his choice of subjects and his manner of describing them in a loose network of brown-ink hatching lines, dashes and dots all place Dupérac squarely in the tradition of Northern *vedute* artists working in Italy.[3] Artists such as Maarten van Heemskerck (1498–1574), Hendrik van Cleve III (c.1525–90/95), Hieronymus Cock (c.1510–70) and Pieter Coecke van Aelst (1502–50) would have preceded Dupérac; Pieter Bruegel the Elder (c.1525/30–69), who also produced a design for a printed view of Tivoli, was in Italy from 1552 to 1554; and Matthijs Bril (1550–83) and Paul Bril (c.1554–1626) arrived in Rome around the time of Dupérac's return to France. Considering the two decades he spent in Rome and the quantity of drawings that must have been made in preparation for his published prints, few of Dupérac's drawings survive. In addition to the British Museum sheet, Benno Geiger's collection included a dense and vibrant view of Roman rooftops, drawn from the roof of the Palazzo della Cancelleria and today in the Vatican Library.[4]

Pen and brown ink over traces of red chalk

Inscribed in pen and brown ink at lower left, *faict a tivollies le 8ᵉ jour / du mois de maie / 1568*

200 × 275 mm

PROVENANCE: Dr Benno Geiger; his sale, Sotheby's, London, 7–10 December 1920, lot 413; bought Colnaghi, from whom purchased in 1921

1921-1-11-4

LITERATURE: Planiscig and Voss, n.d., pl.40; Campbell Dodgson, 'Etienne Duperac,' *Old Master Drawings*, vol.I (June 1926), p.7, pl.11; Lavallée, 1930, no.81, pp.111–12, pl.LXIII; Cordey, 1932, p.14; Adhémar, 1954, p.135, pl.79

EXHIBITIONS: Rome, 1972, no.74; London, 1984a, no.49, n.p.; Nagoya and Tokyo, 2002, no.15, p.44

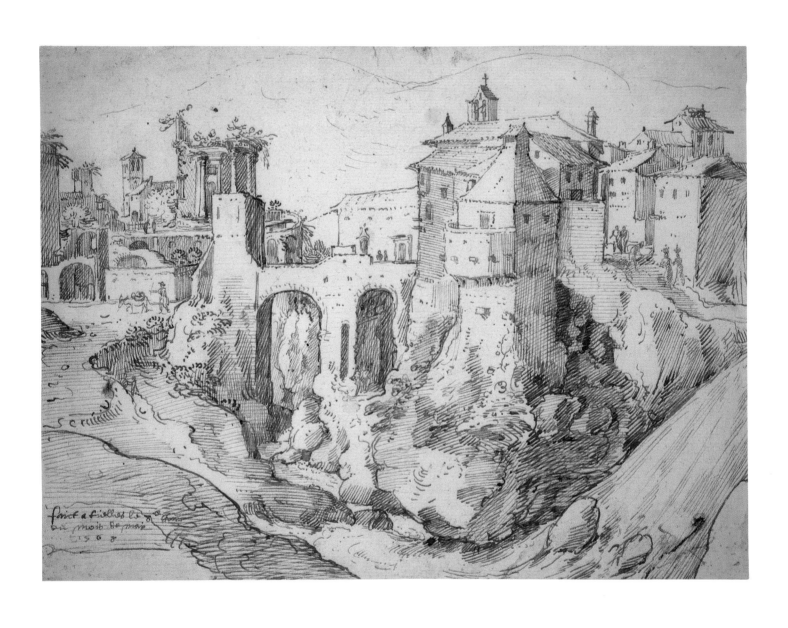

JACQUES LE MOYNE DE MORGUES

*c.*1533 Dieppe – before 1 June 1588, London

10 *Apples on a Branch*

At the outset of the twentieth century Jacques Le Moyne de Morgues was remembered only as an obscure figure credited with providing designs to printmakers for two quite disparate publishing ventures: an account of an ill-fated French Huguenot expedition to Florida in 1564–6, published as part of Theodor de Bry's *America* (1590–92), and *La clef des champs* (1586), a small design book including simple woodcuts of animals and plants. Beginning in 1922, several large groups of watercolours of plants and flowers, some on paper and some on vellum, have been discovered or attributed to Le Moyne. While these may represent only one facet of his production, they have earned Le Moyne de Morgues a place in history as one of the most remarkable early botanical painters.

Le Moyne was born in Dieppe, a centre for cartography and manuscript illumination, but little is known of his early life before he was recruited to accompany René de Laudonnière's mission to Florida. After his return from the New World Le Moyne presumably emigrated to England around 1572 to escape the Huguenot massacres. A group of fifty-nine watercolours in the Victoria and Albert Museum bear inscriptions in French and Latin and are assumed therefore to date to his French period.[1] Another group of twenty-seven sheets comparable in style and on similar paper to the Victoria and Albert watercolours appeared on the market in 2004, followed by a bound florilegium with eighty drawings in 2005.[2] The present sheet and no.11 belong to a group of fifty watercolours of fruit and trees that came to light in 1961 originally bound in an album with a dedicatory sonnet dated 1585, by which point Le Moyne is known to have settled in London.[3]

If the medieval interest in plants revolved around their medicinal properties and religious symbolism, the Renaissance saw a burgeoning interest in the cultivation and representation of plants both as part of scientific inquiry and as objects of beauty. The pursuit of naturalism and aesthetics meld seamlessly in the watercolours of Le Moyne de Morgues. His image of three apples on a branch presents the fruit at different stages of ripeness, with realistic scratches and blemishes. The convincing rendering of volume suggests that the riper apples are projecting into the viewer's space while the partially obscured, greener apple recedes. The bending green leaves on their springy stalks further the illusion of three-dimensionality.

Many of the sheets from the British Museum group seem to have been adapted for the woodcuts of *La clef des champs*, published in 1586.[4] This rare quarto volume pairs simple hand-coloured prints with text supplying the Latin, French and English names for each plant or animal. Neither the woodcut technique, nor the tiny format allowed for the level of detail of the larger watercolour compositions, but comparison reveals that the watercolours were nonetheless plumbed for the basic forms and motifs which were greatly simplified in the corresponding prints (see fig.1).

Watercolour and bodycolour, over traces of black chalk, border in pen and red ink

Inscribed in black chalk at lower right, 38

214 × 141 mm

PROVENANCE: Humphry Bohun, Sotherton; his wife Dorothy Bohun; their nephew Edmund Bohun; his son Edmund Bohun, Westhall; Joseph Offley; William Bennet Martin, Worsborough; his wife Augusta Martin; Miss Sarah Heaven; sale, Sotheby's London, 11 December 1961, lot 177 (as part of an album); H.M. Calmann, from whom the album was purchased in 1962 with contributions from the National Art Collections Fund and private individuals

1962-7-14-1 (40)

LITERATURE: Hulton, 1977, I, no.75, pp.171–2; II, pl.11

Fig.1 After JACQUES LE MOYNE DE MORGUES, *Peach and Apple*, hand-coloured woodcut, each image approx. 75 × 65 mm, British Museum (1952-5-22-1 [37]).

Jacques Le Moyne de Morgues

*c.*1533 Dieppe – before 1 June 1588, London

11 Oak and Dragonfly

For Le Moyne's life and career, see no.10.

In *Oak and Dragonfly* the oak's distinctive scalloped leaves, dark on the top and light underneath, twist and turn to create a complex and pleasing pattern around the acorns. As in many of Le Moyne's botanical compositions, an insect complements the plant. Here, a large dragonfly seems to hover near the branch, its tail extending to, and just over, the ruled corner and its gossamer wing placed in front of a hanging acorn.

Watercolour and bodycolour, over traces of black chalk, traces of gold on upper leaves, border in pen and red ink

Inscribed in black chalk at lower right, 33

213 × 142 mm

PROVENANCE: Humphry Bohun, Sotherton; his wife Dorothy Bohun; their nephew Edmund Bohun; his son Edmund Bohun, Westhall; Joseph Offley; William Bennet Martin, Worsborough; his wife Augusta Martin; Miss Sarah Heaven; sale, Sotheby's London, 11 December 1961, lot 177 (as part of an album); H.M. Calmann, from whom the album was purchased in 1962 with contributions from the National Art Collections Fund and private individuals

1962-7-14-1 (35)

LITERATURE: Hulton, 1977, I, no.70, p.171; II, pl.44b

Fig.1 After JACQUES LE MOYNE DE MORGUES, *Oak and Olive*, hand-coloured woodcut, each image approx. 75 × 65 mm, British Museum (1952-5-22-1 [39]).

JACQUES BELLANGE

*c.*1575 Bassigny? – 1616 Nancy

12 *Young Woman Holding her Skirt*

Despite the high regard in which Bellange's work has long been held, his life and oeuvre present many enigmas. He appears quite suddenly on the royal payrolls at the court of Nancy in the duchy of Lorraine in 1602, already commanding a high salary, but no documents record his origins or training. Aesthetic debts have been noted to the figural types and compositional principles of Northern Mannerism as well as to Italian techniques of etching.[1] Pierre Rosenberg has recently even proposed a visit to Venice.[2]

From surviving records between 1602 and his early death in 1616, it is clear that Bellange held a high-ranking position in the Lorraine court. Not only was he given major ducal commissions and a travel stipend, but Duke Henri II stood as godfather at the baptism of Bellange's first-born son, also named Henri. Unfortunately, little of Bellange's painted output survives,[3] and his contribution must be judged largely on his graphic work.

The British Museum's charming drawing of a young woman gently lifting her outer skirts as she tentatively considers her next step is part of a loosely defined group of secular figures described by Jacques Thuillier as 'studies for costumes for ballet'.[4] Subcategories of the group include bohemians, gardeners, amorous couples, and cavaliers. Most probably they were not actual designs for costumes, but images of generalized types reflective of the refined theatrical milieu at the Lorraine court which enjoyed ballets, mascarades and other elaborately staged *divertissements*.

The group referred to as gardeners, after Bellange's inscription of the Latin word *hortulana* on one of the plates, includes four etchings (see fig.1) – which may or may not have been intended as a set – and four drawings, all in the identical technique of blue wash over pen and brown ink.[5] With their antique sandals, richly ornamented vessels, and low décolletage, Bellange's female gardeners are overwhelmingly sensuous rather than realistic, with attendant allusions to Ceres and fertility – characteristic of what Pierre-Jean Mariette referred to as Bellange's 'manière licentieuse.'[6] One of the drawings, *Gardener with a Vase* (Nationalmuseum, Stockholm), is related to a print, but the other three are not. One in the Département des arts graphiques, Rothschild Collection, Musée du Louvre, Paris, depicts a gardener walking with an ornate vessel on her head; another, in the Musée Condé, Chantilly, shows a gardener with long braids and a basket of fruit on her head, seen from behind. The British Museum sheet, while it shares the bunched skirt and fringed scarf worn by many of the other gardeners, stands apart, as she holds no attribute, perhaps because Bellange wished to show her in the process of lifting or hitching up her skirt (not curtseying as some earlier writers have proposed). She also lacks the apron and stiff laced-up corset worn by others. Possibly the present drawing should be placed early in the series, before Bellange had arrived at the formula which unifies the etched *Hortulanae*.

Pen and brown ink, brush and blue wash on off white antique laid paper

401 × 247 mm

PROVENANCE: Purchased from Edward Daniell in 1870

1870-5-14-1207

LITERATURE: Cordey, 1932, p.15; Pariset, 1951, pp.30 note 1, 33–4, fig.4; Vallery-Radot, 1953, p.179, no.10; Comer, 1980, pp.217–18, no.42, fig.92

EXHIBITIONS: London, 1984b, pp.123, 125, no.115; Nancy, 1992a, no.112, p.320 (entry by Jacques Thuillier); Rennes, 2001, pp.188, 210–11, no.44

Fig.1 JACQUES BELLANGE, *Hortulana*, etching, 306 × 171 mm, Museum of Fine Arts, Boston, Otis Norcross Fund (40.160).

PIERRE DUMONSTIER II

c.1585 Paris – 1656 Paris

13 *Right Hand of Artemisia Gentileschi Holding a Brush, 1625*

This is not a study of a generic hand, but the hand of the famous and talented Italian painter, Artemisia Gentileschi, whom Dumonstier apparently met in Rome. An elegant and calligraphic inscription across the top of the sheet proudly proclaims that the drawing was, 'made in Rome by Pierre Dumonstier, Parisian, the last day of December, 1625, after the worthy hand of the excellent and skilful Artemisia, gentlewoman of Rome.' An inscription on the verso goes on to compare the painter to the goddess Aurora: 'Les mains de l'Aurore sont louées et renommées pour leur rare beauté. Mais celle cy/ plus digne le doit estre mille fois plus, pour scavoir faire des merveilles,/ qui ravissent les yeux des plus Judicieux.' (The hands of Aurora are praised and renowned for their rare beauty. But this one is a thousand times more worthy for knowing how to make marvels that send the most judicious eyes into raptures.) In short, the hand, poised with a delicate grip on a fine-tipped brush, is a substitute for the artist herself, making this a symbolic portrait.

Pierre Dumonstier II was a member of an extended family of artists, at least five of whom, from the sixteenth to the early seventeenth centuries, specialized in portrait drawings in chalk. Pierre II (sometimes called 'le neveu', the nephew) appears, from extant sheets, to have been less prolific than his cousin Daniel Dumonstier. Louis Dimier, in his *Histoire de la peinture de portrait en France au XVI^e siècle*, catalogued only ten chalk drawings by Pierre Dumonstier II.[1] Dumonstier's habit of inscribing his drawings provides some chronological ordering as well as some indications of his travels. Pierre-Jean Mariette, in his brief entry on Dumonstier for his *Abécédario*, mentions having seen a drawing signed and dated 1625, with a note that it had been drawn in Turin.[2] Accepting this, the drawing of Artemisia's hand would have been made not long after Dumonstier's arrival in Rome. In 1625, Artemisia Gentileschi had been back in Rome for five years, following a seven-year period in Florence. Dumonstier's drawing and its adulatory inscription have frequently been cited in the recent literature on Artemisia as evidence of her fame and high standing at this point in her career.[3]

The ten drawings catalogued by Dimier were (with the exception of the present sheet and one copy after Raphael) all portraits or drawings of heads in red and black chalk, sometimes with additional coloured chalks. Since then another drawing of a hand has appeared, a *Hand Holding a Handkerchief* (fig.1; Horvitz collection).[4] Similar in format and technique to the present drawing, the Horvitz *Hand* was done in Rome and bears a signature and a date (12 June 1627). Although it is not known to whom the hand belonged, it is, like Artemisia's hand, modelled with subtlety and eloquently posed to convey a sense of refinement and grace.

Black and red chalk

Signed, dated and inscribed in red chalk along upper margin, *Faict a Rome par Pierre DuMonstier Parisien, Ce dernier de Decemb. 1625. / aprez la digne main de l'excellente et sçavante Artemise gentil done Romaine;* unidentified collector's stamp in black ink at lower right (Lugt 2508)

219 × 180 mm

PROVENANCE: V.C. ? (Lugt 2508, a lion over the initials VC); possibly in the Marquis de Lagoy sale, 17–19 April 1834, lot 230 (as Daniel Dumonstier, 'Une main de femme tenant un pinceau à deux crayons'); Revd Dr Charles Sloman, Rector of Eling; his sale, Wheatley's, London, 20–23 June 1835, part of lot 104; purchased in 1835

1835-7-11-35

LITERATURE: Moreau-Nélaton, 1924, III, p.125, no.4; Dimier, 1924–6, I, p.191; II, pp.300–01, 304; Rosenberg, 1971b, pp.69–70; Garrard, 1989, pp.51, 63–4, 173, 503, 527, fig.49; Bissell, 1999, pp.39, 222, 228, fig.98; Rome, New York and St Louis, 2002, pp.268, 339–40, fig.119

Fig.1 PIERRE DUMONSTIER II, *Hand Holding a Handkerchief*, 1627, black and red chalk, heightened with white chalk on cream antique laid paper, 245 × 190 mm, The Horvitz Collection, Boston (I.1997.47).

Fait a Rome par Pierre — Du Monstier Parisien, le dernier de Decemb. 1625
aprez la digne main de l'excellente et sçauante Artemise gentildone Romaine.

Jacques Callot

1592 Nancy – 1635 Nancy

14 Sheet of Studies with a Horse, after Tempesta

One of the most prolific, innovative and accomplished graphic artists of the seventeenth century, Callot depicted a broad range of subjects, from the pomp of court pageants to the miseries of war. The naturalism and ease that characterize his manner can be traced to his studies during his formative years at the Medici court in Florence. The sketchbook of which this sheet was originally a part documented Callot's activity at that time and included studies of horses and figures drawn from prints, sculpture and the imagination in a range of scales and techniques. The overwhelming preoccupation of the sketchbook, however, was the study of equine anatomy based on a series of etchings by Antonio Tempesta, *Cavalli di differenti paesi*, published in Rome in 1690.

A *Standing Horse Facing Left* (fig.1), plate 8 in Tempesta's publication, was the model for the present sheet, as well as for other more or less finished studies in the British Museum, Uffizi (Florence), Nationalmuseum (Stockholm) and Kupferstichkabinett (Berlin).[1] Callot's horse is treated with a calligraphic bravura, imbuing the image with a

Pen and brown ink, brush and brown wash, touches of red chalk

Inscribed in pen and brown ink at upper left, 23 J.B. (?), and at centre lower margin in pen and brown ink, 263, and in graphite, 244; and on the verso, marked and inscribed with British Museum Fawkener collection stamp and numbers, 5213 / 38, in black ink at lower right (Lugt 921), and unidentified collector's mark at upper left (Lugt 2736)

234 × 342 mm

PROVENANCE: Unidentified collector (Lugt 2736); J.B. (unidentified collector, probably English); bequeathed by William Fawkener (Lugt 2620), 1769

T.14-38 (Fawk. 5213-38)

LITERATURE: Hind, 1912, p.80; Ternois, 1962a, p.47, no.25; Ternois, 1973, pp.214, 237, figs 3, 27; Ternois, ed., 1993, pp.362–3; Cambridge, Toronto, Paris, Edinburgh, New York, and Los Angeles, 1998–2000, under no.7, p.110, fig.4

EXHIBITIONS: Washington, 1975, pp.216–17, no.173; London, 1984b, pp.123, 126, no.116; Nancy, 1992b, no. 41, pp.154, 156 (entry by Daniel Ternois); Nagoya and Tokyo, 2002, no.25, pp.66–7

Fig.1 ANTONIO TEMPESTA, *A Standing Horse Facing Left, Before a Seascape*, no. 8 from *Cavalli di differenti paesi*, etching.

vitality surpassing its print source. Small figures, quickly observed and broadly treated in wash, fill the rest of the sheet.

The verso (fig.2) is dominated by red chalk studies after Lodovico Cigoli's *Lo Scorticato*, or *écorché*, a bronze statuette of a standing man with exposed musculature (Bargello Museum, Florence).[2] The bronze was frequently drawn in early seventeenth-century Florence as part of an artist's training. In Callot's hands the figure takes on an elegant, elongated aspect. Small humorous figure sketches along the right margin have been linked to Callot's prints, *Guerre d'Amour*, *Balli* and *Gobbi*, supporting a date of *c*.1616 for the sketchbook.[3]

Of the twenty known, extant sheets from Callot's Florentine sketchbook,[4] William Fawkener owned four, which formed part of his bequest to the British Museum in 1769.[5] Daniel Ternois has observed that five other sheets from the sketchbook share an eighteenth-century English provenance, having been owned by Nathaniel Hone (1718–84; Lugt 2793) and John Thane (1748–1818; Lugt 1544).[6] What has not been noted in the literature up to this point is that the Fawkener four and the Hone-Thane five share a common provenance before the mid-eighteenth century. The marks of two different unidentified collectors as well as a numbering system link all nine drawings. Ternois had conflated the 'J.B.' inscription and the unidentified stamp (Lugt 2736) as a single collector, whom he consistently placed chronologically after Thane in cataloguing the Hone-Thane drawings. The evidence of the same mark and inscriptions on the Fawkener drawings – not previously noted – disproves that assumption, as Hone and Fawkener were contemporaries, and the two unidentified collectors could therefore only have preceded them.[7] Presumably, the latter at least of the two unidentified collectors was in England in the mid-eighteenth century, selling four sheets to Fawkener and the rest to Hone.

Fig.2 JACQUES CALLOT, *Sheet of Studies with Anatomical Sketches after Cigoli* (verso), red chalk, pen and black ink, graphite, British Museum (T.14-38 [Fawk. 5213-38]).

Jacques Callot

1592 Nancy – 1635 Nancy

15 i Battle in a Valley	15 ii Battle on a Bridge	15 iii Besieging a Fortress
Brush and brown wash over black chalk, incised for transfer	Brush and brown wash, black chalk	Brush and brown wash, black chalk
Fawkener bequest stamp (Lugt 921) at lower right	Fawkener bequest stamp (Lugt 921) at upper right	Fawkener bequest stamp (Lugt 921) at lower right
110 × 231 mm	110 × 231 mm	110 × 231 mm
PROVENANCE: Bequeathed by William Fawkener (Lugt 2620), 1769	PROVENANCE: Bequeathed by William Fawkener (Lugt 2620), 1769	PROVENANCE: Bequeathed by William Fawkener (Lugt 2620), 1769
Gg. 2-346 (Fawk. Add.30)	Gg. 2-347 (Fawk. Add.31)	Gg. 2-348 (Fawk. Add.32)
LITERATURE: Hind, 1912, p.80; Ternois, 1962a, p.131, no.918	LITERATURE: Hind, 1912, p.80; Ternois, 1962a, p.131, no.919	LITERATURE: Hind, 1912, p.80; Ternois, 1962a, p.131, no.920

Daniel Ternois has commented on the remarkable disparity between Callot's graphic manner in his etchings and his wash drawings. In the former the artist's elegant descriptive line and innovative use of hard ground and stop-out varnish to allow multiple bitings of the plate produced results of exceptional detail and legibility. In the latter complex landscapes were boldly distilled into highly abstracted areas of wash and reserve, evoking atmosphere, light and movement with minimal description: in Ternois's words, 'Callot est graveur par métier; il est dessinateur d'instinct.'[1]

These three battle scenes are part of a group of five from the collection of William Fawkener. Whether they were made as part of the planning for a particular project or as study pieces to have in hand in the studio is not certain. One, of a smoke-filled battlefield, is close to a plate in *Les Grandes Misères de la guerre*,[2] and another, to the background in the equestrian portrait of Louis de Lorraine, Prince de Phalsbourg (see no.16).[3] Three other sheets, similar in format and subject are in London, Los Angeles and a private collection in Canada.[4] The three mounted together here have not been linked to any etching project, although the *Battle in a Valley* has been incised for transfer to the copper plate. They date most probably to early in his Lorraine period, although Daniel Ternois does not rule out the possibility that they were drawn in Callot's last years in Florence.[5]

Much has been written on the imagery of warfare in Callot's work. His focus – like Goya's 200 years later – on human suffering as well as the fact that he would have witnessed to several invasions of the small Duchy of Lorraine have engendered numerous unverifiable interpretations.[6] Whatever their underlying sentiments, Callot's wash studies of battles are masterful evocations of warfare with their onrushing masses of troops, billowing smoke and, especially in the case of *Battle on a Bridge*, their dramatic fervour and gruesome detail. In Callot's wake a number of French artists, including Giacomo Cortese (1621–76) and Charles Parrocel (1688–1752), were to make battle paintings their speciality.

Battle in a Valley

Battle on a Bridge

Besieging a Fortress

55

Jacques Callot

1592 Nancy – 1635 Nancy

16 Equestrian Portrait of Louis de Lorraine, Prince de Phalsbourg, 1624

While Callot did not invent the formula of portraying a ruler as a military man of action astride a rearing horse,[1] it was one for which his repertoire of skills made him especially well suited. Through his numerous copies of Antonio Tempesta's muscular horses in motion (see no.14) he assimilated the principles of equine anatomy; the pose of the rearing horse here is reminiscent of plate 13 of Tempesta's *Cavalli di differenti paesi*, which Callot copied twice.[2] The sharp contrast in scale between the equestrian figure and the distant battlefield tableau is characteristic not only of the work of Tempesta and Callot, but of Mannerist compositional principles generally.

Louis de Lorraine-Guise, Baron d'Ancerville (1588?–1631), was a central figure in the Lorraine court when Callot returned from Florence. He was the illegitimate son of Cardinal Louis de Lorraine, who was assassinated shortly after his son's birth. The young Louis de Lorraine was brought to the ducal court where he was raised with the future duke Henri II. The two became close companions and friends, and after Henri II ascended the ducal throne in 1606, Louis was the recipient of many rewards and privileges. He was

Brush and brown wash, black chalk, incised for transfer; the area of the head cut out and a second piece of paper attached from behind

Fawkener bequest stamp (Lugt 921) at lower right

245 × 338 mm

PROVENANCE: Bequeathed by William Fawkener (L2620) in 1769

Gg.2-243 (Fawk. Add.27)

LITERATURE: Hind, 1912, pp.79–80; Vallery-Radot, 1953, p.185; Ternois, 1962a, no.790, p.118; Ternois, 1962b, pp.119, 148; Ternois, 1973, p.242, under no.14; Washington, 1975, p.220, under no.175; Paris, 1993, p.82, under no.28 (entry by Jean-François Méjanès); Ternois, ed., 1993, pp.367–8; Ternois, 1999, p.32, under no.1484; Jaffé, 2002, V, p.570, under no.1607

EXHIBITIONS: Nancy, 1992b, no.493, pp.389–91 (entry by Paulette Choné); Nagoya and Tokyo, 2002, no.27, pp.69–70

Fig.1 JACQUES CALLOT, *Le Prince de Phalsbourg*, 1624, etching with engraving, 188 × 246 mm,
The Metropolitan Museum of Art, The Elisha Whittelsey Collection, The Elisha Whittelsey Fund, 1959 (59.569.15).

Fig.2 JACQUES CALLOT, *Equestrian Portrait of Louis de Lorraine, Prince de Phalsbourg*, brown ink washes over a black chalk underdrawing, 247 × 333 mm, The Metropolitan Museum of Art, New York, promised Gift of Leon D. and Debra R. Black and Purchase, 2003 Benefit Fund, 2004 (2004.235).

made Maréchal de Lorraine in 1613 and head of the ducal armies in 1617. In 1621 he married the sister of Charles de Lorraine-Vaudémont, who would become the next duke following Henri II's death in 1624. The catalyst for Callot's print (fig.1) must have been Emperor Ferdinand II's elevation of Phalsbourg to a principality, thereby conferring on Louis the title of prince. In fact, the etching can be dated to within a six-month period in early 1624, after the elevation but before Henri II's death. Since Louis de Lorraine oversaw many of the court's fêtes and masquerades, Callot may have been seeking his favour as a patron.[3]

Three compositional drawings are associated with the print.[4] The first in the sequence was probably the vibrant and quickly blocked-in study recently acquired by the Metropolitan Museum of Art in New York (fig.2).[5] It is not in reverse to the etching and is partly indented and pricked for transfer around the horse and rider, probably to create a reversed outline for the next stage of preparation. The New York sheet would have been followed by the study in Metz,[6] where both horse and rider are reversed, presumably to have the baton in the prince's left hand to anticipate the reversal in the printing process.

The function of the sheet as a working drawing is underlined by the fact that the costume is in chalk alone, with the head and left arm lightly indicated. The British Museum drawing is closest to the print in both the landscape and foreground group; Callot has left the baton in the rider's left hand, but reversed the position of the horse, giving a dynamic angle to its head. In this he was surely following the rearing horse in his own etching, *The Life of Ferdinando de' Medici: The Defeat of the Turkish Cavalry*,[7] down to details of its rippling mane and tail. This adjustment in the direction of the horse allowed for the inclusion of the elegant billowing scarf, visually balancing the baton and the momentum of the animal.

At this stage Callot made a careful portrait drawing in black chalk of the prince's head and lace collar, cut it out and set it into the British Museum sheet. Whether this reflects a change or uncertainty in Callot's choice of subject for the portrait, as Paulette Choné has proposed,[8] or whether it simply made pragmatic sense for Callot to record a likeness of the prince on a separate sheet and combine it in the studio is difficult to say. One must account, however, for the perfect correspondence of scale between the head and the rest of the sheet. The fact that the contours of the present drawing are indented for transfer, but the scale does not match that of the print, suggests a lost intermediary sheet, where Callot may have outlined the horse and body, and then elaborated and cut out the portrait head.

CLAUDE VIGNON

1593 Tours – 1670 Paris

17 French Christian Lady

Few artists have proved so resistant to art-historical categorization as Claude Vignon, who has been considered indebted to figures as diverse as Tintoretto, Elsheimer and Bellange. Vignon spent a formative decade in Rome at the outset of his career, part of a community of French artists, including Simon Vouet (1590–1649) and Valentin de Boulogne (1591–1632), under the sway of Caravaggio (1571–1610). While Caravaggio's influence can be strongly felt, especially in Vignon's early work, it overlays what is essentially a Mannerist and exotic sensibility. By early 1623 Vignon had returned to Paris where he quickly found success at the court of Louis XIII and also received many ecclesiastic commissions. A richly coloured palette, heavy impasto surface and theatrical presentation were all hallmarks of his style.

With the ascendancy of Vouet as a large-scale decorative painter, however, Vignon seems to have gradually shifted his activity to the design of prints and book illustrations. With this change in function, his manner of drawing changed as well, away from a freer, more expressionistic handling towards a more controlled technique, suitable for translation into the print medium.[1] Among the most successful and often copied print compositions by Vignon were the twenty plates he designed to accompany *La Galerie des femmes fortes*, published in 1647 by Pierre Le Moyne, a Jesuit poet admired both at court and in *précieux* circles. The volume was dedicated to Anne of Austria, 'femme forte par excellence.'[2] Twenty chapters celebrate the achievements of twenty women: Greek, Roman, Jewish and Christian. It was a theme that gained wide popularity in France in a period that saw the regencies of two strong women: Marie de Médicis and Anne of Austria.

Six preparatory drawings survive, one in Rugby, two in Dublin and two in Paris, as well as the present sheet; all are in the same direction as the prints.[3] In addition, a drawing of Cleopatra (private collection) follows the same format and may have originally been intended to form part of the series.[4] In the prints the figures were engraved by Gilles Rousselet and the backgrounds etched by Abraham Bosse. This division of labour, corresponding to emphatic dark figures in the foreground of the prints and paler backgrounds, may well have been anticipated by Vignon when he made the drawings, which use red chalk exclusively for the standing figures and graphite, lightly applied, for the background vignettes; or, alternatively, the backgrounds may have been a later addition.[5] While the other images portray figures from ancient or biblical history, the British Museum drawing is described by Pacht Bassani as 'symbolisant la femme idéale, à la fois chrétienne et française.'[6] The background scene etched by Bosse depicts three figures rushing toward a standing woman bearing a bloody sword, beside an injured man in bed (fig.1). The print's caption sheds some light on the intended meaning of the scene, 'VNE Dame Chrestienne et Francoise combat iusque à la mort pour sa chasteté et par une victoire pareille a celle de Iudith, egale le France à la Iudée.'[7] Gently smiling and softly modelled, Vignon's French Christian woman becomes more severe and monumental under the burin of Rousselet.[8]

Red chalk with graphite

320 × 214 mm

PROVENANCE: Payer Im Of; sale, Hôtel Drouot, Paris, 22 June 1956, lot 84; H.M. Calmann, London, in 1958; H. Shickman Gallery, New York, in 1968 (as borrowed back from a client); H. collection, New York (per Adolphe Stein); purchased from Adolphe Stein in 1983

1983-6-25-2

LITERATURE: London, 1958, no.22; Rosenberg, 1966a, p.290; Ramade, 1980, p.25 note 3; Cleveland, Cambridge and Ottawa, 1989, pp.136–7, under no.66, fig.66b; Pacht Bassani, 1992, p.445, no.449; Meyer, 1998, pp.193–4; Paris, Geneva and New York, 2001, p.31, under no.4 note 23

EXHIBITIONS: New York, 1968, no.75; Nagoya and Tokyo, 2002, p.72, no.30

Fig.1 GILLES ROUSSELET and ABRAHAM BOSSE, after Claude Vignon, *Une Dame Chrétienne et Française*, 1647, engraving and etching, British Museum (1891-5-11-142).

NICOLAS POUSSIN

1594 Les Andelys – 1665 Rome

18 Studies after the Antique: Minerva, a Gladiator seen from Behind, and three Sandalled Feet

Poussin's classicizing manner was continually enriched by his dedicated study of antique and classical motifs from far-ranging sources. These drawn copies, which survive in large numbers, offer significant insight into his working process. From the traces of framing lines in red chalk on many of Poussin's copy drawings and the mention of an album of copies in Jean Dughet's 1678 inventory of Poussin's studio contents, it has been surmised that they were kept together during the artist's lifetime.[1]

The British Museum sheet, dated to c.1632–5 by Pierre Rosenberg and Louis-Antoine Prat,[2] is characteristic of his work in this vein. Numerous motifs from different sources are grouped on a single sheet, unified by their fluid and confident manner and the artist's attentiveness to the *mise-en-page*. With the wash shadows along the edges of the motifs, they read as reliefs, and in the case of the *Minerva Medicea* the ultimate source was indeed a relief, a candelabra in the Vatican found in Hadrian's villa and subsequently kept in the Barberini collection.[3] Anthony Blunt further connected the figure to a drawing of the same subject from the *Museo cartaceo*, or 'paper museum', of Cassiano dal Pozzo (1588–1657; fig.1).[4] This ambitious enterprise employed various artists in the recording of many aspects of classical antiquity and natural history. Given their friendship and shared interests, Poussin's involvement in dal Pozzo's project was initially assumed, although in recent years the idea has been rejected.[5] Instead, close examination suggests that Poussin often drew his copies not directly from the antiquities but after intermediary graphic works. In the present case visual evidence suggests that Poussin's *Minerva* is based on the *Museo cartaceo* sheet (fig.1) rather than on the original relief.

It is curious, of course, that Poussin, who drew after nature in the Roman *campagna*, did not draw antique sculpture after the originals that were readily available to him. Despite the antiquarian milieu in which he lived, Poussin did not share the documentary aspirations that motivated not just dal Pozzo but many of Poussin's contemporaries, including Claude Mellan, François Perrier and Charles Errard, all of whom produced drawings from antique sculptures as models for prints. Poussin's drawings were rarely of whole objects, nor were they presented in a spatially coherent fashion. Termed 'anthological drawings' by Blunt,[6] they were compilations of motifs solely for his own future use and thus less subject to conventional notions of authenticity. In certain cases details from Poussin's copy drawings are worked into his painted compositions – here the costume of the gladiator seen from behind reappears in drawings of *Scipio and the Pirates*[7] – although they often seem not to have been used. Emmanuelle Brugerolles described Poussin's aim in making copy drawings as not simply the assembling of a repertoire of authentic motifs, but more generally as an exercise that allowed him to penetrate, assimilate and ultimately appropriate the antique aesthetic.[8]

Pen and brown ink, brush and brown wash, traces of red chalk framing lines

267 × 192 mm

PROVENANCE: Count Moritz von Fries, Vienna (1777–1826; Lugt 2903, partially legible at lower left); Jean-Baptiste-Florentin-Gabriel de Meryan, Marquis de Lagoy, Saint-Rémy (1764–1829; Lugt 1710, his mark at lower right); possibly in his sale, Paris, 17–19 April 1834, part of lot 214 ('Etudes ... d'après l'antique'); Samuel Woodburn, London (1786–1853); his estate sale, Christie, Manson & Woods, London, 12 June 1860, part of lot 1333; acquired by Sir Thomas Phillipps (1792–1872); his grandson Thomas Fitzroy Phillipps Fenwick (1856–1938); donated anonymously in 1946

1946-7-13-1145

LITERATURE: Popham, 1935, p.228, no.5; Toulouse, 1962, p.84, no.307; Friedlaender and Blunt, IV, 1963, p.25, no.248, pl.203 (verso); Blunt, 1967, p.315 note 3; Friedlaender and Blunt, V, 1974, p.40, no.341, pl.263 (recto); Cropper, 1975, pp.284–5; Blunt, 1979, p.135; Rosenberg and Prat, 1994, I, pp.326–7, no.170; Harris, 1996, p.425; Paris, Geneva and New York, 2001, pp.120–21 note 20

EXHIBITIONS: Oxford, 1990, no.32

Fig.1 ANONYMOUS, *Minerva Medicea*, Royal Library, Windsor (8787).

NICOLAS POUSSIN

1594 Les Andelys – 1665 Rome

19 The Holy Family with St Elizabeth, the Infant St John and Putti, c.1650

Poussin's utilitarian view of drawing is evident in this fascinating sheet of studies where he made a sketch of the Holy Family, turned the sheet 90 degrees, drew a more elaborate variation of the subject, put a line down the centre of the sheet to preserve the second sketch, and then drafted a letter to his close friend and patron Paul Fréart de Chantelou on the other side of the line. Interestingly, he stopped the lines of his letter at different places to preserve his initial rough sketch. The more elaborate design relates closely to *The Holy Family with the Infant Saint John and Saint Elizabeth* (fig.1; Fogg Art Museum), one of five variants of the theme produced by Poussin between 1648 and 1655.[1] All five feature the Holy Family with St Elizabeth and the infant St John in an outdoor setting. In the present drawing and the Fogg painting the infant Christ leans back, into the comforting arms of St John, like a real child afraid of water. Although the arrangement of figures is complex, their rendering is essentially schematic: figures are reduced to cylinders and orbs; hatching lines indicate areas of shadow or light, but there is little further nuance.[2]

While the primary motif on the British Museum sheet is closely connected to the Fogg painting, the more rudimentary, perpendicular sketch appears closer to the Holy

Pen and brown ink, corners at right made up

Inscribed with a draft of a letter in pen and brown ink in the artist's hand

322 × 205 mm

PROVENANCE: F.W. Barry; purchased in 1937

1937-12-11-1

LITERATURE: Friedlaender and Blunt, I, 1939, pp.28–9, no.55, pl.34 (recto); IV, 1963, pp.47–8, no.284 (verso); Blunt, 1979, pp.16, 72, pl.79–80; Rosenberg and Prat, 1994, I, pp.638–41, no.329 (with earlier bibliography); De Grazia, 1999, pp.39, 60 note 88; Rosenberg, 2000, p.99, fig.120; Paris, Geneva and New York, 2001, pp.136–8 note 29, ill.3 (verso)

EXHIBITIONS: London, 1984, n.p., no.66; Oxford, 1990, no.57a–b; Paris, 1994a, pp.439–40, no.195

Fig.1 NICOLAS POUSSIN, *The Holy Family with the Infant Saint John the Baptist and Saint Elizabeth*, c.1650–51, oil on canvas, 101.2 × 133.7 cm, Fogg Art Museum, Harvard University Art Museums, Cambridge, gift of Mrs Samuel Sachs in memory of her husband, Mr Samuel Sachs (1942.168).

Family under a Group of Trees (fig.2; Musée du Louvre), dated *c.*1650–55. St John is seated, not standing, his left arm extended, but not interlaced with Christ's. Rather than falling back, the Christ Child twists at the waist, his weight on his mother's left thigh. Most importantly, the legs of the Virgin are aligned pointing off to the left, not to the right as in the Fogg picture. Although Poussin scholars have dated the Louvre painting five years later than the Fogg one,[3] The artist may have returned to the earlier drawing for inspiration, or else the Louvre version may date closer to the Fogg picture than previously thought. Moreover, some ideas from the more worked-up compositional study on the British Museum sheet that were not used in the Fogg painting are re-introduced in the Louvre canvas: the style of wrapped headscarf worn by St Elizabeth and the way her head rests on her bent-back right hand, as well as the motif of the twin tree trunks just behind the central group, which echoes the forms of Mary and Joseph.[4]

The draft of the letter to Chantelou[5] refers to an unfinished commission for a painting of the Conversion of St Paul, providing a fairly certain date of May 1650. The landscape on the verso (fig.3) has been related to the Louvre *Paysage avec Orphée et Eurydice*, *c.*1649–51,[6] suggesting that both sides of the sheet were executed around the same time.

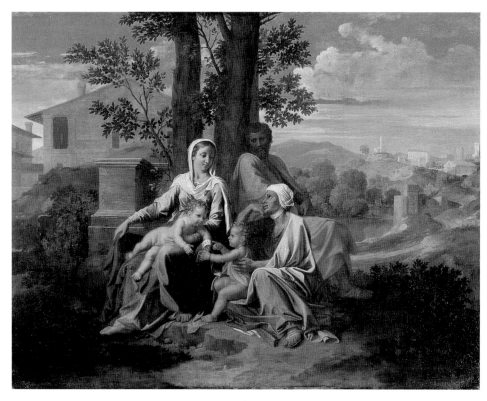

Fig.2 NICOLAS POUSSIN, *Holy Family Under a Group of Trees*, *c.*1650–55, oil on canvas, 95 × 122.4 cm, Musée du Louvre, Paris (7280).

Fig.3 NICOLAS POUSSIN, *Landscape with a Town and a Hilltop Castle in Flames* (verso), pen and brown ink, over a black chalk underdrawing, squared in black chalk, 322 × 205 mm, British Museum (1937-12-11-1).

Although several examples have come to light since the publication of Rosenberg and Prat's catalogue raisonnée in 1994,[7] surviving pen and ink landscape drawings by Poussin are rare. As a group, they tend towards abstraction rather than description; bumpy, broken pen lines outline the major forms, and rudimentary hatching suggests volume and recession. The present sheet shares this characteristic economy of means.[8]

PHILIPPE DE CHAMPAIGNE

1602 Brussels – 1674 Paris

20 Study for the Infant Christ

Flemish by birth and early training, Philippe de Champaigne travelled to Paris in 1621 where he worked in the studio of Georges Lallemant (c.1580–1636) before being hired to participate in the decoration of Marie de Médicis' apartments in the Palais du Luxembourg under the supervision of Nicolas Duchesne (died 1628), whose daughter he married in 1627. Merging the realism of his native Flanders with the restrained Baroque idiom of Simon Vouet (1590–1649) and his generation, Champaigne developed a manner marked by elegant sobriety. His ability to find committed and highly placed patronage with the French court and religious institutions in and around Paris continued unbroken through a number of regime changes from Louis XIII and Cardinal Richelieu, through the regency of Anne of Austria, to Louis XIV and Cardinal Mazarin.

We can only assume that Champaigne's drawings were little appreciated by his contemporaries, for the surviving sheets surely constitute a mere fraction of what must have been a considerable graphic oeuvre. The extant examples suggest that Champaigne employed a methodical and extensive preparatory process for his major commissions. His drawings can be divided into three principal types, corresponding to distinct stages of preparation: initial, broadly treated studies of the overall composition in pen and wash, studies of details – figures and drapery – drawn from life in black chalk heightened with white, and finally large, carefully rendered presentation drawings in ink and wash.[1]

The British Museum's study of a baby and the hands of the figure holding it is among the most engaging and naturalistic of Champaigne's studies from life. It is used, with minor adjustments to the position of the head and legs, for the figure of the infant Christ and the hands of the high priest Simeon in the *Presentation in the Temple* (fig.1). Commissioned for the high altar in the church of Saint-Honoré in Paris, the painting is dated to 1648 by Félibien and Guillet de Saint-Georges.[2] Given its preparatory function, the present sheet would presumably have been made around the same time.[3]

The drapery study on the verso (fig.2) presents a more difficult problem. Dorival related the study to two compositions by Champaigne: a lost canvas of *The Magdalene at the Foot of the Cross*, known through an etching by Jean Morin, and a painting, *Supper in the House of Simon* (Musée du Louvre, Paris), which he dated to c.1656.[4] In the case of the former there is some similarity in the fall of the drapery, although the figure is cropped in the print, limiting the areas for comparison; moreover, one would expect the drawing to be in reverse to the print like the landscape view of Jerusalem in the background, which also appears in a related painting and preparatory drawing.[5] In the case of the latter the drapery of the kneeling woman washing the feet of Christ in the Louvre canvas bears no relation to the British Museum study.

Black and white chalk on buff paper

191 × 290 mm

PROVENANCE: : William Gordon Coesveldt, Esq. (1766–1844); Vizconde de Castelruiz; his sale, Christie's, London, 27–30 April 1846, possibly part of lot 41; purchased by Rodd for the British Museum in 1846

1846-5-9-153

LITERATURE: Ede, 1923, pp.257–8, fig.4; Cordey, 1932, p.17; Rosenberg, 1966b, n.p., fig.4; Rosenberg, 1976, pp.67, 88, fig.12; Dorival, 1976, I, p.116, II, pp.31–32, 47, 143, 407, 413, no.47, figs 47, 72; Sainte Fare Garnot, 2000, pp.14, 52, no.14; Paris, Geneva and New York, 2001, p.280, under no.70

EXHIBITIONS: Nagoya and Tokyo, 2002, pp.80–81, no.36

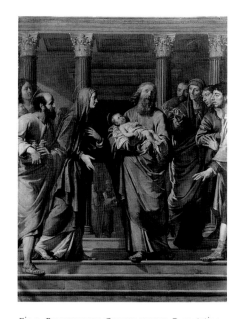

Fig.1 PHILIPPE DE CHAMPAIGNE, *Presentation in the Temple*, 1648, oil on canvas, 257 × 197 cm, Musée Royal des Beaux-Arts, Brussels.

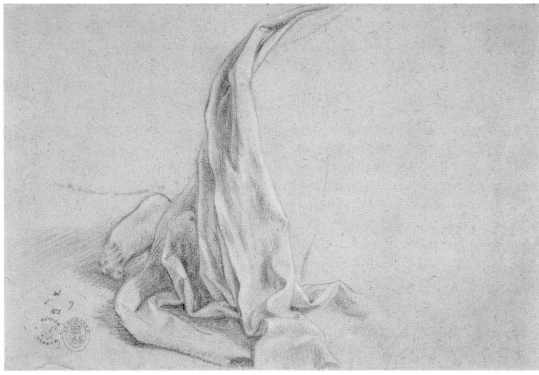

CLAUDE LORRAIN

?1604/5 Chamagne, Lorraine – 1682 Rome

21 Study of a Stream

Although drawings occasionally left Claude's studio – given away as gifts, sent to patrons for approval, or sold – for the most part he guarded his collection of studies and record drawings. Apparently he rebuffed buyers, as Jacopo Salviati explained in a letter to Cardinal Leopoldo de' Medici: 'Mr. Claude has some old drawings, but in small number, and he does not want to part with them, saying that he uses them.'[1] The inventory of possessions made at the time of Claude's death indicated large numbers of drawings, 'some large some small, some good some bad', some in books, some loose.[2] A number of albums date to around this time, although it is not certain whether they were assembled by Claude himself, late in life, or by his heirs just after his death.

This painterly study of a rushing stream and its verdant banks has been identified by Marcel Roethlisberger as a sheet from the Tivoli Book, known today through scattered sheets united by a numbering system and a similarity of format and subject matter. In 1998 Jon Whiteley argued in favour of the Tivoli Book having been an album rather than a sketchbook, citing apparent differences in dates and in the types of paper used for different sheets.[3]

Studies made directly from nature, as this sheet must have been, were never used verbatim by Claude in his paintings, but clearly contributed to his assimilated understanding of natural phenomena and to his achievement in the realm of landscape painting. Joachim von Sandrart (1606–88), in his biography published in 1675, takes credit for inspiring this habit of drawing *en plein air*, describing Claude coming upon him, 'brush in my hands, in Tivoli, in the wild rocks at the famous cascade' and subsequently adopting the same method.[4] Issues of credit aside, sheets such as this one provide ample testimony of Claude's close observation of nature and his ability to evoke it with varied, even intuitive graphic means.

A small waterfall at left spills into a larger stream, rushing and eddying around boulders in the shade of an ancient tree, with sunlit younger trees hugging a steep hillside in the distance. Begun in black chalk, and worked up in painterly washes of brown ink, the contrasting dark forms of the foreground may have been added in the studio as Whiteley has suggested, pointing to the partially unfinished *Stream in Subiaco* (fig.1) to support his thesis.

Typically lacking any direct connection to the paintings, Claude's nature studies have proven difficult to date, although they are generally considered to have been produced early in his career, in the 1630s and 1640s. Of the four nature studies bearing dates in the 1630s, two – *A Waterfall and Trees* (British Museum, Oo.7-209), dated 1635, and *A Stream in Subiaco*, dated 1637 – are extremely close to the present sheet in style and subject matter, suggesting a similar date for this *Study of a Stream*.

Black chalk, brush and brown wash

216 × 312 mm

PROVENANCE: Bequeathed by Richard Payne Knight, 1824

Oo.6-73

LITERATURE: Hind, 1926, p.6, no.62; Roethlisberger, 1961a, I, p.506, under no.238; Roethlisberger, 1968, I, p.191, no.440, II, fig.440

EXHIBITIONS: Paris, 1978, pp.48, 105, no.36; Oxford and London, 1998, p.68, no.24

Fig.1 CLAUDE LORRAIN, A *Stream in Subiaco*, 1637, black chalk with pen and brown ink, brush and brown and pinkish-brown wash, heightened with white bodycolour on blue paper, British Museum (Oo.6-71).

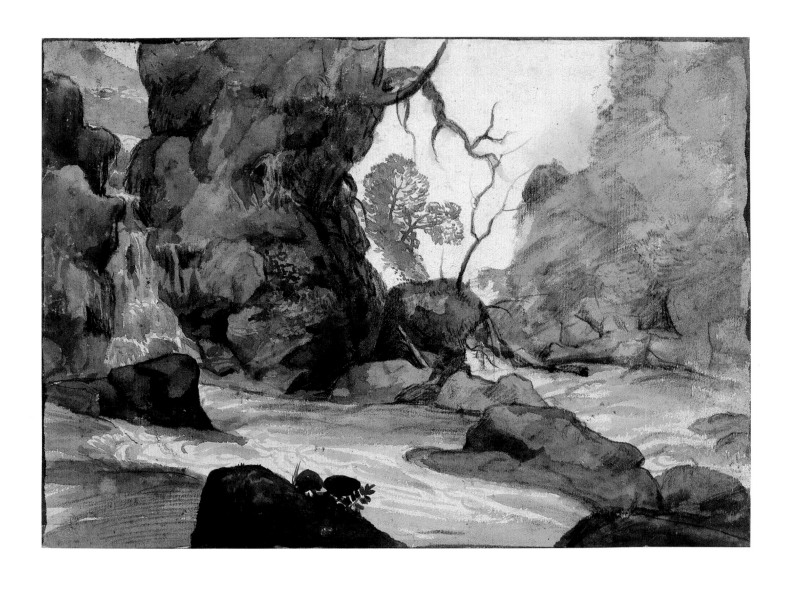

CLAUDE LORRAIN

?1604/5 Chamagne, Lorraine – 1682 Rome

22 St Peter's Basilica Seen from the Doria-Pamphili Gardens

Ruins, bridges, rustic structures, and imaginary buildings evoking classical antiquity all found a place in Claude's painted compositions, but he had little use for the architecture of Baroque Rome. This landscape with St Peter's in the distance, as well as two earlier treatments of the subject, one of which also entered the British Museum with the bequest of Richard Payne Knight in 1824 (fig.1), are rare exceptions to the rule. As Roethlisberger and Whiteley have noted, this view was taken from the Doria-Pamphili gardens, designed by Algardi in 1644 for Prince Camillo Pamphili, the nephew of Pope Innocent X and Claude's patron.

In a sweeping vista the seat of the papacy is framed by tranquil countryside. The recession from fields to the Vatican buildings, and beyond to the distant hills, is carefully delineated in varied tones of wash. The diagonal swathe of shaded hillside in the foreground with grazing goats and a seated goatherd silhouetted in dark wash is probably a studio addition.[1] As with the dark rock and plants in the foreground of *Study of a Stream* (no.21), the addition of a dramatic dark form here works as a pictorial counterweight to the central composition, testimony to the artist's constant impulse to balance, organize and contain nature within a classical structure, even when sketching from nature.

The inscription on the verso (fig.2) dedicates the sheet to a Monsieur De Bertaine, about whom nothing is known, and dates the sheet to 22 May 1646.[2] The date is supported by the absence of Bernini's bell tower on the south-east corner; as it was demolished earlier in 1646 as a result of structural instability.[3] Claude's previous view of St Peter's (fig.1), which shows the tower built up to the second storey, dates to early 1641. An even earlier view of the apse of St Peter's, done shortly after the artist's arrival in Rome, includes the wooden bell tower that came down in 1637 to make way for Bernini's short-lived replacement.[4]

Black chalk, brush and brown wash

212 × 314 mm

PROVENANCE: Bequeathed by Richard Payne Knight, 1824

Oo.7-151

LITERATURE: Hind, 1925, p.29, pl.26; Hind, 1926, p.10, no.101; Roethlisberger, 1968, I, p.242, no.619, II, figs 619r, 619v

EXHIBITIONS: Oxford and London, 1998, p.121, no.66

below left
Fig.1 CLAUDE LORRAIN, *St Peter's Basilica, Seen from the Janiculum*, 1641, black chalk, with touches of grey and brown wash, British Museum (Oo.7-150).

below right
Fig.2 CLAUDE LORRAIN, *A Banner Inscribed: Se Pour. / Qui Ro* (verso), 1646, black chalk, British Museum (Oo.7-151).

CLAUDE LORRAIN

?1604/5 Chamagne, Lorraine – 1682 Rome

23 Figure Study for a Pastoral Landscape

The disparaging of Claude's ability to render the human form is a tradition dating back to the artist's lifetime. Joachim von Sandrart, who knew Claude around 1630, wrote in his biography of the artist: 'however happy [Claude] is in representing well the naturalness of landscapes, so unhappy is he in figures and animals, be they only half a finger long, that they remain unpleasant in spite of the fact that he takes great pains and works hard on them.'[1] Baldinucci, who knew Claude at the end of his career, recalled the artist himself saying that he 'sold the landscapes and gave away the figures'.[2]

If the painted figures tend to confirm the truth of these judgements, Claude's figure drawings testify to his efforts to overcome this difficulty. Unlike the nature studies, which were never intended for direct translation into oil paint, Claude's drawings of figures do correlate closely to their painted counterparts. The British Museum's musical couple were used, with only minor alterations, in a *Pastoral Landscape*, now in Kansas City (fig.1) and dated by Roethlisberger to c.1650–51.[3] As much as anatomy and drapery, the focus of Claude's study is the fall of light. Its source (from the left) and the contrasts between lit and shaded areas are both carried over into the painting. The placement of the trees, however, bears no relation to the painting at all. Rather than an earlier idea for the composition, it is more likely to be a studio addition of dark wash intended to give the sheet pictorial balance and (even if unconsciously) status as an independent and finished work of art in much the same way as studio additions of dark wash can be seen in many of the studies from nature.[4] Given their antique dress and the limited level of detail, one assumes that studies such as this one were drawn not from life but from the artist's imagination. On the verso is a quick preliminary sketch in black chalk exploring the pose of the male figure (fig.2).

Black chalk, brush and brown wash

155 × 229 mm

PROVENANCE: Bequeathed by Richard Payne Knight, 1824

Oo.7-141

LITERATURE: Hind, 1926, p.21, no.213; Roethlisberger, 1961a, I, p.304; Roethlisberger, 1961b, pp.20–21, fig.19; Kitson, 1963, reprinted 2000, pp.68–9, 72, fig.4; Roethlisberger, 1968, I, p.267, no.692, II, figs 692r, 692v

Fig.1 CLAUDE LORRAIN, *Pastoral Landscape*, c.1650–51, oil on canvas, 51 × 68.5 cm, The Nelson-Atkins Museum of Art, Kansas City, Missouri.

Fig.2 CLAUDE LORRAIN, *Study for a Man with a Staff* (verso), black chalk, British Museum (Oo.7-141).

CLAUDE LORRAIN

?1604/5 Chamagne, Lorraine – 1682 Rome

24 Study for 'Coast View with Perseus and the Origin of Coral', 1672

Claude's *Coast View with Perseus and the Origin of Coral* (Viscount Coke, Holkham Hall, Norfolk; fig.1, p.78) was painted in 1674 for Cardinal Camillo Massimi. The inscription on the first of the compositional studies (Metropolitan Museum of Art, New York, Robert Lehman Collection),[1] '[...] pensier / de Ill.mo/ il Cardinalle di massim', suggests that the subject was the idea of the patron, which could well have been the case, as the story was rarely depicted in the visual arts[2] and Massimi already owned a drawing of this subject by Nicolas Poussin (fig.1).[3] Visually, Claude's conception has little to do with Poussin's, as it is a landscape view using the atmosphere of the moonlit shoreline and the towering, dark cliffs to evoke the wonder, beauty and danger inherent in Ovid's tale. In Poussin's drawing, figures essential and non-essential crowd the foreground, creating a solid band, with little landscape visible beyond the solitary palm to which Pegasus is tethered.

The story of the origin of coral is told in Ovid's *Metamorphoses* (Book IV, 670–803). After slaying the snake-haired Gorgon, Medusa, who turned to stone all who beheld her, Perseus took her severed head and flew off on Pegasus, the winged horse born of her blood. Flying over an island, he spied Andromeda tied to a cliff and menaced by a sea monster. He killed this monster as well, freeing Andromeda, and then laid Medusa's head on the ground while he washed his hands. To the enchantment of the sea nymphs, the blood of the Gorgon turned the seaweed into pink stone, explaining the origin of coral.[4]

Claude explored different possibilities for the poses of the curious sea nymphs in two sheets of studies. In the foreground of the British Museum sheet, dated 1672, a nymph holds aloft Medusa's head, while another holds a twig of coral. An alternative scheme in the form of an arc of sketches occupies the upper portion of the sheet. This time the screaming head of Medusa is on the ground, curiously juxtaposed with a tranquil reclining nymph, reminiscent of Poussin's drawing. Only the kneeling figure in the upper right-hand corner, smaller in scale and with her own horizon line, is close to a figure in the painting.

A second sheet of studies, in the collection of Viscount Coke (fig.2), bears a date that has been read as 1671,[5] although it has more poses in common with the final painting. Roethlisberger did not question the date but confessed to 'great doubts about the authenticity of the inscription'.[6] Rejecting 1671 as the date for the Holkham drawing would produce a sequence of greater visual logic. In this scenario, the British Museum study may well be the earliest of the seven drawings associated with the commission, predating even the Lehman compositional study. Claude must have begun in the foreground with the idea of the nymph holding the head of Medusa, but – perhaps after consulting Poussin's drawing – considered and ultimately preferred the alternative scheme, in the upper section of the sheet, with the head on the ground.

Pen and brown ink, brush with brown wash, over traces of black chalk, framing lines in pen and brown ink

Inscribed, signed and dated in pen and brown ink along lower margin, *testa de lamedusa Claudio fecit 1672*

157 × 219 mm

PROVENANCE: Bequeathed by Richard Payne Knight, 1824

Oo.8-260

LITERATURE: Hind, 1926, p.30, no.294; Roethlisberger, 1961a, I, p.435; Roethlisberger, 1968, I, p.393, no.1068, II, fig.1068; Boyer, 1968, pp.374, 379, fig.5; Washington and Paris, 1982, p.286, under no.69; Haverkamp-Begemann *et al.*, 1999, pp.306–9 note 5, fig.109.3

EXHIBITIONS: Paris, 1978, pp.92, 123, no.95; London, 1994, p.114, no.81; Nagoya and Tokyo, 2002, p.84, no.39

Fig.1 NICOLAS POUSSIN, *The Origin of Coral*, pen and brown ink, brush and brown wash, over red chalk underdrawing, 225 × 307 mm, Royal Library, Windsor (inv.11984).

Fig.2 CLAUDE LORRAIN, *Figures for 'Perseus and the Origin of Coral'*, pen and brown ink, brush and brown wash, heightened with white, over black chalk underdrawing, on blue washed paper, 176 × 260 mm, Viscount Coke, Holkham Hall, Norfolk.

CLAUDE LORRAIN

?1604/5 Chamagne, Lorraine – 1682 Rome

25 Coast View with Perseus and the Origin of Coral, 1674

Made as a record of *Coast View with Perseus and the Origin of Coral* (fig.1) before the painting was dispatched to Cardinal Massimi, this sheet was part of the famed *Liber Veritatis* (Book of Truth). Beginning sporadically in 1635, and then continuing more methodically from 1637 until his death, Claude made drawings recording his completed paintings in a bound book, which was dismembered and re-mounted as an album in the eighteenth century. To protect and make more readily accessible the drawings, they were taken out of the album and mounted individually in the 1970s.[1]

As a record, the importance of the *Liber* in our understanding of the artist's oeuvre and development can hardly be overestimated, as it was created chronologically with the year and the name of the patron frequently inscribed on the versos. As a work of art, the *Liber* is equally important; from the care evident in the execution of these drawings, it is clear that the artist meant to convey not just the compositions but also the atmosphere of the paintings. The condition of the sheets, which were bound and little handled for almost three hundred years, is exceptionally fine.

If Claude's aim in creating the *Liber* was, as the contemporary art historian and artist Filippo Baldinucci claimed, to combat forgers,[2] then undoubtedly it served other functions as well, for here, as elsewhere in the *Liber*, atmosphere, technique and certain details are of greater interest than the correctness of internal proportions. Compared to the painting of *Origin of Coral*, the figures in the drawing are less elongated, and even the rock formation behind Pegasus is made more squat to fit the more horizontal proportions of the sheet. Most elaborate is the repoussoir of trees along the left margin, an exuberant and unslavish rendering of its painted counterpart. Like approximately half the sheets from the *Liber*, *Origin of Coral* is executed on blue paper lending a cool, silvery tonality to the image. Although one cannot be certain of the time of day portrayed,[3] effects of light, indicated by white bodycolour, were clearly a central preoccupation, throwing the dramatic rock arch into shadow and backlighting the figures.

Pen and brown ink, brush and grey wash, heightened with white on blue paper

Signed and dated at lower margin, right of centre in pen and brown ink, [CLAVD(?)].1674; inscribed on the verso, *quadro per lemin.*[mo] *e Reve.*[mo] *sig.*[re] / *Cardinale massimi* / *Claudio Gellee. fecit* / *Roma 1674*

195 × 254 mm

PROVENANCE: As part of the *Liber Veritatis*, bequeathed by Claude to his daughter, Agnese in 1682; sold, probably by Joseph Gellée, to a Paris dealer, *c.*1718; in London by *c.*1720; William Cavendish, 2nd Duke of Devonshire, by 1728; by descent to Victor Christian William Cavendish, 9th Duke of Devonshire, ceded to the nation in lieu of estate duty in 1957

1957-12-14-190

LITERATURE: Roethlisberger, 1961a, I, pp.433–44; Kitson, 1963, reprinted 2000, pp.69–70, 73, fig.7; Bean, 1965, p.267, fig.2; Roethlisberger, 1968, I, p.393, no.1069; II, fig.1069; Boyer, 1968, p.379; Kitson, 1978, pp.167–8, pl.184

EXHIBITIONS: Paris, 1978, pp.123–4, no.96; Washington and Paris, 1982, pp.293–4, no.73, illus. in colour, p.32

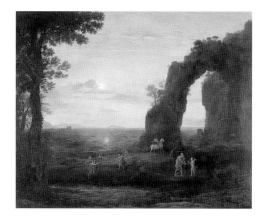

Fig.1 CLAUDE LORRAIN, *Coast View with Perseus and the Origin of Coral*, 1674, oil on canvas, 100 × 127 cm, Viscount Coke, Holkham Hall, Norfolk.

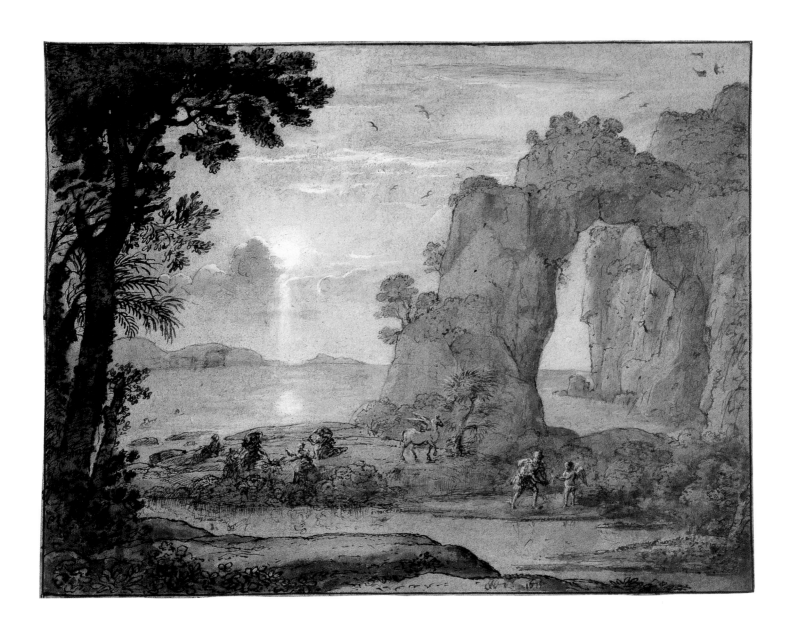

LAURENT DE LA HYRE

1606 Paris – 1656 Paris

26 The Presentation of the Virgin

La Hyre was trained in an essentially Mannerist milieu and nowhere is this more manifest than in the style and function of his drawings. From an affluent family and well educated, he studied at the Château de Fontainebleau from 1622 to 1625, copying works by Francesco Primaticcio and others before spending time in the studio of Georges Lallemant (c.1580–1636). He never adopted the Italian practice, promulgated in Vouet's large studio and later assimilated by the Académie Royale, of studying on paper every aspect of a composition. The majority of La Hyre's extant sheets are compositional studies and only rarely do they correspond precisely with a painted version.

His earliest drawings are elegant and vaporous examples of Mannerist draughtsmanship, with velvety modelling in black chalk and attenuated, graceful figures. From his technique one guesses that he was influenced not only by Primaticcio but also by the artists of the Second School of Fontainebleau, such as Ambroise Dubois (1542/3–1614) and Toussaint Dubreuil (1561–1602). By around 1630 La Hyre adopted a more regular black chalk hatching for his modelling, supplemented with large areas of wash, bold in their application, but soft and pearly grey in tone, endowing his Mannerist style of draughtsmanship with a greater luminosity and precision of form. In the 1640s his work became ever more classicizing until, by mid-decade, it had achieved the more severe form known as Atticism. Figures became more ample and columnar, they were placed closer to the picture plane; their drapery became stiffer and more antique in its conception.

The British Museum sheet, made as a study for an altarpiece dated 1636 (Pushkin Museum, Moscow),[1] is clearly from La Hyre's second phase, the period of his early maturity. A bold architectural setting frames the scene. The figural types, especially their elongated fingers tapering to points, are characteristic of the residual Mannerist sensibility still present in La Hyre's draughtsmanship. Although it is not known for whom the Pushkin altarpiece was painted, Rosenberg and Thuillier point to the flaming heart held by the monk, and the crozier and mitre on the ground, as evidence that painting was commissioned by an abbot.[2] It should also be said that the costume of the kneeling figure in the present drawing is specifically that of a Capuchin monk.[3] The Capuchins were early and loyal patrons of La Hyre. Beginning in around 1626 and continuing until around 1635, he executed a series of altarpieces for the Capuchin church in the Marais, Paris, of which five are known today.[4] This work presumably led to the commission of at least four paintings for Notre-Dame de la Paix, the church of the Capuchin convent on the Rue Saint-Honoré. Only the *Assumption* for the main altar, dated 1635, survives.[5] Although the subject of the Presentation of the Virgin is not mentioned in connection with either the Marais or Saint-Honoré churches in contemporary guidebooks or inventories, the prominence of the kneeling Capuchin monk suggests a possible connection, and a similar figure of a Capuchin monk with hands clasped is inserted into the scene of the Nativity painted for the main altar of the Marais church.[6]

Black chalk, brush and grey wash on light brown paper

Inscribed in pen and brown ink at lower left, *de la hire*

467 × 256 mm (top cut into arched shape)

PROVENANCE: Bequeathed by William Fawkener, 1769

T.14-16 (Fawk. 5213-16)

LITERATURE: Vallery-Radot 1953, p.197, no.80; Rosenberg and Thuillier, 1985, n.p., no.15; Cleveland, Cambridge and Ottawa, 1989, p.169, under no.84

EXHIBITIONS: Grenoble, Rennes and Bordeaux, 1989, pp.45, 194, no.130; Nagoya and Tokyo, 2002, pp.88–9, no.42

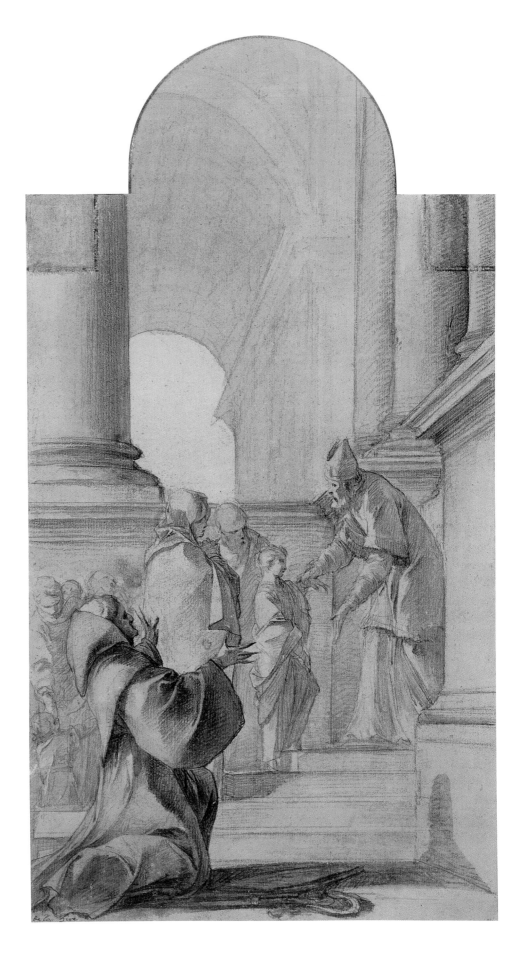

EUSTACHE LE SUEUR

1616 Paris – 1655 Paris

27 Studies for a Figure of Fame

One of the founders of French classicism, Eustache Le Sueur was considered by his contemporaries to be on a par with Nicolas Poussin (1596–1665) and Charles Le Brun (1619–60). His reputation fell into decline in the eighteenth and nineteenth centuries, and it was not until the latter half of the twentieth century that his spare, elegant classicism and subtle colour harmonies were rediscovered. Like many other painters of his generation, Le Sueur received his essential training in the busy studio of Simon Vouet. But instead of going on to continue his study in Italy, Le Sueur remained with Vouet for a decade, working closely with him and absorbing many elements of his graceful and richly decorative manner. Le Sueur's *Life of St Bruno* (Louvre, Paris), a cycle of twenty-two canvases painted between 1645 and 1648, heralded the emergence of a distinctive independent style that continued to take on a greater rigour and severity following Vouet's death in 1649.

In addition to his stylistic impact, Vouet also imparted to his students studio practices learned in Italy, in which paintings were prepared using a standard progression of drawings, from compositional studies to studies of individual figures. For Le Sueur this methodical mode of working became deeply ingrained. Like Vouet, he favoured black and white chalk for his figure studies, although he preferred a darker paper; the grey-brown of this sheet is typical.[2] The mid-level tonality functioned as an effective foil to the elegant and volumetric rendering of form and drapery in black and white chalk.

The British Museum drawing, with its careful modelling and squaring in black chalk, is undoubtedly a study for a lost painting. Mérot relates it stylistically to a figure study in the Harvard University Art Museums for an angel in the *Return of Tobias*, part of a series dating to 1646–7.[3] However, an even closer stylistic comparison can be found in a study for an allegorical figure of France in the École des Beaux-Arts, Paris (fig.1).[4] Both are preparatory for flying allegorical figures seen from below, with additional studies and squaring.

The École des Beaux-Arts sheet is related to *Time Lifting France into the Sky*, part of the decoration of the royal apartments in the Louvre undertaken by Le Sueur in 1653–5. Another canvas by Le Sueur, *Allegory of the French Monarchy Triumphing over its Enemies*, also hung in the bedroom of Louis XIV. Although both paintings are lost today, Guillet de Saint-Georges's 1690 description of the latter is of interest: 'Il représentoit sous des figures allégoriques la Monarchie françoise appuyée sur un globe couronné. La Justice et la Valeur donnoient la fuite aux ennemis de la France, et la Renommée en publioit les avantages' (the French monarchy is represented by an allegorical figure leaning against a crowned globe; Justice and Valour vanquish the enemies of France, and Fame makes known its superiority).[5] Two preparatory studies survive for this important commission,[6] although they both appear to be early in Le Sueur's composing process and neither includes Fame. Given the explicit mention of such a figure by Guillet de Saint-Georges, it is possible that the British Museum *Fame* could be a study for a figure added late in the design process to the *Allegory of the French Monarchy*.

Black chalk, heightened with white chalk, squared for transfer in black chalk, on grey-brown antique laid paper

395 × 214 mm

PROVENANCE: Bequeathed by William Fawkener, 1769[1]

T.14-15 (Fawk. 5213-15)

LITERATURE: Mérot, 2000, pp.314, 335, no.D.367, fig.500

EXHIBITIONS: Nagoya and Tokyo, 2002, p.93, no.46

Fig.1 EUSTACHE LE SUEUR, *Study for the Figure of France, with Additional Studies of Hands and Feet*, black chalk, heightened with white chalk, on brownish paper, squared in black chalk, 428 × 290 mm, École des Beaux-Arts, Paris (inv.1185).

MICHEL DORIGNY

1617 Saint-Quentin – 1665 Paris

28 Bacchanal

Much of the career of Michel Dorigny was overshadowed by the success of his father-in-law Simon Vouet, *premier peintre* to King Louis XIII. Dorigny held a senior position in Vouet's studio, assisting him in fulfilling his painting commissions and publishing engravings of almost ninety of his works. The reconstitution of Dorigny's independent oeuvre, long sheltered under incorrect attributions to his master, is underway, largely due to the scholarship of Pierre Rosenberg and Barbara Brejon de Lavergnée.[2] In addition to the prints after Vouet, Dorigny etched around twenty plates that are indicated by their inscriptions to be after his own designs. Among these is a set of twelve Bacchanals, in two suites of six.[3] The evidence of the prints has allowed a group of related black chalk drawings to rejoin his graphic oeuvre.

The present sheet came to the British Museum in 1952 as part of the Lord James Cavendish album with a traditional attribution to Vouet. Nicholas Turner first suggested an attribution to the Venetian artist Giulio Carpioni (1611–74) before discovering the related print in 1980 (fig.1), allowing him to reassign the British Museum sheet and two others of the series to Dorigny.[4] The group was expanded by Brejon de Lavergnée in an article of 1981,[5] and a further drawing appeared on the art market in 1985.[6] The series now includes five compositional drawings.[7] Since 1981 two have entered the École Nationale Supérieure des Beaux-Arts with the Matthias Polakovits bequest,[8] one was acquired by the Metropolitan Museum of Art, New York, in 2001,[9] and another was acquired in 1985 for a private collection in London.[10]

The compositional drawings for the bacchanal prints are all the same size as their printed counterparts, but in reverse direction, and all have incised contours, indicating Dorigny's mode of transfer. All contain numerous pentimenti revealing Dorigny's quest to perfect the poses of the figures. Backgrounds are only summarily sketched in, and details of foliage, bark and clouds were presumably worked out directly on the copper plate. In the present drawing significant alterations were made to the upper half of the woman's body: her raised arm was lowered slightly and her head and shoulder were shifted closer to the right margin. The resolution of the *mise-en-page* is signalled by dark, decisive contour marks for the figures, sometimes gone over several times.

A range of dates has been proposed for Dorigny's bacchanal prints and their preparatory drawings. Barbara Brejon de Lavergnée saw them as strongly indebted to Vouet's style, situating them in the 1630s.[11] Alvin L. Clark Jr. placed them in the 1650s, after Vouet's death, citing the greater use of the burin in Dorigny's later prints.[12] More recently, Emmanuelle Brugerolles and David Guillet have opted for an intermediary date, 1640–44, a period when Dorigny had achieved a maturity in his style, but still worked closely with Vouet.[13] At the crux of the debate is their relationship to Vouet's manner, an issue clouded by the rarity of surviving compositional studies by Vouet.[14]

Black chalk, indented for transfer

296 × 211 mm

PROVENANCE: Collector 'G.H.'?;[1] presumably 2nd or 3rd Duke of Devonshire; Lord James Cavendish, MP (died 1741), who mounted the sheet in an album; his album is said to have belonged to the family of his great-great-nephew Charles Cavendish, 1st Lord Chesham; until acquired c.1950 by Mr L. Colling-Mudge; purchased with a contribution from the National Art Collections Fund and Vallentin Fund (removed from the Cavendish album in 1964)

1952-1-21-17

LITERATURE: Turner, 1980, p.134, no.58 (as Giulio Carpioni), and erratum slip (as Dorigny); Brejon de Lavergnée, 1981, p.446, pl.29; Milan, 1985, p.50; Paris, 1989, p.100, under no.30 (entry by Barbara Brejon de Lavergnée); Paris, Geneva and New York, 2001, pp.224 and 227 note 12, ill.2; Jaffé, 2002, V, pp.672–3, no.1765

EXHIBITIONS: Nagoya and Tokyo, 2002, p.94, no.47

Fig.1 MICHEL DORIGNY, *Bacchanal*, etching and engraving, The Metropolitan Museum of Art, New York, The Elisha Whittelsey Collection, The Elisha Whittelsey Fund, 1949 (49.95.850).

CHARLES LE BRUN

1619 Paris – 1690 Paris

29 The Sacrifice of Isaac

It is a measure of Le Brun's early promise that he received commissions from Cardinal Richelieu when he was barely twenty years old and was sent to Rome in 1642 in the company of Poussin at the expense of Chancellor Séguier. Returning to Paris in 1646, Le Brun had no shortage of commissions from ecclesiastical, royal and private patrons. He increasingly became known for his skills as a large-scale history painter and his ability to supervise teams of artists. By the 1660s Le Brun's energies were largely devoted to designing and implementing ambitious decorative programmes for Louis XIV at the Château de Versailles, where he was a key author of the visual iconography of the Sun King.

This vigorously worked sheet is a compositional study for a lost painting that formed part of a series of at least three paintings of Old Testament scenes of sacrifice. The *Sacrifice of Manoah* is likewise lost, while the *Sacrifice of Elijah* survives in Geneva.[1] Although it is not known for whom they were first painted, all three were together in the collection of Gui-Crescent Fagon (1638–1718), *premier médecin du roi* and *conseiller d'Etat ordinaire* in the early eighteenth century, when they were engraved by Louis Desplaces (1682–1739).[2] Such commissions from private patrons would probably date from shortly after Le Brun's return to France. As Hidenori Kurita suggested in 2002, a close stylistic parallel for the present drawing can be found in *The Holy Family with St John the Baptist*, another red chalk compositional drawing (private collection, Paris), dated by Pierre Rosenberg to 1648–50.[3] Also relevant for the dating of the British Museum sheet is the fact that the Geneva *Sacrifice of Elijah* reuses a figure from the composition *Moses and the Brazen Serpent* (c.1649–51; City Art Gallery, Bristol), suggesting a date of c.1649–52 for the series of three sacrifices.[4]

One can see in Desplaces' print (fig.1), although the direction of the composition is reversed, the numerous adjustments Le Brun made between the present drawing and the final canvas. The contained and planar composition presented in the drawing, with its compact grouping of figures and reliance on the horizontal lines of the stone platform and the wooden pyre, is given more drama and emotional intensity in the painting. Abraham's pose is more dramatic, with his front leg angled, the muscles of his forearms bulging and his face contorted. Isaac is placed on a white fabric, emphasizing his innocence; his hands are bound at the wrist and his eyes averted as the blade of the knife glints near his throat. The censer is moved to the top of the pyre, its smoke seemingly merging with the clouds that darken the sky. Both the angel's hand and Isaac's praying hands are angled more directly upwards to emphasize the moment of god's intervention.

Red chalk

Inscribed at lower right in pen and brown ink, M *Le Brun*, and in black ink, 134

271 × 240 mm

PROVENANCE: William Gordon Coesveldt, Esq. (1766–1844); Vizconde de Castelruiz; his sale, Christie's, London, 27–30 April 1846, part of lot 45; purchased by Rodd for the British Museum in 1846

1846-5-9-156

LITERATURE: Cordey, 1932, p.18

EXHIBITIONS: Nagoya and Tokyo, 2002, pp.96–7, no.49

Fig.1 LOUIS DESPLACES, after Charles Le Brun, *The Sacrifice of Isaac*, etching and engraving, The Metropolitan Museum of Art, New York. Harris Brisbane Dick Fund, 1930 (30.22.7.1).

M Le Brun

134

ROBERT NANTEUIL

1623 Reims – 1678 Paris

30 Portrait of Gilles Ménage, c.1652

Robert Nantueil engraved over two hundred portraits, the majority after his own designs. His style was sensitive and restrained, capable of conveying the intelligence and gravity of his sitters, many of whom belonged to the highest echelons of society. His early style as a draughtsman owes a debt to Claude Mellan (1598–1688) and Philippe de Champaigne (1602–74), although he would later revive and develop the use of pastel as an effective medium for portraiture. Despite this evolution in technique, his format for portraits varied little, being typically bust or half-length, often in three-quarter view, with the emphasis on physiognomy and character outweighing any interest in dress or accessories.

The British Museum portrait of Gilles Ménage (1613–92) is an early work dating to only five years after Nanteuil's arrival in the French capital from his native city of Reims in 1647. It was the model for a dated engraving used as the frontispiece for *Aegidii Menagii Miscellanea* (Paris, 1652; fig.1).[1] Graphite on vellum was Nanteuil's technique of choice throughout the 1650s. With the fine grain of the graphite and the smoothness of the vellum, he was able to achieve, as here, a breathtakingly subtle modulation of tone. The lucidity and directness of Ménage's gaze withstand translation into the engraving medium, although the luminosity of the flesh tones is not as easily replicated by the burin.

Ménage trained in Angers as a lawyer, but not long after settling in Paris he abandoned the practice to pursue scholarship instead. He became well known in Paris as a man of letters, hosting regular literary evenings on Wednesdays. His publications included etymological studies concerning the origin of the French and Italian languages, histories of philosophy, and satire. His abrasive personality, however, apparently alienated many of his contemporaries, and he was never invited to become a member of the Académie Française. He is often cited as having been Molière's model for the character of Vadius, the pedantic scholar in *Les Femmes savantes*.[2]

Nanteuil himself was far better educated than the typical engraver of his day. He had studied at the Jesuit College of Reims where he submitted his thesis in philosophy in 1645. His education undoubtedly helped him work with sitters of elevated social rank and intellectual standing. In 1658 he was accorded the title *Dessinateur et graveur ordinaire du roi*. It was partly in recognition of Nanteuil's achievements that Louis XIV granted print-makers equal status to painters as academic artists of the liberal arts in 1662.[3]

Graphite on vellum

Signed in graphite along the lower margin, *Rob. Nantueil Faciebat*

167 × 121 mm

PROVENANCE: Paignon-Dijonval; in 1792 to his heir Charles-Gilbert, Vicomte Morel de Vindé; sold in 1816 to Samuel Woodburn; sale, Christie's, London, June 16, 1854, lot 1375; Walter Benjamin Tiffin, from whom acquired in 1854

1854-6-28-68

LITERATURE: Bénard, 1810, p.122, no.2807; Thomas, 1914, pp.337, 340, ill. p.338; Bouvy, 1924, p.49, ill.; Petitjean and Wickert, 1925, pp.303–4, under no.168, ill.; Cordey, 1932, p.18; Vallery-Radot, 1953, p.204, pl.108; Laclotte, 1965, ill. p.178

EXHIBITIONS: Nagoya and Tokyo, 2002, p.101, no.53

Fig.1 ROBERT NANTEUIL, *Gilles Ménage*, engraving, The Metropolitan Museum of Art, New York. Rogers Fund, 1920 (20.13.17).

CHARLES DE LA FOSSE

1636 Paris – 1716 Paris

31 Diana, Aurora and the Morning Star with two Horae Pouring Dew

It is fitting that this drawing, acquired in 1998, should be housed in the British Museum, since it is a study by Charles de La Fosse for a ceiling at Montagu House, the Museum's original home. Ralph, Earl of Montagu, later first Duke of Montagu (1683–1709), was a man of both taste and means who became familiar with the latest achievements in French art and architecture during several stints as ambassador to France. According to Jo Hedley, who has studied closely the relationship between artist and patron, the two were already acquainted before Montagu's return to England in 1686. When he needed the ceilings of his opulent new residence in Bloomsbury Square decorated, Montagu sent for La Fosse who came to London for four months in 1689 to study the space and take measurements. After making sketches in France, he returned in 1690 to execute the ceilings, with Jacques Rousseau (1630–93), Jacques Parmentier (1658–1730) and Jean-Baptiste Monnoyer (1636–99) as collaborators for the subsidiary elements, completed the project and returned to Paris in 1692.[1] La Fosse frescoed the ceilings above the staircase, vestibule and salon, depicting *Phaeton Demanding the Chariot of the Sun from Apollo*, *The Fall of Phaeton*, and *Minerva*.[2] La Fosse's paintings were destroyed in the nineteenth century when Montagu House was razed to make way for the building that houses the Museum today.

This sheet is a preparatory study for *Phaeton Demanding the Chariot of the Sun*, the fresco visible in George Scharf's 1845 watercolour of the staircase at Montagu House (fig.1). The subject is taken from Ovid's *Metamorphoses*, where the arrival of the dawn takes on ominous overtones on the ill-fated day when Apollo had to grant the wish of his son Phaeton to drive his father's chariot across the sky. While "Phaeton is gazing in wonder at the workmanship, behold, Aurora, who keeps watch in the gleaming dawn, has opened wide her purple gates, and her courts glowing with rosy light. The stars all flee away, and the morning star closes their ranks as, last of all, he departs from his watch-tower in the sky ... dewy night has reached her goal on the far western shore. We may no longer delay. We are summoned: the dawn is glowing, and all the shadows have fled."[3]

Following Ovid, La Fosse used a group of female divinities to symbolize the coming dawn: at the centre of the sheet two Hours pour dew onto the earth below; behind them, seated before the arc of the zodiac, are Aurora on the left and Diana on the right. The figure in the centre may represent the Morning Star.[4]

Other drawings have tentatively been associated with the Montagu commission. A drawing of a female allegorical figure seated on a balustrade, likewise in red and black chalk on blue paper, in the Whitworth Art Gallery, Manchester, may well have related to a part of the ceiling not visible in Scharf's watercolour,[5] although the task of linking preparatory works with specific decorative projects is made difficult in the case of La Fosse by the small proportion of ceilings that have survived as well as by his tendency to reuse figural types over the course of his career.[6]

Black, red and white chalk on blue paper

228 × 324 mm

PROVENANCE: Sale, Christie's, New York, 30 January 1998, lot 226; purchased by Diane A. Nixon and presented through the American Friends of the British Museum

1998-4-25-5

LITERATURE: Royalton-Kisch, 1999, pp.11–14; Hedley, 2001, pp.240–41, 243, and 257 note 47, fig.23

Fig.1 GEORGE SCHARF (1820–1895), *The Staircase at Montagu House*, 1845, watercolour, British Museum (1862-6-14-631).

CHARLES DE LA FOSSE

1636 Paris – 1716 Paris

32 Study for a Page

There is no better testimony to the innovation and accomplishment of this sheet and its pendant, *Study for Balthasar* (no.33), than that they were long celebrated as *trois crayons* studies by Antoine Watteau (see no.40), the eighteenth-century master of the technique. They were sold as such in 1854 and were accepted as part of Watteau's oeuvre, beginning with Edmond de Goncourt's catalogue of 1875. It was only when they were exhibited in London in 1980 with other Watteau drawings from the British Museum that Jean-Pierre Cuzin recognized the more weighty, volumetric figural style of La Fosse and connected them with figures in the Louvre's *Adoration of the Magi* (fig.1, p.94).[1]

In her recent study of La Fosse's development as a draughtsman, Jo Hedley traced an evolution in his technique from an early manner indebted to his master Charles Le Brun, with an emphasis on clarity and outline, through the study and assimilation of Rubens's use of *trois crayons*, to the gradual adoption of a loose and tonal blending of red, black and white chalks on roughly textured grey or light brown paper.[2] The present sheets belong to this later period of painterly, sensuous chalk drawings concerned with warmth, colour and surface effect. Also worthy of mention in the context of La Fosse's stylistic evolution is his friendship with the theoretician Roger de Piles (1635–1709), one of the main voices of the *Rubéniste* camp in the debates on colour versus line that divided the Academy in the late seventeenth century.

These sheets were part of the preparatory process for one of La Fosse's last major paintings, the *Adoration of the Magi*, painted for the choir at Notre Dame as part of a series of eight canvases by various artists depicting the life of the Virgin.[3] The commission is first recorded in 1711 and was completed in 1715, the year before the artist's death. As was his practice, La Fosse first made a rough compositional study in pen and ink.[4] The chalk studies of heads can be placed much later in the compositional process, probably c.1713–15, when the format and arrangement of figures had been resolved. Both British Museum studies were drawn from life after the same model, although changes in the expression, turban and costume allowed one to be used for the Magi king Balthasar and the other – with fewer changes – for the figure of his page.

The date of 1715, the *terminus ante quem* for the present drawing, is of no small significance, for it is precisely the moment when Watteau is generally considered to have taken up the technique of *trois crayons*.[5] The association of the two artists, born fifty years apart, is amply documented.[6] La Fosse found lodging in the Parisian hôtel of collector Pierre Crozat (1665–1740) from 1708 until his death in 1716. Watteau was also in Crozat's circle, decorating his dining room with the *Saisons* series from 1713 to 1715 and likewise taking up residence there in 1715. Thus, Watteau would have had La Fosse's painterly *trois crayons* studies, such as the present sheet, directly at hand when he made his first experiments in the style that would ultimately become his trademark.

Red, black and white chalk with touches of pastel on grey-brown paper

180 × 145 mm

PROVENANCE: Samuel Woodburn, London (1786–1853; Lugt 2584); his sale, Christie's, 16 June 1854, lot 1374; purchased in 1854

1854-6-28-66

LITERATURE (selected): Goncourt, 1875, p.348, no.3; Dargenty, 1891, ill. opp. p.16; Fourcaud, 1901, p.341 note 1; Uzanne, 1908, ill. pl.VI; Binyon, 1921a, p.71; Gillet, 1921, pp.90, 241 note 1; Parker, 1930a, pp.10, 20, no.19; Parker, 1931, pp.12, 20; Adhémar, 1950, p.149; Parker and Mathey, 1957, II, p.340, no.727; Huyghe, 1970, fig.42; Eidelberg, 1977, pp.180, 201 notes 24–25; McCorquodale, 1980, p.232 (here, and in all previous references, as 'Watteau'); Cuzin, 1981, pp.19–21, fig.2 (here, and henceforth, as 'La Fosse'); Grasselli, 1981, pp.311–12; Posner, 1984, pp.72, 282 note 29; Grasselli, 1987a, I, p.299 note 81; Rosenberg and Prat, 1996, III, p.1204–5, no. R206; New York and Ottawa, 1999, p.34, fig.27; Rosenberg, 2000, pp.128–9, fig.163; Hedley, 2001, pp.253–4, fig.40

EXHIBITIONS: London, 1980, p.25, no.21 (as 'Watteau'); Nagoya and Tokyo, 2002, p.102, no.54 (as 'La Fosse')

CHARLES DE LA FOSSE

1636 Paris – 1716 Paris

33 Study for Balthasar

See no.32.

Red, black and white chalk, with touches of pastel on grey-brown paper

180 × 145 mm

PROVENANCE: Samuel Woodburn, London (1786–1853; Lugt 2584); his sale, Christie's, 16 June 1854, lot 1374; purchased in 1854

1854-6-28-67

LITERATURE: Goncourt, 1875, p.348, no.2; Dargenty, 1891, ill. opp. p.14; Fourcaud, 1901, p.341 note 1; Uzanne, 1908, ill. pl.VI; Binyon, 1921a, p.71; Gillet, 1921, pp.90, 241 note 1; Parker, 1930a, pp.10, 20, no.18; Parker, 1931, pp.12, 20; Parker and Mathey, 1957, II, p.340, no.728; Eidelberg, 1977, pp.180, 201 notes 24–25; McCorquodale, 1980, p.232 (here, and in all previous references, as 'Watteau'); Cuzin, 1981, pp.19–21, fig.1 (here, and henceforth, as 'La Fosse'); Grasselli, 1981, pp.311–12; Posner, 1984, pp.72, 282 note 29; Grasselli, 1987a, I, p.299 note 81; Rosenberg and Prat, 1996, III, p.1204–05, no. R207; New York and Ottawa, 1999, p.34; Rosenberg, 2000, p.129; Hedley, 2001, p.254

EXHIBITIONS: London, 1980, p.25, no.20 (as 'Watteau')

Fig.1 CHARLES DE LA FOSSE, *Adoration of the Magi*, 1715, oil on canvas, 4.27 × 4.47 m, Musée du Louvre, Paris (M.I. 316).

SÉBASTIEN LECLERC I

1637 Metz – 1714 Paris

34 The Academy of Sciences and Fine Arts

Sébastien Leclerc was primarily a printmaker, producing over 3,000 etchings, many of his own design. He was also accomplished in geometry and perspective and taught these subjects at the Académie Royale de Peinture et de Sculpture. At the same time, although not a member, he was closely associated with the Académie des Sciences where the precision of his work brought him numerous commissions illustrating zoological or botanical works. Leclerc celebrated the rarified world of learning and scientific progress centred around these recently formed Academies in his most ambitious and admired print, *The Academy of Sciences and Fine Arts* (fig.1),[1] for which the British Museum drawing is a study. In a close reading of the iconography Maxime Préaud has interpreted the print as Leclerc's graphic testament, alluding not just to his interest in the arts and sciences, but to his contribution to these fields as well. As such, Préaud situates the imagery in the tradition of the scientific *vanitas*, concerned with the scientist's intellectual legacy.[2]

Published with a dedication to the king in 1698, the *Academy of Sciences and Fine Arts* drew inspiration from Raphael's famous fresco, *The School of Athens* (1511). It presents Leclerc's vision of an imaginary or ideal academy where many subjects are taught and studied within the indoor and outdoor spaces of a vast classical building. In addition to the sciences and plastic arts, Leclerc included representations of the liberal arts. Rhetoric is represented by an orator in the background, framed by an archway in the colonnade, arithmetic by a group in the left foreground studying trigonometry, and music by a group of musicians seated on the stone wall in the background, to the left. Spheres and diagrams to the left represent the study of astronomy. Although they have equal prominence in the title, the fine arts are relegated to the background in the print and scarcely indicated in the present preparatory study (save for a lone draughtsman at the entrance to the peristyle). In addition to these generalized allegories, Leclerc has throughout his composition inserted instructional diagrams and images borrowed from his own graphic oeuvre.[3] If these references were meant to point to Leclerc's personal contribution to the scientific fields represented, then the array of scientific instruments can be seen as self-referential as well, for Leclerc had formed a large collection of them.[4] In a print that remained unfinished at the artist's death, but may have been intended as a retroactive pendant, Leclerc depicted himself standing in an airy cabinet filled with a great variety of scientific instruments and showing an object to a group of erudite visitors.[5]

An earlier stage in the evolution of the composition, quite different from the British Museum version, survives in a pen and wash drawing in the École des Beaux-Arts, Paris (fig.2).[6] Here, the academy of arts is more prominent, with a crowded room of young artists drawing from a live model seen through an arched doorway. Missing, though, from this early conception is the figure of the chiromancer reading the palm of a young man. Bearded and old, practising an art more magic than science, he is used, according to Préaud, as a foil against which to extol the progress of science under the Sun King.

Pen and black and grey ink, with brush and grey wash, over red chalk, on two joined pieces of paper, with many smaller pieces inlaid and overlaid

228 × 371 mm

PROVENANCE: Purchased by Farren for the British Museum in 1886

1886-1-11-18

LITERATURE: Sibertin-Blanc, 1938, pp.53–4 note 3; Rosenberg, 1971a, pp.20, 86, pl.XXXIII; Rosenberg, 1976, pp.19, 86, pl.XXXIII; Paris, 1984, p.10, under no.1; Paris, 1989, p.124, under no.42

EXHIBITIONS: Nagoya and Tokyo, 2002, p.103, no.55

Fig.1 SÉBASTIEN LECLERC I, *The Academy of Sciences and Fine Arts*, etching, The Metropolitan Museum of Art, New York, The Elisha Whittelsey Collection, The Elisha Whittelsey Fund, 1962 (62.598.300).

Fig.2 SÉBASTIEN LECLERC I, *The Academy of Sciences and Fine Arts*, pen and black ink, brush and grey and brown wash, École Nationale Supérieure des Beaux-Arts, Paris (inv.1169).

MICHEL CORNEILLE II

1642 Paris – 1708 Paris

35 The Surrender of a City to Louis XIV

The son of painter Michel Corneille le père (c.1601/3–64), and the elder brother of Jean-Baptiste Corneille, Corneille was referred to in the seventeenth century as l'aîné (the elder), and in more recent times as le fils (the son) or simply 'the second'. Before winning the Prix de Rome in 1659, Corneille spent time in the studios of the two leading artists of the day, Charles Le Brun (1619–90) and Pierre Mignard (1612–95). He made productive use of his four years in Rome, and his sheets of chalk studies of heads and hands especially suggest a deeply ingrained admiration for Raphael (1483–1520). Pierre-Jean Mariette, in his Abécédario, also described Michel Corneille II's early employment copying and retouching drawings in the Jabach collection,[2] a statement supported by Catherine Monbeig Goguel's close study of the Jabach drawings in the Louvre.[3]

The technique of this sheet with its emphatic outlines and pictorial use of wash and gouache is entirely characteristic of Corneille's compositional studies. It must have formed part of a set with Louis XIV Crossing the Rhine (fig.1; Courtauld Institute Galleries). Both sheets celebrate Louis XIV's military campaigns by employing largely allegorical means. A striking compositional parallel can be seen in Corneille's wall painting (1680–81) in the Salle Henri IV, the soldiers' refectory, at the Invalides, although the painting is different in format and certain details.[4] Corneille's monarchical allegories are clearly indebted to Le Brun's iconography for the Galerie des Glaces at Versailles, which used a compartmental-ized ceiling to glorify the military accomplishments of the king.[5] The Histoire du Roy tapestries woven at the Gobelins after designs by Le Brun and Adam van der Meulen (1632–90) portray Louis XIV's military victories without allegory, yet other drawings and cartoons survive, apparently collaborations between Le Brun, van der Meulen, and François Verdier (1651–1730), that treat the same subjects with the addition of flying alle-gorical figures. In 1930 Gaston Brière hypothesized that a second set of tapestries, mixing allegory and naturalism, may have been planned.[6] Michel Corneille II would surely have seen some of these preparatory works in Le Brun's studio, but whether the Courtauld and British Museum drawings represent designs for an unexecuted project, such as a royal decorative scheme, or were merely an exercise or homage is not known.

Unlike the Histoire du Roy tapestries, where the action is set against sweeping vistas based on van der Meulen's detailed landscape drawings, the designs of Michel Corneille II use a large cast of characters to fill the foreground with animation. In the British Museum sheet a stately Louis XIV arrives on horseback, heralded by figures of Victory and Fame, as Jupiter looks on benevolently from the heavens. Allegorical figures representing the city and its inhabitants surrender to the king, among them a lion, the symbol of the United Provinces. In the distance can be seen the city in flames and bodies littering the battle-field. As one frequently finds in the drawings of Corneille, the unused corners are filled with small sketches in a stiff and scratchy ink line, ideas for, or reprises of, some of the figures in the main design.

Pen and black ink, brush and brown wash, heightened with white gouache, traces of black chalk underdrawing

Signed in pen and brown ink at lower left, M corneille; inscribed on the verso in pen and brown ink, de la part de M. François Falconnet- and E.E. Pulteney

247 × 357 mm

PROVENANCE: François Falconnet (?); E.E. Pulteney (?);[1] Alistair Matthews, purchased through the H.L. Florence Fund in 1971

1971-12-11-1

LITERATURE: London, 1991, p.30, under no.11

Fig.1 MICHEL CORNEILLE II, Louis XIV Crossing the Rhine, pen and brown ink, brush and brown wash, with white and yellow gouache, over a black chalk underdrawing, 301 × 449 mm. Courtauld Institute Galleries, London, Witt Bequest 1952 (3636).

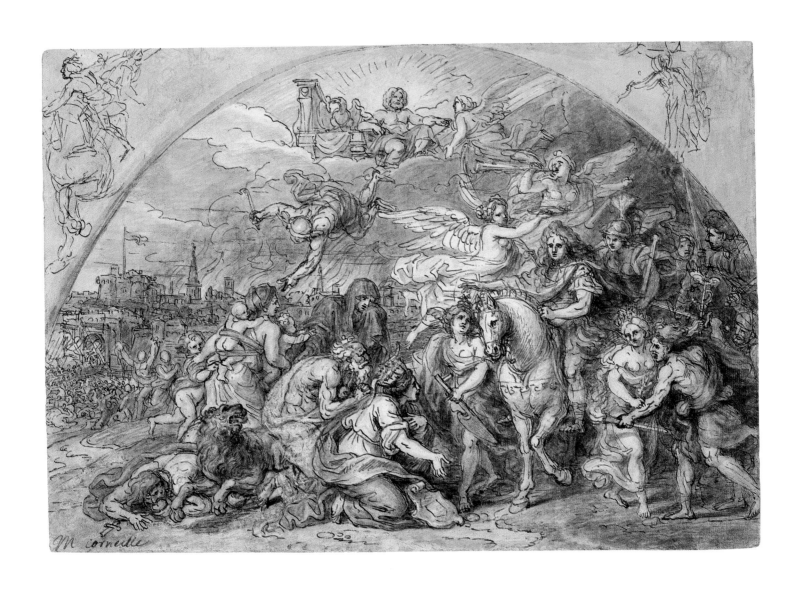

M. corneille

RAYMOND LA FAGE

1656 Lisle-sur-Tarn – 1684 Lyon

36 Allegorical Self-Portrait

Raymond La Fage was compulsively engaged in drawing self-portraits, not primarily, it would seem, to record his likeness, but rather to express an autobiographical impulse, frequently using allegory to disseminate an image in which artistic achievement and debauchery compete for dominance. These efforts at self-promotion notwithstanding, knowledge of his artistic output is patchy. La Fage lived only to the age of twenty-eight and was primarily a graphic artist; he is reputed to have executed several series of paintings on commission, but none survives.

La Fage's early renown is mainly due to Pierre Crozat (1665–1740), for Crozat first began to assemble his celebrated collection in Toulouse with the purchase of a group of drawings by La Fage, who was working there in the year before his death. Crozat's sale catalogue records no less than four self-portraits by La Fage.[1] Pierre-Jean Mariette, the first-known owner of the present sheet, penned a long and laudatory piece on La Fage for his *Abécédario*. This began with the statement – which might appear hyperbolic to modern readers – that La Fage so excelled in drawing, that he could be ranked on a par with the greatest draughtsmen of the past.[2]

Mariette's claim in the *Abécédario* that corrupt morals and debauchery marked La Fage's short life is echoed in the Latin phrase he inscribed on the mount of the British Museum drawing, 'he depicts both his appearance and his habits'.[3] It is important to note, however, that La Fage presents himself as aloof and apart, ready to portray, not take part in, the bacchic frenzy. He is dressed in the antique style, drawing attention to the classical sources of the bacchanal. Surrounded by nymphs, revellers and a priapic term, he dips his pen in an inkwell, preparing to record the scene that swirls around him. Perhaps, more correctly than a self-portrait, the present drawing might be termed an allegory of artistic inspiration. A similar treatment of the subject is recorded in the Crozat, Mariette and Paignon-Dijonval collections. Referred to in the Paignon-Dijonval catalogue as 'Le Génie de la Fage', and known today only through a print by Cornelis Vermeulen (1642–92; fig.1), that composition also showed the artist full-length, but wearing a crown of laurels, holding a piece of chalk and supporting himself by leaning on the Belvedere torso.[4]

Pen with brown and black ink, brush and grey wash, over black chalk underdrawing

Inscribed in pen and black ink on the mount, *Et vultum & mores exprimit ipse suos /* RAYMUNDUS / LA FAGE., and at lower left, 315

418 × 296 mm

PROVENANCE: Pierre-Jean Mariette; his mount and mark (Lugt 1852, at lower right); possibly included in Mariette's sale, Paris, 1775, under no.1235; Count Moritz von Fries (Lugt 2903, blind stamp at lower left); acquired in 1820 by Sir Thomas Lawrence (1769–1830; Lugt 2445, blind stamp at lower left); the executor of Lawrence's estate sold the drawings to Samuel Woodburn (1786–1853), London, in 1835; sale (of the Lawrence drawings from the Woodburn estate), Christie's, London, 4–16 June 1860 (part of lot 383); purchased at the sale by Sir Thomas Phillipps (1792–1872); his grandson Thomas Fitzroy Phillipps Fenwick (1856–1938); presented anonymously in 1946

1946-7-13-123

LITERATURE: Popham, 1935, p.224, no.3; Toulouse, 1962, p.84, no.307; Arvengas, 1962, p.32, fig.2 (as by 'Creccolini'); Whitman, 1963, pp.62, fig.55; Arvengas, 1965, pp.45, 55 note 78, fig.1 (frontispiece); Bjurström, 1976, n.p., under no. 411

Fig.1 CORNELIS VERMEULEN, after Raymond La Fage, *The Genius of La Fage*, etching, British Museum (M.25-23).

CLAUDE GILLOT

1673 Langres – 1722 Paris

37 The Passion for Gaming

Claude Gillot was one of the more bizarre artistic figures at work in the first decades of the eighteenth century, yet ultimately one of the most influential. Trained in oil painting, but with little proficiency or interest, he found freedom in small-scale works on paper, where he could give his unique vision free rein. His drawings, typically conceived in series that he or others could etch, were often allegories or humorous explorations of human nature, peopled by figures from the Italian comedy troupe known as the *Commedia dell'arte* or from the antique tradition of the bacchanal.

In Gillot's Bacchic scenes it was not the gods but the lowly satyrs that took centre-stage. The chronology of these works remains uncertain. *Les Quatre Festes*, designed and etched by Gillot, were probably the earliest of this type, executed, according to the Comte de Caylus, before Watteau entered his studio around 1704.[1] Although the printed inscriptions describe the subjects as 'invented, painted and engraved' (*inventé peint et gravé*) by Gillot, they seem instead to be after corresponding red chalk drawings (New Haven, Cambridge, Mass., European private collection, and untraced).[2] Another set, entitled *La Vie des Satyres*, was etched by Gillot and finished in burin by Jean Audran (1667–1756). These depict events in the life of a satyr – birth, education, marriage and a funeral – and are after drawings in pen and ink with sanguine (red chalk) wash and white gouache.[3]

The series for which the British Museum drawing is a study, *Les Passions des Hommes exprimés par des Satyres*, appears to have been engraved by Jean Audran in 1727, after the death of Gillot. As with the *Festes*, the inscription, 'Gillot Pinx', is misleading; according to Mariette's notes, the designs were engraved under the direction of Audran after drawings by Gillot.[4] All four drawings survive: this sheet and the *Passion for Love* (fig.1) are in the British Museum, the *Passion for Riches* is in the Krugier-Poniatowski collection, and the *Passion of War* is in another private collection.[5] Like the *Festes* drawings, they are executed in red chalk in a frieze-like format. Yet, unlike the *Festes*, the *Passions* are etched in reverse and the prints follow the drawings closely. Certain gestures, like the satyr wielding the dagger or the nymph in the left middle ground holding her fanned out cards, become left-handed, all supporting the idea that the plates were executed without Gillot's involvement.

The series explores, in an openly satirical vein, some of humankind's baser instincts. In *The Passion for Gaming* (fig.2), a chained term of a Fury bearing a torch and serpents presides over a frantic woodland scene of gambling satyrs and nymphs. In places, their intensity erupts into violence, most prominently at the central stone plinth where several satyrs lunge for a pile of coins, while one raises a dagger. Others push or grab or grimace, bearing down on their game, thoroughly consumed by their addiction. In these amusing parodies of human vice Gillot's dark sensibility finds perfect expression.

Red chalk over traces of black chalk

175 × 357 mm

PROVENANCE: Paignon-Dijonval; to his grandson Charles-Gilbert, Vicomte Morel de Vindé; sold in 1816 to Samuel Woodburn, London; Dr J. Law Adam, from whom purchased in 1907

1907-11-18-35

LITERATURE: Bénard, 1810, p.134, part of 3134; Dacier, 1928, p.213, no.8 (as lost); Populus, 1930, p.153, under no.230; Paris, 2002, p.138, under no.57

Fig.1 CLAUDE GILLOT, *The Passion for Love*, red chalk over traces of black chalk, 175 × 356 mm, British Museum (1907-11-18-36).

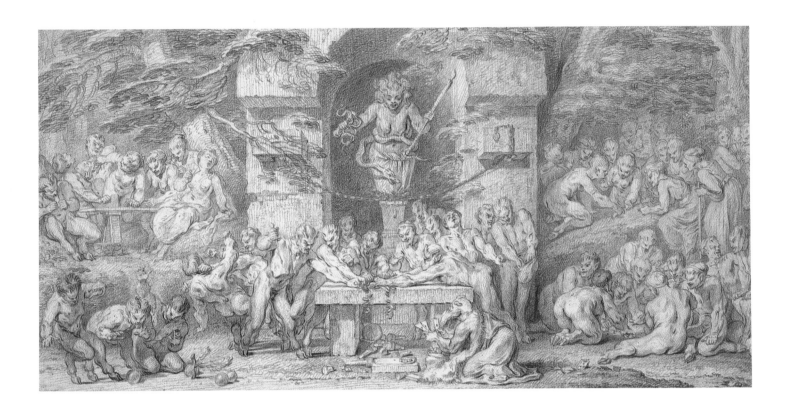

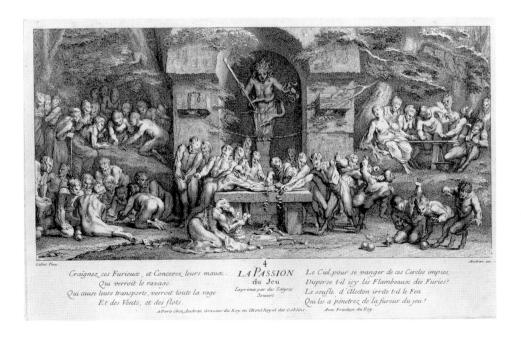

Fig.2 JEAN AUDRAN, after Claude Gillot,
The Passion for Gaming, etching and engraving,
The Metropolitan Museum of Art, New York,
The Elisha Whittelsey Collection, The Elisha
Whittelsey Fund, 1957 (57.581.39 [4]).

ANTOINE WATTEAU

1684 Valenciennes – 1721 Nogent-sur-Marne

38 Sheet of Studies with a Standard-Bearer (RECTO); Study of Hart's Tongue Fern and Grasses with Buildings in the Distance (VERSO)

Antoine Watteau's birth, training and early career situated him at the margins of the Paris arts establishment. The son of a Flemish roofer in Valenciennes, Watteau found employment in the French capital first as a mass-production copyist and then in the workshops of Claude Gillot (see no.37) and Claude Audran III (1658–1734), the latter a designer of ornament for palace interiors. He died young, was plagued by poor health and worked in what the official arts establishment considered a 'lower genre'; yet he became perhaps the most influential French artist of the eighteenth century. Moreover, his renown owed as much to his drawings as to his paintings.

The style of the red chalk studies on the recto of this sheet, with their clear and careful delineation of the figures and their contours, reveals a date very early in the artist's career, perhaps before his acceptance into the Academy in 1712.[1] The standard-bearer, the lightly sketched man holding a basin, the head in a yoke and the uppermost hand all appear in *What Have I Done, Cursed Assassins?* (Pushkin Museum of Fine Arts, Moscow),[2] suggesting that, unlike his later practice of assembling groups of figures from his sketchbooks to people his landscapes, Watteau at this stage was working in a more conventional manner – making a sheet of studies with a specific composition in mind.[3] Although set in a landscape, the painting, with its tableau-like arrangement and humorous subject of a patient in a graveyard attempting to flee a doctor and his menacing band of assistants, may have been inspired by a theatrical production.

The study of plants on the verso dates, on the basis of style, several years later.[4] It is one of a very small surviving group of tree or plant studies apparently done *en plein air*.[5] In his biography of the artist the Comte de Caylus described Watteau as drawing 'sans cesse' the trees in the Luxembourg garden, a place that attracted landscapists for its variety of views and light effects.[6] One can almost picture the artist sitting or lying on the ground to study this clump of ferns at eye level, although the grasses and distant houses suggest a sunny meadow, which would be an odd setting for hart's tongue fern, which is more normally found in damp shade. More numerous, however, at least among the extant sheets, are his red chalk copies after the landscape drawings of earlier masters, especially the Venetian artists he encountered in the collection of Pierre Crozat. His paintings seem more indebted to these second-hand views of Italy than to his own nature studies, which may have been done primarily for his own pleasure – an idea supported by their unusual experimentation in medium. Indeed, the present *Study of Hart's Tongue Fern* is the only known example in Watteau's oeuvre combining black chalk and dark grey wash.

The inscription, numbers and paraph on the recto and verso of this sheet were long associated with Pierre Crozat,[7] although more recent scholarship has identified these marks with Antoine-Joseph Dezallier d'Argenville, collector and author of an insightful art historical work, *Abrégé de la vie des peintres* (first edition 1745), which discussed drawings not only in terms of their school and attribution, but also divided them by function.[8]

Red chalk (recto); black chalk and grey wash (verso)

Inscribed in pen and brown ink at lower right of recto, *Wateau*, and in lighter brown ink, 3275 (Lugt 2951) (recto); inscribed in pen and brown ink at lower left, 3276, with paraph (Lugt 2951), and at lower left in black ink, collector's mark of Thomas Dimsdale (Lugt 2426) (verso)

183 × 238 mm

PROVENANCE: Antoine-Joseph Dezallier d'Argenville (1680–1765); perhaps in his sale, Paris, 18 January 1779 (part of lot 393?, sold to Lenglier); Thomas Dimsdale, London (1758–1823); Samuel Woodburn (1786–1853); Andrew James (died before 1857); his daughter, Sarah Ann James, London; her sale, Christie's, London, 22–3 June 1891, lot 299; bought by Desprez & Gutekunst for the British Museum

1891-7-13-11

LITERATURE: Goncourt, 1875, p.322, under no.787; Fourcaud, 1904, pp.202–4 note 1; Lafenestre, 1907, no.10; Uzanne, 1908, pl.X; Gurlitt, 1909, p.13, no.10 (recto); Parker, 1930, pp.7–8, 18, no.9, fig.5 (verso); Parker, 1931, pp.12 note 4, 16 note 5, 26 note 1; Parker, 1935, pp.5–6 note 1; Mathey, 1939, p.153; Parker and Mathey, I, 1957, pp.5, 9, 60, 63, nos 43, 476, figs 43, 476; Mathey, 1960, p.357; Huyghe, 1970, p.31, fig.11; Cormack, 1970, pp.15, 18, 26, pls 2, 35; Zolotov, 1973, pp.31, 137, under no.5 (entry by I. Kuznetsova); Eidelberg, 1977, pp.61–2, 81 note 38; Roland Michel, 1984, pp.86–7, 176, figs 49, 50; Zolotov, 1986, p.101, under nos 1–6; Grasselli, 1987a, I, pp.136–7, 139, 183, 230–31, 386, 454, no.60, figs 126, 268; Grasselli, 1987b, pp.181, 194 note 4; Labbé and Bicart-Sée, 1996, pp.324–5, nos 3275, 3276; Rosenberg and Prat, 1996, I, pp.216–17, no.136; Rosenberg, 2000, pp.66–8, figs 82, 83, p.220 note 4

EXHIBITIONS: London, 1980, pp.23–4, no.11; Washington, Paris and Berlin, 1984, pp.76–7, 79, 81, 84, 87, 93, 94, 98, 190, 199, no.16

Antoine Watteau

1684 Valenciennes – 1721 Nogent-sur-Marne

39 Two Studies of a Man Playing the Guitar and a Study of a Man's Right Arm

Although Watteau's early training and career took place outside the sphere of the Académie Royale, his work attracted the notice of the history painter Charles de La Fosse who sponsored his candidacy for membership. Watteau's reception piece, *The Embarkation to Cythera* (Musée du Louvre, Paris), did not fit into the established genre categories, and he was received, not as a history painter, but with the newly created title, 'painter of *fêtes galantes*'. These enigmatic scenes of aristocrats and theatrical figures at leisure in imaginary parklands were not built around legible narratives, and Watteau, thus freed from the constraints of conventional subject matter, adopted an unorthodox working method that gave pre-eminence to the drawn study. According to his friend and biographer, the Comte de Caylus, Watteau:

> ordinarily drew without a purpose ... his habit was to draw his studies in a bound book, so that he would always have a great number at hand ... When he decided to paint a picture, he resorted to his collection of studies, selecting the figures that best suited his needs of the moment. He formed them into groups, to go with a landscape background that he had already conceived or prepared.[1]

One can imagine this study of seated guitarists being used by Watteau in exactly the manner described by Caylus, as the figures appear in a number of different painted compositions. The guitarist at the right, as well as the outstretched arm at upper left, can be seen in *La Perspective* (Museum of Fine Arts, Boston),[2] which depicts a gathering on the grounds of Pierre Crozat's Château de Montmorency. The larger guitarist was used in three other compositions, *Récréation galante* (Gemaldegälerie, Berlin), *The Scale of Love* (National Gallery, London) and *Assemblée galante* (lost).[3] The corollary is true as well: when the drawn studies relating to a painted composition are examined as a group, they do not necessarily display a uniformity of manner or of date.[4] Grasselli, Rosenberg and Prat have all suggested a date of *c.*1716 for the present drawing.

Musicians make frequent appearances in Watteau's *fêtes galantes*. Not only do they suggest cultivated leisure but they also function as allegorical representations of courtship or lovemaking. Indeed, the seated guitar player never plays for the assembled group, but always leans towards the woman he plays for, his music a form of amorous overture.

Red, black and white chalk, on buff paper, lower left corner made up

244 × 379 mm

PROVENANCE: John Spencer (1708–46; according to Lugt, the founder of the collection); by descent to John, 1st Earl Spencer (1734–1783); George John, 2nd Earl Spencer (1758–1834) (his mark, Lugt 1530, at lower right); his sale, Th. Philipe, London, 10–17 June 1811, lot 821; William Johnstone White, London; acquired in 1868

1868-8-8-1275

LITERATURE: Goncourt, 1875, no.16, p.350; Dargenty, 1891, opp. p.82; Phillips, 1895, ill. opp. p.30; Lafenestre, 1907, no.33, p.III; Uzanne, 1908, pl.XXIII; Gurlitt, 1909, p.24, no.37; Parker, 1930a, pp.11, 25, no.44, pl.5; Parker, 1931, pp.36, 38, 49, no.91, pl.91; Mauclair, 1942, pl.XV; Brinckmann, 1943, p.57, no.38; Adhémar, 1950, pp.223, 226; Parker and Mathey, II, 1957, pp.353, 358, no.830; Cormack, 1970, p.37, pl.92; Zolotov, 1973, p.139; Posner, 1984, pp.237, 288 note 19; Roland Michel, 1984, p.136; Baticle, 1985, p.64, fig.4; Zolotov, 1986, pp.102–3, under nos 8–11; Grasselli, 1987a, I, pp.188, 272 note 54, 273–4, 290 note 72, 294 note 76, 297, 384 note 14, 504, no.194, fig.330; Roland Michel, 1987, pp.182–3, fig.214; Rosenberg and Prat, 1996, II, pp.800–01, no.479; Washington, Paris and Berlin, 1984, pp.152, 171, 302, fig.5, pp.304, 415, fig.9, pp.416, 443, fig.16; New York and Ottawa, 1999, pp.29–30, fig.20

EXHIBITIONS: London, 1895, p.51, no.252; London, 1968, p.133, no.770, pl.XVI, fig.68; London, 1980, p.29, no.47; Nagoya and Tokyo, 2002, no.69, pp.128–9

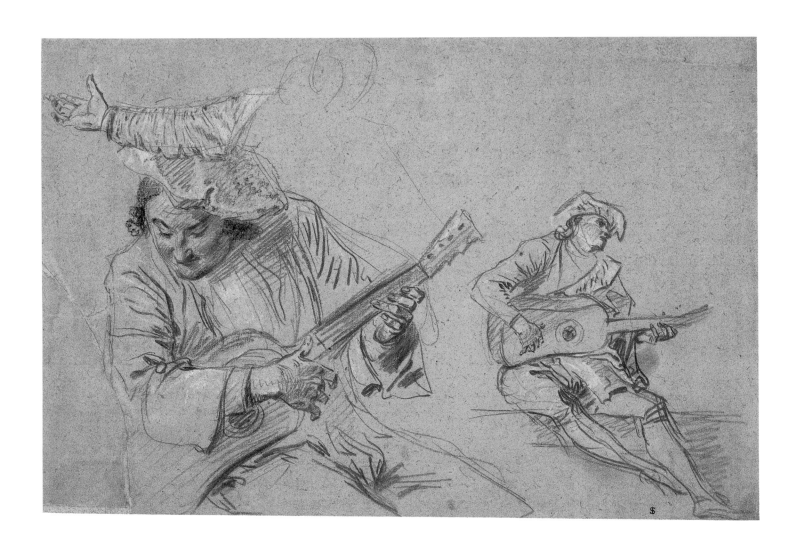

ANTOINE WATTEAU

1684 Valenciennes – 1721 Nogent-sur-Marne

40 Five Studies of a Woman's Head, One Lightly Sketched

In about 1715, just six years before his death at the age of thirty-six, Watteau began to experiment with the technique of *trois crayons*, in which red, black and white chalks were used together, often on a buff-coloured paper. Coloured chalks had been used for portrait drawings in the sixteenth century by the Clouet family and others (see nos. 1–2), but for Watteau, the most relevant forerunners would have been Rubens (1577–1640), Antoine Coypel (1661–1722), and Charles de La Fosse (1636–1716) (see nos. 32–3). Watteau quickly mastered the technique. In his hands, the intermingling of the colours appeared intuitive, producing effects capable of conveying the full range of flesh tones. In this sheet of studies he reversed the typical order of the colours. Instead of adding white heightening at the end, he applied a film of white chalk on the flesh areas before using the red and black for the dark tendrils of hair and the warm flush of the cheeks, emphasizing the model's porcelain complexion and milky décolletage.

In Watteau's paintings, which eschewed conventional narrative, themes were often expressed through the body language of the figures. His figure studies show his focus on the delicate nuances of comportment. In the British Museum sheet he studies a woman's glance, circling around the model, drawing her head from a range of oblique viewpoints and imbuing the *mise-en-page* with a rhythmic sense of movement. It was long referred to as four studies of a woman's head, but there is, in addition, a fifth study, which the artist aborted and began again at the lower right. The session continued onto another sheet (fig.1), where work must have paused after the top two studies to change the model's hat.[1] The sitter, with her sharp nose and cupid's bow mouth, was a favourite of the artist and appears in many drawings and paintings.[2] Her features were well assimilated into Watteau's repertoire, even if these specific studies do not appear to have been used in paintings. Based on style, Grasselli, Rosenberg and Prat have all suggested a date of *c*.1716–17 for the British Museum sheet.

Two shades of red, black and white chalk, on buff paper

331 × 238 mm

PROVENANCE: Edward Vernon Utterson, London (1775/6–1856); Sir John Charles Robinson, London (1824–1913); acquired, with the rest of his collection, around 1860 by John Malcolm of Poltalloch (1805–93); his son Colonel John Wingfield Malcolm; acquired with the Malcolm collection in 1895

1895-9-15-941

LITERATURE: Robinson, 1876, p.166, no.489; Mantz, 1892, ill. opp. p.64; Lafenestre, 1907, no.26, p.III; Uzanne, 1908, pl.II; Gurlitt, 1909, p.20, no.28; Hildebrandt, 1922, p.157, fig.78; Parker, 1930a, pp.10, 20, no.17; Parker, 1931, pp.12–13, 41, ill. on frontispiece; Brinckmann, 1943, pp.35, 62, no.85; Parker and Mathey, II, 1957, p.347, no.788; Mathey, 1967, pp.91–2, fig.4 (detail); Cailleux, 1966, pp.i, v note 5; Cormack, 1970, p.32, pl.63; McCorquodale, 1980, p.232, ill.; Washington, Paris and Berlin, 1984, pp.93 (under no.30), 147 (under no.77), 157, fig.1 (under no.83), p.167 (under no.92); Grasselli, 1987a, I, pp.194, 299, 510, no.206, fig.369; Munger et al., 1992, p.148 note 4 (entry by Eric M. Zafran); Grasselli, 1993, p.112, under no.8; Rosenberg and Prat, 1996, II, pp.876–7, no.521; New York, 1999, p.16, fig.18.1, under no.8 (entry by Mary Tavener Holmes)

EXHIBITIONS: Paris, 1879, p.121, no.474; London, 1895, p.51, no.248; London, 1972a, p.61; London, 1980, p.25, no.19; London, 1984b, p.134, no.124; London, 1996, p.124, no.62

Fig.1 ANTOINE WATTEAU, *Four Studies of the Head of a Woman*, red, black and white chalk, on tan paper, 258 × 235 mm, private collection, New York.

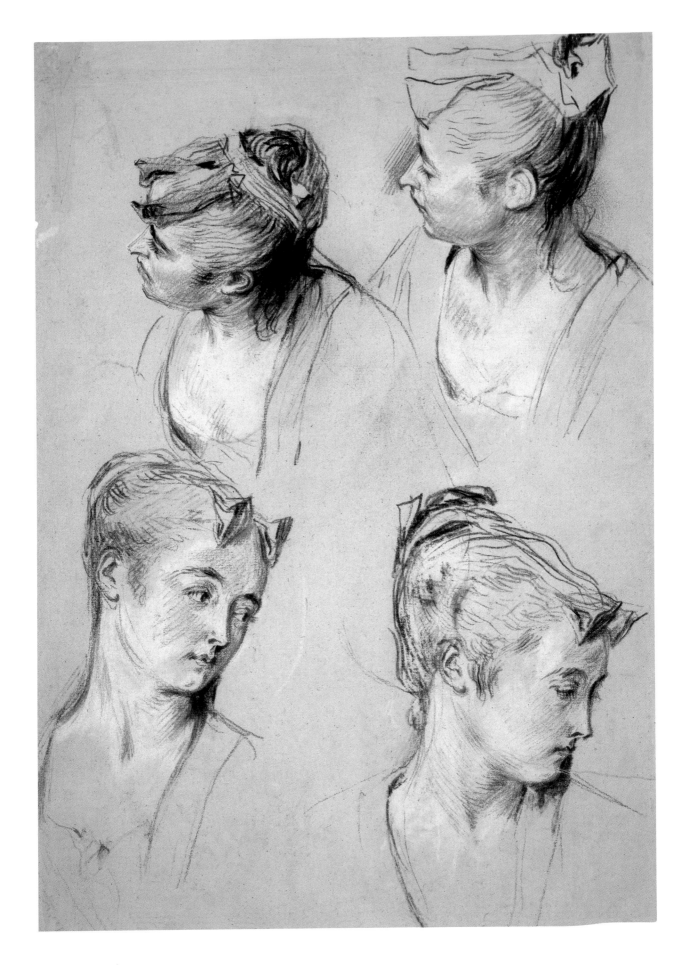

Antoine Watteau

1684 Valenciennes – 1721 Nogent-sur-Marne

41 Two Studies of a Woman, One Raising her Apron

Watteau must have made these two studies in short succession. Presumably he drew first in red chalk the three-quarter-length study of a young woman raising her apron. She is lit from behind, blanching the uplifted fabric, but also cleverly accenting areas of her anatomy: her shoulder, her breast, the nape of her neck, her temple and the tip of her nose. A half-length variation is added above, with the model's head turned to the right and the arms left unfinished. Black chalk was added to her head and to pick out the ribbon at the back of her neck.[1]

The figure of the woman holding up her apron appears in two paintings: *Country Amusements* (private collection)[2] and the second version of *The Embarkation for Cythera* (Schloss Charlottenburg, Berlin),[3] in both cases collecting pink roses thrown by a male lover. With Watteau's working method, it is often difficult to know whether the subject for a drawing was chosen for itself or with a painting in mind. In both canvases she represents, in a general sense, a stage or an aspect of love, although the paintings are otherwise quite different. *Country Amusements* is a small cabinet picture featuring two pairs of lovers in a Venetian-inspired landscape; *The Embarkation for Cythera* is an ambitious reprise of Watteau's reception piece, with figures such as the woman holding her apron among the many figural groups and putti augmenting the first version of the composition. Charming and rustic, her gesture of collecting in her apron the roses tossed by her lover is also symbolic of her willing acceptance of his advances.

Red and black chalk, with touches of white chalk

209 × 148 mm

PROVENANCE: Mr Rutter, from whom purchased in 1846

1846-11-14-23

LITERATURE: Goncourt, 1875, pp.101–2, 348, no.8; Dargenty, 1891, ill. opp. p.70; Lafenestre, 1907, no.34, p.III; Uzanne, 1908, pl.I; Gurlitt, 1909, p.24, no.38; Binyon, 1921b, p.143; Parker, 1930a, pp.3, 21, no.25; Parker, 1931, pp.33, 37, 46, no.56, pl.56; Brinckmann, 1943, pp.31, 61, no.70; Adhémar, 1950, p.242, pl.41 II; Parker and Mathey, II, 1957, p.310, no.551, fig.551; Roland Michel, 1984, pp.97–8, fig.62; Washington, Paris and Berlin, 1984, pp.182–3, fig.1, under no.105, p.374, fig.3, under no.52, pp.410–11, fig.10 (detail), under no.62; Grasselli, 1987a, pp.312–14; 319–20, 521, no.236, fig.385; Vidal, 1992, pp.33, 35, fig.44; Rosenberg and Prat, 1996, II, pp.922–3, no.545

EXHIBITIONS: London, 1980, p.26, no.27

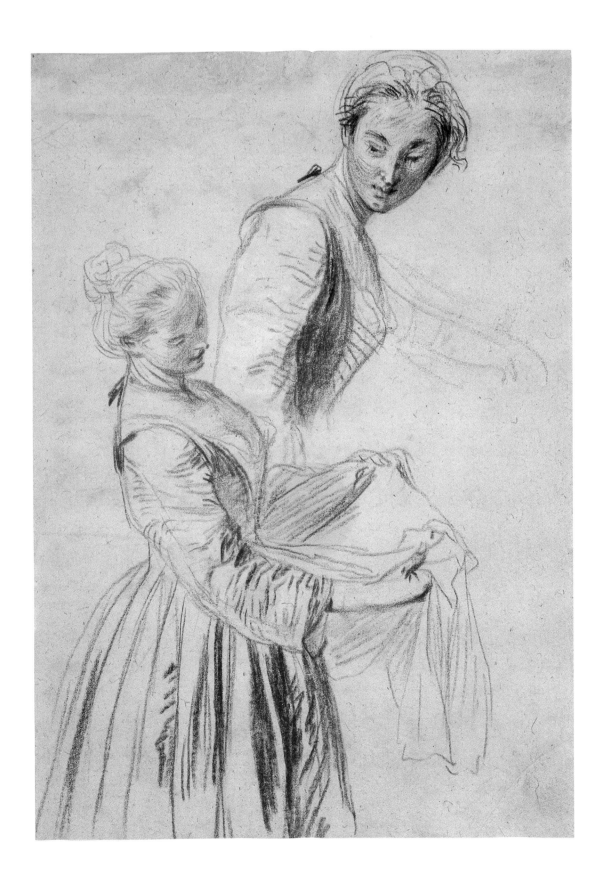

Jean-Baptiste Oudry

1686 Paris – 1755 Beauvais

42 Sleeping Dog

Originally trained in the studio of Nicolas de Largillierre (1656–1746) in the genres of portrait painting and still life, Oudry began adding hunt-related subjects to his repertoire in the early 1720s. An avid hunter, the young Louis XV (1710–74) became aware of his work and by 1725 had commissioned from Oudry painted portraits of some of his favourite dogs in the packs.[1] Oudry proved a talented and accommodating court painter; he is said to have been at his ease painting while the king looked on. In addition to executing decorative cycles for many royal residences, Oudry was active at the Beauvais manufactory and provided panoramic cartoons for the *Royal Hunts of Louis XV* tapestries, which were woven at the Gobelins.

Oudry's painted tableaux of the hunt were admired for their naturalism, their graceful compositions and their exquisite technique. His drawings provide some insight into his working process, although the question of the studies is more complex than once thought, for some of the individual animals were drawn from life while others were copied from paintings and oil sketches in the royal collection. Oudry had access both to the king's hunting dogs and to the menagerie where exotic animals were kept at Versailles. In addition to his studies from life, Oudry also copied animals in works by other artists, including François Desportes (1661–1743), Pieter Boel (1622–74) and Nicasius Bernaerts (1620–78), all of whom also drew exotic animals from the royal menagerie while working at the Gobelins, leaving the status of certain sheets difficult to determine.[2] The present sheet, however, was doubtless drawn from life; for a sleeping dog Oudry would have had little reason to resort to a painted model.

The British Museum dog corresponds to no known painting, although Opperman has called attention to an untraced canvas exhibited in the Salon of 1751 under the title, *Un Doguin en repos*.[3] A late drawing, disarming in its naturalism, it may have been made purely for the artist's enjoyment. Its straightforward technique of black chalk on white paper is also unusual for the artist, who usually favoured black and white chalk on blue paper. The domestic tranquillity suggested by the subject anticipates one of Oudry's most admired canvases, the *Bitch-Hound Nursing her Pups* (1752; Musée de la Chasse et de la Nature, Paris), lauded by visitors to the 1753 Salon as an ode to maternity.[4]

Graphite and black chalk, framing lines in graphite

Signed and dated in pen and brown ink at lower left, J B. *Oudry 1750*

216 × 351 mm

PROVENANCE: Paignon-Dijonval (1708–92); to his grandson Charles-Gilbert, Vicomte Morel de Vindé (1759–1842); sold in 1816 to Samuel Woodburn (1786–1853), London; Barthold Suermondt (1818–87), 'Aix-la-Chapelle; his sale, Prestel, Frankfurt, 5 May 1879 and days following (lot 109); to William Pitcairn Knowles (1820–94); purchased in 1901

1901-4-17-7

LITERATURE: Bénard, 1810, p.138, no.3232; Locquin, 1912, pp.118–19, no.639; Opperman, 1977, I, p.153, II, p.763, no.D678, p.1162, fig.379; Roland Michel, 1987, pp.170–72, no.199

EXHIBITIONS: Paris, 1982, pp.223–34, no.123; Fort Worth and Kansas City, 1983, no.64, pp.181–2

FRANÇOIS LEMOYNE

1688 Paris – 1737 Paris

43 Female Torso, Study for 'Hercules and Omphale', 1724

Lemoyne's opportunity to visit Italy came relatively late: he was already thirty-five and a full member of the Académie Royale when his patron, the financier François Berger (1684–1747), invited him on a trip that took them to Bologna, Venice, Rome and Naples. It was during this period of about nine months in 1723–4 that Lemoyne produced two of his most acclaimed easel pictures, *Hercules and Omphale* (Musée du Louvre, Paris) and *The Bather* (Estate of Michael L. Rosenberg, on loan to the Dallas Museum of Art).[1] Although his style was already established at this point, these works show clearly the impact of Venetian painting with its rich, saturated colours and warm flesh tones.

Hercules, to be absolved of his crime of killing a guest in his house, had agreed to be sold into slavery for one year and to give the payment to the family of his victim. His services were purchased by Omphale, Queen of Lydia, whose lover he became. Hercules' subjugation is expressed by his feminine attributes of distaff and spindle, as well as by his pose and docile expression. Omphale, by contrast, leans over the submissive god in a pose of authority and ease; she wears his discarded lion skin and carries his large club. The subject was one that appealed to eighteenth-century audiences, with their fascination for figures *en travestie*, a taste that would be particularly indulged by Lemoyne's student, François Boucher (1703–70).

There are three extant studies for *Hercules and Omphale*. A full-length drawing of Hercules with subsidiary studies of his hands came to light in 1998 and was acquired as a promised gift for the Art Institute of Chicago.[2] For the figure of Omphale, Lemoyne proceeded in steps. The British Museum sheet focuses on the torso alone. Following the very schematic sketch in red chalk in the upper left corner, the central study exploits the full potential of *trois crayons* to render the warmth and play of light on flesh tones.[3] This technique, which was used little by Lemoyne in his later years, initially led scholars to attribute this sheet to Watteau. A separate study for Omphale's head (fig.1) also uses *trois crayons*, although the luxuriant curls of hair in black chalk would be exchanged, in the painting, for the blond tresses favoured by Venetian painters. An untraced composition study in black and white chalk on blue paper, perhaps similar to the study for *The Bathers* in the Louvre,[4] was catalogued in the Paignon Dijonval collection.[5]

Red, black and white chalk on buff paper

244 × 174 mm

PROVENANCE: Donated in 1873 by John Deffett Francis (1815–1901; Lugt 1444, at lower left)

1873-12-13-128

LITERATURE: Lafenestre, 1907, p.9, no.8; Uzanne, 1908, frontispiece; Gurlitt, 1909, p.12, no.8; Binyon, 1921a, p.73 (here and earlier as by Watteau); Parker, 1929, pp.38–41, pl.43 (here and after as by Lemoyne); Parker, 1930a, p.28, no.60; Wilhelm, 1951, p.222; Paris, 1981, p.268. under no.133; Bordeaux, 1984, pp.95, 154, and 155, no.65, fig.193; New York, New Orleans and Columbus, 1985, p.78 (under no.8); Rosenberg and Prat, 1996, III, pp.1206–7, no.R 212; New York and Ottawa, 1999, pp.218–20, under nos 64–5

EXHIBITIONS: London, 1968, p.93, no.425, pl.II, fig.38; Nagoya and Tokyo, 2002, p.136, no.76

Fig.1 FRANÇOIS LEMOYNE (1688–1737), *Head of Omphale, Study for 'Hercules and Omphale'*, black, red and white chalk on buff paper, 234 × 165 mm, University of California, Berkeley Art Museum, gift of Mr and Mrs John Dillenberger in memory of her son Christopher Karlin (1971.16).

FRANÇOIS LEMOYNE

1688 Paris – 1737 Paris

44 Head of Hebe, Study for the 'Apotheosis of Hercules'

Pastel enjoyed a golden age in the eighteenth century, both as a medium for finished works, comparable to paintings, and for studies of heads, with areas of paper left in reserve. Other artists who produced this kind of pastel study – not for portraits, but for narrative pictures – were Charles de La Fosse (1636–1716), Antoine (1661–1722) and Charles-Antoine (1694–1752) Coypel and François Boucher (1703–70), but few studies match the beauty and vitality of this Hebe where colours bloom in the porcelain flesh tones and flowers cascade down with her hair.

Hebe is one of no less than 142 figures that populate Lemoyne's ceiling for the Salon d'Hercule at the Château de Versailles. Completed in 1736, the Apotheosis of Hercules was the most successful large-scale ceiling decoration painted in eighteenth-century France. Legions of flying figures fill an expansive continuous space, suffused with golden light and cream-coloured clouds. Architectural ornament and trompe-l'oeil figures in grisaille suggesting pale stone sculpture make up the borders. Lemoyne's achievement was widely admired and earned him the title premier peintre, yet he committed suicide the following year.

The genesis of this complicated project was studied by Xavier Salmon in 2001.[1] His analysis allowed him to assign the numerous preparatory studies to one of three stages: before the painted maquette, after the maquette, but before Lemoyne began to lay out his sketch on the ceiling in 1733, and after he realized he had miscalculated and needed to add an additional forty figures. As well as the London pastel, a drapery study in Rouen has occasionally been linked to the figure of Hebe.[2]

The vast majority of the surviving figure studies for the ceiling are in black and white chalk on blue paper. In a few cases, perhaps at a late stage and for certain of the more important figures, Lemoyne would use trois crayons, as in the recently identified Head of Venus,[3] although Bénard's catalogue of the Paignon-Dijonval collection lists seven 'études de têtes d'hommes, de femmes et d'un enfant: aux crayons rouge, noir et blanc coloriés de pastel sur papier de couleur' (studies of the heads of men, women and one child in red, black and white chalk coloured with pastel on coloured paper),[4] leaving open the possibility that others of this type will come to light.[5] The present Hebe appears to have been begun as a drawing in trois crayons, and then worked up in pastels in the head and neck. It was undoubtedly made late in the preparatory process, as the position of Hebe's head is different in the maquette. Yet, from the evidence of the raven black hair in the pastel, changed to chestnut in the painting, we can be fairly certain that the pastel does not post-date the ceiling. Its exceptional quality may be a result of Hebe's importance to the composition as the bride presented to Hercules by Apollo.

Pastel over red, black and white chalk on blue paper, framing lines in pen and black ink

Inscribed in pen and brown ink at lower right, Le Moine

309 × 256 mm

PROVENANCE: Jean-Denis Lempereur (Lugt 1740, at lower right); his sale, Paris, 24–8 May 1773, lot 511; Francis Duroveray; his estate sale, Christie's, London, 22–8 February 1850, part of lot 720; purchased through A.E. Evans and Sons

1850-3-9-1

LITERATURE: Bacou, 1971, p.82, pl.IX; Toronto, Ottawa, San Francisco, and New York, 1972, p.176, under no.79; Bordeaux, 1974, p.312, fig.14; Bordeaux, 1984, p.171, no.147, fig.274; Monnier, 1984, pp.21–2; Aaron, 1985, pp.16–17, 100, no.1; Roland Michel, 1987, pp.114–6, fig.1; Salmon, 2001, pp.96, 106–7, and 194–5, fig.84; Stein, 2003, pp.71–2

EXHIBITIONS: Paris, 1967a, p.148, no.244; London, 1968a, p.94, no.428; London, 1984b, p.130, no.121; Versailles, 2001, pp.29–30, 41, and 66, no.24; Nagoya and Tokyo, 2002, pp.137–8, no.77

EDME BOUCHARDON

1698 Chaumont-en-Bassigny – 1762 Paris

45 'Garçon Boulanger', Design for the First Suite of the 'Cris de Paris', c.1737

Unlike many sculptors who left only a small graphic oeuvre, Bouchardon was among the most prolific and admired draughtsmen of the eighteenth century. Over 500 sheets by his hand figured in the collection of Pierre-Jean Mariette (1694–1774), who described them as fetching prices equivalent to their weight in gold.[2] Even while he was still officially a student in Rome, the effortless verisimilitude of his red chalk copies and *académies*, with their confident and supple quality of line, exerted an influence widely felt among a generation of artists. Bouchardon's Roman period lasted nine years (1723–32), during which time he not only absorbed the lessons of antiquity, the Renaissance and the Baroque but was also busy with commissions, mostly for portrait busts, from both the French and British communities in Rome.[3] Back in France he only began to receive major sculptural commissions from 1739: the Rue de Grenelle fountain, *Cupid Cutting a Bow out of Hercules' Club* (Musée du Louvre, Paris), and the equestrian statue of Louis XV (destroyed 1792).

During the 1730s, when he was underemployed as a sculptor, Bouchardon channelled considerable energy into drawing projects, including the sixty designs he made for the *Études prises dans le bas Peuple, ou les Cris de Paris*, etched by his friend and champion, Anne-Claude-Philippe de Tubières, the Comte de Caylus, and published in five suites of twelve prints between 1737 and 1746. The entire set of sixty drawings has been preserved together, apparently bound in an album since the eighteenth century, interleaved with the prints for which they are studies. The etchings, which reverse the compositions of the drawings, are the work of the Comte de Caylus, amateur printmaker, antiquarian, collector and writer on the arts,[4] and were retouched and published by Etienne Fessard (fig.1). Bouchardon apparently gave the drawings to Caylus and a set of counterproofs to Mariette, in whose sale they appear.[5]

Given the shared antiquarian interests of Bouchardon and Caylus, it is surprising to find their joint endeavour distinguished by down-to-earth, un-idealized embodiments of each profession. Standing out from the theatrical, even comic, tradition of portraying street criers,[6] the *Études prises dans le bas peuple* (studies made among the common folk) have a poignancy owing to their very particularity. They evoke real individuals and real labour, stressing the exhaustion that comes from repetitive work rather than its picturesque appeal. The boy delivering bread does not seek to engage the viewer, but plods along, staring at the ground ahead of him. Bouchardon's series has elicited comparisons with Chardin's sympathetic domestic genre scenes, the earliest examples of which date to the mid-1730s. Stylistically, Bouchardon's drawings retain the visual sensibility of a sculptor. The insistent, albeit elegant, outline, and the effective use of hatching for shading, all crisply delineate the figure from the background, the mass from the void.

Red chalk, on buff paper, mounted in an album

230 × 175 mm

PROVENANCE: Anne-Claude-Philippe de Tubières, Comte de Caylus (1692–1765); his estate sale, November 1765 (no catalogue is known); acquired at the sale for 1,235 livres by Abbé Grimau (?), for Laurent Grimod de La Reynière (1734–93; early provenance per Jean-Georges Wille);[1] A.E. Evans & Sons; purchased in 1857

1857-6-13-744

LITERATURE: Duplessis, ed., 1857, pp.305–6; Roserot, 1910, p.142 (as lost); Parker, 1930b, pp.45–8; Pitsch, 1952, p.39; Jordan, 1985, pp.392–3; Bailey, 2002, pp.211, 303 note 36 (mistakenly identified as the group in the Bibliothèque Nationale de France) – all references refer to the group of drawings as a whole

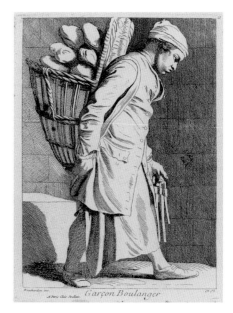

Fig.1 ANNE-CLAUDE-PHILIPPE DE TUBIÈRES, COMTE DE CAYLUS (1692–1765), after EDME BOUCHARDON, *Garçon Boulanger*, c.1737, etching, first suite *Cris de Paris*, 235 × 185 mm, British Museum (1857-6-13-684).

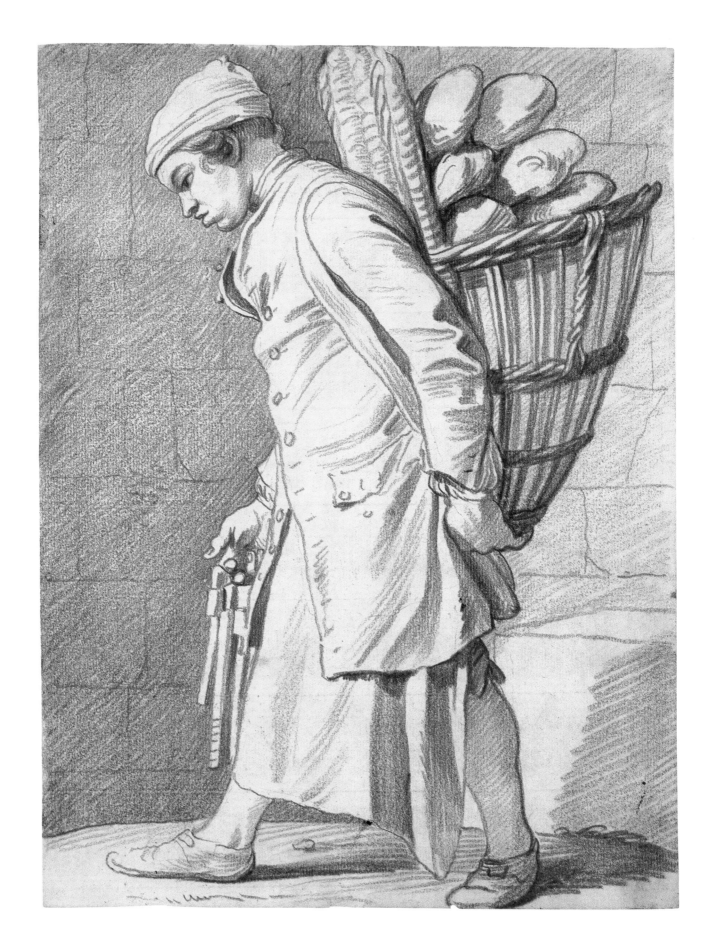

CHARLES-JOSEPH NATOIRE

1700 Nîmes – 1777 Castel Gandolfo

46 Female Nude, Study for 'The Toilet of Psyche', c.1735

Like his near-contemporary François Boucher (1703–70), Charles-Joseph Natoire was a fluent and inventive practitioner of the Rococo idiom. Both men studied with François Lemoyne and were strongly influenced by his luminous palette and lissom figure types. Both worked prodigiously throughout the 1730s and 1740s, producing mythologies, tapestry designs, altarpieces, portraits and genre scenes, but their careers diverged in 1751 when Natoire was appointed Director of the Académie de France in Rome, where he would spend the rest of his life, pouring his energies into his pedagogical role, while Boucher stayed in Paris, where he would eventually attain the position of *premier peintre* to the king.

Classical mythology provided some of Natoire's most felicitous subjects. The story of Cupid and Psyche, with its requisite contingent of nymphs and luxurious stuffs, was the theme of three decorative cycles, the most famous of which was the series of eight shaped canvases painted to fit the *boiserie* (panelling) of the Salon de la Princesse at the Hôtel de Soubise.[1] However, Natoire's earliest treatment of the subject appears to have been the four large canvases commissioned by *fermier général* (tax collector) Louis-Denis de La Live de Bellegarde (1679–1751) for the salon of his recently acquired Château de la Chevrette at Saint-Denis.[2] According to descriptions in contemporary guidebooks, the four paintings were installed in a novel fashion, with two pairs back to back in the centre of the room, mounted on a device that could lower and raise them when the room needed to be either divided or made larger.[3]

Three of the four canvases have been identified: *Venus Showing Psyche to Cupid* (private collection, New York),[4] *Psyche Obtaining the Elixir of Beauty from Proserpine* (Los Angeles County Museum of Art)[5] and *The Toilet of Psyche* (fig.1; New Orleans Museum of Art), for which the British Museum drawing is a study. A debt to his teacher, Lemoyne, can be felt in the abundant light, graceful disposition of forms and rosy gold palette of these canvases. The related drawings indicate that Natoire likewise adopted the methodical preparation practised by his former teacher, proceeding from initial ideas, through composition designs, to detailed chalk studies for the figures, sometimes studying the pose in a drawing of a nude figure before adding the drapery.[6] Principle figures, like the Psyche in the New Orleans painting, merited special attention. The outline of the body, simultaneously crystalline and languorous, reveals in its subtle pentimenti and frequent retracing of contours the effort underlying the apparent ease.

Red chalk, heightened with white chalk, framing lines in pen and black ink, on buff paper

Inscribed at lower left in red chalk, C. *natoire*

351 × 255 mm

PROVENANCE: Francis Duroveray; his estate sale, Christie's, London, 22 February 1850 (possibly part of lot 728, 'Bouchardon – subjects in red chalk [4]'); purchased through A.E. Evans & Sons

1850-3-9-2

LITERATURE: Boyer, 1949, p.95, no.570; Toledo, Chicago and Ottawa, 1975, p.59, under no.72; Orléans, 1984, p.30, under no.7; Paris, Philadelphia and Fort Worth, 1991, pp.351, 353 note 25, and 355, fig.4

EXHIBITIONS: Nagoya and Tokyo, 2002, pp.142–3, no.82

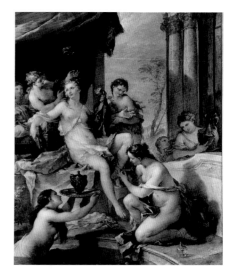

Fig.1 CHARLES-JOSEPH NATOIRE, *The Toilet of Psyche*, c.1735, oil on canvas, 198 × 169 cm, New Orleans Museum of Art (40.2).

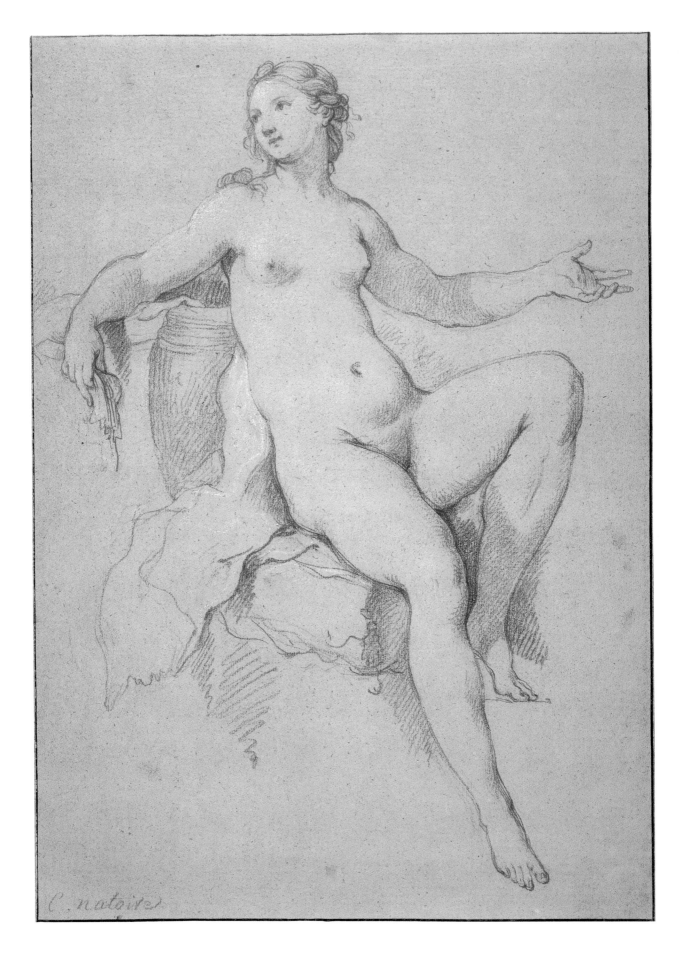

C. nataire

FRANÇOIS BOUCHER

1703 Paris – 1770 Paris

47 Recumbent Nereid, Study for 'The Birth of Venus'

Despite the fact that Boucher would go on to become *premier peintre* to the king and Director of the Académie Royale, details of his early career remain murky. According to Mariette's biography, shortly after returning from Italy, Boucher had furnished the house of a sculptor, 'Monsieur Dorbay', with paintings in order to make himself known.[1] It was only in the 1980s that Georges Brunel discovered the 1743 estate inventory of François Derbais, the lawyer son of marble sculptor Jérôme Derbais, which listed pictures by title, a number of which must refer to Boucher's early masterpieces: *The Rape of Europa* and *Mercury Confiding the Infant Bacchus to the Nymphs* (both Wallace Collection, London); *Venus Asking Vulcan for Arms for Aeneas* (Musée du Louvre, Paris); and *Aurora and Cephalus* (Musée des Beaux-Arts, Nancy).[2] A fifth canvas, the *Birth of Venus* (fig.1), long considered lost, was rediscovered in the Romanian embassy in Paris and published by Alastair Laing in 1994.[3]

The four extant preparatory drawings for the *c.*1731 *Birth of Venus* shed light on Boucher's method of working at this stage of his career. An initial idea in black and white chalk in the E.B. Crocker Art Gallery, Sacramento, envisaged the composition in its essential elements.[4] The central pyramidal grouping of Venus flanked by Nereids would be retained for the final canvas, with some alterations to the groups of Tritons at the sides. Individual studies for the three primary figures were then executed (J. Paul Getty Museum, Los Angeles,[5] private collection,[6] and British Museum), probably using the same studio model, arranged, almost contorted, to conform to the poses sketched in the Sacramento sheet.

Even though several years separated the Derbais commission from Boucher's earlier employment etching Watteau's drawings for Jean de Jullienne, the preparatory studies connected with the Derbais paintings clearly demonstrate for the first time Watteau's influence on Boucher's draughtsmanship. Typically executed in red and white chalk on light brown paper, they seem to embody, especially in their *mise-en-page* and use of white heightening, a conscious awareness of the beauty and potential saleability of chalk figure studies.[7]

Red chalk, heightened with white chalk, framing lines in pen and black ink, on light brown paper

249 × 352 mm

PROVENANCE: Purchased from the daughters of Sir Hans Sloane (1660–1753) in 1753

5223-26

LITERATURE: Macfall, 1908, p.140; Washington and Chicago, 1973, pp.69–70, under no.54, fig.29; Ananoff, 1976, I, pp.299–300, under no.180, fig.579; Jacoby, 1986, p.266, no.III.A.3; Goldner, 1988, p.140, under no.59; Laing, 1994, pp.78–9, fig.5, p.80 note 12

EXHIBITIONS: Nagoya and Tokyo, 2002, p.145, no.84

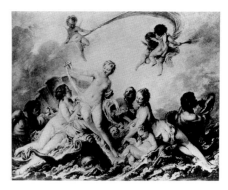

Fig.1 FRANÇOIS BOUCHER, *The Birth of Venus*, *c.*1731–2, oil on canvas, Romanian embassy, Hôtel de Béarn, Paris.

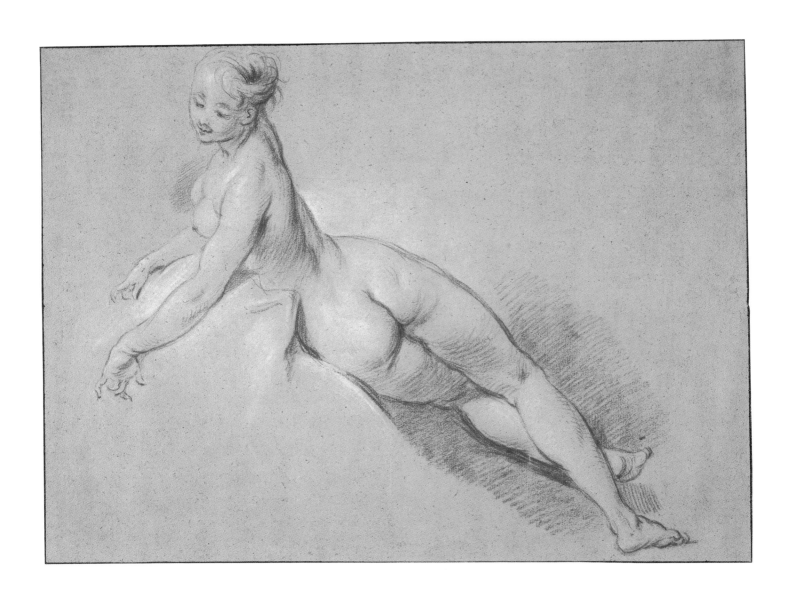

FRANÇOIS BOUCHER

1703 Paris – 1770 Paris

48 A Seated Woman with a Basket

In addition to fulfilling the considerable demand for his services as a portrait painter, holding the position of President of the Royal Academy and producing a large body of theoretical writings, Sir Joshua Reynolds was a devoted collector and connoisseur of old master paintings, drawings, and prints.[2] With some notable exceptions – Poussin, Claude, Rembrandt, Rubens and Van Dyck among them – the Italian school dominated his drawings collection. He had little admiration for his French counterparts, in whose work he claimed, 'great beauties are often found united with great defects.'[3] He did, however, single out Watteau, Coypel and Boucher for the quality of grace in their work, which 'may be said to be separated, by a very thin partition, from the more simple and pure grace of Correggio and Parmeggiano [sic]'.[4]

The first sale of Reynolds's collection in 1794 listed six drawings by Boucher, without describing their subjects.[5] At least one, the *Young Woman with Two Cupids* (The Forsyth Wickes Collection, Museum of Fine Arts, Boston, 65.2538), was apparently given by Boucher to Reynolds when he visited the French artist's studio in 1768.[6] For the others, we are less certain of the path by which they entered his collection.[7]

The British Museum study of a seated young woman is executed in the loose, broad manner characteristic of Boucher's handling of chalk in the mid-1760s. She is a type that occurs frequently as a repoussoir in Boucher's compositions: a young female attendant, seated or kneeling, and seen in 'lost profile', with her hair pulled up exposing the nape of her neck.[8] Often she holds a basket or apron full of flowers. Although there are many close variants – for the most part preceding the present sheet – the precise pose of the British Museum drawing was not used in any painting.[9] The drawing may have appealed to Reynolds because it recalled his own use of a basket of flowers as a feminine attribute in his portrait of *Mrs Thomas Riddell* (Laing Art Gallery, Newcastle upon Tyne).[10]

Black and white chalk on blue paper, framing lines in pen and black ink

306 × 218 mm

PROVENANCE: Sir Joshua Reynolds (1723–92; Lugt 2364, at lower right); his first posthumous sale, A.C. de Poggi, London, 26 May 1794 and following days, part of lots 904, 905 or 906;[1] William Mayor, London (Lugt 2799, at lower left); possibly his sale, 31 May–3 June 1830, Mr Stanley's Rooms, London, lot 256 ('A Study of a draped Female Figure; in black and white chalk'); gift of John Edward Taylor in 1868

1868-6-12-1868

LITERATURE: Ananoff, 1976, II, p.51, under no.350, fig.1026

EXHIBITIONS: London, 1978, p.88, no.288; London, 1984b, p.135, no.128; Tokyo and Kumamoto, 1982, pp.134, 192–93, no.95

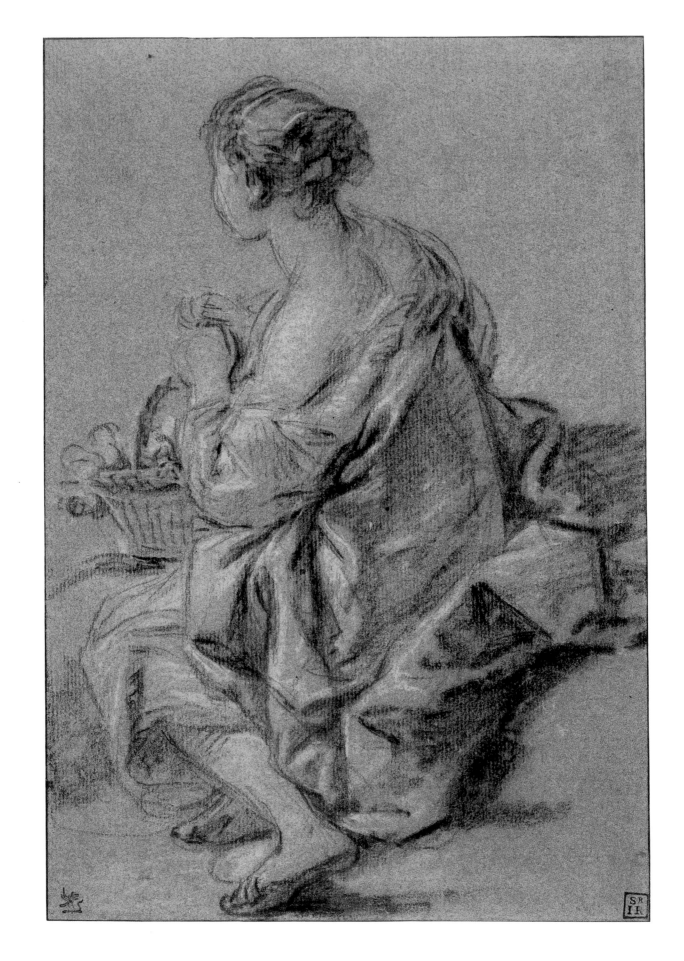

JEAN-BAPTISTE MARIE PIERRE

1714 Paris – 1789 Paris

49 Scene from 'Don Japhet d'Arménie'

Although Pierre enjoyed an illustrious career, was patronized by the church and the crown, and by 1770 had risen to the highest posts of the official arts establishment, he also, like many history painters of the eighteenth century, produced charming works in the so-called lower genres, from designs for ornament and rustic scenes to book illustrations. This comic night-time scene, of a female servant emptying a chamber pot onto the head of an unsuspecting man on the balcony below her window, is taken from a comedy by Paul Scarron (1610–60), *Don Japhet d'Arménie*, first published in 1653, and performed at the Comédie Française several times a year up to the time of the Revolution.[1]

The British Museum drawing is one of four known, highly finished illustrations of theatrical scenes by Pierre, all in the same format and with the same technique of black ink, grey wash and white gouache on blue paper. The other three were based on works by Molière (pseudonym of Jean-Baptiste Poquelin, 1622–73). *Don Japhet* and *Le Sicilien* (fig.1) were sold as a pair in the Villenave sale, where they were acquired by Edmond and Jules de Goncourt in 1848. They were then sold separately, and *Le Sicilien* was later joined by *Le Misanthrope* (fig.2) in the Leboeuf de Mongermont collection (sold 1919). These two were brought together with the third, *Georges Dandin* (fig.3), in the Razsovich collection (by 1929).[2] The three remain together today in a private collection. The function of the series remains elusive: whether they were a commission, models for engravings, or records or designs for actual productions remains to be determined.

With the blue of the paper providing a middle tone, Pierre handled the brush in a very painterly way. He employed thinned white gouache to wash the building's façade in moonlight and pick out highlights in the foliage and figures. The inkiest blacks lend contrast to the shadows and foreground details. In 1993 Olivier Aaron suggested a date of 1760–65 for the present drawing,[3] although he and Nicolas Lesur now lean towards an earlier date, which seems much more likely.[4] While a definitive study of Pierre's stylistic chronology remains to be done, stylistic comparisons would seem to support a date of c.1750–55.

Pen and black ink, brush and black and grey wash, heightened with white gouache, on blue-grey paper

Inscribed in pen and black ink along lower margin, DON JAPHET DARMENIE; in pen and brown ink, *act 4ᵉ Scen 6ᵉ*; and on rock at lower right in pen and black ink, *Pierre*

220 × 282 mm

PROVENANCE: Villenave estate sale, Paris, 1–5 February 1848, lot 123 (with *Le Sicilien*); acquired at the sale by Edmond and Jules de Goncourt; Goncourt sale, Paris, 15 December 1856, lot 72; sale, Sotheby's, London, 4 May 1938 (lot 88, 'property of a well-known family of collectors'); [Colnaghi, London]; purchased through the H.L. Florence Fund in 1938

1938-5-17-2

LITERATURE: 'Le Carnet d'Edmond et Jules de Goncourt', manuscript, Institut Néerlandais, Fondation Custodia (inv. no.9573), p.3, no.7 (cited in Launay, 1991, p.185); Launay, 1991, pp.74, 84–5, 185 and 413, under no.251; Aaron [1993], p.18, no.55

EXHIBITIONS: London, 1968, p.109, no.562; Nagoya and Tokyo, 2002, p.150, no.88

Figs. 1–3 JEAN-BAPTISTE MARIE PIERRE, *Le Sicilien*; *Le Misanthrope*; *Georges Dandin*, each pen and black ink, brush and grey wash, heightened with white gouache, on blue grey paper, private collection.

DON JAPHET DARMENIE *act 4e Seen 6a*

JOSEPH VERNET

1714 Avignon – 1789 Paris

50 River Scene with Fisherman and Laundresses, 1780

In a century when landscape painting flourished, Joseph Vernet was among the most influential and sought after of its practitioners. Born in Provence, he established his reputation during the two decades he spent in Rome (1734–53). From 1746 his paintings were exhibited at the biennial salons of the Académie Royale, and it must have been Abel-François Poisson de Vandières, later the Marquis de Marigny and *Directeur des Bâtiments*, who met Vernet on his Grand Tour in 1750 and later convinced him to return to France and take on the unprecedented royal commission to paint the *Ports of France*, a project that resulted in fifteen large-scale topographical paintings of various French ports.

Vernet's typical fare was less topographically precise. He specialized in scenes inspired by the coasts and ports of Italy. Paintings of storms and shipwrecks were often paired with scenes of calm, and moonlit compositions were often combined with scenes suffused with hazy sunlight. Vernet was accomplished in producing appropriate staffage for his coastal and river landscapes: fishermen, dock workers and washerwomen.

Vernet's drawings are less well studied than his paintings. To his Roman years date most of his *plein air* nature sketches. Precise studies were also undertaken for the *Ports of France* series, but in his later years Vernet relied on his well-established repertoire of motifs, and drawings were made primarily as independent, finished works. The British Museum drawing, carefully rendered in black chalk and delicate grey washes, belongs to this category of highly pictorial sheets made for the market. A fisherman and his dog, both seen from behind, occupy the rocky bank of a river. On the sunlit opposite bank three women wash linens. The winding river leads the eye to a castle and mountainous landscape reminiscent of Italy. To create this exquisitely harmonious view with the dark, curving cliff on the right balancing the light, arching tree on the left, Vernet would not have needed to have had any recourse to nature. Indeed, the composition relies, to some degree, on one he produced over a decade before, *La Source abondante*.[1]

Brush and grey wash over black chalk, framing lines in pen and black ink

Signed and dated in pen and black ink at lower left, *J. Vernet. 1780*

Inscribed in pen and black ink on mount at lower left, *Envoÿé a Mr. Coindet par l'auteur*; blind stamp at lower right of mount: ARD (Lugt 172)

243 × 396 mm

PROVENANCE: Monsieur Coindet? (per inscription); William Gordon Coesveldt, Esq. (1766–1844); Vizconde de Castelruiz; his sale, Christie's, London, 27–30 April 1846, lot 57; purchased by Rodd for the British Museum in 1846

1846-5-9-162

JOSEPH-MARIE VIEN

1716 Montpellier – 1809 Paris

51 Love Carried in Triumph by Nymphs, c.1794–5

Although his reputation would eventually be eclipsed by that of his student, Jacques-Louis David, Vien is nonetheless considered a seminal figure in the early formulation of the Neoclassical style in France. A confluence of factors, including a period of study in Rome, exposure to antiquarian circles and newly published information from archeological excavations, caused Vien to turn his back on his Baroque training in favour of subjects inspired by the antique. In his drawings the vibrant chalk manner of his student years, often black and white chalk on blue paper, gave way to a more restrained technique in pen, ink and wash. Subjects drawn from mythology and ancient history were arranged parallel to the picture plane and rendered in a style emphasizing clarity and outline.

Late in life, shortly before the Revolution, Vien was rewarded with the prestigious appointment, *premier peintre du roi*, but during the Terror came to fear that his standing under the former regime would be his downfall. In the end he was protected by his former student, David, and wrote in his *Mémoires* that during this period he sought solace and escape in his art.[3] *Love Carried in Triumph* belongs to the first of three series of drawings with antique subjects made at this time: *Les Jeux des nymphes et des amours* (1793–6); *Les vicissitudes de la guerre* (1795); and *Le bonheur de la vie ou l'union de l'hymen et de l'amour* (1797–9).[4] The related preparatory drawings are in the Musée des Beaux-Arts, Béziers. The present sheet has the figure of Love borne aloft by a musical band of nymphs. A wall in the middle ground reinforces the planarity of the composition, inspired by the bas-reliefs and wall paintings of antiquity. As a group, they recall the early stages of the Neoclassical style, when pastoral scenes of nymphs in Grecian dress were referred to as in *le gout grec*, a style mid-way between the Rococo and the more severe forms of Neoclassicism that emerged with some of the students of David.

The early provenance of the first series remains mysterious despite Vien's statement in his *Mémoires* that he sold the drawings to the architect of William Beckford. If his further recollection, that he only began the third series after the first two had left his studio, is accurate, the sale would have taken place in 1796–7. Although Beckford liked to visit artists' studios to buy works directly from them, and the style of early Neoclassicism was very much to his taste, Beckford was not in Paris between 1793 and 1801.[5] If, by his architect, Vien was referring to James Wyatt (1746–1813),[6] the designer of Fonthill Abbey, it is not known that he was in Paris at this time either. All we can be certain of is that the twenty-two drawings remained together until they were sold in London in 1932.[7]

Pen and dark brown and grey ink with grey-brown wash, framing lines in dark brown ink

Inscribed on the base of the statue at left, in pen and black ink, Vien / 78;[1] on mount in pen and brown ink at centre along lower margin, *Lamour porté en triomphe par les Nymphes*; and at lower left, 12

198 × 283 mm

PROVENANCE: Acquired from the artist by, 'l'architecte de M. de Becfort, anglais';[2] sale, Sotheby's, London, 20 April 1932 (part of lot 129); [Tomás Harris]; purchased in 1932

1932-5-16-2

LITERATURE: Gaehtgens and Lugand, 1988, p.255, no.165

LOUIS CARROGIS, called DE CARMONTELLE

1717 Paris – 1806 Paris

52 Portrait of Madame la Marquise de La Croix, c.1770

The son of a Parisian cobbler, Louis Carrogis adopted the more aristocratic-sounding surname, de Carmontelle, and employed his wits and talent to gain entrée into some of France's most illustrious courts. He served with the dragoons in the Orléans regiment of the French army during the Seven Years war, after which he was recommended to Louis Philippe, the Duc d'Orléans (1725–85), who hired him as tutor to his son Louis-Philippe-Joseph, Duc de Chartres (1747–85). Although he performed many tasks in the ducal household, from producing short plays to garden design, Carmontelle's primary artistic legacy took the form of a series of drawn portraits, numbering around 750 at his death. Adopting a consistent technique and format early on, he used chalk and watercolour to record the likenesses and pastimes of the broad segment of Enlightenment society that passed through the Orléans court.

Of the identity of the sitter in the British Museum drawing, we cannot be certain. According to the inscription, she is the Marquise de La Croix (née Jarente), who married a lieutenant-general in the service of the king of Spain. After periods in Avignon and Madrid, where she is said to have taken part in various court intrigues,[3] she returned to France, where she was drawn by Carmontelle. In a manuscript by Richard de Lédans, who recorded Carmontelle's portraits and presumably reflected Carmontelle's impressions of his sitters, she is described as a great beauty, completely lacking in judgement and common sense – traits, according to Lédans, common to her sex.[4] In addition to the British Museum drawing, which was sold from the collection some time in the nineteenth century[5] and appears to have been done around 1770, judging from the hairstyle,[6] a second version exists at Chantilly, likewise catalogued as the Marquise de La Croix, but lacking an inscription (fig.1).[7] However, the two do not depict the same woman. The description published by Gruyer, of the marquise as 'une beauté romaine', with 'l'oeil perçant, le nez aquilin, la tête altière',[8] sits easily with the Chantilly version, but not with the London one, with her curving nose and more modest gesture, although it is equally possible that the Chantilly version – the one on which Gruyer based his description – was incorrectly identified.

In both portraits the sitter is placed in a rustic outdoor setting; in the London version she has a letter on her lap, while in the Chantilly version she holds a book, but in both cases she is gazing into the distance, lost in reverie. The wooded setting, with, in the case of the London drawing, a meandering stream and fanciful fountains, recalls Carmontelle's acclaimed designs for the Duc d'Orléans's Jardin Monceau, in which exotic follies dotted the irregular landscape.

Red and black chalk, with watercolour

Inscribed on lower margin of mount in pen and brown ink, partially effaced, *Mme La marquise de la Croix*, and on verso of mount, *Mme La Marquise De la Croix née Jarente, soeur aînée de Mr L'évêque Constitutionnel d'Orléans, et de Mme De La Reynière*[1]

340 × 223 mm

PROVENANCE: In the collection of the artist until his death in 1806; the group of 750 portrait drawings is mentioned in his estate sale, Paris, 17 April 1807, but not sold; purchased by his friend, Pierre-Joseph Richard de Lédans (1736–1816); his estate sale, Paris, 3–18 December 1816, possibly part of lot 531 ('Cent cinquante-deux portraits d'hommes ou de femmes de tous Etats ...')[2]; to Pierre de La Mésangère (1761–1831); possibly included in his estate sale, Paris, 18–23 July 1831 (part of lot 304 'cinq cent vingt portraits dessinés et gouachés'); possibly to John Duff; possibly by descent to Major Lachlan Duff Gordon-Duff; possibly to Colnaghi in 1877; purchased from Colnaghi, London, in 1904

1904-6-14-4

Fig.1 LOUIS CARROGIS, called DE CARMONTELLE, Portrait of *Madame la Marquise de La Croix*, red and black chalk, with watercolour, Musée Condé, Chantilly (Giraudon, Bridgeman Art Gallery).

CHARLES MICHEL-ANGE CHALLE

1718 Paris – 1778 Paris

53 View of the Colosseum, 1747

After initially pursuing training as an architect, Challe spent time in the studios of François Lemoyne and François Boucher. He won the Prix de Rome on his second attempt in 1741 and was sent to Rome as a *pensionnaire* of the king. Finding favour with Jean-François de Troy, the Director of the Académie de France, Challe was able to extend his period of study from 1742 to 1749. However, back in Paris, his ambitions as a history painter ultimately fell victim to the consistently negative critical reception of his paintings at the biennial Salons, especially at the hands of Diderot, who became increasingly virulent in his comments. Challe's work was better received at court, and following his appointment in 1764 as *Dessinateur de la chambre et du cabinet du roi*, he was kept busy with designing settings and decorations for funerals and festivals in a style influenced by Piranesi.

Diderot made an exception to his general disdain, singling out for praise one facet of Challe's production: '[T]his man Challe has brought back from Italy in his portfolio several hundred views drawn from nature in which there is grandeur and truth. Monsieur Challe, continue to give us your views, but don't paint anymore.'[1] Diderot's estimation of Challe's Roman views as numbering in the hundreds is borne out by the catalogue of the artist's estate sale, which lists over a hundred drawings of the Colosseum alone – as loose sheets, in portfolios and framed under glass.[2]

Although it fell outside their official duties, drawing landscapes became very popular among French students in Rome in the 1740s, inspired in part by the proximity of Piranesi (1720–78), whose studio was just across the Corso from the Palazzo Mancini. Many adopted the technique of black and white chalk on blue or buff paper and worked in a fairly large format, applying the chalk in bold, but soft hatching, with strong contrasts of light and dark – a style that no doubt also owed a debt to Boucher's Roman landscapes of a decade earlier. Certain sites appear in the work of many *pensionnaires*, suggesting joint sketching expeditions. Particularly close to Challe's are the landscape drawings of Joseph-Marie Vien, who was in Italy from 1744 to 1750, and Louis-Gabriel Blanchet, in Rome from 1727. From the dates on some of Challe's sheets, he appears to have made most of his landscape drawings during his last years in Rome, from 1746 to 1749.

The Colosseum, the principal amphitheatre of the Roman Empire, inaugurated by Titus in AD 80, presented a multitude of views, with its curved walls and crumbling archways, and was among the most frequently depicted features of ancient Rome drawn by Challe and his contemporaries, including examples in the Rijksmuseum, Amsterdam,[3] and the Metropolitan Museum of Art, New York.[4] Challe's composition, with its gentle sweeping curves and overhanging vegetation, presents this monumental antique ruin within the picturesque idiom of the Rococo. The intermingled black and white chalk promotes pictorial effect over architectural precision, and the reclining figure in antique dress at lower left suggests a mood of reverie.

Black and white chalk on blue paper

Signed and dated in pen and brown ink on stone block at lower left, MA *Challe* / 1747

285 × 470 mm

PROVENANCE: Probably included in the artist's estate sale, Paris, 9 March 1778 and following days; Andreae Lelovics; Galerie Louvois, Paris, from which purchased in 1999

1999-6-26-2

54 Study for an Allegorical Overdoor, c.1769 (RECTO); Lerambert's 'Dancing Hamadryad' with Studies of Flowers, c.1774 (VERSO)

One of the most unconventional artists working in eighteenth-century France, Gabriel de Saint-Aubin was never made a member of the prestigious Académie Royale and produced few paintings over the course of his lifetime. Yet, on the basis of a small corpus of prints and the thousands of drawings left in disarray in his studio at the time of his death, he is admired today as one of the most original artists of his day and an indefatigable chronicler of all aspects of cultural life in eighteenth-century Paris. His sheets often mingle real and allegorical figures, combining sketches made at different times and places, thereby presenting enigmatic puzzles to the modern viewer.

Sculpture figures prominently in Saint-Aubin's oeuvre, and, Pygmalion-like, he seems to have endowed many of his sculpture representations with an animation overshadowing that of their flesh and blood counterparts.[1] On one side of the present sheet a scantily clad nymph lifts one knee, as if poised to step off her pedestal. The sheet was paired from the late nineteenth century until 1957 with a drawing today in the National Gallery, Washington, under the traditional title *Le Rendez-Vous des Tuileries*.[2] In that sheet a carefully rendered frontal view of a statue of a nude male figure is humorously juxtaposed with a seated figure of a proper bourgeois lady. Scholars had considered the pairing of the sheets arbitrary until 1980 when Betsy Jean Rosasco identified their sources as two

Red chalk with stumping, black and blue chalk, brush and brown, grey and black wash, touches of gouache (recto); black chalk with stumping, pen and brown ink (verso)

Inscribed in pen and grey ink at centre right, partially illegible, *lis rouge* [?] (verso)

218 × 148 mm

PROVENANCE: Alfred Beurdeley (1847–1919; Lugt 421, on verso at lower right, stamped twice); his sale, Galerie Georges Petit, Paris, 13–15 March 1905, lot 222 (with pendant); purchased by Mme Salvator Mayer; Jean Dubois; his sale, Hôtel Drouot, Paris, 21–22 March 1927, lot 66 (with pendant); Émile Delagarde; Tony Mayer sale, Galerie Charpentier, Paris, 3 December 1957, lot 18; William H. Schab Gallery, New York; Anne Ford; Thos. Agnew & Sons, London; purchased in 1986

1986-5-10-18

LITERATURE: Dacier, 1929–31, II, p.95, no.544; New York, 1959a, pp.66–7, under no.80; Middletown and Baltimore, 1975, pp.95–6, under no.53; Rosasco, 1980, pp.51–7

EXHIBITIONS: Paris, 1900b, p.39, no.265; Paris, 1951, no.139, n.p; New York, 1959b, p.158, no.166; London, 1968, p.117, no.630; King's Lynn, 1985, p.vii, no.46; London, 1985, pp.6, 8–9, no.5

Fig.1 FRANÇOIS CHAUVEAU (1613–76), *Statue d'une danseuse*, 1675, etching and engraving, British Museum (1889-12-18-119).

Dancing Hamadryad

Fig.2 GABRIEL DE SAINT-AUBIN, *Allegory*, c.1769, oil on canvas, purchased with funds from the Marriner S. Eccles Foundation in honour of Marriner S. Eccles, Utah Museum of Fine Arts, University of Utah, Salt Lake City (1981.013.002).

sculptures from a group of four bacchic figures in stone by Louis Lerambert II (1620–70) for the gardens of Versailles. In 1692 the group was presented by Louis XIV to his brother, the Duc d'Orléans, for the garden of his new residence at the Palais Royal in Paris, where they would have been drawn by Saint-Aubin.[3] Removed from the garden in 1782, the statues are known today only from prints. Lerambert's hamadryad, a woodland nymph who lived and died with the tree she inhabited, is seen from a similar angle in an engraving of 1675 by François Chauveau (fig.1).

If the drawing of the hamadryad dates from the same time as its pendant, 1774, the studies on the other side of the sheet would have been made at least five years before, in preparation for a pair of overdoors with allegorical subjects, one of which bears the date 1769. Now in the Utah Museum of Fine Arts, the pair was mentioned in the nineteenth century by the Goncourt brothers, who recalled seeing them two decades earlier and described their subjects as allegories of Law and Archeology,[4] designations that have been retained in the literature. Eric Zafran put forward a convincing reading of the *Allegory of Law* in 1983,[5] but the iconography of the pendant (fig.2), for which the London drawing is a study, is far less clear.[6] The woman on the right sits, in the painting, on a camel and must represent Asia. The woman on the left with the prominent seals is probably Fidelity, who is often accompanied by a dog. The most curious element of the composition, besides this unusual pairing, is the dark-skinned, bare-chested man in the centre, holding a cloth over his head and a finger to his lips. A very schematic reprise of the composition along the lower margin takes into account the projected oblong format and is closer to the final version, with the camel added and the dog moved to the left, where he stands guard over a huge chest. Perhaps the patron was involved in commerce with Asia.

Allegorical Overdoor

JEAN-BAPTISTE GREUZE

1725 Tournus – 1805 Paris

55 Return from the Wet Nurse

Dramas of the bourgeois household were elevated, in the hands of Greuze, to a new status, their forceful compositions and carefully crafted narratives eliciting comparison with contemporary history painting. The British Museum sheet, long considered lost, is a stellar example of Greuze's fascination with sentiment.[1] It belongs to a group of works depicting wet nurses at a time when contemporary practices were the subject of heated debate. Sending newborn babies to paid wet nurses, where they might remain for years, was still commonplace in the 1760s, although contemporary writers, led by Jean-Jacques Rousseau, had begun to criticize the practice, citing the risks to the infant's health and the importance of bonding with the child during the early stages of development.[2]

The present drawing depicts a wet nurse and her husband returning a young child and his crib home. At the centre of the composition the child resists his natural mother, leaning back into the arms of his more familiar nurse. One might interpret this detail as a condemnation of the practice, yet this reading must be balanced with the eager reception the child receives. The young mother smiles warmly and reaches forward, the grand-mother peers through her glasses for a better look, and the older brother adds to the fanfare with his toy drum. Moreover, the fact that Greuze's own daughter is recorded as in the care of a wet nurse in 1763 must be considered as well.[3]

The drawing was engraved twice: by François Hubert (1744–1809) as *Retour de Nourrice*, dated 1767 and thereby providing a *terminus ante quem*, and by François-Philippe Charpentier (1734–1817) as *Les Préjugés de l'enfance* in *manière du lavis* (the wash manner). Both bore captions identifying the Chevalier de Damery as the owner. Edmond and Jules de Goncourt, who were familiar with his collector's mark and prints after works in his collection, considered de Damery an 'owner of a considerable collection of paintings and drawings, a man of sure taste, a fastidious and refined "chooser" ... [his mark] is never on a mediocre drawing'.[4] Edgar Munhall pointed out that over twenty drawings by Greuze, the majority highly finished genre scenes, are known to have been in his collection, although several were sold in the 1770s when de Damery was having financial difficulties, a point noted in the journal of his friend Jean Georges Wille (1715–1808).[5]

The present drawing has long been neglected by scholars and considered lost, its early provenance sometimes confused with that of an earlier variant of the composition (fig.1).[6] The handling of the two drawings is quite different. The British Museum version has shed all traces of hesitation; the sheet is larger and more resolved with a number of details altered: the father now has the crib atop his head (with the figure at his side replaced by a view onto the street), the cat in the foreground is replaced by the boy with the drum, the mantelpiece at right is omitted, and the foreground still-life elements are added.

Brush and black, brown and grey wash over black chalk underdrawing

477 × 434 mm

PROVENANCE: Chevalier de Damery, Paris; probably Jacqmin, joaillier du roi; his sale, Paris, 26 April–22 May 1773 (lot 858, 'à la plume, lavé au bistre & à l'encre de la chine'); William Gordon Coesveldt, Esq. (1766–1844); Vizconde de Castelruiz; his sale, Christie's, London, 27–30 April 1846, lot 40, purchased by Rodd for the British Museum

1846-5-9-152

LITERATURE: Goncourt, 1880, p.352 (conflated with the ex-Norton Simon version); Martin, 1908, p.25, no.355 (as location unknown, the two versions conflated); Hartford, San Francisco and Dijon, 1976, pp.96, 100, under no.42 (as lost)

Fig.1 JEAN-BAPTISTE GREUZE, *Return from the Wet Nurse*, brush and grey wash, over black chalk underdrawing, 299 × 259 mm, private collection.

Jean-Honoré Fragonard

1732 Grasse – 1806 Paris

56 The Flight of Cloelia, 1761

As a *pensionnaire* of the king at the Académie de France in Rome from 1756 to 1761, Fragonard was considered a rising star, admired for the 'fire' in his brushwork. His precocious skills as a draughtsman and painter of genre scenes were sought after by French collectors and amateurs in Rome. Among the patrons he met in Rome, his most sustained relationship was with Jean-Claude Richard, the Abbé de Saint-Non (1727–91), whom he accompanied on his five-month return voyage to Paris in 1761, making black chalk drawings, mostly after earlier masters, along the way.[1] An amateur printmaker and early practitioner of aquatint, Saint-Non made use of Fragonard's drawings in a number of printing and publishing ventures. The *Griffonis* (1755–78) was made up of Saint-Non's prints, as was the *Fragmens des peintures et des tableaux les plus intéressans des palais et églises d'Italie* (1770–73). For a more lavish publication, the *Voyage pittoresque, ou description des royaumes de Naples et de Sicile* (1781–6), professional printmakers were employed to engrave the many drawings he had commissioned.

The lion's share of the black chalk drawings made by Fragonard for Saint-Non (seventy-one sheets) were presented to the British Museum in 1936 by Mrs Spencer Whately. A few represent views, but most are after paintings by earlier masters, either whole compositions or excerpted motifs. A comment attributed to Fragonard by an early biographer recounted the debilitating sense of awe he experienced before Renaissance masters such as Michelangelo and Raphael, causing him instead to focus his study on artists he could hope to rival: Federico Barocci (c.1535–1612), Pietro da Cortona (1596–1669), Francesco Solimena (1657–1747) and Giovanni Battista Tiepolo (1696–1770).[2] The surviving drawings are consistent with this statement: Baroque masters outnumber Renaissance sources, especially when Fragonard recorded the whole composition, rather than picking out individual figures and motifs.

Saint-Non clearly planned the five-month return journey around points of interest, rather than choosing the most direct route. They began in Naples, took a lengthy detour to Venice and the Veneto, before embarking by boat from Genoa.[3] In Florence from 17 April to 6 May Fragonard made at least forty drawings in a number of different collections, including this one after *The Flight of Cloelia* by Livio Mehus (c.1630–91), then in the Villa Corsini.[4] According to legend, Cloelia was a Roman girl given as a hostage to Porsenna, King of Clusium. By the cover of night, she escaped back to Rome by crossing the Tiber, either on horseback or by swimming. She was recaptured and returned to Porsenna, who was impressed by her bravery and freed her.

A counterproof of the present drawing, subtly reworked in black chalk, probably by Saint-Non,[5] first appeared in the Pigache sale in 1776, illustrated in the margin by Gabriel de Saint-Aubin.[6] The composition (in the same direction) was also among sixteen chosen from the 1761 group that Fragonard himself etched shortly after returning to France.[7]

Black chalk

Inscribed in black chalk at lower right in the hand of the Abbé de Saint-Non, *Livio Meus / Palais Corsini. florence*

204 × 294 mm

PROVENANCE: Sir Samuel Rush Meyrick (1783–1848); by inheritance to Mrs Spencer Whatley; donated in 1936

1936-5-9-5

LITERATURE: Senior, 1937, p.6, pl.IVa; Ananoff, 1961–70, II (1963), p.183, no.1084, fig.290; Rosenberg and Brejon de Lavergnée, 2000, pp.178, 179, 332 and 372, no.155, fig.XVIII

EXHIBITIONS: Tokyo and Kyoto, 1980, n.p., no.107

143

JEAN-HONORÉ FRAGONARD

1732 Grasse – 1806 Paris

57 Venus and Love Asleep, Spied on by a Satyr, 1761

Like the The Flight of Cloelia (no.56), Venus and Love Asleep, Spied on by a Satyr belongs to the British Museum's group of seventy-one black chalk drawings made by Fragonard on his return journey to Paris in 1761 in the company of Jean-Claude Richard, the Abbé de Saint-Non. During their stop in Genoa (21 August–10 September), they must have spent time at the palace of Giacomo Filippo Durazzo II (1672–1764), called the Palazzo Durazzo Pallavicini,[1] where Fragonard drew the divided stair and courtyard and copied three paintings: two by Giovanni Benedetto Castiglione (1609–64)[2] and the Venus and Love Asleep.

Charles-Nicolas Cochin (1715–90), travelling through Italy three years earlier had praised the painting as 'quite beautiful, of a ruddy coloring',[3] apparently not knowing the name of the artist. It was published in eighteenth-century guidebooks with attributions to Annibale Carracci (1560–1609) and Guido Reni (1575–1642),[4] although Saint-Non, according to the inscription on the drawing, believed it to be by Caravaggio (1571–1610). The painting is today considered to be by Giovanni Battista Caracciolo, called Battistello (1578–1635), a Neapolitan Caravaggesque painter, who had a number of Genoese patrons and visited the city on several occasions between 1618 and 1624.[5]

A counterproof of the British Museum drawing is in the Warsaw University Library, and a rare aquatint of the composition in reverse direction was made by Saint-Non,[6] who exploited perfectly the new medium to convey the tonal contrasts of the inky darks of the bed curtains setting off the pale skin of the sleeping Venus and Love. Fragonard was surely drawn to Caracciolo's canvas as much for the subject as the technique, for one can find its echo in such later works as Young Girl in her Bed, Making her Dog Dance (Alte Pinakothek, Munich) and The Happy Lovers (private collection).[7]

Black chalk

Inscribed in black chalk at lower left in the hand of the Abbé de Saint-Non, Caravagio – Palais de Sr. Dorazzo – Gesnes

181 × 225 mm

PROVENANCE: Sir Samuel Rush Meyrick (1783–1848); by inheritance to Mrs Spencer Whatley; London, donated in 1936.

1936-5-9-67

LITERATURE: Rosenberg and Brejon de Lavergnée, 2000, pp.51, 241, 244, 413, no.322, fig.LI.

Caravaggio. Salvi d. Sr. Dovozzo. Gesner.

Jean-Honoré Fragonard

1732 Grasse – 1806 Paris

58 Young Woman Sitting on the Floor

The nineteenth-century owners of this drawing – including Edgar Degas – considered it to be by the Neoclassical artist, Jacques-Louis David, a tradition that persisted well into the twentieth century. Published with its correct attribution by Alexandre Ananoff in 1968,[2] the British Museum sheet is now recognized as part of a stylistically consistent group of red chalk studies of young women depicted seated or standing.[3] Whether set indoors or out, the backgrounds are only summarily indicated and the focus is on the elegant dresses and charming poses, rendered in a rapid and confident manner to sparkling effect.

Fragonard rarely dated his work, and there are few benchmarks with which to construct a chronology of his mature and late drawings. Drawings like the British Museum sheet have in the past generally been thought to date from c.1775–85. In 1978 Eunice Williams drew attention to the fact that two of the series, both formerly owned by the Goncourt brothers, bear dates of 1785.[4] Within Fragonard's oeuvre the group finds a precedent in the series of red chalk portraits of men made on the artist's second journey to Italy in 1773–5,[5] although works from the male group are more highly individualized and detailed and for the most part appear to be portraits, made perhaps for Fragonard's patron Jacques-Onésyme Bergeret de Grancourt (1715–85).

Williams has made the case that the present drawing, and a number of others from the series (e.g. fig.1), represent the artist's daughter Rosalie, who would have been fifteen in 1785.[6] While perfectly plausible, her theory is difficult to confirm as the features are fairly abstracted and idealized. Moreover, the primary function of the drawings, unlike those of the male sitters drawn in and en route to Italy, does not appear to be portraiture, but rather spontaneous studies redolent of Fragonard's genre production, where fetching silk-clad girls might stroll in gardens or relax indoors.

It is not known whether Fragonard was aware of the sanguine drawings of fashionable women by Louis-Roland Trinquesse (c.1745–c.1800),[7] which were presumably earlier. Trinquesse's drawings are more stylized and harder in their execution, but still can be considered as a comparable example of the genre of figure study made not in preparation for a painting or a print, but as an end in itself.

Red chalk

190 × 191 mm

PROVENANCE: L.J.A. Coutan, Paris, died 1830 (Lugt 464, at lower left); to his wife, died 1838; to their brother-in-law Ferdinand Hauguet, died 1860; to his son, Maurice-Jacques-Albert Hauguet; to his wife (née Schubert); to her sister, Mme Gustave Milliet; Coutan-Hauguet sale, Hôtel Drouot, Paris, 16–17 December 1889 (lot 110, as by Jacques-Louis David); purchased at the sale by S. Meyer;[1] Edgar Degas (1837–1917); his sale, Galerie Georges Petit, Paris, 26–7 March 1918 (lot 109, as by David); purchased by the Tate Gallery, London; on deposit at the British Museum since 1964; transferred in 1975

1975-3-1-33

LITERATURE: Rosenau, 1948, p.24, pl.I, opp. p.32 (as by Jacques Louis David, 'Mlle Sedaine'); Cooper, 1949, p.21 (as 'French, eighteenth-century'); Hautecoeur, 1954, p.25 note 31 (as by David); Ananoff, 1961–70, III (1968), p.26, no.1177 (as by Fragonard), and IV (1970), p.417, no.1177, fig.732; Rosenberg, 1969, p.99, no.183; Nash, 1973, pp.23–5, 198–9 note 56, fig.15; Paris and New York, 1987, p.569, under no.299, fig.3 (as Fragonard, 'present where-abouts unknown'); Paris and Versailles, 1989, p.156, under no.63, entry by Arlette Sérullaz; A. Sérullaz, 1991, p.153, under no.193; Rosenberg, 1993, I, pp.13, 16 note 33; Rosenberg and Prat, 2002, II, p.1192, no.R75

EXHIBITIONS: London, 1968a, p.64, no.183 (as 'attributed to David'); New York, 1997, I, p.307, fig.393, II, p.53, no.475 (as by Fragonard)

Fig.1 JEAN-HONORÉ FRAGONARD, Young Woman Dozing, red chalk, 241 × 188 mm, private collection, New York.

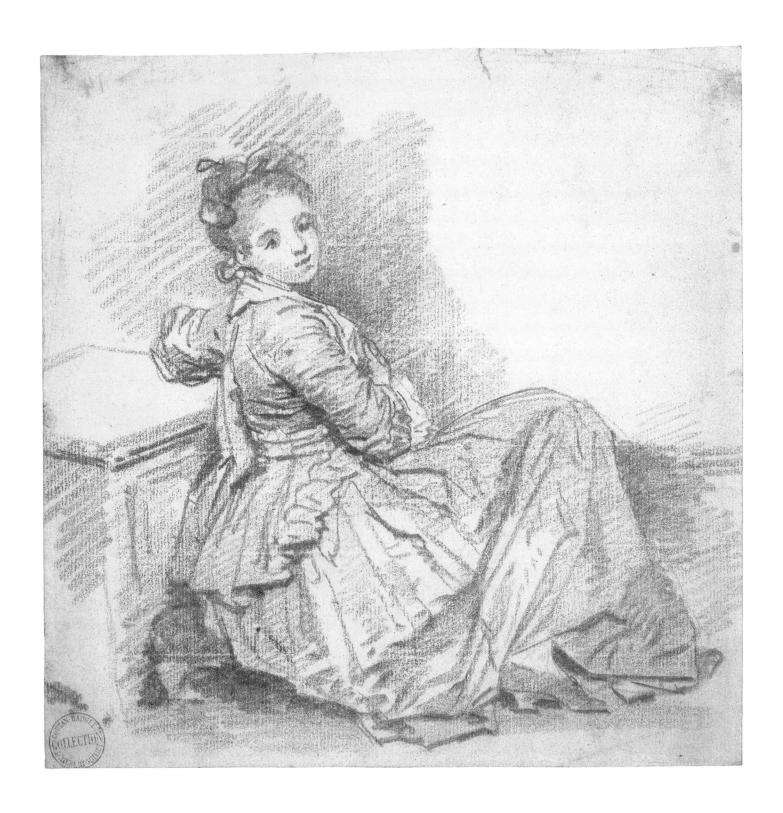

HUBERT ROBERT

1733 Paris – 1808 Paris

59 Coastal Scene at Fiumicino, 1765

Robert arrived in Rome in 1754, aged twenty-one, and would remain there for just over ten years. His precocious talents as a draughtsman and painter were acknowledged by the Marquis de Marigny who granted him special dispensation to attend the Académie de France in Rome despite the fact that he had never studied at the École des Élèves Protégés nor competed for the Prix de Rome. His talents were also recognized by various French collectors and amateurs back in Paris, as well as those based in Italy, who sought out his work and supported him. In addition to the finished paintings and drawings of architecture, landscape and ruins he produced for patrons, Robert filled sketchbooks with studies that would allow him to continue the production of his picturesque Italianate scenes long after his return to Paris.

From inscriptions on a number of sketchbook pages, Robert appears to have made one or more visits to the coastal town of Fiumicino, directly west of Rome, in the years 1763–5. From these small sketches made on the spot, he worked up a number of larger, more finished sheets for collectors, including this watercolour and its pendant, *Figures Gathered around a Cauldron* (fig.1), also in the British Museum,[1] which date to Robert's last year in Italy. Away from the venerable architecture and antiquities of Rome, Robert was attracted to the picturesque details of the waterfront: the felucca (a small boat used for travel along the Mediterranean coast in Italy), with its triangular lateen sails, and the lantern attached by a pulley to a post, which was used as a beacon, both details he studied in a sketchbook dating probably to 1764 (dismembered in 1989).[2] Yet, more than the setting, the focus is on the colourful revellers filling the foreground. A barefoot couple dance to the sound of a lute and a tambourine, while sailors, young women and children look on. Musicians and dancers occur frequently in Robert's paintings,[3] recalling the artistic precedent of Claude and Watteau, but also offering to the Enlightenment viewer a poignant counterpoint to the reverie inspired by crumbling ruins or a timeless landscape.

Pen and black ink with watercolour, over black chalk underdrawing

Signed and dated in pen and brown ink at lower margin, right of centre, H. ROBERTI D. / 1765. FIUMICINO

381 × 608 mm

PROVENANCE: Purchased from Holloway & Son in 1872

1872-1-13-367

LITERATURE: Washington, 1978, p.74, under no.24, and p.94, under no.34; Geneva, 1979, n.p., under no.8; Paris and Geneva, 1986, n.p., under no.49; Rome, 1990, pp.45, 48, fig.10 (essay by Catherine Boulot)

EXHIBITIONS: London, 1968a, p.114, no.607, fig.270; Nagoya and Tokyo, 2002, pp.162–3, no.99

Fig.1 HUBERT ROBERT, *Figures Gathered around a Cauldron*, pen and brown and black ink, 378 × 604 mm, British Museum (1872-1-13-366).

JEAN-ROBERT ANGO

Active Rome 1759–70, died after 16 January 1773

60 Wooded Landscape with a Shepherd Fording a Stream with his Flock

A shadowy figure operating on the margins of the French artistic community in Rome, Jean-Robert Ango had no official affiliation with the Académie de France, but was acquainted with several of the *pensionnaires* and was employed by French collectors and amateurs in Rome. In the twentieth century he was all but forgotten until Alexandre Ananoff's two short articles appeared in 1963 and 1965.[1] Since then a considerable oeuvre of drawings has been established, but few documents have been found to illuminate his biography.[2] Dated drawings suggest that Ango was active between 1759 and 1770, and he is documented in 1761 making drawings in the Capodimonte Gallery in Naples in the company of Jean-Honoré Fragonard. According to Jean-Antoine Julien, he suffered a stroke in 1772 and was reduced to begging in the streets in his final years.[3]

From his surviving works it seems that Ango worked primarily as a copyist. He found his subjects in the churches and palaces of Rome where he drew paintings, sculptures and details of architectural decoration. He also copied drawings and reworked counterproofs by his friends, Hubert Robert and Fragonard, often adding prominent inscriptions indicating the author of the original. While this practice was probably not intended to deceive, over time many such works came to be classified under the name given in the inscription. Such was the case with this large bucolic landscape acquired by the British Museum in 1865 as a work by Fragonard. The vibrant and energetic manner of describing the dense stand of sunlit trees with their gnarled branches and lush foliage suggests an awareness of Fragonard's and Robert's sanguine landscapes of the early 1760s, when they together forged an influential and widely admired new style of landscape drawing. However, despite the superficial similarities, the technique of the London sheet is unmistakably Ango's with its emphasis on outline, modelling with broad hatching and *horror vacui*.[4] As with many sheets by him, his tendency to reinforce contours lends a slightly vibrating quality to the forms.

Although the preponderance of his extant sheets are studies of isolated motifs,[5] Ango also produced highly finished drawings of entire compositions, typically when copying paintings or drawings. The present sheet is quite similar in style and format to a number of copies made for Jacques-Laure Le Tonnelier, Bailli de Breteuil and Ambassador to the Order of Malta (1723–85), who asked Ango to record the works in his collection in 1765–8, essentially as an illustrated inventory. Copies in sanguine of identical dimensions to the British Museum sheet were made after works such as *Landscape in Calm Weather with Flocks and Shepherds* by Giovanni Francesco Grimaldi (1606–80) and *Landscape with a Caravan* by Giovanni Benedetto Castiglione (1609–64).[6] Were it not for the inscription, one would assume a similar seventeenth-century source for the London drawing. The possibility that Ango was copying a lost painting by Fragonard in a Salvator Rosa or Castiglionesque vein should not be dismissed, although Fragonard had returned to Paris by 1761.

Red chalk

Inscribed in red chalk at lower left, *honore fragonard In. et pinxit*

345 × 465 mm

PROVENANCE: Purchased from Edward Daniell in 1865

1865-10-14-371

LITERATURE: Ananoff, 1965, pp.165–6

Jean-Baptiste Le Prince

1734 Metz – 1781 Saint-Denis-du-Port

61 A Mountebank before a Crowd

Born in the provincial city of Metz in the north-east of France, Jean-Baptiste Le Prince gained the sponsorship of the Maréchal de Belle-Isle, which enabled him to travel to Paris and enter the studio of François Boucher around 1750. Le Prince proved himself an adept student, assimilating his master's style and subject matter with apparent ease. Le Prince ultimately distinguished himself from other members of Boucher's atelier by his decision at the age of twenty-two to leave Paris for St Petersburg, following two older siblings already established there. He would return from his five-year sojourn in 1763 with a horde of sketches recording many aspects of Russian life and habits, as well as boxes of Russian folk costumes. Russian themes would dominate his output for the remainder of the decade until poor health forced him to abandon the capital in favour of the surrounding countryside. In this final period Le Prince returned to the bucolic landscapes and pastoral subjects popularized by Boucher.

In his later years in Saint-Denis-du-Port Le Prince continued to produce autonomous, finished drawings in addition to paintings and prints. Increasingly, his medium of choice was bistre wash, a technique also popular with Jean-Honoré Fragonard and François-André Vincent (1746–1816) during the same period. Here, the wash is handled with great facility, producing a sparkling sunlit scene. A mountebank stands atop a rough-hewn platform, a musician at his side to attract attention. A crowd of rustic types has gathered around, gullible expressions evident on their upturned faces. Le Prince has adopted an unusual viewpoint, showing the performers from behind and emphasizing two spectators in the foreground. One, in a fur hat and exotic boots, listens raptly, while the figure at left, revealed by his dress and posture to be of a higher class than the others, turns away, one hand on his hip, the other extended holding his walking stick, the picture of educated scepticism.

The locale depicted is ambiguous: the musical instrument and dress of the figure at left are European, while the figure at right and the hats of some of the men in the audience confer a vaguely Russian aura. Ultimately, the subject has less to do with the people's nationality than with the dichotomy of enlightenment and ignorance. Such themes can be traced back to Le Prince's illustrations for Chappe d'Auteroche's *Voyage en Sibérie* (Paris, 1768), the 'Experiment with Natural Electricity', for instance, where a westerner uses scientific means to investigate a natural phenomena that sends local onlookers into panicked retreat.[1] In *Mountebank Before a Crowd* Le Prince steers clear of heavy-handedness, inviting the viewer to share the bemusement of the outward-facing gentleman, charmed but not tricked by the wiles of the country charlatan.

Pen and grey ink, brush and brown wash, over black chalk underdrawing

Signed and dated in brush and brown ink at lower left, *Le Prince 1777*

236 × 314 mm

PROVENANCE: Sale, Sotheby's, London, 8 July 1853; purchased in 1853

1853-8-13-57

LITERATURE: Roland Michel, 1987, pp.194, 196, fig.231

EXHIBITIONS: Nagoya and Tokyo, 2002, p.164, no.100

153

LOUIS-JEAN DESPREZ

1743 Auxerre – 1804 Stockholm

62 View of the Grand Harbour, Valetta, Malta

A quirky and talented artist, Desprez was first trained as an architect at Jacques-François Blondel's school in Paris. He eventually switched to the Académie Royale and went on to win the Prix de Rome in 1776. While a student in Italy, he was hired to join the Abbé de Saint-Non's team to provide drawings for the *Voyage pittoresque, ou description ... de Naples et de Sicile*, published in Paris between 1781 and 1786 (see no.56). He ultimately produced 135 finished drawings for the project; along with Claude-Louis Châtelet (1749/50–95), he was among the most prolific contributors. Without forsaking architectural accuracy, Desprez's scenes were dramatically composed and lit and were often enlivened with colourful street scenes or festivities rendered in a delicate ink line and watercolour washes.

In April 1778 Desprez and Châtelet set off for Naples, Sicily and Malta in the company of Baron Dominique Vivant Denon (1747–1826), who would provide the text for Saint-Non's book. After nine months of making careful ink line drawings, Desprez returned to Rome where he would use these models to produce finished drawings for the engravers. From 6 to 17 September the group sojourned in Malta, a sovereign archipelago under the control of the Knights of Malta, a religious and military order of the Roman Catholic church.[1] Four views engraved after Desprez of the capital city Valetta and its harbours appear in the *Voyage pittoresque*.[2] The city is located on the promontory of Sceberras, dividing the bay into two harbours. The British Museum sheet represents the Grand Harbour, to the south-east of the city, and two other scenes depict Marsamxett Harbour to the north.[3] Renowned for its fortifications, hospitals and Baroque palaces, Valetta rises steeply from the quay in Desprez's drawing, a dense jumble of imposing structures, fortified walls, steeples and domes. Unlike the mostly empty expanse of water in the preparatory study (Royal Academy of Fine Arts, Stockholm),[4] the bay in the finished watercolour bustles with activity. A great variety of vessels, many with elaborate masts and rigging, balance the composition by adding mass and interest to the left side of the sheet. Washes of blue and grey create the effect of a brilliant sunlit day.

Pen and black ink with watercolour

Inscribed in black chalk at centre of lower margin, 135

208 × 342 mm

PROVENANCE: Samuel Woodburn, London (1786–1853); his estate sale, Christie, Manson & Woods, London, 12 June 1860, part of lot 1098 ('Andriessen (J.) – A pair of classical landscapes with figures – in colours; other coloured views, theatrical scenes, &c'); acquired by Sir Thomas Phillipps (1792–1872); his grandson Thomas Fitzroy Phillipps Fenwick (1856–1938); presented by the National Art Collections Fund in 1946

1946-7-13-119

LITERATURE: Popham, 1935, p.220, no.1, pl.XCV; Wollin, 1935, p.95; Lamers, 1995, pp.28–81, no.283b

EXHIBITIONS: London, 1984b, pp.137–8, no.129; Stockholm, 1992, p.50, no.31

JEAN-BAPTISTE HUET

1745 Paris – 1811 Paris

63 Peasants with their Flocks Travelling by Night, 1775

From a family of animal, flower and ornament painters, Huet first trained with animal painter Charles Dagomer (died before 1768) before joining the studio of Jean-Baptiste Le Prince. Laure Hug's recent archival research on Huet has brought to light several inventories that reveal that he also assembled an extensive collection, especially of works on paper, and that the artists he collected in depth correlate with the artistic influences evident in his work.[1] Among the most prominent contemporary French artists represented in his collection were his master, Le Prince, and, in turn, his master, François Boucher, both of whom Huet apparently befriended, followed by Hubert Robert, Jean-Honoré Fragonard and Jean-Jacques Lagrenée. Although a taste for Northern genre painting could have been gleaned indirectly through examples of Boucher's work, the inventory made after Huet's death enumerated substantial holdings of prints after Northern artists specializing in animals and rustic scenes, including Nicolas Berchem, Paulus Potter, Johann-Elias Ridinger and Philips Wouwerman.

Although the emphatic and abbreviated handling of chalk in the British Museum sheet, as well as its Castiglionesque subject of rustic figures herding a flock of sheep by torchlight are strongly suggestive of Boucher's late pastorals, the compositional source has been identified as a pen and wash drawing by Nicolaes Berchem (1620–83), which entered the British Museum in 1824 (fig.1).[2] This work may well have been in France at the time Huet created his drawing as it was etched in reverse by the collector and amateur, Claude-Henri Watelet (1718–86).[3] Huet's use of Berchem's drawing finds ample precedent in the studio practice of François Boucher and others of his circle.[4]

No painting related to Huet's composition is known to survive,[5] although he did return to the composition twice: once to rework the counterproof, a sheet which bears the date 1792, and once to etch it in reverse, with a printed date, 'l'an 6'.[6] The procession by torchlight of rustic figures and sheep, travelling in the night with a woman and child riding a donkey is reminiscent of depictions of the Holy Family's Flight to Egypt. The breakdown of boundaries between rustic genre and scenes from the life of Christ is characteristic of the third quarter of the eighteenth century, especially in the work of Boucher and his circle.

Brown chalk, with brush and brown wash, over red chalk underdrawing

Signed and dated in pen and brown ink at lower left, J.B. *Huet 1775* (partially obscured)

424 × 319 mm

PROVENANCE: Purchased from Edward Daniell in 1861

1861-8-10-77

LITERATURE: Didier Aaron, New York, *French Master Drawings*, 16 May–9 June 1984, under no.21; Roland Michel, 1987, pp.100–102, 105, fig.97; Jacoby, 1992, pp.261, 266, 273–4, fig.11

Fig.1 NICOLAES BERCHEM (1620–83), *Shepherd Family Travelling at Night*, 1655, pen and brown ink, brush and brown wash, British Museum, bequeathed by Richard Payne Knight, 1824 (Oo. 10-200).

JACQUES-LOUIS DAVID

1748 Paris – 1825 Brussels

64 An Antique Bed with Scenes from the Life of Hector

Jacques-Louis David's major canvases of the 1780s, *The Mourning of Andromache* (Louvre, Paris), *The Oath of the Horatii* (Louvre, Paris) and *The Death of Socrates* (Metropolitan Museum of Art, New York), were visual manifestos of the fledgling Neoclassical style. If these works came as a stunning revelation to Parisian audiences, their genesis was nonetheless the product of methodical preparation. The essential components of David's mature style – sober, moral subjects, planar compositions and the emulation of antiquity – all guided his choices in the five years he spent in Rome as a *pensionnaire* of the crown, assiduously producing the copies which would become a life-long resource.

Shortly after returning from Italy in 1780, David cut apart his Roman sketchbooks (presumably organized chronologically) and reordered his drawings, pasting them into large albums by type: figures after the antique, copies after old masters, landscapes, antique furniture and tracings, mostly after prints of Greek vases. These albums (referred to as the original or 'primitifs' albums) remained in his studio until his death when his heirs dismantled them and had the pages rebound into twelve smaller albums, each featuring a representation of the various types of drawings David made in Italy. Of the twelve, some have remained intact, while others have been partially or wholly dismembered – and in two cases completely dispersed.[1] This ravishing drawing of an antique bed was part of album 6, dismembered in 1979.

David made many drawings of antique furniture in Rome, clearly anticipating their utility in composing scenes drawn from ancient history. This bed evidently was of special importance, for it is of an exceptionally large format, filling an entire sketchbook page. Freely sketched in black chalk, the design is further elaborated in several shades of grey wash, producing the effect of a dim interior with the bed awash in a pool of bright light. Similar studies from the Roman albums were drawn after antiquities or prints, but for the present sheet no source has been identified, and indeed the fresh white bed linens are an unlikely detail, suggesting that it may have been an invention rather than a copy.[2]

The connection between this bed, with its relief featuring episodes from the life of Hector, and David's *Andromache Mourning Hector* (fig.1) was first made in 1979.[3] The central vignette of the bed's decoration in the drawing – Achilles killing Hector – was refined in a drawing of an antique frieze (Musée de Peinture et de Sculpture, Grenoble)[4] and was then used near the foot of the bed in the painting. What has not been noted is that the lightly applied black chalk lines in the upper register are not pentimenti for the bed but, rather, preliminary indications of a corpse. A spherical shape just by the corpse's knees may even have been David's first idea for the placement of Andromache. If one accepts this interpretation of the lightly sketched lines as indications for the placement of Hector and Andromache, then the British Museum drawing constitutes further evidence that David's initial concept for his reception piece of 1783 was born during his student years in Italy.[5]

Brush and grey wash over black chalk

Inscribed in pen and brown ink at lower left with the paraphs of the artist's sons, Jules David (Lugt 1437) and Eugène David (Lugt 839)

213 × 387 mm

PROVENANCE: Mounted to the verso of sheet 189 of David's original albums ('albums primitifs'); rebound by David's heirs as the verso of sheet 20 of Roman album no.6; David estate sale, Paris, 17 April 1826 and days following, part of lot 66 ('douze grand livres de croquis'), withdrawn by his family; included in the inventory of 27 June 1826 made after the death of Madame David; listed in the document of succession of David and his wife, 1 June 1827, part of no.19; second David sale, Paris, 11 March 1835, part of lot 16; Galerie Prouté, Paris, in 1978; Galerie de Bayser, Paris, 1979 (at which point the album was dismembered); Harry Bailey; sale ('property of a European foundation'), Sotheby's, New York, 26 October 1990, lot 36 (bought in); sale, Christie's, New York, January 30, 1998, lot 328 (bought in); Thomas Le Claire Kunsthandel, Hamburg; Purchased with funds provided by the Patrons of Old Master Drawings in 2003

2003-4-29-9

LITERATURE: Korshak, 1987, p.109 note 26; Schnapper and Sérullaz, 1989, p.15, fig.21; New York, Fort Worth and Ottawa, 1990, p.162, under no.64; Gonzalez-Palacios, 1993a, pp.933–4, fig.189; González-Palacios, 1993b, I, p.63, II, fig.47; Rosenberg and Prat, 2002, I, p.532, no.715, and II, p.809, fig.189 verso; Le Claire, 2003, no.19, n.p.; Rosenberg and Peronnet, 2003, p.52, note 32

EXHIBITIONS: *Catalogue Centenaire*, part II, *Dessins originaux anciens et modernes*, Galerie Paul Prouté, Paris, 1978, p.45, part of no.58 (F.20 d), illus. p.43; *Louis David, 1748–1825, Dessins du premier séjour romain, 1775–1780*, Galerie de Bayser, Paris, 1–15 December 1979 (catalogue by Marc Simonet-Lenglart), no.46, n.p.; Paris and Versailles, 1989, pp.81, 148, no.21; Kate de Rothschild-Didier Aaron, *Master Drawings*, New York, Paris and London, 1993, no.37, n.p.

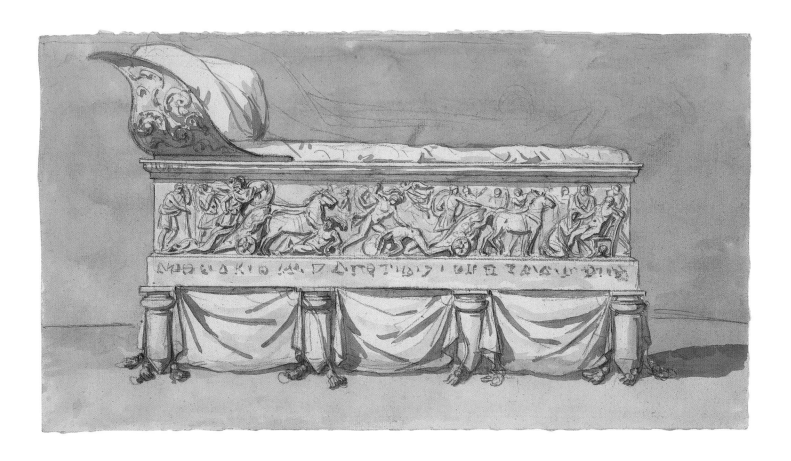

Fig.1 JACQUES-LOUIS DAVID, *Andromache Mourning Hector*, 1783, oil on canvas, Musée du Louvre, Paris.

JACQUES-LOUIS DAVID

1748 Paris – 1825 Brussels

65 Head of Brutus, after the Antique

Begun as a royal commission in 1787 and completed during the first summer of the Revolution in 1789, David's large canvas *Lictors Returning to Brutus the Bodies of his Sons* (Louvre, Paris) was profoundly prescient in its subject matter and came to embody moral principles at the heart of the young Republic. Lucius Junius Brutus lived during the brutal regime of Rome's last king, Tarquin. When Tarquin's son Sextus raped the virtuous Lucretia and the dishonour drove her to commit suicide, Brutus drew the knife from her wound and vowed to free Rome of monarchy. He succeeded and established the first Roman Republic in 509 BC only to later find his two sons involved in a royalist conspiracy. Standing by his convictions, he ordered their execution. This principled, but seemingly inhuman, act is the focus of David's highly original canvas, which envisages the domestic aftermath: the brooding resolve of Brutus contrasted with the emotional anguish and despair of his wife and daughters.

Although the composition went through many stages of evolution,[1] David's conception of his protagonist remained deeply rooted in the noble yet grim features of the Capitoline *Brutus*, a frequently copied antique bust (fig.1).[2] This paternity was long acknowledged in the literature, and the appearance of the present sheet at Christie's in 2000 only confirmed the link. Drawn emphatically in black chalk, the London *Brutus* is faithful in its details to its antique source: the curls of hair stuck to the forehead, the closely trimmed beard, the asymmetrical placement of the ears. It is distinguished however from the majority of David's copies after the antique by its emphasis on psychological portrayal. For Pierre Rosenberg and Louis-Antoine Prat the drawing dates stylistically to David's second trip to Rome (October 1784–August 1785), when he was largely occupied with completing *The Oath of the Horatii* (1785, Louvre, Paris). The inscription, 'David a granet. L'an.2', could not, they point out, refer to the painter François-Marius Granet (1775–1849), who made his first trip to Paris only in 1796 and entered David's studio two years later.[3] A more likely candidate as the dedicatee would be François-Omer Granet (1758–1821), a cooper from Marseilles who was elected in 1792 to the National Convention where he served alongside David. Granet took part in the events of 10 August and voted in favour of regicide, although he would ultimately oppose the policies of Robespierre. Between 20 June and 30 July 1794 (l'an 2), he collaborated with David supervising work on the palace and gardens of the Tuileries.[4]

The Brutus drawing would have made an extremely appropriate gift in the summer of 1794. Effigies of Brutus were omnipresent at the height of the Terror, in the form of busts, prints, porcelain, even theatrical dramatizations. Brutus's image became synonymous with patriotism and the ideal of sacrifice for the republican cause.[5] A copy of the Capitoline bust was placed by the speaker's podium in the chamber where the Convention met, presiding over many sessions where executions were ordered in the name of the Republic.[6] For David and Granet, taking part in many of these sessions, the bust must have been a constant reminder of the gravity of their task.

Black chalk on off-white antique laid paper

Signed, with a dedication in black chalk along the lower margin, *David a granet.*, followed by a date in graphite, *L'an.2*

139 × 109 mm

PROVENANCE: Given by the artist to François-Omer Granet (1758–1821), member of the National Convention; private collection; sale, Christie's, London, July 4, 2000, lot 186; Colnaghi, London; purchased with contributions from the Patrons of Old Master Drawings and Katrin Bellinger in 2000

2000-9-29-11

LITERATURE: Rosenberg and Prat, 2002, I, p.92, no.75 bis

Fig.1 *Capitoline Brutus*, 4th–3rd century BC, bronze, Musei Capitolini, Rome.

160

David a grànet. L'an 2.

PIERRE-HENRI DE VALENCIENNES

1750 Toulouse – 1819 Paris

66 A Classical Landscape with Figures, 1796

Although he is appreciated today for his *plein air* studies and oil sketches, Valenciennes's historical contribution was the elevation of the genre of landscape, which he promoted through his work and his theoretical writings. Inspired by Poussin and Claude, Valenciennes revived for his generation the *paysage historique*, idealized landscapes featuring antique subjects or motifs. With his many students, he encouraged the practice of working directly from nature, an exercise that he believed underpinned any understanding of aerial perspective.

After studying with Gabriel-François Doyen (1726–1806) and Joseph Vernet (1714–89) in Paris and spending two periods in Rome, Valenciennes was received with great enthusiasm into the Académie Royale in 1787. He survived the Revolution, dropping the 'de' from his last name, and went on to teach perspective in the various reincarnations of the Académie following the fall of the monarchy. The British Museum drawing, dated 1796, is very much in the vein of the oil paintings he exhibited at the Salon in the 1790s, a carefully crafted idealized landscape with figures in classical dress. The scene is permeated with calm as an isolated ray of sun illuminates a building across a mirror-flat lake and a carefully placed ancient vase and column further identify the setting as Arcadian rather than actual.

Valenciennes's technique for this finished, autonomous work is quite different from that of his studies after nature. An exquisitely subtle range of tone is achieved through the controlled application of the black crayon and the stump, which could blur and blend transitions of tone. The selective use of white chalk further augments the luminous effects of light as the artist picks out the breaks in the clouds, the reflection on the lake and the areas of brightness in the sky to silhouette the dark branches of the tree on the right. That Valenciennes sought to pass on to his students the means of achieving these poetic effects is recorded in two pedagogical series of drawn studies in the Louvre, each of which records an identical composition taken to three different degrees of finish, allowing others to see the step-by-step process of creation.[1] The steps in creating the London drawing would have been the same: first a simple sketch in black crayon, followed by stumping in the shaded areas and the addition of white chalk in the lit areas, and finally finished with a reworking of the main foreground forms and trees in a dark black medium. In this way he adhered to his own principles of melding linear and aerial perspective, whereby the forms in the distance gradually grew lighter and lost their sharpness of outline.[2]

Black crayon, with stumping, conté crayon, heightened with white chalk, on light brown paper

Signed and dated in pen and brown ink at lower right, P. *Valenciennes*. 1796

378 × 518 mm

PROVENANCE: [William H. Schab, New York]; Christie's, London, July 8, 1980 (lot 94); purchased through Richard Day in 1980

1980-7-26-1

EXHIBITIONS: *A Collection of Fifty Master Drawings from the Fifteenth to Twentieth Centuries*, William H. Schab Gallery, New York, 21 January–28 February 1970, pp.70–71, no.40

Pierre-Paul Prud'hon

1758 Cluny – 1823 Paris

67 Psyche Trying to Prevent Cupid from Leaving

Although few works can be definitively dated to Prud'hon's early years, his biography reveals an ambitious young man determined to rise above his provincial roots and find success in the French capital. Born the tenth son of a stone carver in the Burgundian town of Cluny, Prud'hon was awarded a scholarship to study at the École de Dessin in Dijon under François Devosge (1732–1811). In 1776 he was introduced to the Baron de Joursanvault (1748–92), a patron of the arts who commissioned works from Prud'hon and would sponsor his period of study in Paris from 1780 to 1783.

Prud'hon's independent spirit and resistance to instruction is evident in his correspondence from Paris. He enrolled at the École des Élèves Protégés, but he chose not to work in the studio of an established painter, as many of the students did. He lodged with Jean-Raphaël Fauconnier, a lace merchant whom he befriended, and appears to have been romantically involved with Fauconnier's sister, Marie. In order to compete for the Dijon Prix de Rome, Prud'hon returned to Burgundy in late 1783. Writing to Fauconnier in 1783–4, Prud'hon mentioned that he was sending some drawings or paintings. Charles Clément, in his 1872 monograph on the artist, identified these works as the present sheet and its pendant, Psyche Watching Cupid Asleep.[2]

Although earlier works survive, the British Museum sheet is the first where we glimpse Prud'hon's genius. The influence of his first master, Devosge, remains evident in the elegant ink contours and delicate modelling in wash, as well as the restrained, late Rococo sensibility,[3] with the overlay of a new awareness of nascent Neoclassicism in the architectural elements and tightly orchestrated planar composition. The sensuality of the intertwined figures has also been compared to Primaticcio.[4] Moreover, the pair of Psyche drawings are among the earliest manifestation of Prud'hon's attraction to subjects of erotic mythology and allegory.[5] The story of Psyche, in particular, which he would return to in 1808 with Psyche Carried off by the Zephyrs (Musée du Louvre, Paris), embodied the fleeting nature of love and the complications of amorous entanglements. As his allegories of the years of the Revolution and the Republic would make explicit, love, for Prud'hon, was often accompanied by remorse and regret, themes not unrelated perhaps to his own life, encumbered by an early and unhappy marriage in 1778 to Jeanne Pennet, already pregnant with their first child.

Pen and black ink, brush and grey wash, with charcoal, heightened with white, on two joined pieces of buff paper

292 × 259 mm

PROVENANCE: Sent from Dijon by the artist to the Fauconnier family, Paris, in 1783–4; Pelée family, Pelée sale, 29 June 1871, Paris (with pendant),[1] to Hector Brame; Jean-François Marmontel, by 1874; Marmontel sale, Hôtel Drouot, Paris, 25–6 January 1883 (lot 236); purchased by Lacene; possibly re-purchased by Marmontel; Anatole Marmontel sale, Hôtel Drouot, Paris, 28–9 March 1898 (lot 49); anonymous sale, Hôtel Drouot, Paris, 8 May 1908 (lot 89); Anatole France; his sale, 20–21 April 1932 (lot 143, as 'attributed to Prud'hon'); Galerie de Bayser, Paris, 1987; acquired in 1988

1988-6-18-18

LITERATURE: Sensier, 1869, p.511; Goncourt, 1876, pp.104–5; Clément, 1880, p.83 note 1, pp.327–8, 374–5; Guiffrey, 1924, p.51–2, no.144 (conflates two drawings); Grappe, 1958, p.60; 'Recent Acquisitions of drawings at The British Museum', Burlington Magazine, CXXX, no.1028 (November 1988), p.882, fig.10; Lévis-Godechot, 1997, pp.55–56 (erroneously connecting two different drawings with early mentions of this sheet and its pendant); Laveissière, 1997, pp.16–17; Guffey, 2001, pp.33–4, fig.14

EXHIBITIONS: Paris, 1874, pp.66 and 67, no.182 or 183; Paris and New York, 1997, pp.37, 43–5, no.7

PIERRE-PAUL PRUD'HON

1758 Cluny – 1823 Paris

68 Standing Female Nude

Among Prud'hon's most esteemed accomplishments as a draughtsman are his sensuous chalk *académies*, studies after posed nude models drawn in black and white chalk on blue paper. Employing a complex and idiosyncratic technique, Prud'hon built up each figure in a series of steps. Bold parallel strokes in black and white chalk, applied in layers alternating with stumping to blend the chalk, produced ethereal effects suggesting moonlit, Leonardesque figures.

The term *académie* derived from the practice of drawing from nude models, a method that existed in public art academies but also in private settings where an artist or group of artists would hire a model. Written accounts suggest that Prud'hon often joined the drawing sessions organized by Pierre-Félix Trézel (1782–1855), one of his students, while the two had lodgings at the Sorbonne, and the existence of sheets by other hands portraying the same models from different angles confirms this idea. Unlike the more restrictive policies at the former Académie Royale, both male and female models were used in Trézel's studio, and the name Marguerite has been associated with many sheets of a young woman with curly hair, often tied in a high bun with loose strands falling out, as in the British Museum sheet.

Although mostly associated with student training, such drawings were also made by mature artists – François Boucher, for example – either to sell to collectors or to provide models for students or engravers. In the case of Prud'hon, the majority are stylistically works of his maturity, dating probably to *c.*1810–20.[1] Few relate to painted compositions, ruling out a preparatory function, and few appear to have left his studio before his death,[2] ruling out a commercial intent. Presumably they were made for his own pleasure or as inspiration for his students.

Judging by the sketchy indications of the prop in the figure's hands, which is usually read as an oar, Jean Guiffrey suggested in 1924 that this drawing might have been a study for the figure of Navigation designed by Prud'hon as part of the temporary decorations constructed for the festivities held by the city of Paris in 1810 to mark the wedding of Napoleon and Marie-Louise. To create a setting for the imperial couple to view the fireworks over the Seine, a semicircular colonnade was constructed in the square in front of the Hôtel de Ville. On top of the colonnade were placed ten statues of allegorical figures based on drawings by Prud'hon, including one of Navigation. Although the pose of the British Museum drawing does closely echo, in reverse, the pose of Navigation, the differences, and the fact that such correspondences can be found for only one other of the allegorical statues,[3] suggest that the similarities can be attributed either to the natural recurrence of certain types and poses that occur in an artist's oeuvre, or to the possibility that Prud'hon, in the years shortly after the wedding, may have posed a model to recall the figure of Navigation.

Black chalk, heightened with white, stumped on blue-grey paper, with strips added at top and bottom

Collector's mark of Charles de Boisfremont (Lugt 353) in red ink at lower right

625 × 415 mm

PROVENANCE: Charles-Pompée Le Boulanger de Boisfremont (1773–1838; Lugt 353); his son Oscar de Boisfremont; his sale, 9 April 1870, Hôtel Drouot, Paris (lot 46); purchased by Rouart; Henri Rouart, Paris; his second sale, Galerie Manzi-Joyant, Paris, 16–18 December 1912 (lot 271); purchased by Monsieur Chialiva; re-purchased by the Rouart family; Ernest Rouart, in 1917; T. Ampion, in 1951 (listed in 1950 exhibition catalogue as 'T. Antion'); Galerie Hector Brame, Paris; bequeathed by César Mange de Hauke

1968-2-10-18

LITERATURE (SELECTED): Goncourt, 1876, p.301; Guiffrey, 1924, pp.358–9, no.953; Rowlands, 1968, pp.42–4, fig.1; Slayman, 1970, pp.114–15, 140; Johnson, 1995, pp.10–11, fig.2; Elderfield and Gordon, 1996, pp.80, 116, pl.12; Guffey, 2001, p.214, fig.156

EXHIBITIONS (SELECTED): Paris, 1874, p.130, no.427; Paris, 1900a, p.101, no.1252; Stockholm, 1917, p.3, fig.1; London, 1950, p.22, no.69, pl.IX; Paris, 1951, no.112; Winterthur, 1955, p.61, no.265; London, 1968b, pp.8–9, no.1; London, 1972b, p.405, no.739 (entry by Pierrette Jean-Richard); London, 1984b, pp.140, 142, no.134; Paris and New York, 1997, pp.255, 263–4, no.188

PHILIPPE-AUGUSTE HENNEQUIN

1762 Lyon – 1833 Leuze

69 Sir Sidney Smith Transferred from the Abbaye Prison to the Tower of the Temple, July 3rd, 1796

A Neoclassical artist of the generation of Pierre-Paul Prud'hon and Anne Louis Girodet de Roussy Trioson (1767–1824), Hennequin was briefly in the studio of David, but left after he was accused of theft. He found an Englishman to sponsor his trip to Rome and stayed for several years, until just after the French Revolution when his masonic affiliation led to his expulsion from the city. Back in his native city of Lyons, Hennequin became increasingly inclined towards Jacobinism. After the fall of Robespierre, Hennequin was attacked in the streets by Royalist sympathizers, part of the *Terreur blanche* that rose up in several cities across southern France, causing him to flee to Paris. His safety in the French capital was short-lived and he was arrested in September 1796. He was released five months later, although during his imprisonment Hennequin saw two of his friends executed.

Like Hubert Robert and Jacques-Louis David, who were both also imprisoned during the Terror or the years that followed, Hennequin seems to have been allowed drawing materials in prison and a number of sheets associated with this period survive. Some, like *Homer Reciting his Verses to the Greeks* (Louvre, Paris),[1] contain no reference to his circumstances and are typical of Hennequin's manner: classicizing figures arranged in the foreground plane, their exaggerated musculature delineated in taut ink lines. Others, like the British Museum sheet, were portraits of fellow prisoners.

In the Temple prison Hennequin made the acquaintance of William Sidney Smith (1764–1840), commodore, and later admiral, in the British navy who had been captured near Le Havre and would stage a daring escape two years later. After seeing Hennequin's sketches, Smith commissioned this large and exceptionally finished sheet dated 12 December 1796.[2] In a stone room with barred windows, Smith stands at the right, leaning casually against a stone plinth projecting the calm assurance of an aristocrat. Standing beside him is Mr Wright, his secretary, who accompanied him to prison. The seated man has been identified as François de Tromelin, a French émigré sought by the police who eluded detection by posing as Smith's Canadian servant, John Brownley.[3] Their situation at Temple was a considerable improvement to their treatment at the Abbaye prison where Smith had been kept in solitary confinement and Wright and 'Brownley' had been harshly treated.[4] A few weeks later, after accepting payment for the London drawing, Hennequin presented Smith with an additional sketch in which the commodore is shown seated, in profile, with a book in hand. The drawing is untraced, but known through an etching of 1797 by Maria Cosway.[5] Another treatment of a Revolution-era prison scene can be found in a group of works depicting the *Martyrs of Prairial*, an event of 1795, which has been dated by Benoit to Hennequin's last years.[6]

Pen and brown ink with brush and grey wash

Inscribed in pen and brown ink at lower left, *fait au temple ce 12 frimaire an 5. / par hennequin prisonnier...*; inscribed in pen and brown ink on the old mount, *Sir Sidney Smith Transferr'd from the Abbaye prison to the tower of the Temple Paris and confined separate from his friend and fellow prisoner / Mr Wright / 3 July 1796*

272 × 442 mm

PROVENANCE: Commodore William Sidney Smith (1764–1840); Sir Bruce Ingram; Mme Avril Prost, from whom purchased in 1963

1963-12-14-14

LITERATURE: Hennequin, 1933, pp.187–8; Bordes, 1979, p.210, fig.17, note 20; Roland Michel, 1987, pp.231–3, fig.281; Benoit, 1994, pp.144–5, no.D.73

JEAN-BAPTISTE ISABEY
1767 Nancy – 1855 Paris

70 Young Woman Seated in a Landscape, 1791

As a young artist who came of age at the time of the French Revolution, Isabey not only weathered political upheaval, but forged a successful career producing portrait drawings and miniatures. He had not undergone the traditional training of the academician and was thus well positioned to take advantage of the numerous changes brought to the production of art, the art market and the prevailing aesthetic by the dissolution of the Académie Royale in 1793.[1] Indeed, the so-called higher genres saw their means of patronage falter following the Revolution, while the demand for portraiture continued unabated. Isabey also found favour at the Napoleonic court, where he not only drew portraits and painted miniatures, but was employed in many other capacities as well, designing public festivities, theatre decoration and porcelain for the Sèvres manufactory.

Born in Lorraine, Isabey studied in Nancy with Jean Girardet (died 1778) and Jean-Baptiste-Charles Claudot (1733–1805) before moving to the French capital in 1785. In Paris he first found employment painting snuffboxes and later entered the studios of François Dumont (1751–1831) and Jacques-Louis David (1748–1825). Isabey earned early recognition for the portrait drawings he exhibited at the Exposition de la Jeunesse and the Salon in 1791 which were described as 'in the English manner', probably in reference to their subtle tonal range, similar in effect to the mezzotint prints popular in England. According to contemporary reviews, they elicited much admiration.[2] Although the British Museum drawing bears the date 1791, one cannot know whether it was among those exhibited.[3] Yet, it clearly shares this mezzotint-inspired style. With the exception of the sitter's right arm, the entire composition is rendered in a subtle range of middle tones suggesting a deeply receding pastoral setting illuminated by a diffuse light. A large, autonomous work, Isabey's *Seated Woman*, adapts the oval format popular in the Rococo period for both miniatures and oil portraits to a more affordable and informal medium appropriate to less ostentatious times. Over the course of the decade Isabey's style became ever darker, relying on the contrast of sparing white gouache highlights against a velvety-black expanse, a style that became known by the term, *la manière noire*, and culminated in his masterpiece, the *Barque d'Isabey* (Musée du Louvre, Paris).[4]

Graphite and black chalk, stumping

Signed and dated in black chalk at lower left, *Isabey painted*, and at lower right, UL 1791; monogram at bottom centre

385 × 287 mm

PROVENANCE: Galerie de Bayser, Paris; purchased in 1998

1998-6-6-5

Jean-Auguste-Dominique Ingres

Montauban 1780 – 1867 Paris

71 Charles Hayard and his Daughter Marguerite, 1815

Five years after winning the Prix de Rome in 1801, Ingres received word that the French government had at long last found sufficient funds to finance his trip to Italy. His deeply held aspiration to become a history painter suffered a blow, however, when news of the negative reviews of his submissions to the 1806 *Salon* reached him en route to Rome. Once established at the Académie de France there, Ingres threw himself into the required student exercises and into sketching the sites and monuments of ancient, Renaissance and contemporary Rome. When his term of study came to an end in 1810, Ingres chose to stay on and installed himself in rooms nearby. He received occasional commissions for history paintings, but it was primarily the production of portraits, in both oil and pencil, that paid the expenses of Ingres and his wife over the next ten years. His sitters ran the gamut, from compatriots, friends and fellow artists to ambassadors, their families and grand tourists from England. For speed and incisive truthfulness – as well as for portability and price – many of his patrons chose to have their likenesses captured in graphite on paper.

Between approximately 1811 and 1815 Ingres executed seven portrait drawings of various members of the Hayard family. Hans Naef's research, published in 1966, pieced together a picture of a large family with whom Ingres was apparently close.[1] Charles-Roch Hayard (1768–1839) and his wife, born Jeanne-Suzanne Alliou (1775–1854), moved from Paris to Rome with their two young daughters, Albertine and Jeannette, sometime between 1799 and 1805. Two more daughters, Marguerite and Caroline, were born in Italy. The family's business, a shop selling art supplies, was located near the Villa Medici and brought them into contact with the local community of French artists. Because the Hayard portraits date to the years of Ingres's greatest financial difficulties, Naef has hypothesized that they were commissioned with the aim of providing support to a friend in need,[2] although the dedicatory inscriptions on the present sheet, its pendant of Mme Hayard with Caroline (fig.1), and the portrait of Jeannette suggest that at least those three were presented as gifts.[3]

Marguerite Hayard (1806–81), the third eldest daughter, was probably nine years old when she and her father were portrayed by Ingres. She would later marry Félix Duban (1797–1870), who won the Prix de Rome for architecture in 1823 and spent five years as a *pensionnaire* at the Académie de France before pursuing a successful career in Paris as part of the first generation of Romantic architects. His most notable achievement was the expansion and redesign of the École des Beaux-Arts in Paris, where an exhibition commemorating Ingres's career was mounted in the year of his death, 1867, and included the present sheet, lent from the Dubans's collection. In this graphite portrait of the young Marguerite with her father, Ingres captured not only their likenesses but also the bonds of familial affection, conveyed by the embrace in which the artist with psychological acuity posed the pair.

Graphite

Signed, dated and inscribed in graphite at lower right, *Ingres à / Madame hayard / rome 1815*

308 × 229 mm

PROVENANCE: Mme Charles Hayard, née Jeanne-Susanne Alliou (1775–1854); her daughter Marguerite and son-in-law Félix Duban; to their daughter Mme Théodore Maillot, née Félicie-Charlotte Duban (1830–98), Paris; her cousin, Félix Flachéron, Paris; Joseph Gillet; his son Edmond Gillet; Mme Edmond Gillet, née Motte; sold by her in 1944 to César Mange de Hauke, by whom bequeathed

1968-2-10-19

LITERATURE (SELECTED): Naef, 1966, p.44, fig.5; Rowlands, 1968, pp.43–4, fig.2; Naef, 1977–80, IV (1977), p.242, no.133; Lyons, London and New York, 2003, p.172, under no.56

EXHIBITIONS (SELECTED): Paris, 1861, p.359; Paris 1867, p.59, no.352; London, 1968b, p.10, no.2; London, 1972b, p.933, no.663; London, 1974a, p.82, no.309; London, 1984b, pp.43–4, fig.2; London, Washington, and New York, 1999, pp.174–5, 180, no.50 (exhibited London and Washington only, entry by Hans Naef)

Fig.1 Jean-Auguste-Dominique Ingres, *Madame Hayard and her Daughter Caroline*, graphite, 292 × 220 mm, Fogg Art Museum, Cambridge, Mass. (1943.843).

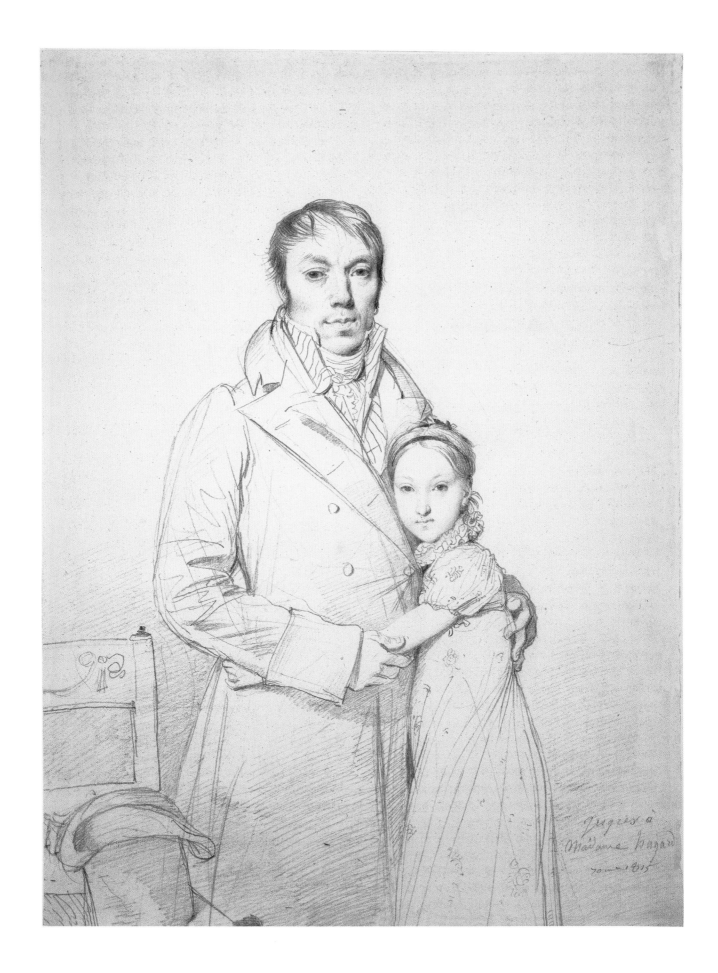

Jean-Auguste-Dominique Ingres

1780 Montauban – 1867 Paris

72 Study for 'Odalisque with a Slave'

Despite Ingres's innate facility in the genre of portraiture and the substantial income he derived from it, he nourished throughout his career dreams of achieving lasting fame as a history painter. He relished the sporadic commissions he received for history and genre paintings, although he suffered considerably from the mixed reviews that were inevitable in an artistic climate sharply divided between the proponents of Romanticism and those of Ingres's brand of classicism.

The British Museum sheet belongs to a series of studies Ingres executed for *Odalisque with a Slave* (fig.1), a painting commissioned by his friend Charles Marcotte in 1821, but not completed until 1840. It was one of several paintings in which Ingres treated the theme of the harem, a subject that combined his predilections for the erotic female nude and the sumptuous surfaces and exquisite detail of historical or exotic interiors. As was his normal practice, Ingres began work on the painting by making thumbnail compositional sketches, which were followed by a number of studies to resolve the poses of the major figures, typically taken from nude models.[1]

The pose of the seated female musician evolved in a series of preparatory studies. A free study in the Musée de Montauban experiments with multiple positions of the limbs laid one over another in black chalk.[2] The British Museum sheet came next in the sequence; it is executed full-scale and is considerably more resolved. The contours are shifted in several places, with the preferred outlines incised, perhaps to produce the linear recension of the pose in the Montauban study.[3] The pose is essentially carried over to the painting, with the exception of the figure's right foot which has been moved behind her left ankle.

With the extremely protracted genesis of the painting, dating of the preparatory studies is difficult. Ingres had returned to Rome to assume the directorship at the Académie de France in 1835 and was preoccupied with administrative duties for several years. He must have returned to the project in 1837 when the city of Rome was placed under quarantine during an outbreak of cholera, for the duration of which Ingres, together with the students and staff of the Académie, remained shut inside the Palazzo Medici. He wrote to his friend Édouard Gatteaux:

> In fact, a great many things in this picture, if not all, were painted from drawings, in the absence of a live model (this is between the two of us), which by your way of thinking – and mine too – is indispensable in giving life to a work and causing its heart to beat.[4]

The painting was finished in 1840 (despite being dated 1839) and was dispatched to Paris where it met with wide approval.[5] In a letter dated the day after he had shipped the painting, Ingres asked Marcotte to beg his wife's pardon for the eroticism of the subject.[6] Marcotte was thrilled with his picture and only agonized, in letters to their common friend Gatteaux, that the price he had agreed on with Ingres in 1821 was no longer adequate for a masterpiece by an artist of Ingres's current standing.[7]

Graphite over red chalk underdrawing, incised

Signed or inscribed in black chalk at lower right, Ing; estate stamp of Ingres (Lugt 1477) at lower right

447 × 336 mm

PROVENANCE: Probably sold to the dealer Haro in 1866; Alphonse Wyatt Thibaudeau, from whom purchased in 1886

1886-4-10-33

LITERATURE: Alazard, 1950, pl.CVIII; George, 1967, pp.69–70

EXHIBITIONS: Paris, 1967b, p.244, no.180

Fig.1 JEAN-AUGUSTE-DOMINIQUE INGRES, *Odalisque with a Slave*, 1840, oil on canvas, 72 × 100 cm, Fogg Art Museum, Harvard University Art Museums, Cambridge, Mass., bequest of Grenville L. Winthrop (1943.251).

THÉODORE GÉRICAULT

1791 Rouen – 1824 Paris

73 Study of a Standing Woman (RECTO); Male Académie (VERSO)

Although he spent brief periods in the studios of Carle Vernet (1758–1836) and Pierre Guérin (1774–1833), Géricault was essentially a self-taught artist. His experience of classicism, which vied with nature as his chief source of inspiration, was gained directly from antique and Renaissance sources and had little in common with the cool aesthetic of Davidian Neoclassicism. He exhibited the groundbreaking Raft of the Medusa at the Louvre when he was only twenty-seven and died five years later, leaving a surprisingly murky chronology for a career so brief. The challenge in ordering his large corpus of drawings and sketches lies in the fact that his study of the art of the past and his original compositions do not belong to distinct periods, but were often concurrent. Moreover, certain favoured types and poses recur with variations throughout his oeuvre.

The muscular male torso seen from behind on the verso is one such motif: with its strong echoes of the Belvedere Torso and Michelangelo's Ignudi,[1] it unites virility and classicism in a way not often seen among David's students. Various theories have been put forward regarding the function and date of the British Museum drawing. It has been associated with Géricault's series of oil académies, dated to c.1815–16,[2] and with the preparatory studies for The Dying Paris Rejected by Oenone painted for the 1816 Prix de Rome competition.[3] More recently, Gary Tinterow has pointed to a close parallel between the present drawing and a schematic figure in the foreground of some compositional studies for decorative panels on a sketchbook sheet in the Musée Bonnat, Bayonne (fig.1). The sketches may represent unexecuted ideas for the Château de Grand-Chesnay made around 1816 and later loosely adapted in the monumental Times of Day landscape paintings of 1818.[4]

On the recto is a sketch of a standing woman in classically inspired dress with her arms crossed over her head. The blunt and forceful use of ink, and the abstracted planes and volumes all bear an affinity to Géricault's series of figure studies inspired by antique statuary made around 1815, many after the intermediary designs of John Flaxman (1755–1826).[5] The present drawing likewise makes expressive use of wash, heightening and broad ink outlines while rendering the face as broad abstract planes. Bazin has dated the British Museum recto and several others from this group slightly later, to Géricault's Roman trip of 1816–17.

Brush and brown wash, with black chalk, over red chalk, heightened with white gouache, on brown paper (recto); graphite, pen and brown ink, brush and brown and blue-grey wash, heightened with white gouache, on brown paper (verso)

208 × 133 mm

PROVENANCE: Aimé-Charles-Horace His de la Salle (1795–1878; his mark, Lugt 1333, at lower right corner); Charles Fairfax Murray; his sale, Christie's, London, 30 January–2 February 1920, lot 177; R. E. Arnsley-Wilson, from whom purchased with the H. L. Florence Fund in 1920

1920-2-16-2

LITERATURE (SELECTED): Opresco, 1928, p.240; Eitner, 1953, pp.59–60, fig.3; Eitner, 1963, p.24, pl.25b; Eitner, 1983, p.92, fig.76; Bazin, 1987–97, III (1989), pp.78, 230, no.935 (verso), IV (1990), p.95, no.1064 (recto); Tinterow, 1990, p.36, fig.1c

EXHIBITIONS: Paris, 1991, p.329, no.6, fig.22

Fig.1 THÉODORE GÉRICAULT, Studies for Decorative Panels, graphite and wash on paper, 213 × 284 mm, Musée Bonnat, Bayonne (inv. 745v).

Study of a Standing Woman

Male Académie

JEAN-BAPTISTE-CAMILLE COROT

1796 Paris – 1875 Paris

74 A Seated Woman

Corot's legacy is defined largely in terms of landscape. His distinctive manner was the product of an admiration for the constructed academic landscapes of the seventeenth century combined with a training and practice that stressed studies made from nature. His finished canvases are hazy and poetic evocations of an idyllic countryside, reminiscent of Claude's atmospheric scenes, while anticipating the abstraction and painterly technique of the Impressionists. Sometimes peopled with mythological or biblical characters, Corot's scenes more often eschewed narrative in favour of the timelessness suggested by figures in regional dress.

Studies of half- or three-quarter-length seated women in Italian regional dress were initially made as part of the preparatory process for his painted landscapes but, by his maturity, had become an independent genre in Corot's oeuvre.[1] These are not portraits but are painted, at least for the most part, from paid models. Their expressions vary from happy to morose, but reverie and melancholy predominate, thematic extensions of the timelessness they are meant to evoke as staffage in Corot's landscapes. The figure in the British Museum drawing does not correspond to any in his painted compositions, although works like the Woman Meditating (The Hugh Lane Municipal Gallery of Modern Art, Dublin) come close in spirit. The growing importance of this type of independent figure subject in Corot's work is evident in letters dating to 1856–7 in which he asks friends in Italy to send costumes from specific Italian cities,[2] although the sharp handling of the graphite suggests an earlier date for the present sheet. A curious elaboration on the theme appeared in a series of canvases dating from the 1860s, which depict models in Italian or exotic garb situated not in a landscape but in the artist's studio, often holding a musical instrument and gazing either off into the distance or intently at a landscape painting left on an easel, at once model and muse.[3]

Corot apparently shared the names of his models with other artists, and several are listed in Eugène Delacroix's journal entries for 1859, with names, addresses and comments.[4] No Flore is mentioned by Delacroix, but Corot's inscription may well indicate the name and address of the young woman who modelled for this careful graphite study. Her heavy-lidded and somewhat lugubrious expression is difficult to read – its ambiguity perhaps appreciated by Corot. Unlike the majority of his drawings, this sheet does not bear the stamp of Corot's estate sale, and must have left his studio, either purchased or presented as a gift, during his lifetime.

Graphite

Signed and inscribed at lower left in graphite, Corot / Flore / rue de l'hotel de Ville / 110

281 × 231 mm

PROVENANCE: John Postle Heseltine, London; his estate sale, Sotheby & Co., London, 27–9 May 1935, lot 274 (framed); Pawsey and Payne; presented by the National Art Collections Fund in 1935

1935-6-8-2

LITERATURE: Fry, 1918, p.62, pl. II; Hind, 1935, pp.21–2, pl.VI; Maison, 1955, pp.3–4, fig.II

EXHIBITIONS: London, 1917, no.2; London, 1984b, pp.142–3, no.136; Manchester and Norwich, 1991, pp.64–5, no.46

Corot

Flore
rue de l'Hôtel de Ville –
110

EUGÈNE DELACROIX

1798 Charenton-Saint-Maurice – 1863 Paris

75 Studies of a Seated Arab

Delacroix was the undisputed leader of the Romantic school in France; his work was perceived to represent a break with the classical ideal through the embrace of bold colours and expressive handling. His early masterpieces, the *Barque of Dante*, *Massacre at Chios* and *The Death of Sardanapalus* (all Louvre, Paris), combined realism and exoticism, savagery and beauty.

Delacroix's taste for orientalism was already well entrenched when he was offered the opportunity to visit Spain, Morocco and Algeria in 1832 in the company of the Comte de Mornay, Louis-Philippe's ambassador to the Sultan of Morocco. That Delacroix was enthralled by all he saw is manifest in his effusive journal entries over this six-month period. In his fury to capture everything on paper Delacroix must have sketched incessantly, leaving a great amount of visual material ranging from sketchbook pages, where thumbnail sketches and words vie to convey the figures, architecture and scenes he came across, to more worked-up figure studies and landscapes in chalk or watercolour. Taken together, these visual records provided a rich compendium of source material that would nourish Delacroix's output for the remainder of his career.

In the British Museum sheet Delacroix made a careful study of an Arab man in a turban and striped cloak. He is shown in profile, still and at ease on a European-style chair. His face is studied a second time in a larger scale on the right. Touches of red and white chalk and watercolour convey the complexion of the sitter and the detailing of his cloak with an impressive economy of means. To judge from the descriptions of the lots in the 1864 sale, Delacroix apparently drew the same sitter three times consecutively.[2] The first, a half-length view, probably drawn in graphite or black chalk, is untraced, while the second, a frontal view of the same man seated on the floor with his hands clasped, is in the Louvre, Paris (fig.1).[3] In the British Museum drawing Delacroix has placed the sitter in a chair and altered the vantage point to produce a wholly different effect. In the Paris drawing the man is seen from above, with his eyes downcast; in the London sheet he is on the same level as the viewer, his steady gaze somewhat inscrutable, but suggestive of a calm authority.

Black, red and white chalk, brush and red-brown wash

308 × 274 mm

PROVENANCE: Delacroix's estate sale (Lugt supplement 838a, at lower left), Hôtel Drouot, Paris, 22–7 February 1864 (lot 538)[1]; bought by A. Bornot; his son-in-law Porlier in 1877; Gady; bequeathed by César Mange de Hauke

1968-2-10-24

LITERATURE: Robaut, 1885, p.107, no.392; Gaunt, 1968, p.229; Rowlands, 1968, pp.44–5, fig.4; M. Sérullaz, 1984, II, p.145, under no.1597; Johnson, 1995, pp.98–99; Jobert, 1998, p.142; A. Sérullaz, 1998, pp.54–5

EXHIBITIONS: London, 1968b, pp.14–15, no.4; London, 1981, pp.52–3, no.160; London, 1984b, p.43, fig.4; Paris, 1994b, pp.148–9, no.14; Karlsruhe, 2003, pp.223–4, no.108 (entry by Klaus Schrenk)

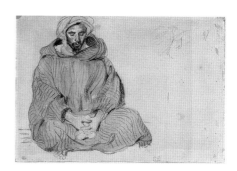

Fig.1 EUGÈNE DELACROIX, *Seated Arab*, graphite, red chalk, and watercolour, 193 × 276 mm, Musée du Louvre, Paris (RF5633).

EUGÈNE DELACROIX

1798 Charenton-Saint-Maurice – 1863 Paris

76 Study of the Sky at Sunset

This brilliant pastel study of the sky at sunset belongs to a group of cloud studies, traditionally dated to 1849–50.[1] Not interested in landscape per se, Delacroix, like many of his generation, believed that the natural settings for his history and religious subjects would be enhanced by the direct and frequent study of nature advocated by Pierre-Henri de Valenciennes (1750–1819).[2] Declining health led Delacroix to spend an increasing amount of time in the countryside from the 1840s, and his journal contains frequent notes of time spent observing and recording natural phenomena. Few of his sketches are pure cloud studies. More often, a foreboding dark plane anchors the composition, suggesting the moment when the earth has fallen into shadow and the last rays of light assume a fleeting intensity of colour.

Although Delacroix's studies of the evening sky are atmospheric in effect and coincide with a greater moodiness and expressiveness in his late work, they also reveal a sustained formal exploration of colouristic effect. Various influences have been suggested in connection with the brightening palette of his later years, from the colour theories of Michel-Eugène Chevreul (1786–1889) to the example of Veronese and Venetian painting. Delacroix's fascination with the contrasting hues of the sky at sunset is articulated at some length in a journal entry from 14 November 1850:

> During this walk we observed a number of striking effects. The sun was setting: the most brilliant chrome and lake in the light, and the cold blue shadows between ... This law of opposites is precisely what made the effect seem so vivid in this landscape. Yesterday I noticed the same phenomenon at sunset. If it is more dazzling, more striking, than at noon, this is because the contrasts are sharper. In the evening, the grey of the clouds shades to blue. The pure part of the sky is bright yellow, or orange coloured. As a general rule, the greater the contrast, the more striking it is.[3]

The British Museum sheet is recorded in the collection of Edgar Degas, a great admirer of the work of Delacroix.[4]

Pastel on blue paper

228 × 268 mm

PROVENANCE: Possibly in Delacroix's estate sale, Hôtel Drouot, Paris, 22–7 February 1864 (17 pastel studies of skies were included in lots 608–13); Edgar Degas; his sale, Galerie Georges Petit, Paris, 26–7 March 1918, lot 111; [Knoedler]; Tate Gallery, London; on loan to the British Museum since 1963; transferred in 1975

1975-3-1-34

LITERATURE: Robaut, 1885, p.453, possibly under nos 1817–22; Dumas, 1996, pp.36, 38, 67, fig.38

EXHIBITIONS: London, 1984b, p.146, no.141; National Gallery, London, 22 May–26 August 1996, no.18 (no catalogue); New York, 1997, I, pp.43, 306–7, fig.391; II, p.29, no.208; Karlsruhe, 2003, pp.290–1, no.159 (entry by Astrid Reuter)

VICTOR HUGO

1802 Besançon – 1885 Paris

77 Landscape with a Castle on a Cliff

Among the most esteemed French Romantic writers, Victor Hugo was prolific in many genres, including poetry, drama and fiction, although he is perhaps best remembered today for his historical novels, *The Hunchback of Notre-Dame* (1831) and *Les Misérables* (1862). Aside from his writing and political involvement, he was an inspired draughtsman, producing about 3,000 drawings. Working mostly in a monochrome manner in ink wash, Hugo created dramatic and moody evocations, drawing on the same Romantic sensibility that fuelled his writing. In addition to his dark and stormy landscapes, he produced many humorous caricatures and conducted bold technical experiments, using ink blotches, paper stencils and lace impressions to create a body of works on paper of prescient modernism.

His period of greatest artistic productivity was during the almost two decades he spent in political exile on the Channel Islands (the English territory off the French coast), first on Jersey from 1852 to 1855 and then on neighbouring Guernsey from 1855 to 1870. Hugo ultimately found much inspiration in the dramatic landscape of the Channel Islands where craggy cliffs met the sea along a ragged shoreline. The sea and sky, especially at their most tempestuous and threatening, took on a growing importance in his work, and many of his technical innovations were in the service of expressing all forms of ominous natural phenomena.

The present sheet includes many of Hugo's favoured motifs and themes. The fortified castle perched on the hillside expresses his predilection for medieval architecture, with its organic asymmetry. The effect of the castle looming over the cliff, almost supernaturally lit against the tenebrous sky, was achieved through the use of a paper stencil cut into the shape of a castle and held down on the paper while the background washes were laid on.[2] Architectural details were then added to this 'reverse' silhouette. From his abstract experiments in the application of ink wash, Hugo developed effective, albeit unconventional, means for conveying the watery, gloomy atmosphere of a stormy seacoast at dusk.

Brush and brown wash, with stencilling and touches of white gouache

Signed, dated and inscribed at lower right, *Victor Hugo Guernsey / 1857*

311 × 490 mm

PROVENANCE: E. Kersley;[1] Mme Louis Latour; purchased with the H.L. Florence Fund in 1930

1930-7-16-3

LITERATURE: Villequier and Paris, 1971, pp.154, 168 (under nos 98 and 107); Paris, 1985, p.141, under no.175B

EXHIBITIONS: London, 1969, p.108, no.319; London, 1974b, n.p., no.50; Norwich and Manchester, 1987, p.35, no.33

HONORÉ DAUMIER

1808 Marseille – 1879 Valmondois

78 Clown Playing a Drum

Daumier's principal occupation was the production of political caricatures for the opposition newspaper *Le Charivari* founded in 1832. It was the first daily newspaper to be illustrated by lithographs, and over the course of his career Daumier published almost 4,000 prints in its pages. Invented in the 1790s, the technique of lithography allowed Daumier great technical freedom, as he could draw directly on the limestone block with a greasy crayon, without any intermediate step necessary for the mass production of his imagery. As Colta Ives has observed, lithography won drawing a wide audience and a firm identity as an autonomous art form during a period when it was increasingly losing its relevance to a generation of painters working in the Romantic and Realist styles.[1]

Daumier was not trained as a painter and his intermittent efforts in this area share the spontaneous, sketch-like qualities of his graphic oeuvre. Surprisingly few preparatory studies survive for either his lithographs or his oil paintings, although they must have been numerous. In 1860, when the editor of *Le Charivari* terminated his contract, claiming that readers had tired of his work, Daumier turned to drawing with a new dedication, producing a series of highly finished watercolour sheets for sale to collectors.[2] Among his greatest achievements, these watercolours avoided the pitfalls of his work on canvas – where the technique often shows signs of struggle – by building on a framework drawn in chalk and ink, where his hand was sure, and adding washes of grey ink and watercolour, often with touches of gouache and conté crayon to reinforce the contours, without obliterating the vigour of his underlying sketch.

One recurring subject for these late watercolours was the itinerant street performers of Paris and the surrounding countryside. Performing in *parades* (sideshows) or small groups, they included clowns, magicians, acrobats, strong men and fat ladies. They were the last residue of a centuries-old tradition, and the difficulty and struggle of their meagre existence were hardly lost on Daumier. The irony of their plight, where suffering plagued those meant to offer light divertissement, was a popular theme among artists and writers of the period, although it has been suggested that the world-weary clown beating his drum without an audience may have held special resonance for Daumier, the out-of-work caricaturist.[3]

In the present drawing the clown is placed on a bustling Parisian street with his back to the well-healed crowd rushing by. He is ignored by all except for the dour little boy staring at him from behind. Displaying the mastery of light effects characteristic of his late work, the composition has been orchestrated to present the clown as boldly lit against a band of figures in shadow, further emphasizing his isolation from the urban scene. An artful still life of unattended magician's props occupies a table set up behind him. The poignant figure of the drumming clown appears in several variant images, including a scene of a sideshow in a wooded setting where he is placed before a poster of a fat lady, his expression grim and his attempts to drum up business fruitless.[4]

Pen and black and grey ink, brush and grey wash, watercolour, touches of gouache, and conté crayon, over black chalk underdrawing

Signed in pen and black ink at lower right, h. *Daumier*

354 × 256 mm

PROVENANCE: Georges Berger, Paris; Jean Dollfus, Paris, in 1934; bequeathed by César Mange de Hauke

1968-2-10-30

LITERATURE (SELECTED): Maison, 1960, p.24, no.82; Gaunt, 1968, p.229; Maison, 1968, II, p.180, no.539, pl.191; Rowlands, 1968, pp.45–6, fig.6; Haskell, 1972, pp.9, 12, fig.9; Harper, 1981, pp.175–8, fig.63; Laughton, 1991, pp.42, 175, fig.10.20

EXHIBITIONS (SELECTED): Paris, 1934, p.116, no.111; London, 1961, p.58, no.178, pl.29c; London, 1968b, p.20, no.7; Frankfurt and New York, 1992, pp.204, 226–8, and 230, no.113; Ottawa, Paris and Washington, 1999, pp.486, 489–90, no.328

187

JEAN-FRANÇOIS MILLET

1814 Gruchy, near Gréville – 1875 Barbizon

79 Study for 'Summer, the Gleaners', c.1853

Born in a seaside village in Normandy to a prosperous peasant family, Millet received a solid education before embarking on his artistic training. Most of his early work consisted of portraits for the bourgeois families in nearby Cherbourg, although after moving to The Hague, and later to Paris, he shifted his focus to erotic pastoral subjects. Millet had already begun adding peasant subjects to his repertoire when the Revolution of 1848 radically altered the artistic hierarchy, elevating to prominence contemporary subjects of the common people. The term 'Epic Naturalism' is sometimes applied to Millet's work, giving expression to his assimilation of the grand traditions of Western art – both pictorial and literary – in his scenes of this contemporary genre.

Resettling in Barbizon after the revolution, Millet befriended Théodore Rousseau (1812–67) and other painters of the Barbizon school, but in his own work continued to emphasize the human presence in the landscape, portraying the brutality and timelessness of rural labour in monumental terms. The subject of the gleaners typified his pessimistic view. The practice of gleaning, which permitted the poorest members of the community to comb over recently harvested fields for any remaining bits of grain, had been in existence since biblical times and was still mandated in certain regions of France. Millet's first painting of the subject (Summer, the Gleaners, Yamanashi Prefectural Museum of Art) was completed in 1853 and formed part of a set of four seasons commissioned by Alfred Feydeau.[2] Three peasant women occupy the foreground of the composition. Against the sun-bleached background their forms are echoed and dwarfed by mountains of grain representing the prosperity of others. Although Millet's portrayals of poverty in the French countryside were acclaimed by liberal critics, many in Paris found them discomforting. Millet was undeterred by criticism, however, writing to his friend Alfred Sensier in 1863 that he chose such subjects, 'knowing the enmities that result because it disturbs the repose of fortunate people'.[3]

Even if Millet saw gleaners at work in the fields around Barbizon, the naturalism of his figures was nonetheless filtered through both an awareness of the art of the past[4] and a painstaking working process where the elements of the composition were reworked, rearranged and refined in an elaborate series of preliminary studies.[5] Following the completion of the Feydeau picture in 1853, Millet went on revising the composition, ultimately producing a much larger horizontal canvas that he would submit to the salon of 1857 (Musée d'Orsay, Paris), as well as a replica that remained unfinished at his death (Museum of Fine Arts, Springfield, Mass.). In the sequence of preparatory works the British Museum sheet is closest to the Feydeau painting; the debate among scholars has been whether it should be placed just before or just after.[6] Most probably, given the numerous small differences between drawing and painting – in detail and in tone – the London sheet was Millet's final compositional study for Summer and the basis for the Springfield replica as well, as he would have retained the drawing but not the painting.

Black crayon on grey paper

Signed in black chalk at lower right, J.F. Millet

283 × 222 mm

PROVENANCE: Alfred Lebrun;[1] James Staats Forbes; Ernest Brown & Phillips, from whom purchased in 1906

1906-2-13-1

LITERATURE (SELECTED): Cartwright, 1904, pp.50–1, 57; Paris, 1975, p.144; Yamanashi, 1998, pp.149, 157–8

EXHIBITIONS (SELECTED): London, 1906, p.10, no.50; London, 1956, p.30, no.39; Minneapolis, 1978, pp.17, 33, 44, no.15, fig.17

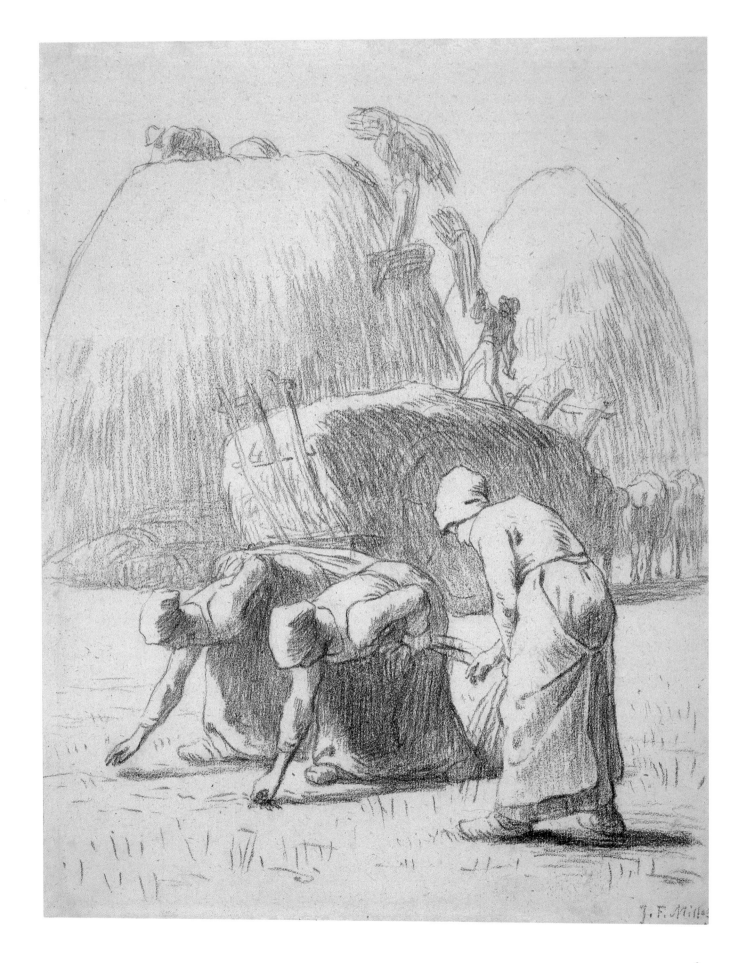

189

GUSTAVE COURBET

1819 Ornans – 1877 La Tour-de-Peilz, Switzerland

80 Self-Portrait, 1852

Born in Ornans, a small village in the Franche-Comté region near Switzerland, Courbet came to Paris at the age of twenty but, unlike many provincial-born artists, chose to retain, even to foster, his image as an outsider. His subjects owed more to his background and personal experience than to the sanctioned themes on the walls of the Salon. Inspired by principles of Realism, Courbet produced works that subverted all academic norms and standards by treating the subject of contemporary labourers on the grand scale of history painting and by presenting scenes of eroticism stripped of the veneer of mythology.

He cultivated his own persona with equal obsession and daring, producing over the course of his career a series of self-portraits that have been likened to Rembrandt's. In numerous guises, both painted and drawn, Courbet's self-portraits chronicle his search for identity.[2] His earliest were largely Romantic in character; he explored emotional states by presenting himself as contemplative, injured or distraught. In the 1840s the period of his major achievements in formulating a Realist style coincided with his development of a new type of self-portrait where the tortured young man was replaced by a burly and self-confident man of the people. Dark and heavily worked sheets in Cambridge, Massachusetts, and Hartford, Connecticut, present the artist in a worker's hat and smoking a pipe.[3]

The British Museum sheet is one of Courbet's largest and least affected self-portraits, dated 1852, the year following the public exhibition of his groundbreaking works, A Burial at Ornans (Musée d'Orsay, Paris) and The Stone Breakers (formerly the Gemäldegalerie, Dresden). He presents himself in a well-lit space, directly engaging the viewer, and without props or attributes, although the full beard would have made him easily recognizable. A seemingly unfinished self-portrait in oil in the Ny Carlsberg Glyptotek in Copenhagen is identical in pose and lighting to the London drawing, although the hair, beard and shirt all differ.[4] As Haavard Rostrup pointed out in 1931, Courbet never adopted the traditional practice of preparing canvases by first making drawn studies; thus one cannot assume the London drawing is preparatory to the Copenhagen painting.[5]

Ultimately, Courbet's image of himself, his bohemian lifestyle and his deeply held political convictions all become inseparable from his oeuvre. His self-portrait plays a central role in two major canvases in the years just after the London drawing: Bonjour, Monsieur Courbet (1854; Musée Fabre, Montpellier) and The Painter's Studio, A Real Allegory (1855; Musée d'Orsay, Paris). In 1854 he wrote to Alfred Bruyas, his friend and staunch supporter: 'I have made in my life quite a few portraits of myself, in proportion as I changed my mental situation; in a word, I have written my life.'[6]

Black chalk and charcoal

Signed and dated in black chalk at lower left, G. Courbet / 1852

570 × 450 mm

PROVENANCE: Spierski collection; Turner collection;[1] presented by the National Art Collections Fund, Samuel Courtauld, and other subscribers

1925-7-11-1

LITERATURE (SELECTED): Opresco, 1928, pp.245, 251; Rostrup, 1931, pp.111–13; Maison, 1955, pp.3, 5, fig.III; Paris, 1973, pp.37–8, no.46 (a photograph of the work was exhibited); Fernier, 1978, II, pp.296–7, no.37; Paris, 1995, p.62, under no.5

EXHIBITIONS (SELECTED): London, 1984b, pp.143–4, no.138

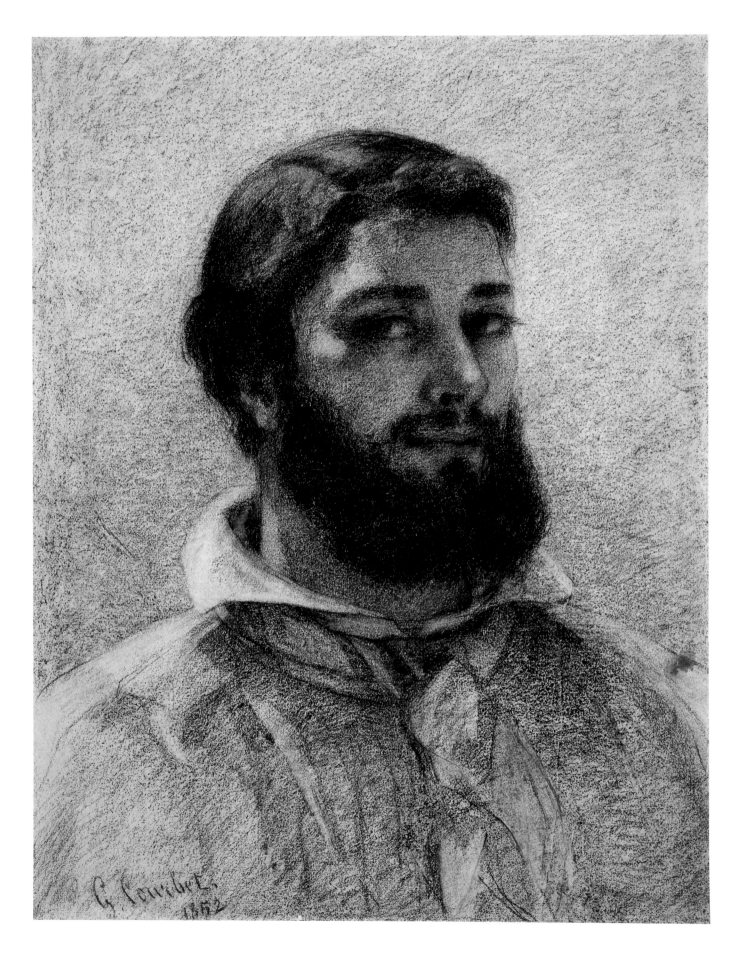

Henri-Joseph Harpignies

1819 Valenciennes – 1916 Saint-Privé

81 *View over the Rhône River, 1884*

Born to a prosperous bourgeois family, Harpignies worked first in his family's sugar refinery and iron forges before entering the studio of the landscape painter Jean-Alexis Achard (1807–84) in 1846. In the years following the 1848 Revolution, Harpignies travelled to Germany and Italy where he found much inspiration in the sun-washed landscape of southern Italy, particularly Capri and the Bay of Naples. Although he painted a few still lifes and interior scenes, landscape would remain the central focus of his long and prolific career.

Harpignies's early work shows the strong imprint of the Barbizon school and the landscape paintings of Corot (1796–1875). His light-infused landscapes, like Corot's, have a timelessness born of the direct study of nature and of earlier masters of landscape painting, especially Claude Lorrain (1604/5–82). He remained loyal to this approach, which relied on exquisitely blended hues and the linear precision of forms, throughout his career, even though the Barbizon school eventually lost favour to the Impressionists and Post-Impressionists.

Ultimately, Harpignies's influence and lasting fame as a watercolourist have overshadowed his renown as a painter. He became a member of the Société des Aquarellistes Français in 1881 and had many students to whom he taught his technique. His numerous surviving watercolours also reflect his predilection for travel. The British Museum sheet has traditionally been considered a view of the Rhône, although the precise location cannot be determined. The largest of the French rivers, the Rhône originates in Switzerland, entering eastern France near Geneva. It joins the Saône river at Lyons and empties into the Mediterranean near Marseilles.

The present sheet explores the ephemeral quality of late afternoon light. From a hill-top vantage point high above the river, the view appears to be towards the west, with the sun perhaps blocked by the darkest of the four trees at the crest of the hill. The wispy clouds have begun to darken and only slivers of light remain on the rocks in the foreground, although the sailing boat and the calm surface of the river are still bathed in light.

Watercolour

Signed and dated in pen and brown ink at lower left, *h j harpignie 84*

189 × 280 mm

PROVENANCE: James Staats Forbes; bequeathed by Campbell Dodgson in 1954

1954-6-10-19

EXHIBITIONS: London, 1932, p.444, no.936

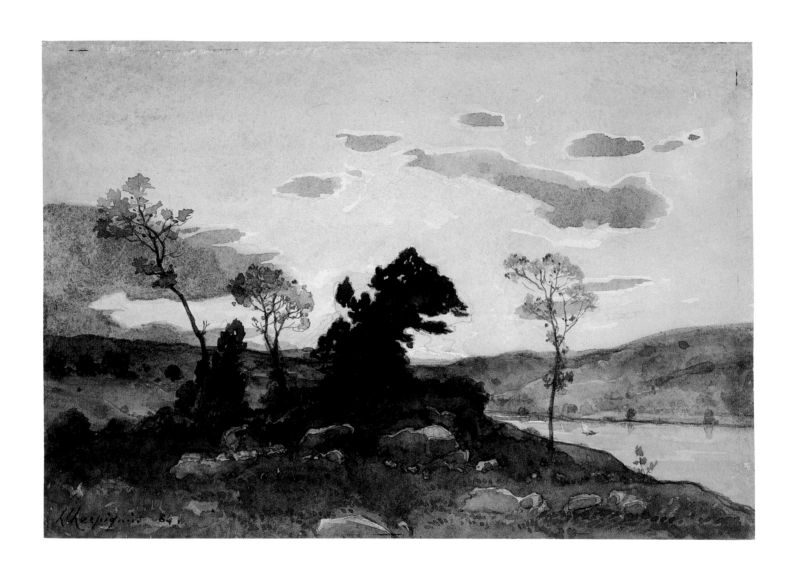

HENRI-JOSEPH HARPIGNIES

1819 Valenciennes – 1916 Saint-Privé

82 Landscape with Setting Sun, 1888

For Harpignies's life and career, see the entry for no.81.

Like Delacroix's *Study of the Sky at Sunset* (no.76), this sheet is an exploration of the transformative quality of light in the moments before dusk. The near-abstract simplicity of the composition, with its horizon line just below the midpoint of the page, is broken only by a nondescript country road, lined with stones and brambles, crossing diagonally through the foreground. The riveting coral semicircle of the setting sun alone breaks the line of the distant hills washed in shadowy shades of plum.

Watercolour

Signed and dated in pen and brown ink at lower left, *h j harpignies* 88

194 × 281 mm

PROVENANCE: Purchased from Battersby Antique Company in 1936

1936-2-1-1

194

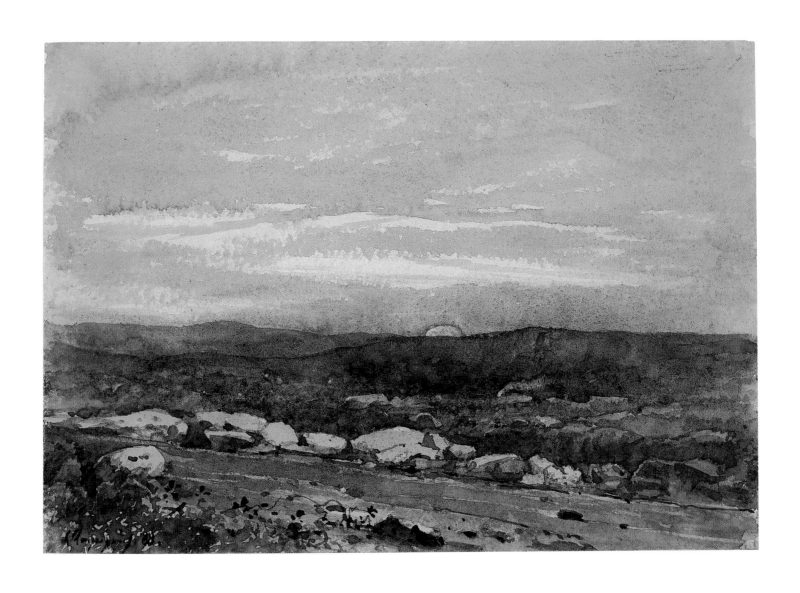

JEAN-LÉON GÉRÔME

1824 Vésoul, Haute-Saône – 1904 Paris

83 Study of a Girl Playing a Stringed Instrument

Studying first in the studio of Paul Delaroche (1797–1856), and then briefly with Charles Gleyre (1806–74), Gérôme shared with his two teachers a taste for historical and exotic subjects and the technical ability to infuse them with a startling sense of ethnographic accuracy. He first found fame with the exhibition of The Cock Fight (Musée d'Orsay, Paris) at the Salon of 1847. His early 'Néo-Grec' style soon expanded to include historical subjects and exotic genre scenes. There was a broad audience for orientalizing pictures in the mid- and later nineteenth century and Gérôme's appetite for travel allowed him to collect the raw material for his precisely detailed scenes. Reflecting European stereotypes of the Near East, his output was largely dedicated to subjects of violence and sensuality, but also included scenes of caravans, markets and prayer.

Following his visit to Constantinople in 1875, it is known that Gérôme had the court painter Abdullah Siriez send him photographs,[1] yet one must assume that, for the most part, his own drawings made on his travels underpinned his orientalizing pictures. Despite their essential role in his working process, little study has been devoted to Gérôme's drawings. In general, they are impressive visual records, even if the motifs are sometimes anachronistic or implausibly combined in the paintings.

The figure of the seated musician is used in a canvas, Terrace of the Seraglio (1886; private collection, London), painted late in Gérôme's career.[2] Much like Ingres's musician (no.72), her music-making accentuates the idle languor of the odalisques. Yet in Gérôme's harem scenes, there is a greater disjunction between the apparent authenticity of the various features of the canvas. The architecture, the standing eunuch with the pipe and the seated musician all appear to be based on observed reality while the porcelain-skinned bathers all seem like harbingers of the belle époque.

In the present drawing Gérôme transcribes with care the exotic costume and elaborate coiffure of the musician, with minor pentimenti throughout. The woman's eyes are hidden behind her hair, but her open mouth suggests that she is singing as she plays her instrument. Yet the realism is undermined by Gérôme's practice of freely mixing together elements taken from different cultures. In Terrace of the Seraglio both the eunuch who appears to be a Nubian slave and the girl playing the instrument seem to be based on studies made in Egypt rather than in Constantinople. The fringe of hair across the musician's forehead, the kurs (concave ornament at the crown of her head) and the safa (braids to which black silk cords were tied with thin gold ornaments attached at intervals) were all typical of the dress of Egyptian women in the nineteenth century.[3]

Black crayon

Signed in black crayon at lower right, JL. Gérome

283 × 234 mm

PROVENANCE: Galerie Arnoldi-Livie, Munich; purchased in 1999

1999-6-26-20

EXHIBITIONS: Munich, 1987, pp.52–3, no.38

CAMILLE PISSARRO

1830 Danish Virgin Islands – 1903 Paris

84 Three Studies of a Woman Dressing

Born on the Caribbean island of St Thomas, then under Danish control, Pissarro received only limited artistic training from an itinerant Danish painter, Fritz Georg Melbye (1826–96). Arriving in the French capital in 1855, he formed friendships with painters of the Barbizon school, and his landscapes of this period show the influence of Corot, Daubigny, Rousseau and Courbet. In the 1870s he became allied with the emerging Impressionist movement and exhibited in all eight of their exhibitions between 1874 and 1886, forming friendships with Claude Monet and Paul Cézanne. In 1885 he met Georges Seurat (1859–91) and Paul Signac (1863–1935) and worked for a period of time in a pointillist style. In the final decade of his life he returned to a more purely Impressionist style and focused increasingly on the graphic arts, especially designs for prints and finished sheets in pastel and watercolour.

In general, Impressionist painters considered preparatory drawings part of an orthodox academic practice for which they had little use. Pissarro, like Edgar Degas, was an exception to this rule. Indeed, the paradigm of the Impressionist landscape painter working *en plein air*, his easel set up in a field, recording his impressions of nature directly onto canvas, is belied in the case of Pissarro by the sheer number of study sheets and the evidence of craft and refinement that they reveal. By the 1870s explorations of colour and the human form had emerged as predominant themes in Pissarro's drawings. The British Museum drawing, which dates to the last decade of his life, exemplifies the accomplishment of the late figure drawings with their incisive quality of line and embrace of colour. Choosing a rose paper to act as a middle ground, he used saturated hues of pastel, from chocolate brown outlines to chartreuse shadows, with little blending to depict what is probably the same woman (despite shifts of colour) in progressive stages of getting dressed. Unlike Millet (see no.79), who likewise portrayed scenes of rural labour, Pissarro did not focus on the hardship and underlying social inequities. Instead, he harboured an idealistic vision of the joy and dignity of agricultural work. Pissarro's peasants work in a sunlit communal environment, and exude vigour and well-being.

The poses of the figure in the present sheet can be found in a number of related works. The one in the centre putting on her jacket appears in two studies for *La Fenaison*, a wood engraving from the second phase of the *Travaux des champs* (a collaborative print-making venture that Pissarro produced with the help of his son Lucien),[1] and in a large canvas, *Hay Harvest at Eragny* (1901; National Gallery of Canada, Ottawa).[2] She is also used in an undated gouache whose pendant groups together the woman's poses on the left and right sides of the British Museum drawing.[3] If *La Fenaison* dates from c.1895[4] and the *Hay Harvest* from 1901, the place of the gouaches and the British Museum sheet in the sequence is less clear.[5] This ambiguity is typical of Pissarro's working process, especially in his maturity when he reworked and recombined various components from prints, gouaches and life studies in his major canvases.

Pastel on pink paper

461 × 608 mm

PROVENANCE: Ernest Brown & Phillips, from whom purchased with the H.L. Florence Fund in 1920

1920-7-12-2

LITERATURE: Opresco, 1928, p.248; Brettell and Lloyd, 1980, pp.25–6, fig.9, p.191, under no.276

EXHIBITIONS: London, Paris and Boston, 1980, p.189, no.148

EDGAR DEGAS

1834 Paris – 1917 Paris

85 Young Woman with Field Glasses

A founding member of the Impressionist group, Edgar Degas had a classical training and in his student years was deeply engaged with the art of the past. Over the course of the 1860s the history subjects of his early career gave way to innovative depictions of contemporary Paris – from the cafés to the racetracks to the ballet. The modernity of Degas's work is also due in large measure to the unconventional compositions and cropping of his pictures. Yet, unlike many of his fellow Impressionists, Degas saw no need to forsake traditional methods of preparation. His painted compositions were based on numerous studies drawn from life, and the psychological intensity of his figures – in both portraits and scenes of contemporary life – reflects the close observation afforded by this process. Like Pissarro, his late career is marked by a growing emphasis on works on paper, especially autonomous compositions in pastel.

The present drawing of a young woman looking through field glasses belongs to Degas's early exploration of the racetrack as a venue for upper class leisure.[1] Datable to c.1866–8,[2] it is probably the prototype for the three full-length versions (Galerie Neue Meister, Dresden; The Burrell Collection, Glasgow; and a private collection), usually dated a decade later.[3] A graphite study is with the Galerie Eric Coatalem, Paris,[4] and an additional variant appeared on the art market in 1992, in which a bust-length study of the woman with binoculars is juxtaposed with two studies of jockeys.[5] Finally, a schematic rendition of the figure is included on the same sheet as a graphite drawing of *Manet at the Races* (fig. 1; Metropolitan Museum of Art, New York),[6] only to explore how her figure might relate to that of a male companion who watches her, unseen, as she peers through her binoculars. Notable differences in the hat and hairstyle between the British Museum drawing and the other known versions have led to the proposal that the model for this earliest version may have been the artist's sister, Marguerite De Gas Fevre, pregnant with her first child in 1866.[7]

As one would expect given the numerous recensions of the pose, Degas did include this boldly conceived figure in a painting. She appears in the foreground of a landscape with horses and jockeys paired with the figure of Achille De Gas, the artist's brother. The canvas remained in Degas's studio where he continued to work on it intermittently, eventually painting her out altogether. The woman with field glasses only re-emerged when the picture was restored following its sale in 1959.[8]

As in his scenes of ballet and theatre, Degas's horse-race scenes display an equal interest in the spectators and the performers. The woman with binoculars is a particularly daring conception; she focuses her gaze directly on the viewer, turning the tables on the traditional relationship of viewer and subject. The technique employed by Degas, of brushing oil paint thinned with turpentine (*essence*) directly onto paper, allowed him to work at great speed, capturing with incisive strokes what may have initially been an impromptu pose.

Oil thinned with turpentine on faded pink paper

279 × 224 mm

PROVENANCE: Edgar Degas (1837–1917), his sale stamp (Lugt 658) in red at lower right; his sale, Galerie Georges Petit, Paris, 2–4 July 1919 (lot 261c), purchased by Marcel Guérin; bequeathed by César Mange de Hauke

1968-2-10-26

LITERATURE (SELECTED): Lemoisne, 1946–9, II (1946), pp.92–3, no.179; Nicolson, 1960, p.536; Gaunt, 1968, pp.229–30; Russoli and Minervino, 1970, p.96, no.232; Washington, 1998, pp.97–8, fig.60

EXHIBITIONS (SELECTED): London, 1968b, p.22, no.8; Edinburgh, 1979, no.3; Tübingen and Berlin, 1984, p.351, no.60; London, 1984b, p.148, no. 143; Paris, Ottawa and New York, 1988, pp.129–30, no.74 (with earlier literature; exhibited Paris only)

Fig.1 EDGAR DEGAS (1834–1917), *Manet at the Races*, c.1868–70, graphite on paper, The Metropolitan Museum of Art, New York (19.51.8).

EDGAR DEGAS

1834 Paris – 1917 Paris

86 Dancers at the Barre

Raised in a cultured household, Degas was a habitué of the Paris Opéra virtually his entire adult life, first at the theatre on Rue Le Peletier, until it was destroyed by fire in 1873, and then at the new Paris Opéra designed by Charles Garnier, inaugurated in 1875 and still in use today.[1] In his day, ballet was incorporated into most operas, and its culture, from the gruelling training sessions to the performances, became one of Degas's favoured subjects from modern life. The theme had obvious appeal, from the beauty of the dancers and the colourful sets and costumes to the elegant figures of the *abonnés*, or season subscription holders, who occupied the best seats and were granted the privilege of mingling with the dancers backstage. Moreover, its physical setting provided a complex space whose possibilities for unconventional viewpoints and juxtapositions of the audience and performers were exploited by Degas to produce compositions of unheralded modernity.

Of the ten works Degas submitted to the First Impressionist Exhibition of 1874, four were of ballet subjects. From his sketchbooks it can be deduced that he began drawing at the Opéra as early as c.1860–62, shortly after his return in 1859 from an extended study tour in Italy.[2] His earliest ballet paintings depict performances, often taking as their vantage point the seats just behind the orchestra pit, where dramatically cropped views of the instruments and the backs of the heads of the musicians compete visually with the more distant and ethereal figures of the dancers. Degas was also drawn to the classroom and backstage milieu where the monotony of the training and the attendant exhaustion and strain emerge as themes. As with his depictions of bathers, he sought out the unguarded moment: the dancer performing routine exercises or tying her shoe or scratching her back.

Decades of haunting the classrooms where the dancers practised inspired a large body of drawings in a range of media and formats. The British Museum drawing is an early example, executed in thinned oil paint on a brilliant green paper and comprising two spatially unrelated studies of a dancer stretching at the barre. On the left Degas captured the pose in a rapid sketch, allowing her head to be cropped by the sheet of paper and pausing only to study her right leg and foot in white paint mixed in with the black. He laboured longer over the figure on the right, the position of her back and head expressing the strain of the exercise.[3]

It has been suggested that the proximity of the two studies on the present sheet gave rise to the idea for the composition of *Dancers Practising at the Barre* (1876–7; fig.1). Traditionally considered to date from about the same time as the painting, the study has been dated in more recent literature to c.1873, just after the artist returned from New Orleans.[4] To adapt the poses to a unified perspective, several intermediary studies were required.[5] Despite sharing a space, the two dancers in the New York painting are notable for their isolation and self-absorption. This sense of the individual alone, even among others, as typified in Degas's *Absinthe Drinker* (Musée d'Orsay, Paris),[6] is characteristic of the modern sensibility Degas shared with Daumier (see no.78).

Oil thinned with turpentine on prepared green paper

Signed in black crayon at lower right, *Degas*

472 × 625 mm

PROVENANCE: Edgar Degas (1837–1917), his studio stamp (Lugt 657) on the verso; his sale, Galerie Georges Petit, Paris, 11–13 December 1918 (lot 338); bought by Gustave Pellet, Paris; Harris Whittemore, Naugatuck, Conn.; J.H. Whittemore Co., Naugatuck, Conn.; bequeathed by César Mange de Hauke

1968-2-10-25

LITERATURE (SELECTED): Lemoisne, 1946, II, pp.224–5, no.409; Browse, 1949, p.354, pl.47; Russoli and Minervino, 1970, p.110, no.496; New York, 1997, I, p.94, fig.115

EXHIBITIONS (SELECTED): London, 1968b, p.24, no.9; Tübingen and Berlin, 1984, p.364, no.103; Manchester and Cambridge, 1987, pp.48, 59, 140, no.48; Paris, Ottawa and New York, 1988, pp.276–8, no. 164 (with earlier literature) (exhibited in New York only); Detroit and Philadelphia, 2002, pp.138–9, 290, pl.147 (exhibited in Philadelphia only)

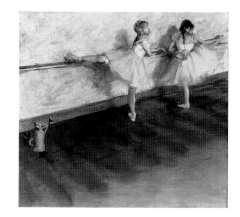

Fig.1 EDGAR DEGAS, *Dancers Practising at the Barre*, oil mixed with turpentine on canvas, 75.6 × 81.3 cm, The Metropolitan Museum of Art, New York, Bequest of Mrs H.O. Havemeyer, 1929. H.O. Havemeyer Collection (29.100.34).

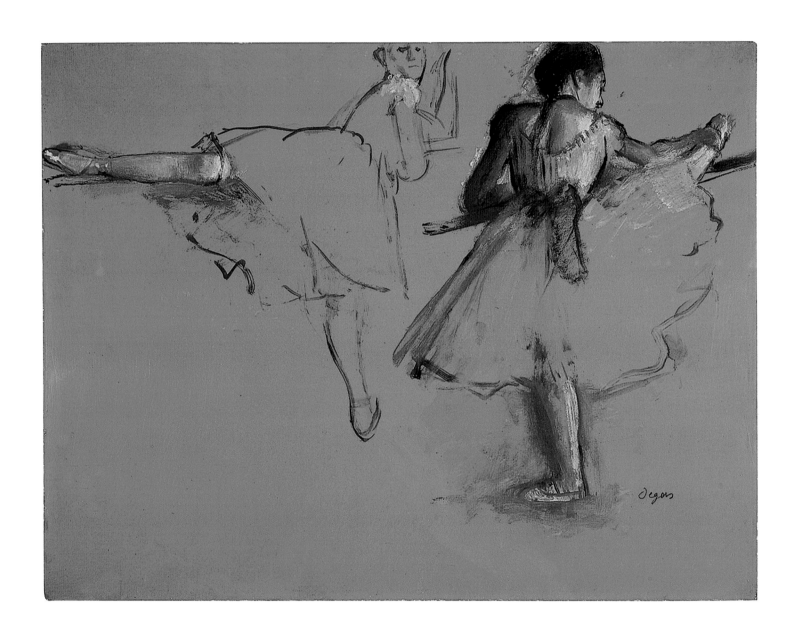

Henri Fantin-Latour

1836 Grenoble – 1904 Buré, Orne

87 Paradise and the Peri

Since his own day Fantin-Latour's work has earned respect but resisted easy categorization. He exhibited in the Salon des Refusés of 1863 but did not take part in any of the Impressionist exhibitions. In his portraits, still lifes and interiors he maintained a meticulous, uninflected realism which earned him medals at the Academy. However, emerging in the early 1860s and co-existing with the realist strain in his oeuvre were subjects drawn from the imagination, often inspired by musical and literary sources, for which he developed an ethereal manner of broken strokes and dappled light. Although this technique had much in common with the Impressionist technique of brilliant colour and distinct strokes, the underlying sensibility is better characterized as Romantic revivalism. Exposed to Realism in his student years and having spent a brief period in 1861 in the studio of Courbet, Fantin-Latour viewed the Romanticism of Delacroix and the early nineteenth century with nostalgia and avidly collected their prints.

Fantin's discovery of the music of Richard Wagner (1813–83), who was considered a modern Romantic and had a devoted international following, was another factor in his development and choice of subjects. He was also introduced to the technique of transfer lithography in 1876, and these two interests would flourish in tandem, as his prints with their subjects often drawn from modern German music initiated a revival of the tradition of the painter-lithographer. He pushed the technique to create magnificently textured areas of tone capable of conveying luminous, other-worldly effects. Lithography became so central a concern to Fantin-Latour that his compositions were often first developed in this medium, and only later would they be treated in pastel or oil.

The subject of the British Museum drawing is taken from *Paradise and the Peri*, a tale in *Lalla Rookh*, Thomas Moore's (1779–1852) orientalizing narrative poem, which was set to music by Robert Schumann (1810–56). Based on Persian folklore, the Peris were a race descended from fallen angels who were forbidden to enter paradise. In Moore's poem the disconsolate Peri was told she could enter Heaven's gates only when she brought the gift preferred above all others. She succeeded at the third attempt when she brought the repentant tear of an old sinner mourning his lost innocence.

Fantin-Latour made lithographs of the subject twice, in 1884 and 1894.[1] The catalogue raisonné compiled by his widow lists three related drawings: two studies for the 1884 lithograph and a 'very summary' first idea for the 1894 version.[2] The present sheet is not listed but is undoubtedly a more developed study for the 1894 version (fig.1), worked in a manner anticipating his use of the lithographic crayon and scraper. The chief differences in the later lithograph are the more fractured treatment of light, lending the surface a scintillating quality and the more dynamic pose of the angel, rendered as if flying through the air. The angel's pose, full of movement and grace, has been seen as inspired by the *Victory of Samothrace*, discovered and brought to the Louvre in the 1860s when Fantin-Latour was a frequent visitor.[3]

Charcoal

Signed in black crayon at lower left, h. *Fantin*

355 × 403 mm

PROVENANCE: Acquired from Obach and Co. 1908-6-16-53

LITERATURE: Opresco, 1928, pp.247, 251

Fig.1 Henri Fantin-Latour, *Paradise and the Peri*, 1894, lithograph, 356 × 403 mm, British Museum (1899-4-20-221).

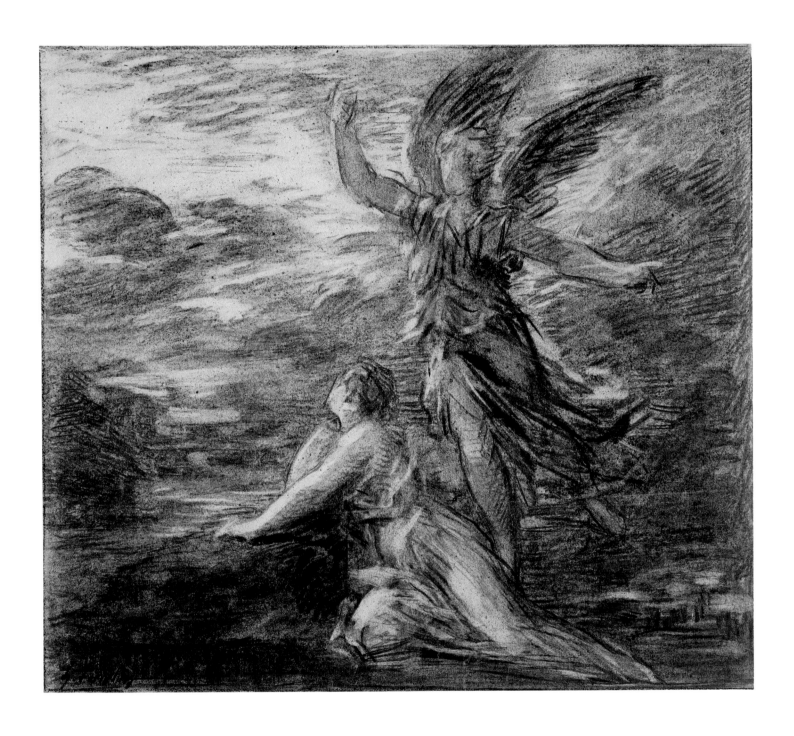

PAUL CÉZANNE

1839 Aix-en-Provence – 1906 Aix-en-Provence

88 The Apotheosis of Delacroix

Born in Aix-en-Provence, Cézanne remained in Provence much of his adult life developing into one of the most original artistic personalities of the later nineteenth century and recognized as a leading figure of Post-Impressionism. From 1861 he spent intermittent periods of time in Paris, where his dark and thickly painted canvases were poorly received. However, after encountering the Impressionist artists, especially Camille Pissarro, he changed direction and increasingly gravitated towards landscape and still-life subjects. His palette eventually brightened as he began to favour blue, green and ochre, although light effects never interested him as much as structure, and he famously stated that he wanted to 'make of Impressionism something solid and enduring, like the art in museums.'[1] In his later work Cézanne focused more and more on the construction of his forms, distilling their essence into facets and planes in a synthetic process that presaged Cubism.

Although he attended drawing classes, Cézanne arrived at his mature style by studying nature and copying earlier masters in the Louvre. His copying was sustained and interpretative, in that he didn't seek to imitate the technique of earlier masters, but to grasp their essence. Titian, Veronese, and Rubens all figure among his sources, but no earlier artist seems to have matched Delacroix in his estimation. Over the course of his life Cézanne made over twenty copies after Delacroix, including fragments as well as whole compositions.[2] This long-held admiration gave rise to the idea of painting a homage to Delacroix,[3] a project that never came to fruition, but for which several studies survive, including the British Museum watercolour.

Studies were made for the project over an extended period, creating much uncertainty over the dating of the preparatory works.[4] An oil sketch for the composition, differing from the watercolour most notably in the right foreground, entered the Musée d'Orsay in 1982 (fig.1).[5] Based on the dating of a photograph showing Cézanne at work on the small canvas in his Paris studio, John Rewald has dated the oil sketch to around 1894.[6] Stylistically, the London sheet dates considerably earlier, to around 1875–80,[7] although Rewald was certainly correct in noting that the strip of paper at the bottom and the pigments in the watercolour were later additions.

The figures have been identified according to an account by Émile Bernard. Delacroix is carried to heaven by angels, one of whom bears his palette and brushes. In the landscape below, Pissarro stands at his easel painting,[8] while Monet sits at his feet in the shade of an umbrella. In the foreground Cézanne sits in a chair with his back to the viewer and walking stick in hand, the barking dog alongside him symbolizing hostile critics. Of the two men applauding, the standing figure represents his friend Victor Chocquet.[9] Cézanne's homage suggests that while Impressionist and Post-Impressionist artists rebelled against the academic art of their own time, many of them found inspiration in Delacroix's brand of Romanticism with its heightened colour, painterly qualities and emotional content.

Pen and brown ink with watercolour and touches of gouache over graphite underdrawing, on two joined pieces of paper

Inscribed in graphite at lower right, B. M. S.

200 × 233 mm

PROVENANCE: Paul Cézanne, fils, Paris; Feilchenfeldt, Zürich; R. Zinser, New York; Fritz and Peter Nathan, Zürich; Peter Nathan, Zürich; Reid & Lefevre, London; Mrs Aimée Goldberg; accepted in lieu of Capital Transfer Tax from the estate of Mrs Aimée Goldberg.

1987-6-20-31

LITERATURE (SELECTED): Venturi, 1936, I, pp.249–50, no.891; Andersen, 1967, p.137; Rewald, 1983, pp.102–3 (with earlier literature), no.68; Gache-Patin, 1984, pp.138–9, 145; Karlsruhe, 2003, p.70

EXHIBITIONS (SELECTED): Newcastle upon Tyne and London, 1973, pp.156–7, no.35

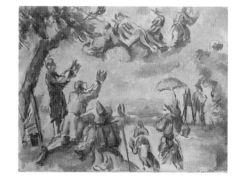

Fig.1 PAUL CÉZANNE, The Apotheosis of Delacroix, c.1894, oil on canvas, 27 × 35 cm., Musée d'Orsay, Paris (R.F. 1982-38).

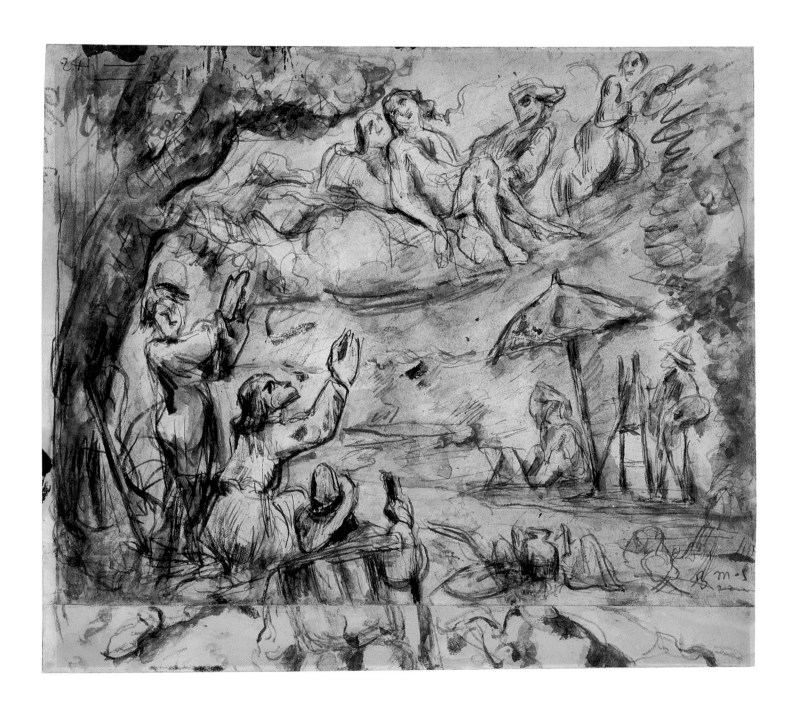

PAUL CÉZANNE

1839 Aix-en-Provence – 1906 Aix-en-Provence

89 Study of a Plaster Cupid

Drawings after sculpture form an important part of Cézanne's graphic oeuvre, accounting for perhaps one fifth of his extant sheets. For Cézanne statues had various advantages over live or painted models: they allowed a sustained study of the motif from various angles and through multiple visits over time and were without psychological complication. He was a regular visitor to the Louvre, the École des Beaux-Arts and the Musée de Sculpture Comparée in the Trocadéro, copying both original marbles and plaster casts. His sources were diverse, ranging from the antique to the Renaissance and works of the seventeenth and eighteenth centuries. Judging from the number of copies he drew, his favourite sculptor was his fellow Provençal, Pierre Puget (1602–94). Cézanne wrote to his friend Joachim Gasquet that when he felt homesick in Paris, he would go see the Pugets in the Louvre because they had been 'washed over by the mistral', the strong winter wind of Provence and the Rhône valley.[1]

In addition to the works he sketched on his museum expeditions, Cézanne owned at least two small plaster casts, both of which he drew frequently. One was an *écorché*, a flayed figure used by artists to study musculature, after a work attributed to Michelangelo in Cézanne's time.[2] The second, an armless cupid,[3] is the subject of canvases at the Nationalmuseum, Stockholm, and the Courtauld Institute Galleries, London, as well as four watercolours and ten drawings, in addition to the British Museum sheet.[4] Although the attribution is debated today,[5] Cézanne considered his plaster cupid to be after a work by Puget.

Cézanne began making studies of the plaster cupid in the mid-1870s and continued throughout his life, leaving no angle unexplored. He seems to have been attracted both to the lumpy musculature and the dynamic quality of the striding pose and twisting torso, producing an arc-shaped contour. The vantage point chosen for the London drawing emphasizes this long curve and even leaves off the right leg entirely. In viewpoint, it is closest to the cupid in the Stockholm painting[6] and is likewise lit from the left, but should not be considered preparatory in any strict sense as Cézanne would no doubt have painted directly from his statue with no need for recourse to drawn studies. In the drawings, many of which, like the London sheet, are fully life-size,[7] he explored the graphic means of rendering three-dimensional form. Rather than continuous contour, he conveyed mass through bundled strokes and patches of hatching, comparable to the strokes that built up form in his oil paintings.

Graphite

505 × 322 mm

PROVENANCE: Reid & Lefevre, London; presented by the National Art Collections Fund

1935-4-13-2

LITERATURE (SELECTED): Hind, 1935–6, p.22; Venturi, 1936, I, p.323, no.1462; Chappuis, 1973, I, p.229, no.988 (with earlier literature), II, fig.998; Los Angeles, 2004, pp.85–8, fig.33

EXHIBITIONS (SELECTED): Tübingen, 1978, no. 179; London, 1984b, p.152, no.147; Newcastle upon Tyne and London, 1973, p.165, no.75; Paris, London and Philadelphia, 1995, pp.388, 394, no.163; Stockholm, 1997, p.88, no.28

ODILON REDON

1840 Bordeaux – 1916 Paris

90 Christ Crowned with Thorns, 1895

Redon's imagery and unconventional sensibility were informed by a deeply unhappy childhood, when for his first eleven years he was raised apart from his parents and siblings.[1] He spent a brief period in the studio of Jean-Léon Gérôme (1824–1904), whose pragmatic approach was incompatible with Redon's desire to use art as a vehicle for imaginative expression. He found encouragement instead with Rodolphe Bresdin (1822–1885), whom he met in Bordeaux and whose intricate quirky manner he found sympathetic. After serving as a soldier in the Franco-Prussian War, Redon settled in Paris where he was soon integrated into the artistic and literary life of the French capital.

During the 1870s and 1880s Redon became known for his *noirs*, large charcoal drawings dark in both mood and tone. They were worked in a heavy and experimental manner, with subtractive techniques like stumping and scraping used to pick out highlights. Their subjects were emotional and visionary in character; when they drew on literary and religious sources, it was in a dream-like rather than a literal fashion. In transfer lithography Redon found the means to replicate his drawings and build his reputation. He had been introduced to the technique around 1878 by Fantin-Latour, who likewise found the process well suited to his densely worked monochrome draughtsmanship and fantasy-inspired subjects (see no.87).

Redon often produced his lithographs in suites, and his need to raise funds to buy a set of lithographic stones for his planned album *The Temptation of St Anthony* in 1895 led him to sell some of his drawings. Camille Redon, in a letter of 20 August, described her husband as at work on a drawing depicting *Christ Crowned with Thorns*, a subject that Redon's patron Baron Robert de Domecy had been requesting for two years. However, before the sale could be arranged, Dr Albert Edward Tebb, described by Camille as a 'gentleman from England who was a fanatic for Redon', visited the artist and purchased the drawing as well as two others.[2]

Christian imagery had been rare in Redon's oeuvre before the mid-1890s; when it did appear, it was mostly focused on the figure of Christ, either crowned in thorns or crucified.[3] Often with brutal oversized thorns, these images emphasized themes of suffering and transcendence. Mixing charcoal and black pastel with stumping and scraping, Redon produced in the present sheet an enveloping bramble of thorns sunk in inky shadow, the half-lit head of Christ floating as if disembodied, and the large eyes suggesting mystical vision. Redon sought to imbue the limited areas of exposed paper with a golden hue, infusing the paper with a resinous fixative.[4] Having achieved perhaps all there was to achieve with the *noirs*, and citing how emotionally draining they were to create,[5] Redon began to shift to coloured pastels over the course of the 1890s.

Charcoal, black pastel and black crayon, stumping, erasing, and incising on tan wove paper toned gold

Signed at lower right in black pastel, ODILON REDON

522 × 379 mm

PROVENANCE: Purchased from Dr Albert Edward Tebb

1921-4-11-1

LITERATURE (SELECTED): Opresco, 1928, p.253; Sandström, 1955, pp.100–102, 223, fig.79; Hobbs, 1977, pp.112–13, fig.74; Wildenstein, 1992–8, I, p.198, no.501

EXHIBITIONS (SELECTED): London, 1984b, p.148, no.144; Chicago, Amsterdam and London, 1994, pp.227, 250, 252, 411, 445, no.121, fig.68

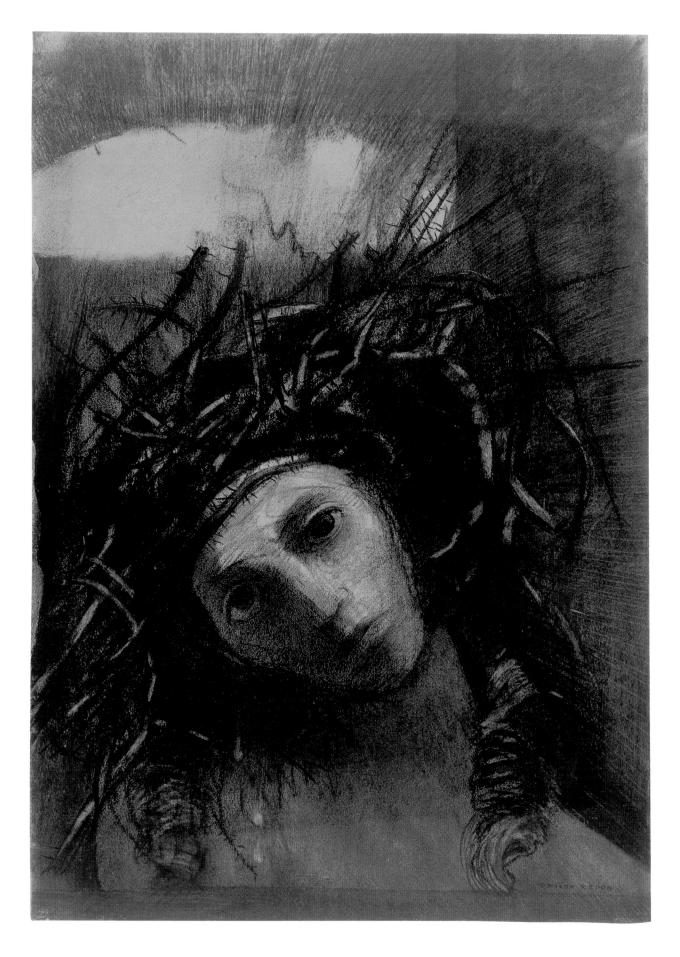

GEORGES SEURAT

1859 Paris – 1891 Paris

91 Landscape with Dog: Study for 'La Grande Jatte', 1884

Although he did not live past the age of thirty-one, Georges Seurat had a lasting effect both on his contemporaries and on the development of modern art in the twentieth century. His technique of pointillism, in which unblended dabs of pure colour were juxtaposed on the canvas, was adopted by many of the Neo-Impressionists, and his focus on scientific principles and optical effects was broadly influential. Seurat entered the École des Beaux-Arts in 1878 as a student of Henri Lehmann, a follower of Ingres, and applied himself to academic drawing and the study of theoretical treatises, especially Charles Blanc's *Grammaire des arts du dessin* (1867) and Michel-Eugène Chevreul's *De la loi du contraste simultané des couleurs* (1839), both of which stressed the use of contrast to achieve harmony. The following year Seurat was exposed to the work of Monet and Pissarro at the Fourth Impressionist Exhibition and left the École des Beaux-Arts to work independently.

Ambitious and determined to apply his scientific methodology to an art that would meld contemporary subject matter with the monumental simplicity of classical and primitive art, Seurat produced his first major work, *The Bathers at Asnières* (National Gallery, London), in 1883 at the age of twenty-four. On the scale of a Salon painting and with sculptural semi-nude figures, it depicts a group of manual labourers relaxing on the banks of the Seine, with factories and smokestacks in the distance. It was rejected by the Salon jury but exhibited at the Salon des Indépendants in 1884, by which time Seurat was already at work on its companion piece, *A Sunday on La Grande Jatte* (fig.1).

La Grande Jatte represents the sunny banks of an island in the Seine across from Asnières as the site of leisure and relaxation. The complexity of the scene with almost fifty figures engaged in myriad activities and arranged throughout a deeply receding space was the result of an elaborate preparatory process involving at least twenty-eight drawings, twenty-eight small panels painted in oil, and three oil studies on canvas.[1] The drawings reveal not only Seurat's quest to refine the figures and their placement, but also his method of making monochrome studies of the distribution of light and dark to establish the tonal values to be followed in the painting. To serve this purpose, Seurat developed a style of draughtsmanship in which interlaced strokes of conté crayon created a mesh-like pattern capable of conveying subtle gradations of tone. By not pressing the crayon into the textured paper, flecks of white remain visible in areas of dark grey, producing a shimmering effect that anticipated the vibrating contrasts of hue in his oil technique.

In the British Museum drawing Seurat set out the serene tableau of the entire wooded bank and glistening river like an empty stage set. The drawing presumably followed another near-empty landscape study done in oil on canvas,[2] but was the first to take into account the proportions of the final canvas, which like *The Bathers at Asnières* has a two-to-three height-to-width ratio. To achieve this, Seurat cropped portions from the top and bottom and stretched the composition horizontally, further separating the two closest trees.

Conté crayon

Signed at lower right in conté crayon, *Seurat*

425 × 628 mm

PROVENANCE: The artist's mother, Mme Ernestine Seurat; by inheritance to the artist's brother, Émile Seurat, Paris; Louis Bouglé, Paris; André Berthellemy, Paris; bequeathed by César Mange de Hauke

1968-2-10-17

LITERATURE (SELECTED): Dorra and Rewald, 1959, p.124, no.116c; Hauke, 1961, pp.220–1, no.641; Rowlands, 1968, pp.46, 48, fig.12; Thomson, 1985, pp.99, 101, fig.105

EXHIBITIONS (SELECTED): London, 1968b, pp.30–1, no.12; London, 1984b, p.151, no.146; Paris and New York, 1991, pp.206–7, no.140 (exhibited in Paris only); London, 1997, pp.134–5, no.81, pl.158; Chicago, 2004, pp.78–9, 86, 180, 268, 275, no.63

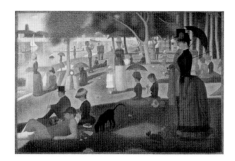

Fig.1 GEORGES SEURAT, A Sunday on La Grande Jatte, 1884–6, oil on canvas, 207.5 × 308.1 cm, The Art Institute of Chicago (1926.224).

GEORGES SEURAT

1859 Paris – 1891 Paris

92 The Couple: Study for 'La Grande Jatte', 1884

Like no. 91, this study of an elegant couple in the park formed part of Georges Seurat's elaborate preparations for his *Sunday on La Grande Jatte* in the Art Institute of Chicago (fig.1, p.212). Recent technical investigations have furthered our knowledge of the sequence and function of the nearly sixty studies he made for the picture,[1] although whether the British Museum *Couple* pre- or post-dates a compositional study in oil in the Metropolitan Museum of Art, New York (fig.1), remains a matter of debate.[2] As with the majority of the drawings in conté crayon, its purpose was to resolve the final form of figures that may have made their first appearance in the small oil panels; this involved simplifying and perfecting the forms into a pure geometry that was both recognizably modern and at the same time redolent of the power of primitive art or ancient reliefs.

Clues to the method by which Seurat enlarged and transferred his figures can be found in the residue of grids on some of his canvases.[3] The small, evenly spaced marks along the edge of the London drawing relate to this system of transfer.[4] The conté drawings also sought to establish the relative tonal values, which would then be replicated in colour on the final canvas. To this end, Seurat's handling of the crayon, worked lightly over the rough surface in a variety of directions, created luminous areas of tone with amorphous edges. In areas where a clearer definition of forms was needed, he reworked contours with a sharper-tipped point. These reinforced areas can be seen in the woman's bustle, her right forearm and her parasol. X-radiographs of the Chicago painting reveal that Seurat was still occupied with the precise silhouette of the woman's bustle when the execution of the painting was well advanced.[5]

La Grande Jatte has been a magnet for socio-historical interpretation, suggesting readings ranging from an allegory of social harmony to a dystopia of isolation within capitalist society.[6] The promenading couple in particular has proved enigmatic. Are they a proper and fashionable bourgeois couple enjoying a weekend stroll or, in their stiffness and flatness, are they being mocked for their pretension? Certainly Seurat's presentation of his fellow Parisians in *La Grande Jatte* is not without whimsy, but the drawings and panels reflect his tireless labour in crafting a monumental composition where the disparate figures of contemporary Paris were arranged, like so many pieces of a jigsaw puzzle, into a harmonious whole.

Conté crayon

314 × 236 mm

PROVENANCE: Georges Lévy, Paris; sale, Hôtel Drouot, Paris, 31 May 1927, lot 424; bought by Hodebert, Paris; bequeathed by César Mange de Hauke

1968-2-10-16

LITERATURE (SELECTED): Dorra and Rewald, 1959, p.148, no.135a; Hauke, 1961, pp.222–3, no.644; Gaunt, 1968, p.231; Rowlands, 1968, pp.46, 48, fig.11; Thomson, 1985, pp.106, 109, fig.116

EXHIBITIONS (SELECTED): London, 1968b, pp.32–3, no.13; Paris and New York, 1991, pp.203–4, no.138 (exhibited in New York only); London, 1997, pp.134–5, no.82, pl.156; Chicago, 2004, pp.79, 82, 85, 180, 181, 184, 187, 268, 275, no.61

Fig.1 GEORGES SEURAT, *Study for 'A Sunday on La Grande Jatte'*, 1884, oil on canvas, 70.5 × 104.1 cm, The Metropolitan Museum of Art, New York (51.112.6).

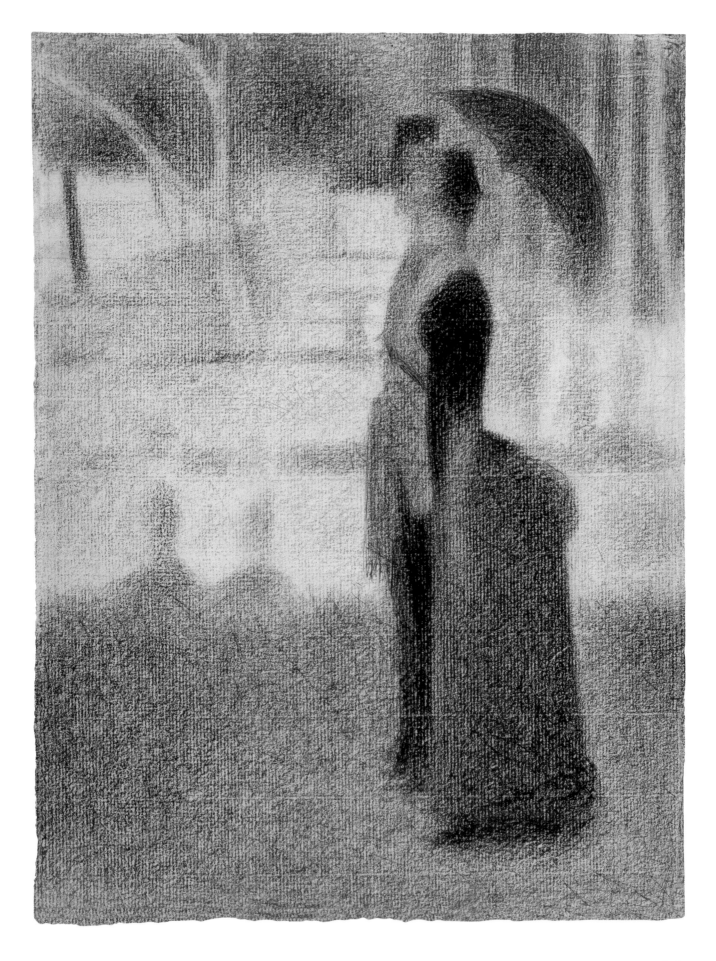

HENRI DE TOULOUSE-LAUTREC

1865 Albi, Tarn – 1901 Château de Malromé, near Langon, Gironde

93 Portrait of Marcelle Lender, c.1893–5

The only son of wealthy aristocratic first cousins, Henri de Toulouse-Lautrec inherited from his parents eccentricity and an artistic disposition, but was also plagued by a genetic disorder that left him dwarfed and crippled. It was in part because of the limitations imposed by these disabilities that his family allowed him to pursue a career as a painter in the French capital. He was initially placed in the studio of the respectable Léon Bonnat (1833–1922) and then with history painter Fernand Cormon (1845–1924), where he mastered and then quickly disregarded academic training in favour of the colourful and seedy life of Montmartre. Lautrec found his subjects and his companions in the raunchy milieu where artists, writers and rebellious members of the privileged classes mixed with nightclub entertainers and prostitutes. His bohemian lifestyle fed the innovative quality of his work, although alcoholism and syphilis contributed to his early death at the age of thirty-six.

Lautrec was not disposed to art theory and did not belong to a particular school, although his work was undoubtedly influenced by Degas, Daumier and, like many of his generation, Japanese woodblock prints.[2] His flattening of form, bright colour and use of pattern can also be compared with other Post-Impressionist and Nabis artists. His technique was often brash and colourful, mirroring his subjects, and demonstrated an incisive use of line to capture telling gestures and poses in a sharp and unsentimental way. Although he painted occasional portraits, he was not disposed to flattery, and ultimately found his greatest success in the commercial world of posters, lithographs and illustration.

In addition to the commissioned posters advertising cabarets such as Le Moulin Rouge, a great number of Lautrec's independent prints drew their subjects from the garish world of the café concert. In contrast to Degas's studies of anonymous dancers (no.85), Lautrec immortalized the celebrities of the day. Grouped chronologically, his theatre subjects reveal a series of infatuations. Marcelle Lender,[3] for instance, was the object of an obsession that inspired an oil painting in addition to numerous prints and drawings, all executed between 1893 and 1895.[4] He was especially drawn to her performance as Galswinthe in the 1895 revival of Hervé's operetta Chilpéric.[5] According to Romain Coolus, a writer for La Revue blanche, Lautrec attended twenty performances, always sitting in the same seat, where he never tired of watching Lender dance the bolero in her low-cut gown.[6]

Lender epitomized Lautrec's feminine ideal: red hair, a chiselled nose, pointy chin and expressive eyes. In the British Museum drawing these features are emphasized by black chalk accents and set off by the dark choker at her neck. The pallor of her cheeks against the shading of the eye sockets and across the bridge of the nose suggests the type of artificial theatrical lighting that increasingly lent Lautrec's figures a lurid quality. Lit and seen from below, the London Portrait of Marcelle Lender evokes in its viewpoint both the diminutive physical stature of the artist and his role as observer, always seated just below the stage.

Black chalk

Lautrec's estate stamp in red ink at lower right, HTL (monogram in a circle)[1]

329 × 222 mm

PROVENANCE: Mme Théo van Rysselberghe; Galerie des Quatre Chemins, Paris; bequeathed by César Mange de Hauke

1968-2-10-22

LITERATURE (SELECTED): Gaunt, 1968, p.231; Rowlands, 1968, pp.49–50, fig.15; Dortu, 1971, VI, pp.636–7, no.D.3.766 (with earlier literature)

EXHIBITIONS (SELECTED): London, 1968b, pp.36–7, no.15; London, 1984b, p.149, no.145

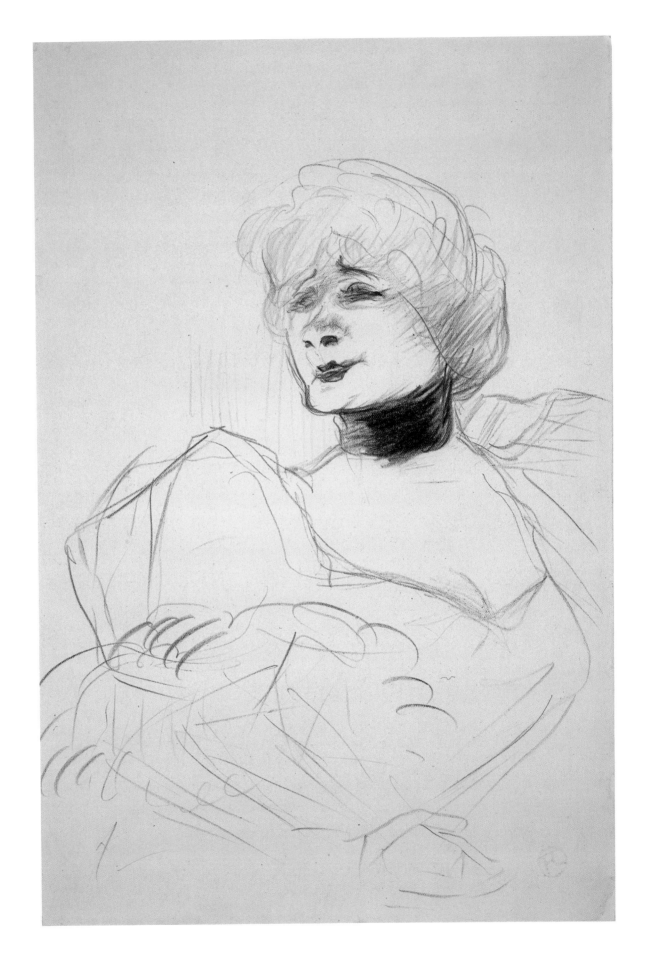

NOTES

Notes to no.1

1 Chantilly, 2002, pp.19–21. On drawings in red and black chalk by Jean Perréal, see Nicole Reynaud, 'Deux portraits inconnus par Jean Perréal au Louvre', *Revue du Louvre et des Musées de France*, XLVI, no.4 (October 1996), pp.36–46. On Fouquet, see *Jean Fouquet, Peintre et enlumineur du XVe siècle*, ed. François Avril, Bibliothèque Nationale de France, Paris, 25 March–22 June 2003, pp.118–20; 142–8, under nos 6, 12–13.

2 See e.g. Chantilly, 2002, p.28, no.2, and p.135, no.63.

3 *Ibid.*, p.28.

Notes to no.2

1 The dispersal of the Bouverie collection is discussed in Nicholas Turner, 'John Bouverie as a collector of drawings', *Burlington Magazine*, CXXXVI, no.1091 (February 1994), pp.90–9.

2 George Salting's collection is studied by Stephen Coppel in *Landmarks in Print Collecting, Connoisseurs and Donors at the British Museum since 1753*, ed. Antony Griffiths, London, 1996, pp.189–210 (circle of Clouet album mentioned p.191).

3 Quoted in Chantilly, 2002, p.23.

4 For Catherine de Médicis as a collector of drawings; see Chantilly, 2002, pp.6–11.

5 *Ibid.*, pp.56–7 and 59.

6 *Ibid.*, no.23, pp.68–70. Mediocre copies of these and others, which may conceivably have been part of this group, are included in the Recueil Brisacier in the Bibliothèque Nationale de France, Paris; see Jean Adhémar, 'Les portraits dessinés du XVIe siècle au Cabinet des Estampes', *Gazette des Beaux-Arts*, LXXXII, no.1256 (September 1973), pp.136–41.

Notes to no.3

1 The most recent discussion of the Appartements des Bains is in Paris, 2004, pp.186–92 (essay by Dominique Cordelier).

2 The precise moment in the story was identified by Chantal Eschenfelder in 1993 (pp.46–7). Before that, the episode had been described as the more conventional 'Diana Discovering the Pregnancy of Callisto'.

3 The two sheets were connected by Louis Dimier in 1900 (pp.455–6), although the British Museum drawing had already been referred to as 'A Portion of the bath of Diana' in 1860, in the catalogue of the Woodburn sale of drawings from the collection of Thomas Lawrence; Christie, Manson, & Woods, London, 6 June 1860, lot 644, p.47.

4 See Paris, 2004, pp.215–19.

Notes to no.4

1 Per Dimier, 1900, p.456, although his mark (Lugt 2248) does not appear on the drawing.

2 See Lugt, 1956, p.329.

3 The relevant passages are reprinted in Béguin, Guillaume and Roy, 1985, p.183.

4 Paris, 2004, p.293.

Notes to no.5

1 London, 1951, p.33, no.99. A.E. Popham concurred with Antal that the British Museum drawing dated to dell'Abbate's French period, calling attention to the French watermark; see Tokyo and Nagoya, 1996, p.28, no.40 (English supplement).

2 Noted by Pouncey in the Museum files and cited by Michiaki Koshikawa in Tokyo and Nagoya, 1996, p.28 (English supplement), although the sale was cited incorrectly; it took place at Sotheby's, New York, 8 January 1981, lot 121.

3 Described in Jabach's inventory as 'Flora', the sheet has been published by Sylvie Béguin as an allegory of Abundance; see Py, 2001, p.193, no.805, Béguin, 1992, pp.90–1, 16, fig.11, and Modena, 2005, pp.439–40 (entry by Sylvie Béguin).

4 Jabach's collection also included another series of drawings considered by him to be by Primaticcio and today catalogued as Dell'Abbate that included depictions of Charity and Flora (Louvre, Paris, inv.5876 and inv.5850).

Notes to no.6

1 The information that the Marquis de Lagoy purchased this drawing from the Zanetti family in Venice in 1791 was kindly supplied by Béatrice de Moustier (correspondence, 12 October 2004). On Zanetti, see also Py, 2001, p.27.

2 Py, 2001, p.72, no.168.

3 Kusenberg, 1931–2, p.89.

4 See Paris, Cambridge and New York, 1994, pp.92–129.

5 Dacos, 1996a and b.

6 She posits that the poses of the central figures, especially the soldier with his leg extended towards Christ's shoulder, convey a clear memory of van Orley's tapestry design on the same subject; see Dacos, 1996a, pp.208–9.

Notes to no.7

1 Two drawings are associated with the commission: *St Mamas Saved from Drowning* (Bibliothèque Nationale de France, Paris) and *Amya Petitioning Faustus for the Custody of St Mamas* (Metropolitan Museum of Art, New York). See Stein, 2002, pp.63–76.

2 Félix Herbert, 'Les Graveurs de l'École de Fontainebleau', *Annales de la Société de Historique & Archéologique du Gâtinais* I. Catalogue de l'Oeuvre de L.D., 1896, p.101, no.218.

3 See *Le XVIe Siècle Européen, Dessins du Louvre*, Musée du Louvre, Paris, October–December 1965, p.66, under no.151 (entry by Geneviève Monnier).

4 Zerner, 1969, p.22 note 1. The sheet was published as Cousin *père* by Sylvie Béguin in 1972; see Paris, 1972, pp.63–5, no.62.

5 Paris, 1972, pp.62–3, no.61.

6 '[S]ingulièrement beaux paisages, tant bien representans le naturel, que ceulx qui les regardoyent, & avec ce les gestes de plusieurs personnages s'esbatans à tous les ieux ausquels la venerable antiquité se souloit avec pris exerciter, perdoyent le souvenance de boire & de manger' in C'EST L'ORDRE QVI / A ESTE TENV A LA NOVVELLE / ET IOYEUSE ENTRÉE, QVE TRES- /hault, tresexcellent, & trespuissant Prince, le Roy / treschrestien Henry deuxième de ce nom, a faicte en sa bonne ville & cité de Paris, / capitale de son Royaume, le seziesme iour de Iuing / M.D. XLIX / A PARIS, p.35, quoted and translated in Paris, Cambridge and New York, 1994, pp.162, 164 note 7.

Notes to no.8

1 Otto Benesch, 'Jean Cousin fils, dessinateur', *Prométhée* 20 (1939), pp.271–80. For a facsimile edition of the *Livre de Fortune*, see Ludovic Lalanne, *The Book of Fortune, Two Hundred Unpublished Drawings by Jean Cousin*, translated by H. Mainwaring Dunstan, Paris and London, 1883.

2 Zerner, 1996, p.238, and pl.398 note 58.

3 Zerner, 1996, fig.268, p.235, and Lalanne, *op. cit.*

4 Ovid's *Metamorphoses*, III, 259–315.

5 Considered today to be by Léon Davent, they were catalogued as Master L.D. nos 11 and 68 in Zerner, 1969. See also Jean Adhémar, *Inventaire du fonds français, Graveurs du seizième siècle*, II, Paris, 1971, p.285. Léonard Thiry also seems to have been inspired by Primaticcio's treatment of the Semele myth. In a design for a small wine barrel in the Edmond de Rothschild Collection, Département des Arts Graphiques, Musée du Louvre, Paris, he fills the cartouches with scenes from the birth and infancy of Bacchus, including, at the right, Jupiter pulling the unborn Bacchus from the burning body of Semele, her pose a paraphrase of Primiticcio's treatment of the subject (as in Zerner, 1969, Master L.D. no.11; see Paris, Cambridge and New York, 1994, pp.104 and 107, fig.36a).

Notes to no.9

1 Linzeler, 1932, I, no.87, p.324.

2 See Paris and New York, 1987, pp.94–104 (English edn).

3 See *Fiamminghi a Roma, 1508–1608*, exh. cat., Palais des Beaux-Arts, Brussels, 24 February–21 May 1995 and Palazzo delle Esposizioni, Rome, 16 June–10 September 1995.

4 Raymond Keaveney, *Views of Rome from the Thomas Ashby Collection in the Vatican Library*, London, 1988, no.44, pp.180–1. The manner in which the date is inscribed on the Vatican sheet, *Faict a Roma/ au mois d'aout/ le 9e Jour/ 1567*, also corresponds to that of the London drawing.

Notes to no.10

1 *Portraits of Plants, Jacques Le Moyne de Morgues (1533–1588)*, Victoria and Albert Museum, London [1984?].

2 See Sotheby's, New York, 21 January 2004, lots 29–55 and Sotheby's, New York, 26 January 2005, lot 46. A highly finished group of six gouaches on vellum were sold from the Korner collection in 1997 (Sotheby's, New York, January 29, 1997, lots 55–60).

3 Hulton, 1977, I, p.12.

4 Hulton, 1977, I, pp.186–200.

Notes to no.12

1 Antony Griffiths and Craig Hartley, *Jacques Bellange, c.1676–1616: Printmaker of Lorraine*, London, 1997, p.39.

2 Pierre Rosenberg, 'Did Jacques de Bellange go to Italy? Notes on the exhibition in Rennes', *Burlington Magazine*, CXLIII, no.1183 (October 2001), pp.631–4.

3 See Rosenberg, *op. cit.*, pp.631–32.

4 Rennes, 2001, pp.187–8.

5 Rennes, 2001, nos 38–44, pp.197–211.

6 Quoted in Rosenberg, *op. cit.*, p.631.

Notes to no.13

1 Dimier, 1924–6, II, pp.300–4.

2 Chennevières and Montaiglon, 1851–60, II (1853–4), p.131.

3 See Garrard, 1989, pp.63–4; Bissell, 1999, pp.39; and Rome, New York and St Louis, 2002, pp.268 and 339.

4 Cambridge, Toronto, Paris, Edinburgh, New York and Los Angeles, 1998–2000, p.416, no.A117.

Notes to no.14

1 Ternois, 1962a, pp.47–8, nos 26, 29 and 38; for the Berlin drawing, Ternois, 1999, p.21, no.1461.

2 Nancy, 1992b, no.40, pp.155–6.

3 Nancy, 1992b, no.41, pp.156.

4 Ternois, 1962a, nos 25–36, pp.46–8 (nos 37–9 are also related to this group, pp.48–9), and Ternois, 1999, *op. cit.*, nos S.1459–66, pp.20–2; 54–61.

5 Ternois, 1962a, nos 25–8, p.47.

6 Ternois, 1999, nos 1459–60; 1463; and

1465–6, pp.20–2, and Cambridge, Toronto, Paris, Edinburgh, New York and Los Angeles, 1998–2000, no.7, pp.110–13. A number of these seem to have appeared on the art market in England in the 1950s and 1960s. The sheet catalogued in Ternois's *Supplément* as no.1463 has since been acquired by the Metropolitan Museum of Art, New York, as a partial and promised gift of Mr and Mrs David M. Tobey (2000.253a,b); see 'Recent Acquisitions, A Selection: 2000–2001', *The Metropolitan Museum of Art Bulletin* vol. LIX, no.2 (Fall 2001), p.28 (entry by Perrin Stein). Despite the presence of Hone's and Thane's collectors' marks, Ternois did not include them in the provenance of no.1463.

7 Lugt described mark 2736 as 'probably 17th-century', adding that eighteen sheets bearing this mark were left to Christ Church, Oxford, in 1765; see Lugt, 1956, p.513.

Notes to no.15

1 Ternois, 1962b, p.125.

2 Lieure, III, 1927, p.73, no.1341.

3 Ternois, 1962a, p.131, nos 916–17.

4 Ternois, 1962a, p.131, no.915, and Ternois, 1999, pp.40–1, nos 1503, 1505.

5 Nancy, 1992b, pp.392, 394.

6 Paulette Choné reviews this aspect of the literature in her essay on *Les Misères de la guerre* in Nancy, 1992b, pp.396–400.

Notes to no.16

1 Paulette Choné discusses the equestrian portrait in the early seventeenth century in Nancy, 1992b, p.389.

2 Ternois, 1962a, pp.47–8, nos 28 and 32.

3 Nancy, 1992b, p.389.

4 In addition to the compositional studies, a black chalk study for the armour is in the Hermitage Museum and a chalk and wash study for the battle in the background is in the British Museum; see Ternois, 1962a, pp.118, 131, nos 791 and 917. A black chalk study in the Paignon-Dijonval collection (no.2525) long considered to be related to the Prince de Phalsbourg composition should be linked instead to Callot's *Portrait de Louis XIII* according to Jean-François Méjanès; see Paris, 1993, p.82, under no.28.

5 Promised gift of Leon D. and Debra R. Black and Purchase, 2003 Benefit Fund, 2004 (2004.235). From the Chatsworth collection the drawing was sold at Christie's, London, 3 July 1984, lot 47; purchased by Mr and Mrs Walter Gernsheim, Geneva.

6 Nancy, 1992b, p.390, no.492.

7 Lieure, I, 1924, p.55, no.154.

8 Nancy, 1992b, p.391, no.493.

Notes to no.17

1 As Emmanuelle Brugerolles has observed, Vignon's designs for prints were most often executed in red chalk in the years following his return from Rome with the addition of black becoming more prevalent beginning in the 1640s. Paris, Geneva and New York, 2001, p.30. The date inscribed on the mount of the drawing, 1630, is presumably incorrect, although others from the series bear similar inscriptions; see *Master European Drawings from the Collection of the National Gallery of Ireland*, travelling exh. cat., Smithsonian Institution, 1983, pp.108, 110.

2 Pacht Bassani, 1992, p.437.

3 Ibid., pp.437–47, nos 440, 442, 446, 447, 449 and 451. Hilliard Goldfarb observed that the known drawings associated with the *Galerie des femmes fortes* are neither squared nor incised, suggesting that they may have been made as presentation drawings; see Cleveland, Cambridge and Ottawa, 1989, p.137, under no.66.

4 Pacht Bassani, 1992, pp.447–8, no.454. The idea was first proposed in Rosenberg, 1966a, p.291.

5 Pacht Bassani, in stating that Bosse invented the architecture and a landscape at right that did not figure in Vignon's drawing, must have been working from the over-exposed photograph that she illustrates in her book. In fact, the London drawing does specify these elements, albeit lightly.

6 Pacht Bassani, 1992, p.445.

7 Gregor. Thuron. lib.9, cap.17.

8 The stylistic imprint of Rousselet on the series is discussed in Meyer, 1998, pp.193–5.

Notes to no.18

1 Rosenberg and Prat, 1994, I, pp.xx, 338, under no.178; Paris, Geneva and New York, 2001, pp.103, 107 note 6.

2 Rosenberg and Prat, 1994, I, p.326. In a review of Rosenberg and Prat's catalogue raisonné Ann Sutherland Harris observed that the sketch of cartouches on the verso (fig.1) exhibits the shaky line associated with Poussin's hand from the late 1630s and must therefore date to later than the studies on the recto; see Harris, 1996, p.425.

3 Salomon Reinach, *Répertoire des reliefs grecs et romains*, Paris, III, p.396.

4 Friedlaender and Blunt, V, 1974, p.40, no.341.

5 Nicholas Turner, 'Some of the Copyists after the Antique Employed by Cassiano', in *The Paper Museum of Cassiano dal Pozzo*, British Museum, London, 14 May – 30 August 1993, pp.31–2; Pierre Rosenberg, *From Drawing to Painting: Poussin, Watteau, Fragonard, David & Ingres*, Princeton, 2000, p.57; and Paris, Geneva and New York, 2001, pp.103, 107 note 13.

6 Blunt, 1979, p.135.

7 Oxford, 1990, n.p., no.32. See also London, Houston, Cleveland and New York, 1995, pp.152–3, no.52.

8 Paris, Geneva and New York, 2001, pp.104.

Notes to no.19

1 The group was studied in the exhibition, 'A Painting in Focus: Nicolas Poussin's "Holy Family on the Steps"', Cleveland Museum of Art, 14 November 1999 – 23 January 2000. The catalogue was published as *Cleveland Studies in the History of Art*, IV (1999). The five paintings are in Cleveland (pl.1, p.9), Dublin (pl.10, p.18), Cambridge (pl.12, p.20), shared between Los Angeles and Pasadena (pl.13, p.21), and Paris (pl.14, p.22).

2 A fragment of an old copy in the Hermitage suggests that a more detailed treatment of this composition once existed; see Rosenberg and Prat, 1994, II, pp.1072–3, no.R1120.

3 *Ibid.*, pp.40–1.

4 The connection between the British Museum drawing and the Louvre *Holy Family under a Group of Trees* has been noted by Elizabeth Senior, 'A Sheet of Studies by Nicolas Poussin', *British Museum Quarterly* XII, no.2 (April 1938), Friedlaender [and Blunt], I, 1939, p.28, no.55, Anthony Blunt, 'Further Newly Identified Drawings by Poussin and His Followers', *Master Drawings*, XVII, no.2 (Summer 1979), p.127, and de Grazia, 1999, p.39, mostly in relation to the stand of trees behind the central group.

5 The text is transcribed in Rosenberg and Prat, 1994, I, p.638.

6 Rosenberg and Prat, 1994, I, pp.638–40.

7 See Pierre Rosenberg, *From Drawing to Painting: Poussin, Watteau, Fragonard, David, and Ingres*, Princeton, 2000, p.27, fig.25; sale, Tajan, Paris, 27 March 2001, lot 94; 'Recent Acquisitions, A Selection: 2001–2002', *The Metropolitan Museum of Art Bulletin*, LX, no.2 (Fall 2002), pp.20–1 (notice by Perrin Stein); sale, Tajan, Paris, 4 July 2002, lot 41; and *French Drawings: 1600–1900*, W.M. Brady & Co., New York, 20 January–12 February 2004, no.3, n.p.

8 Without meaning to imply that the view depicted here is anything other than an invented classical landscape, it is nonetheless worth noting that Les Andelys, in Normandy, where Poussin spent his first eighteen years, was a town built on the banks of a curving river, dominated by a round stone castle on a hilltop. See photograph in Paris, 1994, p.124, with Château Gaillard, erected in the twelfth century, in the centre middle ground.

Notes to no.20

1 Paris, Geneva and New York, 2001, pp.279–80.

2 Dorival, 1976, I, p.31.

3 Not *c.*1642, the date assigned to it by Bernard Dorival (*ibid.*). This was corrected in 2000 by Nicolas Sainte Fare Garnot (p.14, no.14).

4 Dorival, 1976, II, p.143, no.264 and pp.34–5, no.53.

5 *Ibid.*, II, p.412, nos 67 and 68.

Notes to no.21

1 Quoted in Oxford and London, 1998, p.34.

2 The inventory is reprinted and translated into English in Roethlisberger, 1961, I, pp.72–6.

3 Oxford and London, 1998, p.17.

4 Quoted in Roethlisberger, 1961, I, p.48. Sandrart knew Claude around 1630, but did not publish his biography until 1675. According to Martin Royalton-Kisch, Sandrart's mention of *plein air* landscapes may have been a reference to oil sketches, not drawings; see London and Antwerp, 1999, p.28.

Notes to no.22

1 Oxford and London, 1998, p.121.

2 Inscribed by the artist in pen and brown ink, *A Monsieur* [Collier crossed out] *De Bertaine faict par moy/ Claude Gellee dit il lorains a Roma/ ce 22 maigio 1646, la vuie de la/ vigne du papa innocent et st. piere de Roma* and, in pen and black ink in another hand (inverted), *Claude lorrain*.

3 For a recent study of the project, see Sarah McPhee, *Bernini and the Bell Towers: Architecture and Politics at the Vatican*, New Haven and London, 2002.

4 Roethlisberger, 1968, I, pp.88–9, no.42, II, fig.42.

Notes to no.23

1 Roethlisberger, 1961, I, p.49.

2 *Ibid.*, p.56. The subject of Claude's difficulty with figures is discussed in London, 1994, pp.12–13.

3 The inscription on the verso of the record drawing in the *Liber Veritatis* gives the name of the buyer as 'Sr Lorette'. He has not been identified, nor does he seem to have commissioned any other works. See Roethlisberger, 1961, I, p.302.

4 The practice of working up figure studies into more finished sheets through the addition of trees and wash can be seen in other examples from around this time; see Oxford and London, 1998, nos 68 and 78.

Notes to no.24

1 See Haverkamp-Begemann *et al.*, 1999, pp.306–9, no.109.

2 Washington and Paris, 1982, p.288.

3 Rosenberg and Prat, 1994, I, pp.68–9, no.36.

4 From certain iconographic details (Cupid pouring water for Perseus, Pegasus tied to the palm tree, etc.), it has been determined that Poussin and Claude were using Giovanni Andrea dell'Anguillara's Italian translation of Ovid first published in 1561; see Washington and Paris, 1982, p.288.

5 Roethlisberger in 1968, I, pp.392–3, no.1067, reads the date as 1671, and this is followed by Russell in Washington and Paris, 1982, p.292, no.72. Interestingly, when Roethlisberger mentioned the drawing in his 1961 catalogue of the paintings (I, p.435), he read the date as 1674, which is more likely to be correct. Moreover, the Holkham study employs the colour scheme of blue paper and white heightening present in all the composition studies but the first.

6 Roethlisberger, 1968, I, p.392, under no.1067.

Notes to no.25

1 For a full study of the *Liber Veritatis*, see Kitson, 1978.

2 Quoted in Kitson, 1978, p.20.

3 Washington and Paris, 1982, pp.289–90.

Notes to no.26

1 Grenoble, Rennes, and Bordeaux, 1989, p.194, no.131.

2 *Ibid.*

3 Friars of this Franciscan order had beards and tonsures, and wore sharp-pointed capuches or hooded cloaks.

4 *Ibid.*, pp.136–9.

5 *Ibid.*, pp.188–91.

6 Now in the Musée des Beaux-Arts, Rouen; *ibid.*, pp.192–3, no.128.

Notes to no.27

1 In his cataloguing of the present sheet Alain Mérot mentions that there was a drawing entitled *Renommée (Fame)* in 'crayon noir et blanc' in the Nourri sale, Paris, 24 February 1785, part of lot 986, Mérot, 2000, p.335, no.D.367. This could not refer to the British Museum sheet, of course, which had already entered the collection in 1769.

2 Mérot, 2000, pp.78–9.

3 Mérot, 2000, p.218, no.D.175.

4 *Ibid.*, p.313, no.D.314, fig.444.

5 Guillet de Saint-Georges, p.154, quoted in Mérot, 2000, p.313.

6 Mérot, 2000, p.313, nos D.315 and D.316, both Musée du Louvre, Paris. The possibility that the London drawing might relate to the *Allegory of the French Monarchy* was raised but rejected by Mérot on the basis of the compositional studies; *ibid.*, p.314.

Notes to no.28

1 Cited in Jaffé, 2002, p.673.

2 *Mostra di disegni francesi da Callot a Ingres*, Gabinetto Disegni e Stampe degli Uffizi,

Florence, catalogue by Pierre Rosenberg, 1968, pp.42–4, no.35, fig.29, and Brejon de Lavergnée, 1981, pp.445–55.

3 Roger-Armand Weigert, *Inventaire du fonds français, Graveurs du XVIIe siècle*, III, Paris, 1954, pp.476–7, nos 6–17. The London drawing is a study for no.10, *Bacchanale*.

4 Turner, 1980, p.134, no.58 and erratum slip.

5 Brejon de Lavergnée, 1981, pp.445–55.

6 Milan, 1985, p.50; Succi Ltd; acquired in 1992 by a private collector, England.

7 In her 1981 article, Barbara Brejon de Lavergnée published as by Dorigny a *Silenus Hoisted onto a Donkey by Three Satyrs* in the Albertina, Vienna. In 1997, she published the drawing again, putting forward Nicolas Chaperon (1612–c.1656) as the more likely author. See Brejon de Lavergnée, 1981, p.449, pl.35, and Barbara Brejon de Lavergnée, Nicole de Reyniès, and Nicolas Sainte Fare Garnot, *Charles Poerson, 1609–1667*, Paris, 1997, p.213, no.129.

8 Paris, 1989, pp.100–3, nos 30 and 31 (entries by Barbara Brejon de Lavergnée), and Paris, Geneva and New York, 2001, pp.222–7, nos 55–6.

9 Michel Dorigny, *Bacchanal*, black chalk, brush and grey wash, incised, 284 × 20.8 mm, Metropolitan Museum of Art, New York, Purchase, Stephen Geiger Gift and Harry G. Sperling Fund, 2001 (2001.120).

10 See note 6.

11 Paris, 1989, p.100, under no.30.

12 Boston, Ottawa and Paris, 1998, p.233, under no.124.

13 Paris, Geneva and New York, 2001, p.227, under nos 55–6.

14 Brejon de Lavergnée has charted an evolution in their manner proposing that Vouet's late compositional studies moved away from the Mannerist emphasis on wash and fluid effect and adopted a more straightforward reliance on black chalk and the clear delineation of outline; see Cambridge, Toronto, Paris, Edinburgh, New York and Los Angeles, 1998–2000, pp.106–7. Indeed, it is this late method, from the period when the two artists worked closely together, that forms the basis of Dorigny's style.

Notes to no.29

1 Renée Loche, *Catalogue raisonné des peintures et pastels de l'école française, XVIe, XVIIe et XVIIIe siècles*, Geneva, Musée d'Art et d'Histoire, 1996, pp.173–7, no.40.

2 Marcel Roux, *Inventaire du Fonds Français, Graveurs du XVIIIe siècle*, vol.7, Paris, 1951, pp.74–5, nos 2–4. Henry Jouin included the painting in his 1889 catalogue raisonné based on his knowledge of the print; see Henry Jouin, *Charles Le Brun et les arts sous Louis XIV.*

Le Premier peintre, sa vie, son oeuvre, ses écrits, ses contemporains, son influence, Paris, 1889, p.463.

3 Nagoya and Tokyo, 2002, p.96, no.49, and New York, Fort Worth and Ottawa, 1990, pp.64–5, no.15.

4 *Charles Le Brun, 1619–1690, Peintre et dessinateur*, exh. cat., Château de Versailles, July–October 1963, p.33, under no.14 (entry by Jacques Thuillier).

Notes to no.30

1 Petitjean and Wickert, 1925, pp.303–4, no.168. The caption for the print describes it as done from life.

2 Ibid., pp.303–4, and Sir Paul Harvey and J.E. Heseltine, *The Oxford Companion to French Literature*, Oxford, 1966.

3 Cleveland, Cambridge and Ottawa, 1989, p.201.

Notes to no.31

1 Hedley, 2002, pp.208–9. Her study of the Montagu House commission and its iconography is forthcoming.

2 See Stuffman, 1964, pp.76–80 and 105.

3 Ovid, *Metamorphoses*, Frank Justus Miller, translator, Cambridge, Mass. and London, 1977, Book II, 111–116; 143–5.

4 As suggested in the auction catalogue, Christie's, New York, 30 January 1998, lot 226. These three figures are identified as the moon, the sun and the stars by Margret Stuffman based on the Scharf watercolour; see Stuffman, 1964, p.79.

5 *The Draughtsman's Art: Master Drawings in the Whitworth Art Gallery*, catalogue by Michael Clarke, Whitworth Art Gallery, Manchester, 1983, p.5, no.6, pl.II. *A Figure of an Hour with an Urn* (Städelsches Kunstinstitut, Frankfurt) has also been cited as a study, although its looser and softer handling of the chalk may indicate a later date; see Hedley, 2001, p.243.

6 Hedley, 2001, p.248.

Notes to no.32

1 Cuzin, 1981, pp.19–21.

2 Hedley, 2001, pp.223–59.

3 Cuzin, 1981, pp.20–1.

4 See Hedley, 2001, p.254, fig.41.

5 Rosenberg and Prat, 1996, I, p.XX.

6 See Cuzin, 1981, p.21, and Hedley, 2001, pp.248 and 254.

Notes to no.34

1 *Inventaire du fonds français, Graveurs du XVIIe siècle*, vol. 8: *Sébastien Leclerc I*, catalogue by Maxime Préaud, Bibliothèque Nationale de France, Paris, 1980, pp.235–8, no.859.

2 Maxime Préaud, '"L'Académie des sciences et des beaux-arts": le testament graphique de Sébastien Leclerc', *Racar*, X, no.1 (1983), pp.73–81.

3 Ibid.

4 Ibid., p.74 note 7.

5 *Inventaire du fonds français, Graveurs du XVIIe siècle*, vol. 8, 'Sébastien Leclerc I', catalogue by Maxime Préaud, Bibliothèque Nationale de France, Paris, 1980, pp.334–5, 337, no.1309. Leclerc's self-referential tendencies are further evident in the preparatory drawing for the unfinished print of the cabinet in the École des Beaux-Arts, Paris (inv.1168), in which a rudimentary sketch of *The Academy of Sciences and Fine Arts* appears as a framed image on the wall, just below the window on the left. See *Colbert, 1619–1683*, Hotel de la Monnaie, Paris, 4 October–30 November 1983, pp.371–2, no.525 (entry by Françoise Magny).

6 Pen and black ink, brush, and grey and brown wash, 204 × 354 mm (inv.1159). See *Colbert, 1619–1683*, Hotel de la Monnaie, Paris, 4 October–30 November 1983, pp.368–70, no.524 (entry by Françoise Magny). Two other drawings have been associated with the composition. A red chalk drawing in the Ecole des Beaux-Arts was considered by Préaud as an initial idea for the composition, but its use of an allegorical female figure and a group of putti instead of savants and students, as well as obvious differences in setting and format, leave this suggestion in the realm of hypothesis. See Paris, 1989, pp.124–5, no.42 (entry by Maxime Préaud). A drawing in the Städelschen Kunstinstitut, Frankfurt (inv. 1105), mentioned in *Colbert, 1619–1683*, op. cit., p.368, under no.524 and in the subsequent literature as a preparatory work, appears from the photograph to be so close to the print as to be done after it. Moreover, it includes numerous details that do not appear in the early states of the print, but were only all added by the seventh state. Dr Martin Sonnabend of the Graphische Sammlung has kindly examined the drawing and concurs with this judgement (correspondence, 10 October 2003). For a description of the states, see *Inventaire du fonds français, op. cit.*, pp.235–8.

Notes to no.35

1 Per annotations on the verso in the hand of Charles Francis Bell. Similar annotations can be found on the verso of a drawing by Hyacinthe Collin de Vermont in the Ashmolean Museum, Oxford (1964.16.4; see Whiteley, 2000, I, p.211, no.661), and on the verso of a copy after Annibale Carracci attributed to Carlo Cignani in the Courtauld Institute of Art, London (D.1952.RW.3814). E.E. Pulteney has not been identified, although an Elizabeth Evelyn Pulteney of Ashley, Northamptonshire married Major Arthur Gerald Boyle on 7 June 1890; see Brian Tompsett, University of Hull, UK, 'Directory of Royal Genealogical Data',

http://www3.dcs.hull.ac.uk/cgi-bin/gedlkup/n=royal?royal25318, accessed 15 April 2005.

2 Chennevières and Montaiglon, 1851–60, II (1853–4), p.7.

3 Catherine Monbeig-Goguel, 'Taste and trade: the retouched drawings in the Everard Jabach collection at the Louvre', *Burlington Magazine*, CXXX, no.1028, pp.821–35.

4 See Nicole Hanotaux, 'De nouvelles attributions pour les peintures murales des refectoires des soldats aux Invalides', *Revue de la Société des Amis du Musée de l'Armée*, no.102 (December 1991), pp.12–23. Jean-Claude Boyer drew my attention to this article in connection with the British Museum drawing (correspondence, 4 January 2005).

5 Beauvais, 2000, I, pp.151–280.

6 Gaston Brière, 'Van der Meulen collaborateur de Le Brun', *Bulletin de la Société de l'Histoire de l'Art francais*, 1930, pp.150–56. See also Fabian Stein, *Charles Le Brun, La Tenture de l'Histoire du Roy*, Worms, 1985, and *A la gloire du Roi, Van der Meulen, peintre des conquêtes de Louis XIV*, Musée des Beaux-Arts de Dijon, 9 June–28 September, 1998, and Musée d'Histoire de la Ville de Luxembourg, 29 October 1998–17 January 1999, pp.142–60.

Notes to no.36

1 See sale catalogue, Pierre Crozat, Paris, 10 April–13 May 1741, lot nos 1027, 1034, 1037 and 1040. Lot 1027 is described as 'douze Desseins, dont son portrait fait par lui-même pendant son séjour à Rome', although an annotated copy of Crozat's sale catalogue, sold Christie's, New York, 23 January 2002, lot 80 (notice by Nicolas Schwed), and now in the Bibliothèque Nationale de France, Paris, lists the buyer of that lot as Nourri, not Mariette. The annotations describe lot 1037 as bought by Gouvernay and given to Mariette, although the printed description of that lot states that it was engraved by Vermeulen (see fig.1, a composition that does not correspond to the British Museum drawing). On Crozat's collection, see Cordélia Hattori, 'À la recherche des dessins de Pierre Crozat', *Bulletin de la Société de l'Histoire de l'Art Français* (1997), pp.179–208. His early purchase of La Fage drawings is mentioned on page 180.

2 Chennevières and Montaiglon, 1851–60, III (1854–6), p.30.

3 'Et vultum et mores exprimit ipse suous'; the English translation was kindly provided by Michael Tinkler.

4 Chennevières and Montaiglon, 1851–60, III (1854–6), p.38; Crozat sale catalogue, *op. cit.*, lot 1037; and M. Bénard, *Cabinet de M. Paignon Dijonval*, Paris, 1810, p.129, no.2992. Catalogued with the lost works known

through engravings in Toulouse, 1962, p.104, no.442.

Notes to no.37

1 Paulette Choné et al., *Claude Gillot (1673–1722), Comédies, sabbats et autres sujets bizarres*, Musée d'art et d'histoire de Langres, 2 July–27 September 1999, p.154. See also Populus, 1930, nos 1–4, pp.75–9.

2 See New York and Ottawa, 1999, no.56, pp.202–3.

3 The models for *Birth* and *Marriage* are in the Graphische Sammlung Albertina, Vienna. A preparatory study for the burial scene in pen and ink alone is in the Horvitz collection; see Cambridge, Toronto, Paris, Edinburgh, New York and Los Angeles, 1998–2000, no.33, pp.166–7. For the prints, see Populus, 1930, nos 5–8, pp.79–82.

4 Populus, 1930, nos 227–230, pp.150–153.

5 The four drawings remained together until they were acquired by Samuel Woodburn, after which they were separated into two pairs. *War* and *Riches* are recorded in the Greverath sale, 7 April 1859, lot 30, and Sotheby's, London, 5 July 2000, lots 54 and 55. For *Riches*, see Paris, 2002, pp.138–9, no.57.

Notes to no.38

1 Grasselli assigned a date of c.1711–12 to the sheet in 1987 (p.454); Rosenberg and Prat concurred in 1996 (I, p.216).

2 See Posner, 1984, pp.53–4, fig.46.

3 A second preparatory drawing is known from a surviving counterproof; see Grasselli, 1987, I, pp.136–7, no.60, fig.126.

4 Rosenberg and Prat, 1996, I, p.216 suggest c.1714–15.

5 See Grasselli, 1987a, I, pp.230–1, and Rosenberg-Prat, 1996, I, pp.220–1, 516–17, nos 138 and 321.

6 See Pierre Rosenberg, *Vies anciennes de Watteau*, Paris, 1984, pp.61–2.

7 This despite the fact that the drawing had been engraved in the crayon manner as part of a set of six by Jean-Charles François (1717–69) known to be after works in the Dezallier d'Argenville collection; see Émile Dacier and Albert Vuaflart, *Jean de Jullienne et les Graveurs de Watteau au XVIIIe siècle*, Paris, I, 1929, pp.192–3.

8 His contribution is discussed in Rosenberg, 2000, pp.66–95. Dezallier D'Argenville's collection is the subject of Labbé and Bicart-Sée, 1996.

Notes to no.39

1 Quoted in Rosenberg, 2000, pp.78–9. For the full text, see Pierre Rosenberg, *Vies anciennes de Watteau*, Paris, 1984, pp.53–89.

2 As was pointed out by Grasselli, 1987a, I,

p.504, no.194.

3 Rosenberg and Prat, 1996, II, p.800.

4 See Grasselli, 1987a, I, pp.272–3, 289–90 note 72, 294 note 76, 297, and Washington, Paris and Berlin, 1984, pp.300–04, and 411–16.

Notes to no.40

1 The relationship of the two drawings was analysed by Grasselli in Washington, Paris and Berlin, 1984, p.157 (under no.83).

2 Rosenberg and Prat, 1996, II, p.876, give as examples nos 226, 520, 522, and 571, although that list is not exhaustive.

Notes to no.41

1 Her features and the manner of drawing both find parallels in a sheet of studies in the Institut Néerlandais, Paris; see Rosenberg and Prat, 1996, II, pp.944–5, no.557.

2 Washington, Paris and Berlin, 1984, pp.373–5, no.52.

3 *Ibid.*, pp.406–11, no.62.

Notes to no.42

1 *Animaux d'Oudry, Collection des ducs de Mecklembourg-Schwerin*, Musée National du Château de Fontainebleau, 5 November 2003–9 February 2004, and Musée National des Châteaux de Versailles et de Trianon, 5 November 2003–9 February 2004, pp.17–18 and nos 11–12, pp.62–5 (essay and entries by Danièle Véron-Denise). François Desportes had earlier painted portraits of dogs for Louis XIV (*ibid.*, p.17).

2 The most recent discussion of this issue is in *Animaux d'Oudry, op. cit.*, pp.142, 162–3, 186–202, nos 62–3 and 77–87 (essay and entries by Xavier Salmon).

3 A sleeping dog, albeit in a different pose, does appear in a canvas dated 1747, *Two Dogs with a Dead Partridge and a Dead Hare*; see Paris, 1982, no.117, pp.216–17.

4 *Ibid.*, no.124, pp.224–6.

Notes to no.43

1 There are multiple versions of both compositions; see Bordeaux, 1984, pp.93–7, nos 47–9.

2 See New York and Ottawa, 1999, pp.218–21, no.65.

3 Edmond and Jules de Goncourt, nineteenth-century aficionados of the Rococo style known for their flowery language, became rhapsodic when describing Lemoyne's painting, dwelling in particular on the figure of Omphale as a marvel: 'The wonderful luminosity of the skin, its moistness, its satin radiance, its pulpy whiteness, all that is downy, tender, and delicate in the naked glory of the female form as modeled by daylight, has been admirably rendered in this most polished *académie*'

(quoted by Colin B. Bailey in Paris, Philadelphia and Fort Worth, 1991).

4 Inv.30512.

5 Bénard, 1810, p.139, no.3249.

Notes to no.44

1 Versailles, 2001.

2 Bordeaux pointed out the similarity of their poses (see Bordeaux, 1984, p.172, no. D 149), although more recent scholars have preferred to associate the Rouen study with the figure of History; see Salmon, 2001, pp.114, 196, fig.99. While the question may never be resolved, the present author tends to see the Rouen drawing as an early study for Hebe's pose, made just after the Versailles maquette, but before the revisions to the composition.

3 Versailles, 2001, pp.40, 66, no.23.

4 Bénard, 1810, p.139, no.3254.

5 Another head of a woman in pastel, long conflated with the London Hebe, was in the P.-J. Mariette and Prince de Conti sales (see Paris 1967a, p.148, no.244). Gabriel de Saint-Aubin, who sketched the pastel in the margins of both of those sale catalogues, noted that it was not a study for Hebe, but rather for a figure in Lemoyne's painting for the Salon de la Paix at Versailles. See Émile Dacier, ed., Catalogues de ventes et livrets de Salons illustrés par Gabriel de Saint-Aubin, Paris, 1919, part X, pp.74–5.

Notes to no.45

1 Duplessis, ed., 1857, pp.305–6. The catalogue of the Grimod de La Reynière sale, Paris, 7–17 September 1797 (originally scheduled for 21 August 1797) did not include any mention of an album of Bouchardon drawings and prints.

2 Chennevières and Montaiglon, 1851–60, I (1851–3), p.164.

3 See Guilhem Scherf, 'Le portrait de Madame Vleughels, sculpté en 1732 par Bouchardon, revient en France pour entrer au Louvre', Revue du Louvre et des Musées de France, XLIX, no.2 (April 1999), pp.18–21, and Malcolm Baker, Colin Harrison, and Alastair Laing, 'Bouchardon's British Sitters: Sculptural Portraiture in Rome and the Classicizing Bust around 1730', Burlington Magazine, CXLII, no.1173 (December 2000), pp.752–62.

4 See Caylus, mécène du roi. Collectioner les antiquités au XVIIIe siècle, ed. Irène Aghion, Musée des Monnaies, médailles et antiques de la Bibliothèque Nationale de France, Paris, 17 December 2002–17 March 2003; René Démoris, 'Le comte de Caylus et la peinture, Pour une théorie de l'inachevé', Revue de l'Art, no.142 (2003–4), pp.31–43; and Samuel Rocheblave, Essai sur le comte de Caylus, l'homme, l'artiste, l'antiquaire, Paris 1889.

5 Paris, 1775, lot 1150. A misleading title page,

presumably added after 1775, suggests that the British Museum drawings were given by the artist to Mariette, although Parker effectively refuted this in 1930, pointing to Jean-Georges Wille's memoirs, where Wille mentions Bouchardon's drawings as sold in the 1765 Caylus sale. See Parker 1930b, pp.45–6. The counterproofs also appear in the catalogue of the estate sale of Augustin de Saint-Aubin, Paris, 1808, lot 14, reprinted in Emmanuel Bocher, Catalogue raisonné des estampes, vignettes, eaux-fortes, pièces en couleur au bistre et au lavis, de 1700–1800, Augustin de Saint-Aubin, Paris, 1879, p.242.

6 For the history of street crier prints, see Pitsch, 1952; Karen F. Beall, Kaufrufe und Strassenhändler, Hamburg, 1975; and Vincent Milliot, Les 'cris de Paris', ou le peuple travesti, Les représentations des petits métiers parisiens (XVe – XVIIIe siècles), Paris, 1995.

Notes to no.46

1 Paris, Philadelphia and Fort Worth, 1991, pp.348–55.

2 While he was working at La Chevrette, Natoire was also engaged to give drawing lessons to the children of the household. The third son, Ange-Laurent de La Live de Jully (1725–70), who went on to become an influential amateur, collector and patron, would have been about ten years old. See Bailey, 2002, pp.36–8.

3 Paris, Philadelphia and Fort Worth, 1991, pp.348–50.

4 The painting appeared at auction at Christie's, London, 5 July 1991, lot 66, and is also illustrated in colour in Bailey, 2002, p.177, fig.159.

5 Oil on canvas, 281.6 × 169.6 cm, gift of the Ahmanson Foundation (M.2001.80). Illustrated in the recent acquisitions supplement, Gazette des Beaux Arts, CXXXIX (March 2002), p.45, fig.89, and in Susanna Caviglia-Brunel, 'Des finalités du dessin chez Charles-Joseph Natoire', Revue de l'Art, 143 (2004, no.1), p.40, fig.7.

6 The stages of the preparatory process are discussed in Caviglia-Brunel, 2004, op. cit., pp.39–41.

Notes to no.47

1 Chennevières and de Montaiglon, 1966, vol. I, p.165.

2 New York, Detroit and Paris, 1986, pp.133–8, under nos 171–8, and Brunel, 1986, pp.59–71.

3 Laing, 1994. The illustration of the painting on p.77 is reversed.

4 Laing, 1994, p.78, fig.2.

5 Goldner, 1988, pp.140–1, no.59.

6 Laing, 1994, pp.78–9, fig.3.

7 See, for example, the Étude de nymphes, Musée des Beaux-Arts, Tours, in Paris, 2003, no.20,

pp.58–9, entry by Françoise Joulie, and New York and Fort Worth, 2003, pp.27–8, figs 17 and 18, essay by Alastair Laing.

Notes to no.48

1 For a discussion of the Boucher drawings in the Reynolds sale, see New York and Fort Worth, 2003, pp.152 and 248 (under no.55). Many lots were unsold in the 1794 sale and many sheets reappeared in subsequent sales. The sale that took place at Phillips, London, on 5 March 1798 and following days included as lot 1392 '2 Bauche'.

2 See Martin Royalton-Kisch in London, 1978, pp.61–75.

3 Sir Joshua Reynolds, Discourses on Art, ed. Robert R. Wark, London and New Haven, 1975, p.108.

4 Ibid.

5 New York and Fort Worth, 2003, p.248, under no.55 note 1.

6 Reynolds, op. cit. (note 3), pp.224–5, and New York and Fort Worth, 2003, pp.152–3, 239 and 248, no.55.

7 Reynolds's second trip to Paris in 1771 was five months after Boucher's estate sale. Appendices listing sales where Reynolds acquired works of art can be found in London, 1978, pp.89–91.

8 This view of a girl's head in profil perdu, considered a quintessential Boucher motif, was found by Françoise Joulie to have its source in a print after Abraham Bloemaert. See Boucher et les peintres du Nord, catalogue by Françoise Joulie, Musée Magnin, Dijon, 8 October–14 December 2004, and Wallace Collection, London, 6 January–6 March 2005, pp.80–3.

9 Similar figures can be found in the foreground of The Rape of Europa (Musée du Louvre, Paris), painted in 1747, and a camieu brun oil sketch of a pastoral scene, dated by Alastair Laing to the late 1750s; see Old Master Drawings, C.G. Boerner, Inc., New York, 23 January–8 February 2002, n.p., no.23.

10 Nicholas Penny, ed., Reynolds, New York, 1986, pp.218–19, no.51.

Notes to no.49

1 Paul Scarron, Don Japhet d'Arménie, ed. Robert Garapon, Paris, 1967, p.XXXI.

2 Launay, 1991, pp.413–15, under no.251. Le Sicilien and Le Misanthrope are illustrated in the Leboeuf de Mongermont sale catalogue, Galerie Georges Petit, Paris, 16–19 June 1919 (lots 269–70). Georges Dandin is mentioned in Le Théatre a Paris (XVIIe–XVIIIe siècles), 19 March–4 May 1929, Musée Carnavalet, Paris, p.36, no.182.

3 Aaron [1993], p.18, no.55.

4 They also point to Pierre's involvement with the Duc d'Orléans's private theatre in 1754; correspondence, 10 September 2004.

Notes to no.50

1 Florence Ingersoll-Smouse, *Joseph Vernet, peintre de marine, 1714–1789, Étude critique suivie d'un catalogue raisonné de son oeuvre peint*, Paris, 1926, II, p.10, no.819, pl.LXXXIV, and Pierre Arlaud, *Catalogue raisonné des estampes gravées d'après Joseph Vernet*, Avignon, 1976, p.61, no.229. The print, by Jacques Philippe Le Bas, is dated 1771 and is based on a painting of c.1765.

Notes to no.51

1 78 refers to the artist's age at the time he made the drawing, not the date.
2 'Les Mémoires de Joseph-Marie Vien', reprinted in Gaehtgens and Lugand, 1988, p.318.
3 *Ibid.*, pp.317–18.
4 Gaehtgens and Lugand, 1988, pp.252–66, nos 144–81, 188–96 and 197–253.
5 See Anne Eschapasse, 'William Beckford in Paris, 1788–1814: "Le Faste Solitaire"', in *William Beckford, 1760–1844: An Eye for the Magnificent*, ed. Derek E. Ostergard, Bard Graduate Center, New York, 18 October 2001–6 January 2002, and Dulwich Picture Gallery, London, 5 February–14 April 2002, pp.99–115.
6 The name Wyatt is put forward in Gaehtgens and Lugand, 1988, p.110 note 381.
7 The British Museum acquired at the same time another sheet from the series, *L'Amour obtient son pardon* (1932-5-16-1). A group of three also went to the Courtauld Institute, London; see Gaehtgens and Lugand, 1988, pp.255–6, nos 159, 167 and 171.

Notes to no.52

1 Per British Museum database; the verso cannot be seen. The siblings referred to in the inscription would have been Louis François Alexandre de Jarente Senas-d'Orgeval, Abbé Commandataire de Saint-Eloy de Noyon, Évêque d'Orléans, who was bishop from 1788 to 1802, and Suzanne-Françoise-Elizabeth de Jarente d'Orgeval (1733–1815), who married the wealthy *fermier général* (tax collector), Laurent Grimod de La Reynière; see Bailey, 2002, pp.209–11.
2 Lédans certainly owned more than 152 portraits by Carmontelle. The catalogue of his sale may contain a typographical error.
3 Gruyer, 1902, no.273, pp.197–8.
4 Pierre-Joseph Richard de Lédans, 'Appel nominal des portraits composant le Receüil de feu Mr. de Carmontelle', Paris, 1807, manuscript, Musée Condé, Chantilly. The discussion of Madame de La Croix appears on pp.79–80 of the 1902 manuscript copy by Gustave Macon (the original is unpaginated).
5 The Lédans manuscript, *op. cit.*, after listing the contents of the thirteen albums, records the presence of further portraits in various groupings, under headings such as, '1re colonne de droite', which included a 'marquise de La Croix, née Gérante', p.119, no.574, which presumably refers to the London drawing.
6 Harold Koda (telephone conversation, 18 June 2004) relates the marquise's hairstyle to one made popular by Joseph Legros de Rumigny between 1768 and 1772. See Joseph Legros de Rumigny, *L'art de la coëffure des dames françoises, avec des estampes, ou sont représentées les têtes coeffées*, Paris, 1767–70.
7 Gruyer 1902, pp.197–8.
8 Gruyer 1902, p.197.

Notes to no.53

1 Quoted in English translation in Richard P. Wunder, 'Charles Michel-Ange Challe: A Study of his Life and Work', in *Apollo*, LXXXVII (January 1968), p.26, and in French ('[C]e Challe a rapporté d'Italie dans son porte-feuille quelques centaines de vues dessinées d'après nature où il y a de la grandeur et de la vérité. Monsieur Challe, continuez à nous donner des vues mais ne peignez plus ...') in Rome, Dijon and Paris, 1976, p.72, under no.20 (entry by Jean-François Méjanès).
2 Sale, Paris, 9 March 1778 and following days (Lugt 2800).
3 Amsterdam and Paris, 2003, pp.144–7, no.46.
4 Bean, 1986, pp.56–7, no.53.

Notes to no.54

1 In this regard, one can note Saint-Aubin's fascination with the jointed, posable mannequin in the boutique of Mlle Saint-Quentin that he recorded in two drawings in 1777; see Rosenberg, 2002, pp.98–101, nos 31–2.
2 Dacier, 1929–31, II (1931), p.95, nos 543–4.
3 Rosasco, 1980, pp.51–7.
4 Goncourt, 1880, I, p.431.
5 See Atlanta, 1983, pp.50, 57–8, no.19.
6 *Allegory of Archeology* was reproduced in colour when the pair was sold in 1980 (Hôtel Drouot, Paris, 15 December 1980, lot 40).

Notes to no.55

1 Emma Barker (*Greuze and the Painting of Sentiment*, Cambridge, 2005) discusses the terms 'sentiment' and *sensibilité* and their place in the art-historical literature.
2 The subject is explored in *Farewell to the Wet Nurse: Etienne Aubry and Images of Breast-Feeding in Eighteenth-Century France*, catalogue by Patricia R. Ivinski *et al.*, Sterling and Francine Clark Art Institute, Williamstown, Massachusetts, 12 September 1998–3 January 1999.
3 See Hartford, San Francisco and Dijon, 1976, p.100, under no.42.
4 Quoted in Hartford, San Francisco and Dijon, 1976, p.96, under no.40. I have adapted Edgar Munhall's translation.
5 *Ibid.*, p.96.
6 Norton Simon, 1969–78; to Robert Light; sold Sotheby's, New York, 16 January 1985, lot 119 (together with a pendant, *The Departure for the Wet Nurse*), acquired by Wildenstein and Co., New York. The pair was then split, with *The Return from the Wet Nurse* acquired by Flavia Ormond Fine Arts Limited, London, and now in a private collection. For earlier provenance, see Hartford, San Francisco and Dijon, 1976, p.98.

Notes to no.56

1 For an exhaustive study of the journey and the drawings, see Rosenberg and Brejon de Lavergnée, 2000, and for a useful review of the 1986 edition of this, Laura Mascoli, 'Le Journal du voyage en Italie de l'abbé de Saint-Non (1759–1761)', *Dix-huitième Siècle*, no.21 (1989), pp.423–38.
2 Le Noir, 1816, quoted in Rosenberg and Brejon de Lavergnée, 2000, p.54.
3 See Rosenberg and Brejon de Lavergnée, 2000, p.424, for their itinerary.
4 The canvas is untraced today, although what was probably a variant was exhibited in Venice in 1947 as by Luca Giordano (1643–1705). In that version the setting is a moonlit landscape with two additional female onlookers in the background to the left. See *Quattrocento pitture inedite*, catalogue by Alberto Riccoboni, Venice, 1947, p.15, no.99, pl.96.
5 This very plausible suggestion, that it is Saint-Non's hand we see in the reworked counterproofs from this trip, was made by Rosenberg and Brejon de Lavergnée, 2000, p.326.
6 Pigache sale, Paris, 21 October 1776. The copy with illustrations by Saint-Aubin is in the Bibliothèque Nationale de France, Paris. Page 74, with the counterproof after *The Flight of Cloelia*, is illustrated in Rosenberg and Brejon de Lavergnée, 2000, p.334. The counterproof was also illustrated in the catalogue of the sale of the collection of Madame X***, Galerie Charpentier, Paris, 6 April 1957, lot 2.
7 Of the sixteen prints, two bear the date '1764'. See Georges Wildenstein, *Fragonard aquafortiste*, Paris, 1956, pp. 19, 25 and 28, nos, X, XVI and XIX.

Notes to no.57

1 The Durazzo family and their role in the cultural life of Genoa is the subject of Osvaldo Raggio, *Storia di una passione, Cultura aristocratica e collezionismo alla fine dell'ancien régime*, Venice, 2000.
2 Rosenberg and Brejon de Lavergnée, 2000, pp.412–13, nos 319–321.

3 Charles-Nicolas Cochin, *Le Voyage d'Italie* (original edn Paris, 1758), ed. with an introduction and annotations by Christian Michel, Rome, 1991, p.436.

4 Carlotta Cattaneo Adorno et al., *Il Palazzo Durazzo Pallavicini*, Bologna, 1995, pp.249–51, no.121.

5 *Ibid*, p.250.

6 Louis Guimbaud, *Saint-Non et Fragonard, d'après des documents inédits*, Paris, 1928, p.197, no.55, ill. opp. p.64.

7 Paris and New York, 1987, pp.232–5 and 310–12, nos 110 and 147.

Notes to no.58

1 New York, 1997, II, p.53, no.475.

2 Ananoff, III, 1968, p.26, no.1177.

3 See Paris and New York, 1987, pp.432–6, nos 203–6; Launay, 1991, pp.291–2, nos 92–3; New York, 1999, pp.174–5, no.75; and Amsterdam and Paris, 2003, pp.192–6, nos 65–6. Several sheets have also appeared on the market in recent years, including *A Standing Young Woman* (Colnaghi, *Master Drawings*, 9 May–1 June 1990, no.39) and *La coquette*, Sotheby's, New York, 28 January 1998, lot 56.

4 Washington, Cambridge and New York, 1978, p.136, under no.54. For Pierre Rosenberg, the inscription is not in Fragonard's hand, but is nonetheless credible; see Paris and New York, 1987, p.568, under no.298.

5 This dating, long hypothesized, was confirmed by the discovery of an anonymous print at the time of the Fragonard exhibition in 1987–8 identifying one of the sitters as Adam Nalet, a lawyer in Négrepelisse. The print is illustrated in the English edition of the catalogue, Paris and New York, 1987, p.409 (under no.198) and discussed in Nicq and Nicq, 1996, p.54, under no.22.

6 Washington, Cambridge and New York, 1978, p.136 (under no.54).

7 See Amsterdam and Paris, 2003, pp.230–33, no.78, and New York, 1999, pp.220–21 (entry by Perrin Stein).

Notes to no.59

1 Pen and brown and black ink, with watercolour, over black chalk, 378 × 604 mm (1872-1-13-366), inscribed in pen and brown ink H *Roberti* FF. 1765 ('FF', presumably for fecit Fiumicino).

2 The sketchbook, from the collection of the Marquis de Ganay, was exhibited in *Hubert Robert, Louis Moreau, Exposition du cent-cinquantenaire de leur mort*, Galerie Cailleux, Paris, 26 November–20 December 1957, pp.17–19, no.1, and Washington, 1978, pp.74–5, no.24. The sketchbook was broken up and sold at Sotheby's, Monaco, 1 December 1989, lots 1–68. For the British Museum

watercolour, Robert presumably made use of lot 30, a study of a beacon (also the basis for Robert's etching, *Le poteau*, 1764, from *Les soirées de Rome*), and lot 40, depicting a felucca docked near a fort.

3 See Washington, 1978, pp.76–7, 94, 95, nos 25 and 34, and Katharine Baetjer, *European Paintings in The Metropolitan Museum of Art by Artists born before 1865*, New York, 1995, pp.382–3, nos 35.40.2 and 17.190.28.

Notes to no.60

1 Alexandre Ananoff, 'Fragonard et Ango, collaborateurs de Saint-Non', *Bulletin de la Société de l'Histoire de l'Art Français* (1963), pp.117–20, and Ananoff, 1965.

2 See Marianne Roland Michel, 'Un peintre français nommé Ango … ', *Burlington Magazine*, no.40 (December 1981), supplement, pp.ii–viii; *Rome 1760–1770, Fragonard, Hubert Robert, et leurs amis*, exh. cat., Galerie Cailleux, Paris, 1983, nos 2–10, n.p.; and Raoul Ergmann, 'La collection inédite du bailli de Breteuil', *Connaissance des Arts*, no.413–14 (July–August 1986), pp.70–5.

3 Pierre Rosenberg, 'La fin d'Ango', letter, *Burlington Magazine*, CXXIV (April 1982), pp.236–9.

4 Alexandre Ananoff proposed an attribution to Ango in 1965, although his suggestion does not seem to have been noted in the files of the British Museum. See Ananoff, 1965, pp.165–6.

5 The four albums at the Cooper-Hewitt National Design Museum, New York contain typical examples. See Phyllis Dearborn Massar, 'Drawings by Jean-Robert Ango after Paintings and Sculpture in Rome', *Master Drawings*, vol.36, no.4 (1998), pp.35–46, and New York, 1999, no.40, pp.92–4 (entry by Perrin Stein).

6 The album of eighty-eight drawings has remained with the Bailli de Breteuil's descendants, although the collection itself was dispersed. See *Un grand collectionneur sous Louis XV, Le cabinet de Jacques-Laure de Breteuil, Bailli de l'Ordre de Malte 1723–1785*, exh. cat., Château, Breteuil (Oise), 1 May–11 November 1986, p.10, nos 40–3.

Notes to no.61

1 *Drawings by Jean-Baptiste Le Prince for the 'Voyage en Sibérie'*, catalogue by Kimerly Rorschach, Rosenbach Museum & Library, Philadelphia, 17 October 1986–4 January 1987; Frick Art Museum, Pittsburgh, 29 January–29 March 1987; and The Frick Collection, New York, 21 April–14 June 1987, p.33, cat.28.

Notes to no.62

1 A detailed chronology of Desprez's life and travels assembled by Bruno Chenique can be found in *La chimère de Monsieur Desprez*,

catalogue by Régis Michel et al., Musée du Louvre, Paris, 10 February–2 May 1994, pp.207–34.

2 Lamers, 1995, pp.278–81, nos 282–5.

3 *Ibid.*, pp.278–81, nos 282 and 284.

4 *Ibid.*, pp.279–80, no.283a.

Notes to no.63

1 Laure Hug, 'Recherches sur la biographie du peintre Jean-Baptiste Huet, 1745–1811', *Bulletin de la Société de l'Histoire de l'Art Français*, 1998, pp.159–73. An index of names cited in the inventories appears on p.173.

2 Arthur M. Hind, *Catalogue of Drawings by Dutch and Flemish Artists Preserved in the Department of Prints and Drawings in the British Museum*, III, London, 1926, p.29, no.13, pl.XVI.

3 *Ibid.*, p.29.

4 See Françoise Joulie, *Boucher et les peintres du nord*, exh. cat., Musée Magnin, Dijon, 8 October–14 December 2004, and Wallace Collection, London, 6 January–6 March 2005.

5 Numerous canvases are referred to as Caravans or Rests on the Flight to Egypt in the inventory of Huet's estate, making the identification of specific works difficult. See Hug, *op. cit.*, pp.169–72.

6 For the former, see Didier Aaron, New York, *French Master Drawings*, 16 May–9 June 1984, no.21, fig.34. The latter appears in the 'cinquième cahier' of Huet's *Oeuvre*, no.30.

Notes to no.64

1 Rosenberg and Prat, 2002, I, pp.391–746, II, pp.754–830.

2 A tiny sketch that may represent a preliminary study for the bed in the British Museum drawing appears in the recently rediscovered album 5 (p.21 verso, lower left). See Pierre Rosenberg and Benjamin Peronnet, 'Un album inédit de David', *Revue de L'Art*, vol.142 (2003, no.4), p.76, no.79.

3 *Louis David, 1748–1825, Dessins du premier séjour romain, 1775–1780*, Galerie de Bayser, Paris, 1–15 December 1979 (catalogue by Marc Simonet-Lenglart), no.46, n.p.

4 Rosenberg and Prat, 2002, I, pp.55–7, no.34.

5 For other sketches from the Roman albums that have been related to *Andromache Mourning Hector*, see Rosenberg and Prat, 2002, I, p.462, no.558 verso, p.646, no.962 verso, p.648, no.965 verso, p.651, nos 972 and 973 verso, and p.656, no.982.

Notes to no.65

1 Rosenberg and Prat, 2002, I, pp.104–11, nos 90–8.

2 Bronze, 69 cm, Cardinal de' Carpi donation (1564), Capitoline Museums, Rome (inv. MC1183). A 1774 copy of the bust by François-André Vincent (1746–1816) is in the Hood

Museum of Art, Dartmouth College, Hanover, New Hampshire (D.988.16).

3 Rosenberg and Prat, 2002, I, p. 92, no.75 bis. In year 2 of the revolutionary calendar (1793–4) Granet would have been about eighteen years old and living in Aix-en-Provence.

4 Paris and Versailles, 1989, p.587, and Daniel and Guy Wildenstein, *Documents complémentaires au catalogue de l'oeuvre de Louis David*, Paris, 1973, p.104, no.1043.

5 Robert L. Herbert, in his 1972 monograph on David's *Brutus*, devotes a chapter to 'David, Brutus, and Martyrs to Liberty, 1793–4'; see Robert L. Herbert, *David, Voltaire, Brutus and the French Revolution: An Essay in Art and Politics*, London, 1972, pp.95–112.

6 Wildenstein, *op. cit.*, p.49, no.414. The importance of the Capitoline bust to David was even understood by Napoleon who, in distributing looted art from Italy, presented it to David for his cabinet in the Tuileries Palace; see Wildenstein, *op. cit.*, p.151, no.1336.

Notes to no.66

1 'La nature l'avait créé peintre', *Pierre-Henri de Valenciennes 1750–1819*, Musée Paul-Dupuy, Toulouse, 19 March–30 June 2003, pp.106–11, nos 124–9.

2 'La perspective linéaire assure la justesse, la vérité et la grâce des contours; mais elle ne constitue que le dessin et la composition; au lieu que le perspective aérienne, jointe à la linéaire, et bien entendue, forme ce qu'on appelle un tableau, ou la représentation fidèle de la nature', from Valenciennes' *Élémens de perspective pratique, à l'usage des artistes*, Paris, 1800, reprinted Geneva, 1973, quoted in Toulouse, 2003, *op. cit.*, p.106.

Notes to no.67

1 Cited in Paris and New York, 1997, pp.43–4. A copy of the sale catalogue has not been located.

2 Clément, 1880, p.83 note 1. For the pendant, see Paris and New York, 1997, pp.43–5, fig.7a, as 'location unknown'.

3 See Guffey, 2001, pp.17, 19, figs 1 and 2.

4 Paris and New York, 1997, p.45.

5 Echoes of the *Psyche* composition can be found a decade later in *Joseph and the Wife of Potiphar*, private collection, illustrated in Elderfield and Gordon, 1996, p.25.

Notes to no.68

1 This dating follows that proposed by Sylvain Laveissière; the reasoning behind it is given in Paris and New York, 1997, pp.255–6.

2 *Ibid.*, pp.29–30. The London sheet, like many of the series went at Prud'hon's death to his friend and former student Charles-Pompée Le Boulanger de Boisfremont, in whose apartment he lived in his final years.

3 In the case of the *Standing Female Nude Holding a Lyre*, the pose is similarly reversed and contains numerous differences when compared to the design for the statue, *Poetry*. See Paris and New York, 1997, p.266, no.190.

Notes to no.69

1 Benoit, 1994, pp.142–3, no.D.71.

2 Hennequin recounts his impressions of the commodore and the circumstances of the commission in his *Mémoires*, 1933, pp.186–8.

3 *Ibid.*, p.145, under no.D.73. See also Bordes, 1979, p.210 note 20.

4 The episode of Smith's capture is recounted and various letters relating to the period of his incarceration reprinted in Lord Russell of Liverpool, *Knight of the Sword: The Life and Letters of Admiral Sir William Sidney Smith*, London, 1964, pp.51–63.

5 Benoit, 1994, p.230, no.G.5.

6 *Ibid.*, pp.211–14, nos D.306–D.308. Another version appeared on the market in 2001; see sale catalogue, Etude Tajan, Hôtel Drouot, Paris, 6 July 2001, lot 158.

Notes to no.70

1 This subject is explored in Tony Halliday, 'Academic Outsiders at the Paris Salons of the Revolution: the Case of Drawings *à la manière noire*', *Oxford Art Journal*, vol.21, no.1 (1998), pp.69–86.

2 'Exposition des tableaux faite par mm. les artistes libres', in *Collection de pièces sur les beaux-arts (1673–1808), dite Collection Deloynes*, Bibliothèque Nationale de France, Paris, 1980 (microfiche), vol.17, no.428, p.8; see also vol.17, no.439, p.319, cited in Halliday, *op. cit.*, p.71 note 3.

3 Isabey's submissions to the Exposition de la Jeunesse included no.100, 'miniature en pieds, portrait de femme assise dans un bois', and no.101, 'plusieurs portraits dessinés d'après nature, dans la manière anglaise.' Cited in Sanchez, 2004, II, p.872. His exhibits at the Salon of the same year were not listed in the official *livret* (catalogue) and are only known from contemporary reviews; see note 2.

4 Illustrated in Halliday, 1998, p.78, fig.6.

Notes to no.71

1 Naef, 1966, pp.37–50.

2 London, Washington and New York, 1999, p.174.

3 Naef, 1977, pp.240–5, nos 132–4.

Notes to no.72

1 Vigne, 1995, pp.406–8. See also Véronique Burnod, *Fantasme d'Ingres: Variations autour de la Grand Odalisque*, exh. cat., Musée de Cambrai, 16 June–30 October 2004, n.p., nos 17–22.

2 Vigne, 1995, p.407, no.2293.

3 Vigne, 1995, p.407, no.2294.

4 Quoted and translated in London, Washington and New York, 1999, p.329, essay by Christopher Riopelle.

5 *Ibid.*, pp.535–36, essay by Georges Vigne, and Naef, 1968.

6 *Ingres & Marcotte, Lettres, documents, dessins et gravures*, ed. Mària van Berge-Gerbaud, Fondation Custodia, Paris, 22 February–1 April 2001, p.37, no.36.

7 Naef, 1968, pp.82–3.

Notes to no.73

1 An example of one of the *Ignudi*, the nude youths on the Sistine Chapel ceiling, is illustrated in Whitney, 1997, pp.121–2, fig.159.

2 Eitner, 1953, pp.59–60, fig.3 and Eitner, 1983, p.92, fig.75.

3 Eitner, 1963, p.24.

4 Tinterow, 1990, pp.34–6, fig.1b. Although the pose is not identical, *Evening: Landscape with an Aqueduct* (Metropolitan Museum, New York) features a seated nude man gesturing with his right arm.

5 Eitner, 1983, pp.78–82.

Notes to no.74

1 The *Harvester Holding her Sickle* (*Moissonneuse tenant sa faucille*), 1838, may represent Corot's first foray into this type of subject; others appeared in the 1840s, and the subject became a frequent one for him beginning in the late 1850s. See Paris, Ottawa and New York, 1996, nos 70, 72–4 and 107.

2 See Paris, Ottawa and New York, 1996, p.242.

3 See Paris, Ottawa and New York, 1996, nos 133–9.

4 *Ibid.*, p.242.

Notes to no.75

1 The lot number for the London drawing was for a long time given as 536, but Arlette Sérullaz is probably correct in suggesting that it was lot 538 (see following note).

2 '536. Maure vêtu d'un burnous rayé, vu à mi-corps, dessin / 537. Le même vu de face, assis, les jambes croisées, dessin rehaussée / 538. Le même, assis, vu de profil, dessin rehaussée.' See Hôtel Drouot, Paris, 22–7 February 1864.

3 Sérullaz, 1984, II, p.145, no.1597.

Notes to no.76

1 For a discussion of the dating, see Lee Johnson, *Delacroix: Pastels*, New York, 1995, p.143.

2 Pierre-Henri de Valenciennes, *Réflexions et conseils à un élève sur la peinture et particulièrement sur le genre du paysage*, Paris, 1800, p.407 (cited in *Delacroix: The Late Work*, exh. cat., Galeries Nationales du Grand Palais, Paris, 7 April–20

July 1998, and Philadelphia Museum of Art, 15 September 1998–3 January 1999, English edn, essay by Vincent Pomarède, pp.160–4).

3 Quoted in *Delacroix: The Late Work*, 1998–99, p.163.

4 See New York, 1997, II, pp.27–50, nos 192–441.

Notes to no.77

1 Kersley is cited as a prior owner by Pierre Georgel in Villequier and Paris, 1971, p.168.

2 Both the cut-out and the stencil survive, as do two additional drawings made with them, one light on dark like the London sheet (Musée Victor Hugo, Villequier, inv.57) and the other with a dark castle against a light sky (Maison de Victor Hugo, Paris, inv.183). All are illustrated in *Du chaos dans le pinceau ... Victor Hugo, Dessins*, exh. cat., Museo Thyssen-Bornemisza, Madrid, 2 June–10 September 2000, and Maison Victor Hugo, Paris, 12 October 2000–7 January 2001, pp.130–1, 353–5, nos 70–3.

Notes to no.78

1 Frankfurt and New York, 1992, pp.5 and 7.

2 The income Daumier derived from drawings sold directly to collectors is evident in his surviving account books. See Jean Cherpin, 'Le quatrième carnet de comptes de Daumier', *Gazette des Beaux-Arts*, 6th series, vol.56 (December 1960), pp.353–62.

3 See Harper, 1981, especially pp.178–86.

4 The various related and preparatory works are discussed and illustrated in Frankfurt and New York, 1992, pp. 226–30.

Notes to no.79

1 A sale of Lebrun's collection took place at the Hôtel Drouot, Paris, 4–6 May 1899; lots 68–87 were by Millet, but the British Museum sheet does not seem to have been among them.

2 According to Robert Herbert, the other three would have been *Spring*, *In the Vineyard* (Museum of Fine Arts, Boston), *Woman Burning Weeds* (Autumn) and *The Woodcutter* (Winter) (both Louvre, Paris); see Minneapolis, 1978, p.16.

3 Quoted in Minneapolis, 1978, p.19.

4 One wonders if Millet would have known Primaticcio's figure of a woman harvesting grain in the foreground of the pendentive fresco *Ceres* in the Salle de Bal at the Château de Fontainebleau, not far from Barbizon. See Paris, Cambridge and New York, 1994, p.78, fig.27a.

5 Minneapolis, 1978.

6 For Robert Herbert the London drawing was likely to have been made just after the Feydeau painting (Minneapolis, 1978, p.17), while Masayuki Tachiiri proposed that it preceded the painting (Yamanashi, 1998, pp.157–8).

Notes to no.80

1 Early provenance per Fernier, 1978, II, p.296.

2 See Paris, 1973.

3 Paris, 1973, pp.28 and 37, nos 32 and 45.

4 Paris, 1995, pp.62–3, no.5.

5 Rostrup, 1931, pp.112–13.

6 Quoted in *Courbet Reconsidered*, catalogue by Sarah Faunce and Linda Nochlin, Brooklyn Museum, 4 November 1988–16 January 1989, and Minneapolis Institute of the Arts, 18 February–30 April 1989, p.10.

Notes to no.83

1 Ackerman, 2000, p.112–13.

2 The painting is illustrated in Ackermann, 2000, p.316, no.339, and was sold at Christie's, New York, 11 November 1998, lot 134.

3 Lane, 1871, vol.I, pp.53–5, and vol.II, pp.312–14.

Notes to no.84

1 Brettell and Lloyd, 1980, pp.66–86, 211–12, nos 334–5.

2 Richard Thomson, *Camille Pissarro: Impressionism, Landscape and Rural Labour*, exh. cat., City Museum and Art Gallery, Birmingham, 8 March–22 April 1990, and Burrell Collection, Glasgow, 4 May–17 June 1990, p.94, fig.116, and Pissarro and Venturi, 1989, I, p.249, no.1207, II, pl.237.

3 Pissarro and Venturi, 1989, I, p.286, nos 1486 and 1487, II, pl.287.

4 The dating of the project is discussed in Brettell and Lloyd, 1980, p.77.

5 A date of c.1900 has been proposed for the British Museum sheet in both Brettell and Lloyd, 1980, p.191, under no.276, and London, Paris and Boston, 1980, p.189, no.148.

Notes to no.85

1 In the 1860s, when Degas and Manet first began frequenting the racetracks, the sport was a novelty, imported from England. See Kimberly Jones, 'A Day at the Races: A Brief History of Horse Racing in France', in Washington, 1998, pp.208–23.

2 As suggested by Jean Sutherland Boggs in Washington, 1998, p.98.

3 See Paris, Ottawa and New York, 1988, pp.262–3, no.154 and fig.131, and Lemoisne, 1946, II, p.128, no.269.

4 See *Degas, 1834–1917*, Galerie Schmit, Paris, 1975, no.57.

5 Private collection, Paris; see Washington, 1998, pp.89, 249, no.41.

6 Ibid., pp.98, 251, no.51.

7 Paris, Ottawa and New York, 1988, p.129.

8 See Nicolson, 1960, and *Art Investments, Selections from Three Alabama Corporate Collections*, Blount Inc., Weil Enterprises and Investments, Ltd., Vulcan Materials Company, exh. cat., Birmingham Museum of Art, 5 August–9 September 1984, pp.22–3.

Notes to no.86

1 The literature on Degas's images of dancers is extensive, beginning with Lillian Browse's *Degas Dancers*, London, 1949. Most recently, *Degas and the Dance* (Detroit and Philadelphia, 2002) provides an in-depth study not only of Degas's work, but also of its cultural and historical milieu.

2 See Detroit and Philadelphia, 2002, pp.14–15.

3 The place of these particular stretches in the ballet lesson is discussed in Detroit and Philadelphia, 2002, p.139.

4 Paris, Ottawa and New York, 1988, p.276, no.164, and Detroit and Philadelphia, 2002, p.139.

5 See Paris, Ottawa and New York, 1988, pp.276–8, figs 138–9, under nos 164–5.

6 Paris, Ottawa and New York, 1988, pp.286–8, no.172.

Notes to no.87

1 Germain Hédiard, *Fantin-Latour: catalogue de l'oeuvre lithographique du maître*, Paris, 1906, p.52, no.50, and p.62, no.115.

2 Victoria Dubourg Fantin-Latour, *Catalogue de l'oeuvre complet de Fantin-Latour*, Paris, 1911, p.121, nos 1177–8, and p.160, no.1515.

3 Frank Gibson, *The Art of Fantin-Latour: His Life and Work*, London, 1924, p.159.

Notes to no.88

1 Quoted in Michael Doran, ed., *Conversations with Cézanne*, Los Angeles, 2001, p.169.

2 Sara Lichtenstein, 'Cézanne's Copies and Variants after Delacroix', *Apollo*, vol.CI, no.156 (February 1975), pp.116–27.

3 The idea was not entirely novel; Fantin-Latour had painted a *Homage to Delacroix* only a decade earlier, although his was more Realist in conception, featuring a group of contemporary painters and writers standing around a painted portrait of Delacroix. See Paris, Ottawa and San Francisco, 1982, pp.167–80.

4 In 1904 Cézanne wrote to his friend Émile Bernard, lamenting, 'I do not know if my indifferent health will allow me ever to realize my dream of painting [Delacroix's] apotheosis.' Quoted in Rewald, 1983, p.102.

5 Gache-Patin, 1984, pp.137–9, 145. For studies relating to individual figures, see Rewald, 1983, p.103, no.69, and Chappuis, 1973, I, p.85, no.174, II, fig.174.

6 Rewald, 1983, p.102.

7 The various dates suggested by earlier scholars are cited in Rewald, 1983, p.102.

8 Several sheets dated by Chappuis to the mid-

1870s depict Pissarro outdoors; see Chappuis, 1973, I, p.112, nos 299–301.

9 Émile Bernard, *Sur Paul Cézanne*, Paris, 1925, p.51.

Notes to no.89

1 Quoted in Paris, London and Philadelphia, 1995, p.240, under no.81.

2 See e.g. Paris, London and Philadelphia, 1995, pp.292–3, no.111.

3 The cast survives today in Cézanne's studio at Les Lauves and is illustrated in Chappuis, 1973, I, p.228, fig.117.

4 See Paris, London and Philadelphia, pp.388–96, nos 161–5, and p.396 notes 11 and 31, and Chappuis, 1973, I, pp.227–2,9, nos 980 bis–990. For two sketches in oil, see John Rewald, *The Paintings of Paul Cézanne: A Catalogue Raisonné*, New York, 1996, I, pp.472–3, nos 783–4.

5 The names François Duquesnoy (1594–1643) and Nicolas Coustou (1658–1733) have also been put forward. See Paris, London and Philadelphia, 1995, pp.389, 396 notes 9 and 10.

6 Paris, London and Philadelphia, 1995, pp.388–93, no.161.

7 Ibid., p.396 note 20 gives the height of the plaster as 46 cm.

Notes to no.90

1 Douglas W. Druick and Peter Kort Zegers, 'Painful Origins', in Chicago, Amsterdam and London, 1994, pp.14–24.

2 Chicago, Amsterdam and London, 1994, pp.248, 250, 411 note 31. On a visit in March Tebb had bought *The Golden Cell*, also later acquired by the British Museum (1949-4-11-78).

3 Wildenstein, 1992–98, I, pp.192–207, nos 485–523.

4 André Mellorio, Redon's friend and biographer recalled him comparing the tone of the fixative to the patina that paintings by Rembrandt acquire with age. Quoted in Chicago, Amsterdam and London, 1994, p.326; see also Harriet K. Stratis's discussion of Redon's methods and materials in the same catalogue, pp.354–77.

5 From a letter to Émile Bernard dated 14 April 1895, quoted in Chicago, Amsterdam and London, 1994, pp.366, 429 note 39.

Notes to no.91

1 The picture and its genesis were the subject of a major recent exhibition; see Chicago, 2004.

2 Private collection, 65.3 × 81.2 cm.; see Chicago, 2004, pp.80, 274, no.60.

Notes to no.92

1 Chicago, 2004, pp.178–95.

2 Robert L. Herbert argues in favor of the traditional ordering with the London drawing preceding the New York sketch – see Chicago, 2004, pp.79, 82 – while Frank Zuccari and Allison Langley in the same catalogue propose the reverse, pp.184–7.

3 Chicago, 2004, pp.179–80.

4 For a composite photograph illustrating the placement of grid lines on the British Museum drawing, see Chicago, 2004, p.181, fig.6.

5 Chicago, 2004, p.185, figs 9–11.

6 Art-historical interpretations of the painting are surveyed by Herbert in Chicago, 2004, pp.162–9.

Notes to no.93

1 Two variations on this stamp (Lugt 1338) are identified in Stanford L. Optner, 'Toulouse-Lautrec's Two Stamps', *Print Quarterly*, vol.XIII, no.4 (December 1996), pp.411–12.

2 The subject of Toulouse-Lautrec and Japonisme is explored by Colta Ives in her *Toulouse-Lautrec in The Metropolitan Museum of Art*, New York, 1996.

3 Marcelle Lender was the stage name of Anne-Marie Marcelle Bastien (1862–1926).

4 The painting, *Marcelle Lender Dancing the Bolero in 'Chilpéric'* is in the National Gallery of Art, Washington (1990.127.1). For the prints, see Loys Delteil, H. *de Toulouse-Lautrec*, vol.2 in *Le Peintre-graveur illustré* (XIX et XX siècles) series, Paris, 1920, n.p., nos 41, 43, 58, 102–9, 163–4, 261 (this last considered by Götz Adriani to depict Jeanne Granier; see Toulouse-Lautrec, *The Complete Graphic Works: A Catalogue Raisonné, The Gerstenberg Collection*, London, 1988, p.369, no.302). For the drawings see Dortu, 1971, V, no.D.3.327, pp.550–1, VI, nos D.3.765, D.3.767, D.3.813, D.3.814, D.3.815, D.3.897, D.3.898, D.4.241, D.4.242, pp.734–7, 646–7, 662–3 and 740–41.

5 Hervé was the stage name of Florimond Ronger (1825–92); *Chilpéric* was first performed in 1868.

6 Quoted in Julia Frey, *Toulouse-Lautrec: A Life*, New York, 1994, p.357.

General Bibliography

Aaron, Olivier. *Dessins insolites du XVIII^e français*, Paris, 1985.

——. *Jean-Baptiste Marie Pierre, 1714–1789*, Cahier du dessin Français, no.9, Paris [1993].

Ackerman, Gerald M. *Jean-Léon Gérôme, Monographie révisée, Catalogue raisonné mis à jour*, Paris, 2000 (originally published in London and New York, 1986).

Adhémar, Hélène. *Watteau, Sa vie – son oeuvre*, Paris, 1950.

Adhémar, Jean. *Le Dessin français au XVI^e siècle*, Lausanne, 1954.

Alazard, Jean. *Ingres et l'ingrisme*, Paris, 1950.

Ananoff, Alexandre. *L'Oeuvre dessiné de Jean-Honoré Fragonard (1732–1806), Catalogue raisonné*, 4 vols, Paris, 1961–70.

——. 'Les Paysages d'Ango', *Bulletin de la Société de l'Histoire de l'Art Français*, 1965 (published 1966), pp.163–8.

—— with the collaboration of Daniel Wildenstein. *François Boucher*, 2 vols, Lausanne and Paris, 1976.

Andersen, Wayne V. 'Cézanne, Tanguy, Choquet', *The Art Bulletin* XLIX, no.1 (March 1967), pp.137–9.

Arvengas, Jeanne. 'A Rome, Autour du Palais Riario avec Raymond Lafage', *Bulletin de la Société de l'Histoire de l'Art Français* (1962), pp.25–32.

——. *Raymond Lafage, Dessinateur*, Paris, 1965.

Bacou, Roseline. *Il settecento francese*, Milan [1971?].

Bailey, Colin B. *Patriotic Taste, Collecting Modern Art in Pre-Revolutionary Paris*, New Haven and London, 2002.

Barocchi, Paola. *Il Rosso Fiorentino*, Rome, 1950.

Baticle, Jeannine. 'Le chanoine Haranger, ami de Watteau', *Revue de l'Art*, no.69 (1985), pp.55–68.

Bazin, Germain. *Théodore Géricault: étude critique, documents et catalogue raisonné*, 7 vols, Paris, 1987–97.

Bean, Jacob. 'A Rediscovered drawing by Claude', *Master Drawings*, III, no.3 (1965), pp.266–8.

——, with the assistance of Lawrence Turčić. *15th–18th Century French Drawings in the Metropolitan Museum of Art*, New York, 1986.

Beauvais, Lydia. *Musée du Louvre, Département des Arts Graphiques, Inventaire général des dessins école française, Charles Le Brun, 1619–1690*, 2 vols, Paris, 2000.

Béguin, Sylvie, Jean Guillaume and Alain Roy. *La galerie d'Ulysse à Fontainebleau*, Paris, 1985.

——. 'Projets bellifontains', in *Dal disegno all'opera compiuta*, ed. Mario Di Giampaolo (Proceedings of a conference held in Torgiano, 1987), Perugia, 1992.

Bénard, M. *Cabinet de M. Paignon Dijonval. État détaillé et raisonné des dessins et estampes*, Paris, 1810.

Benoit, Jérémie. *Philippe-Auguste Hennequin, 1762–1833*, Paris, 1994.

Binyon, Laurence, 'Les dessins de Watteau du Musée Britannique', in *Bi-centenaire de la mort de A. Watteau, 1684–1721, Études*, Paris, 1921a.

——. 'Les Dessins de Watteau du Musée Britannique', *La Revue de l'Art Ancien et Moderne*, XL, July–August, 1921b, pp.139–46.

Bissell, R. Ward. *Artemisia Gentileschi and the Authority of Art: Critical Reading and Catalogue Raisonné*, University Park, Pennsylvania, 1999.

Bjurström, Per. *French Drawings, Sixteenth and Seventeenth Centuries*, Stockholm, 1976.

Blunt, Anthony. *Nicolas Poussin*, The A.W. Mellon Lectures in the Fine Arts, National Gallery of Art, Washington, DC, 1958, published New York, 1967.

——. *The Drawings of Poussin*, New Haven and London, 1979.

Bordeaux, Jean-Luc. 'François Le Moyne's Painted Ceiling in the 'Salon d'Hercule' at Versailles, A Long Overdue Study', *Gazette des Beaux-Arts*, LXXXIII (May–June 1974), pp.301–18.

——. *François Le Moyne and his Generation, 1688–1737*, Paris, 1984.

Bordes, Philippe. 'Les arts après la Terreur, Topino-Lebrun, Hennequin et la peinture politique sous le Directoire', *La Revue du Louvre et des Musées de France*, XXIX (1979, no.3), pp.199–212.

Bouvy, Eugène. *Le Portrait gravé et ses maitres, Nanteuil*, Paris, 1924.

Boyer, Ferdinand. 'Catalogue raisonné de l'oeuvre de Charles Natoire', *Archives de l'Art Français*, XXI (1949), pp.31–107.

Boyer, Linda Lee. 'The Origin of Coral by Claude Lorrain', *The Metropolitan Museum of Art Bulletin* (May 1968), pp.370–79.

Brejon de Lavergnée, Barbara. 'New Light on Michel Dorigny', *Master Drawings*, XIX, no.4 (Winter 1981), pp.445–55.

Brettell, Richard, and Christopher Lloyd. *A Catalogue of the Drawings by Camille Pissarro in the Ashmolean Museum, Oxford*, Oxford, 1980.

Brinckmann, A.E. *J.A. Watteau*, Vienna, 1943.

Browse, Lillian, 1949. *Degas Dancers*, New York, 1949.

Brunel, Georges. *Boucher*, Paris, 1986.

Cailleux, Jean. 'L'Art du Dix-huitième Siècle, Four Artists in Search of the Same Nude Girl', advertising supplement, *Burlington Magazine*, vol.CVIII, no.757 (April 1966), pp.i–v.

Carroll, Eugene A. *The Drawings of Rosso Fiorentino*, 2 vols, New York and London, 1976.

Cartwright, Julia. 'The Drawings of Jean-François Millet in the Collection of Mr. James Staats Forbes, Part I', *The Burlington Magazine*, no.XIII, vol.V (April 1904), pp.47–68.

Chappuis, Adrien. *The Drawings of Paul Cézanne: A Catalogue Raisonné*, 2 vols, Greenwich, Conn., 1973.

Chennevières, Philippe de, and Anatole de Montaiglon, eds. *Abécédario de P. J. Mariette*, vols 1–6, Paris, 1851–60 (reprinted 1966).

Clément, Charles. *Prud'hon, Sa vie, ses oeuvres et sa correspondance*, Paris, 1880.

Comer, Christopher Duran. 'Studies in Lorraine Art, c.1580–c.1625', Ph.D. dissertation, Princeton University, 1980 (University Microfilms).

Cooper, Douglas. 'The David Exhibition at the Tate Gallery', *Burlington Magazine*, XCI, no.550 (1949), pp.21–2.

Cordey, Jean. 'Les dessins français des XV^e et XVII^e siècles au British Museum', *Bulletin de la Société de l'Histoire de l'Art Français* (1932), pp.13–18.

Cormack, Malcolm. *The Drawings of Watteau*, London, New York, Sydney and Toronto, 1970.

Cropper, Elizabeth. 'The Drawings of Nicolas Poussin: Catalogue Raisonné, ed. Walter Friedlaender and Anthony Blunt' (book review), *Master Drawings*, XIII, no.3 (Autumn 1975), pp.281–8.

Cuzin, Jean-Pierre. 'Deux dessins du British Museum: Watteau, ou plutôt La Fosse', *La Revue du Louvre et des Musées de France*, XXXI, no.1 (1981), pp.19–21.

Dacier, Émile. 'Gillot 1673 à 1722', in *Les peintres français du XVIII^e siècle*, ed. Louis Dimier, Paris and Brussels, 1928, pp.157–214.

——. *Gabriel de Saint-Aubin, Peintre, dessinateur et graveur (1724–1780)*, 2 vols, Paris, 1929–31.

Dacos, Nicole. 'Léonard Thiry de Belges, Peintre excellent. De Bruxelles à Fontainebleau en passant par Rome', *Gazette des Beaux-Arts*, CXXVII (May–June 1996a), pp.199–212.

——. 'Léonard Thiry de Belges, Peintre excellent. De Fontainebleau à Bruxelles', *Gazette des Beaux-Arts*, CXXVIII (July–August 1996b), pp.21–36.

Dargenty, G. *Les Artistes célèbres: Antoine Watteau*, Paris, 1891.

De Grazia, Diane. 'Poussin's "Holy Family on the Steps" in Context', in *Cleveland Studies in the History of Art*, IV (1999), pp.26–63.

Dimier, Louis. *Le Primatice, Peintre, sculpteur et architecte des rois de France*, Paris, 1900.

——. *Histoire de la peinture de portrait en France au XVIe siècle*, 3 vols, Paris and Brussels, 1924–6.

Dorival, Bernard. *Philippe de Champaigne, 1602–1674, La vie, l'oeuvre, et le catalogue raisonné de l'oeuvre*, 2 vols, Paris, 1976.

Dorra, Henri and John Rewald. *Seurat, L'oeuvre peint, biographie et catalogue critique*, Paris, 1959.

Dortu, M.G. *Toulouse-Lautrec et son oeuvre*, 6 vols, Paris, 1971.

Dumas, Ann. *Degas as a Collector*, Apollo magazine in association with National Gallery Publications, London, 1996.

Duplessis, Georges, ed. *Mémoires et Journal de Jean-Georges Wille, Graveur du Roi*, 2 vols, Paris, 1857.

Ede, H.S. 'The Drawings of Philippe de Champaigne', *Art in America*, vol. XII, no.VI (October 1924), pp.253–68.

Eidelberg, Martin P. *Watteau's Drawings: Their Use and Significance*, New York and London, 1977.

Eitner, Lorenz. 'Deux Oeuvres inconnues de Géricault au Musée d'Art Moderne', *Musée Royaux des Beaux-Arts Bulletin*, no.2 (June 1953), pp.55–64.

——. 'Géricault's "Dying Paris" and the Meaning of his Romantic Classicism', *Master Drawings*, vol.I, no.1 (Spring 1963), pp.21–34.

——. *Géricault: His Life and Work*, London, 1983.

Elderfield, John and Robert Gordon. *The Language of the Body: Drawings by Pierre-Paul Prud'hon*, New York, 1996.

Eschenfelder, Chantal. 'Les Bains de Fontainebleau: nouveaux documents sur les décors du Primatice', *Revue de L'Art*, no.99 (1993, no.1), pp.45–52.

Fernier, Robert. *La Vie et l'oeuvre de Gustave Courbet, Catalogue raisonné*, 2 vols, Lausanne and Paris, 1978.

Fourcaud, Louis de. 'L'invention sentimentale, l'effort technique et les pratiques de composition et d'exécution de Watteau', *Revue de l'Art ancien et moderne*, X, no.56 (November 1901), pp.236–349.

——. 'Antoine Watteau, Scènes et figures théâtrales', *Revue de l'Art ancien et moderne*, XV (March 1904), pp.193–213.

Friedlaender, Walter and Anthony Blunt, 1939–74. *The Drawings of Nicolas Poussin: Catalogue raisonné*, 5 vols, London (I, 1939; II, 1949; III, 1953; IV, 1963; V, 1974).

Fry, Roger. 'Drawings at the Burlington Fine Arts Club', *Burlington Magazine*, XXXII, no.CLXXIX (February 1918), pp.51–62.

Gache-Patin, Sylvie. 'Douze oeuvres de Cézanne de l'ancienne collection Pellerin', *La Revue du Louvre et des Musées de France*, vol.XXXIV, no.2 (1984), pp.128–46.

Gaehtgens, Thomas W. and Jacques Lugand. *Joseph-Marie Vien, Peintre du Roi (1716–1809)*, Paris, 1988.

Garrard, Mary D. *The Image of the Female Hero in Italian Baroque Art*, Princeton and Oxford, 1989.

Gaunt, William. 'Mr. de Hauke and the British Museum', *The Connoisseur*, vol.169, no.682 (December 1968), pp.228–31.

George, Waldemar. *Dessins d'Ingres*, Paris, 1967.

Gillet, Louis. *Un grand maître du XVIIIe siècle, Watteau*, Paris, 1921.

Goldner, George R., with the assistance of Lee Hendrix and Gloria Williams. *European Drawings I: Catalogue of the Collections*, Malibu, 1988.

Goncourt, Edmond de. *Catalogue raisonné de l'oeuvre peint, dessiné et gravé d'Antoine Watteau*, Paris, 1875.

——. *Catalogue raisonné de l'oeuvre peint, dessiné et gravé de P.P. Prud'hon*, Paris, 1876.

—— and Jules de. *L'Art du dix-huitième siècle*, 3rd edn, vol.I, Paris, 1880.

González-Palacios, Alvar. 'Jacques-Louis David: le décor de l'Antiquité', *David contre David*, II, Actes du colloque, 6–10 December 1989, Musée du Louvre, Paris, 1993a, II, pp.927–63.

——. *Il Gusto dei principi, Arte di corte del XVII e del XVIII secolo*, 2 vols, Milan, 1993b.

Grappe, Georges. *P.-P. Prud'hon*, Paris, 1958.

Grasselli, Margaret Morgan. 'Watteau Drawings in the British Museum', (book review), *Master Drawings* vol.XIX, no.3 (Autumn 1981), pp.310–12.

——. 'The Drawings of Antoine Watteau: Stylistic Development and Problems of Chronology', 3 vols, Ph.D. dissertation, Harvard University, 1987a.

——. 'Watteau's Use of the Trois-Crayons Technique', in *Drawings Defined*, ed. Walter Strauss and Tracie Felker, New York, 1987b.

——. 'Eighteen Drawings by Watteau: A Chronological Study', *Master Drawings*, vol.XXXI, no.2 (Summer 1993), pp.103–27.

Gruyer, François-Anatole. *Chantilly, Les Portraits de Carmontelle*, Paris, 1902.

Guffey, Elizabeth E. *Drawing an Elusive Line: The Art of Pierre-Paul Prud'hon*, Newark and London, 2001.

Guiffrey, Jean. 'L'Oeuvre de Pierre-Paul Prud'hon', *Archives de l'Art Français, Société de l'Histoire de l'Art Français*, XIII (1924).

Gurlitt, Cornelius. *Handzeichnungen von Watteau*, Berlin, 1909.

Harper, Paula Hays. *Daumier's Clowns: Les Saltimbanques et Les Parades, New Biographical and Political Functions for a Nineteenth Century Myth*, New York and London, 1981.

Harris, Ann Sutherland. 'Pierre Rosenberg and Louis-Antoine Prat: "Nicolas Poussin, 1594–1665. Catalogue raisonné des dessins"', *Master Drawings*, vol. XXXIV, no.4 (Winter 1996), pp.421–8.

Haskell, Francis. 'The Sad Clown: Some Notes on a 19th century Myth', in *French 19th Century Painting and Literature*, New York, 1972, pp.2–16.

Hauke, César Mange de. *Seurat et son oeuvre*, Paris, 1961.

Hautecoeur, Louis. *Louis David*, Paris, 1954.

Haverkamp-Begemann et al. *The Robert Lehman Collection, VII: Fifteenth- to Eighteenth-Century Drawings, Central Europe, The Netherlands, France, England*, New York and Princeton, 1999.

Hedley, Jo. 'Toward a New Century: Charles de La Fosse as a Draftsman', *Master Drawings*, vol.39, no.3 (Fall 2001), pp.223–59.

——. 'Charles de La Fosse's "Rinaldo and Armida" and "Rape of Europa" at Basildon Park', *Burlington Magazine*, vol.CXLIV, no.1189 (April 2002), pp.204–12.

Hennequin, Philippe-Auguste. *Mémoires*, ed. Jenny Hennequin, Paris, 1933.

Hildebrandt, Edmund. *Antoine Watteau*, Berlin, 1922.

Hind, Arthur M. 'Jacques Callot', *Burlington Magazine*, vol. XXI (May 1912), pp.74–80.

——. *The Drawings of Claude Lorrain*, London, 1925.

——. *Catalogue of The Drawings of Claude Lorrain Preserved in the Department of Prints and Drawings*, London, 1926.

——. 'Drawings by Corot and Cézanne', *The British Museum Quarterly*, vol.X, no.1 (1935–6), pp.21–2.

Hobbs, Richard. *Odilon Redon*, Boston, 1977.

Hulton, Paul. *The Work of Jacques Le Moyne de Morgues: A Huguenot Artist in France, Florida and England*, 2 vols, London, 1977.

Huyghe, René. *Watteau*, New York, 1970.

Jacoby, Beverly Schreiber. *François Boucher's Early Development as a Draughtsman, 1720–1734*, New York and London, 1986.

——. 'Boucher's Late Brown Chalk Composition Drawings', *Master Drawings*, XXX, No.3 (Autumn 1992), pp.255–86.

Jaffé, Michael. *The Devonshire Collection of Northern European Drawings*, 5 vols, Turin, 2002.

Jobert, Barthélémy. *Delacroix*, Princeton, 1998.

Johnson, Lee. *Delacroix Pastels*, New York, 1995.

Jollet, Étienne. *Jean & François Clouet*, Paris, 1997.

Jordan, Marc. 'Edme Bouchardon: A Sculptor, a Draughtsman, and his Reputation in Eighteenth-Century France', *Apollo*, no.121, (June 1985), pp.388–94.

Kitson, Michael. 'The Place of Drawings in the Art of Claude Lorrain', *Studies in Western Art*, III (Proceedings of the XXth International Congress of the History of Art, New York, 1961), Princeton, 1963 (reprinted in *Studies on Claude and Poussin*, London, 2000).
——. *Claude Lorrain: Liber Veritatis*, London, 1978.

Korshak, Yvonne. 'Paris and Helen by Jacques-Louis David: Choice and Judgement on the Eve of the French Revolution', *The Art Bulletin*, LXIX, no.1 (March 1987), pp.102–16.

Kusenberg, Kurt. *Le Rosso*, Paris, 1931.
——. 'Zeichnungen von Rosso und Leonard Thiry', *Zeitschrift für Bildende Kunst*, 65 (1931–2), pp.85–90.

Labbé, Jacqueline and Lise Bicart-Sée. *La Collection de dessins d'Antoine-Joseph Dezallier d'Argenville, reconstituée d'après son 'Abrégé de la vie des plus fameux peintres', édition de 1762*, Louvre, Département des Arts graphiques, Notes et documents des musées de France, no.27, Paris, 1996.

Laclotte, Michel, ed. *French Art from 1350 to 1850*, New York, 1965.

Lafenestre, Georges. *Dessins de A. Watteau*, Paris, 1907.

Laing, Alastair. 'Le Re-Naissance de Vénus: une oeuvre des débuts de Boucher retrouvée à Paris', *Revue de l'Art*, no.103 (1994, no.1), pp.77–81.

Lamers, Petra. *Il viaggio nel Sud dell'Abbé de Saint-Non, Il 'Voyage pittoresque à Naples et en Sicile': la genesi, i disegni preparatori, le incisioni*, Naples, 1995.

Lane, Edward William. *An Account of the Manners and Customs of the Modern Egyptians*, 2 vols (5th edn), London, 1871,

Laughton, Bruce. *The Drawings of Daumier and Millet*, New Haven and London, 1991.

Launay, Élisabeth. *Les Frères Goncourt, Collectionneurs de dessins*, Paris, 1991.

Lavallée, Pierre. *Le Dessin français du XIIIe au XVIe siècle*, Paris, 1930.

Laveissière, Sylvain. *Le Cabinet des dessins, Prud'hon*, Paris, 1997.

Le Claire, Thomas. *Master Drawings, Recent Acquisitions: A Review of the Years 1982–2002*, Thomas Le Claire Kunsthandel, Hamburg, 2003.

Lemoisne, Paul-André. *Degas et son oeuvre*, 4 vols, Paris, 1946–9.

Lévêque, Jean-Jacques. *L'École de Fontainebleau*, Neuchâtel, 1984.

Lévis-Godechot, Nicole. *La Jeunesse de Pierre-Paul Prud'hon (1758–1796)*, Paris, 1997 (posthumous publication of a 1982 thesis).

Lieure, Jules. *Jacques Callot, catalogue d'oeuvre gravé*, Paris, 3 vols, 1924–9.

Linzeler, André. *Inventaire du Fonds Français, Graveurs du seizième siècle*, vol.I, Paris, 1932.

Locquin, Jean. 'Catalogue raisonné de l'oeuvre de Jean-Baptiste Oudry, peintre du roi (1686–1755)', *Archives de l'Art Français, Recueil de documents inédits publiés par la Société de l'Histoire de l'Art Français*, VI, 1912, pp.1–244.

Lugt, Frits. *Les Marques de collections de dessins et d'estampes*, Amsterdam, 1921, reprinted with supplement, The Hague, 1956 (referred to as 'Lugt' in the text).

McCorquodale, Charles. 'Arts Reviewed: UK', *The Connoisseur*, vol.205, no.826 (December 1980), p.232.

Macfall, Haldane. *Boucher: The Man, his Times, his Art, and his Significance*, London, 1908.

Maison, K.E. 'French Drawings of the XIXth Century in the British Museum', *Apollo*, LXII, no.365 (July 1955), pp.3–6.
——. *Daumier: Drawings*, New York and London, 1960.
——. *Honoré Daumier: Catalogue Raisonné of the Paintings, Watercolours, and Drawings*, 2 vols, New York, 1968.

Mantz, Paul. *Antoine Watteau*, Paris, 1892.

Martin, Jean. *Oeuvre de J.-B. Greuze, Catalogue raisonné, Suivi de la liste des gravures exécutées d'après ses ouvrages*, Paris, 1908.

Mathey, Jacques. 'Remarques sur la chronologie des peintures et dessins d'Antoine Watteau', *Bulletin de la Société de l'Histoire de l'Art Français*, 1939, pp.150–62.
——. 'Drawings by Watteau and Gillot', *Burlington Magazine*, vol.CII, no.689 (August 1960), pp.354–61.
——. 'La comedienne: An unpublished Watteau', *The Connoisseur*, vol.165, no.664 (June 1967), pp.90–3.

Mauclair, Camille. *Le Secret de Watteau*, Paris, 1942.

Mellen, Peter. *Jean Clouet: Complete Edition of the Drawings, Miniatures, and Paintings*, London, 1971.

Mérot, Alain. *Eustache Le Sueur (1616–1655)*, Paris, 2000.

Meyer, Véronique, 'Bosse, Rousselet et Vignon', in *Claude Vignon en son temps, Actes du colloque international de l'université de Tours (28–29 janvier 1994)*, 1998, pp.189–208.

Monnier, Geneviève. *Pastels from the 16th to the 20th Century*, Geneva, 1984.

Moreau-Nélaton, Étienne. *Le Portrait en France à la cour des Valois, Crayons Français du XVIe siècle conservés dans la collection de M.G. Salting à Londres*, Paris [1908].
——. *Les Clouet et leurs émules*, 3 vols, Paris, 1924.

Munger, Jeffrey H., et al. *The Forsyth Wickes Collection in the Museum of Fine Arts, Boston*, Boston, 1992.

Naef, Hans. 'Ingres et la famille Hayard', *Gazette des Beaux-Arts*, 67 (January 1966), pp.37–50.
——. 'Odalisque a l'esclave by J.A.D. Ingres', *Fogg Art Museum: Acquisitions*, Harvard University, Cambridge, 1968, pp.80–99.
——. *Die Bildniszeichnungen von J.-A.-D. Ingres*, 5 vols, Bern, 1977–80.

Nash, Steven Alan. 'The Drawings of Jacques-Louis David, Selected Problems', Ph.D. dissertation, Stanford University (May 1973).

Nicolson, Benedict. 'The Recovery of a Degas Race Course Scene', *The Burlington Magazine*, vol.CII, no.693 (December 1960), pp.536–7.

Nicq, Christiane and Pierre Nicq. *Petits et Grands Maîtres du Musée Atger, Cent dessins Français des 17ème et 18ème siècles*, Montpellier, 1996.

Opperman, Hal N. *Jean-Baptiste Oudry (1686–1755), with a Sketch for a Catalogue Raisonné of his Paintings, Drawings, and Prints*, 2 vols, New York and London, 1977.

Opresco, G. 'Dessins français du XIXème siècle au musée britannique', *La Revue de L'Art Ancien et Moderne*, vol.LIV (June–December 1928), pp.235–54.

Pacht Bassani, Paola. *Claude Vignon, 1593–1670*, Paris, 1992.

Pariset, F.-G. 'Figures feminines de Jacques de Bellange', *Bulletin de la Société de l'Histoire de l'Art Français*, 1951, pp.27–53.

Parker, Karl Theodore. 'François Lemoine', *Old Master Drawings*, no.15 (December 1929), pp.38–41.
——. 'The Drawings of Antoine Watteau in the British Museum', *Old Master Drawings*, V, no.17 (June 1930a), pp.1–28, pls.1–8.
——. 'Bouchardon's "Cries of Paris"', *Old Master Drawings*, V, no.19 (December 1930b), pp.45–8.
——. *The Drawings of Antoine Watteau*, London 1931 (reprinted, New York, 1970).
——. 'Sidelights on Watteau', *Old Master Drawings*, X (June 1935), pp.3–9.

Parker, Karl Theodore and Jacques Mathey. *Antoine Watteau, Catalogue complet de son oeuvre dessiné*, 2 vols, Paris, 1957.

Petitjean, Ch. and Ch. Wickert. *Catalogue de l'Oeuvre gravé de Robert Nanteuil*, Paris, 1925.

Phillips, Claude. *Antoine Watteau*, London, 1895.

Pissarro, Ludovic Rodo and Lionello Venturi, *Camille Pissarro, Son art – son oeuvre*, 2 vols, San Francisco, 1989.

Pitsch, Marguerite. *Essai de catalogue sur l'iconographie de la vie populaire a Paris au XVIIIe siècle*, Paris, 1952.

Planiscig, Leo, and Hermann Voss. *Drawings of Old Masters from the Collection of Dr. Benno Geiger* (preface by Hugo von Hofmannsthal), Zurich, n.d.

Popham, Arthur Ewart. *Catalogue of Drawings in the Collection Formed by Sir Thomas Phillipps, Bart., F.S.R., now in the Possession of his Grandson T. Fitzroy Phillipps Fenwick of Thirlestaine House, Cheltenham*, London, 1935.

——. *A Handbook to the Drawings and Water-colours in the Department of Prints and Drawings, British Museum*, London, 1939.

Popp, Anny E. 'Rosso Fiorentino', *Old Master Drawings*, I (March 1927), pp.50–1.

Populus, Bernard. *Claude Gillot (1673–1722), Catalogue de l'oeuvre gravé*, Paris, 1930.

Posner, Donald. *Antoine Watteau*, London, 1984.

Py, Bernadette. *Everhard Jabach collectionneur (1618–1695), Les dessins de l'inventaire de 1695* (Notes et documents des musées de France 36), Paris, 2001.

Ramade, Patrick. 'Une source d'inspiration du XVIIᵉ siècle, La Galerie des Femmes fortes de Claude Vignon', *Bulletin des Amis du Musée de Rennes*, no.4 (1980), pp.19–26.

Rewald, John. *Paul Cézanne: The Watercolors*, Boston, 1983.

Robaut, Alfred. *L'Oeuvre complet de Eugène Delacroix*, Paris, 1885.

Robinson, J.C. *Descriptive Catalogue of Drawings by the Old Masters, forming the Collection of John Malcolm of Poltalloch, Esq*, London, 2nd edition, 1876.

Roethlisberger, Marcel. *Claude Lorrain: The Paintings*, 2 vols, New Haven, 1961a.

——. 'Les dessins à figures de Claude Lorrain', *Critica d'arte*, VIII, no.47 (September–October 1961b), pp.16–26.

——. *Claude Lorrain: The Drawings*, 2 vols, Berkeley and Los Angeles, 1968.

Roland Michel, Marianne. *Watteau: An Artist of the Eighteenth Century*, New York, 1984.

——. *Le Dessin français au XVIIIᵉ siècle*, Paris, 1987.

Rosasco, Betsy Jean. 'Notes on Two Gabriel de Saint-Aubin Drawings and the Statues they Depict', *Studies in the History of Art, National Gallery of Art, Washington*, vol.9 (1980), pp.51–7.

Rosenau, Helen. *The Painter Jacques-Louis David*, London, Paris and Brussels, 1948.

Rosenberg, Pierre. 'Some Drawings by Claude Vignon', *Master Drawings*, IV, 3 (1966a), pp.289–93.

——. *Philippe de Champaigne*, Milan, 1966b.

——. 'Le XVIIIe siècle français à la Royal Academy (Londres)', *Revue de l'Art* (1969, no.3), pp.98–100.

——. *Il seicento francese*, Milan [1971a].

——. 'La main d'Artémise', *Paragone* 22, no.261 (November 1971b), pp.69–70.

——. *Le XVIIᵉ siècle français*, Paris, 1976 (French translation of Milan 1971 edition).

——. 'Watteau, Peintre de Louis XIV', in *Sun King: The Ascendancy of French Culture during the Reign of Louis XIV*, ed. David Lee Rubin, Washington, London, and Toronto, 1992.

——. 'Fragonard and David', in *David contre David*, ed. Régis Michel, Paris, 1993, I, pp.3–16.

——. *From Drawing to Painting: Poussin, Watteau, Fragonard, David & Ingres, The A.W. Mellon Lectures in the Fine Arts*, 1996, Princeton, New Jersey, 2000.

——. *Le Livre des Saint-Aubin, Collection solo*, Département des Arts Graphiques, Paris, 2002.

Rosenberg, Pierre and Barbara Brejon de Lavergnée, eds. *Panopticon Italiano, Un diario di viaggio ritrovato, 1759–1761*, Rome, 2000.

Rosenberg, Pierre and Benjamin Peronnet. *Un album inédit de David, Revue de l'Art*, no.142 (2003–4), pp.45–83.

Rosenberg, Pierre and Louis-Antoine Prat. *Nicolas Poussin, 1594–1665, Catalogue raisonné des dessins*, 2 vols, Milan, 1994.

——. *Antoine Watteau, 1684–1721, Catalogue raisonné des dessins*, 3 vols, Milan, 1996.

——. *Jacques-Louis David, 1748–1825, Catalogue raisonné des dessins*, 2 vols, Milan, 2002.

Rosenberg, Pierre and Jacques Thuillier. *Laurent de La Hyre, 1606–1656, Cahiers de dessins*, no.1, Paris, 1985.

Roserot, Alphonse. *Edme Bouchardon*, Paris, 1910.

Rostrup, Haavard. 'Trois tableaux de Courbet', in *From the Collections of the Ny Carlsberg Glyptotek*, vol.I, Copenhagen, 1931, pp.96–144.

Rowlands, John. 'Treasures of a Connoisseur: The César de Hauke Bequest', *Apollo*, LXXXVIII, no.77 (July 1968), pp.42–50.

Royalton-Kisch, Martin. 'Diana and Aurora at Home', *British Museum Magazine*, no.3 (Spring 1999), pp.11–14.

Russoli, Franco and Fiorella Minervino. *L'opera completa di Degas*, Milan, 1970.

Sainte Fare Garnot, Nicolas. *Philippe de Champaigne (1602–1674), Jean-Baptiste de Champaigne (1631–1681), Nicolas de Plattemontagne (1631–1706)*, Paris, 2000.

Salmon, Xavier. 'François Lemoyne at Versailles', in Emmanuel Ducamp, ed., *The Apotheosis of Hercules by François Lemoyne at the château de Versailles: History and Reception of a Masterpiece*, Paris, 2001.

Sanchez, Pierre. *Dictionnaire des artistes exposant dans les salons des XVII et XVIIIeme siècles à Paris et en Province, 1673–1800*, 3 vols, Dijon, 2004.

Sandström, Sven. *Le Monde imaginaire d'Odilon Redon, Étude iconologique*, Lund and New York, 1955.

Schnapper, Antoine and Arlette Sérullaz. *Jacques-Louis David; 1748–1825; l'album*, Paris, 1989.

Senior, Elizabeth. 'Drawings Made in Italy by Fragonard', *The British Museum Quarterly*, XI, 1937, pp.5–9.

Sensier, Alfred. 'Le Roman de Prud'hon', *Revue Internationale de l'Art et de la Curiosité*, vol.2, no.1, July 15, 1869, pp.502–15.

Sérullaz, Arlette. *Musée du Louvre, Cabinet des Dessins, Inventaire général des dessins, École française, Dessins de Jacques-Louis David, 1748–1825*, Paris, 1991.

——. *Le Cabinet des dessins, Delacroix*, Paris, 1998.

Sérullaz, Maurice, with the collaboration of Arlette Sérullaz, Louis-Antoine Prat, and Claudine Ganeval. *Inventaire général des dessins, École française, Dessins d'Eugène Delacroix, 1798–1863*, 2 vols, Paris, 1984.

Sibertin-Blanc, Claude. 'Remarques sur les dessins de Sébastien Iᵉʳ Le Clerc exposés a Metz, pour le tricentenaire de sa naissance (été 1937)', *Bulletin de la Société de l'Histoire de l'Art Français* (1938), pp.43–58.

Slayman, James Hugus. 'The Drawings of Pierre-Paul Prud'hon: A Critical Study', Ph.D. thesis, University of Wisconsin, 1970.

Souchal, François. *French Sculptors of the 17th and 18th Centuries: The Reign of Louis XIV*, 4 vols, Oxford, 1977–87.

Stein, Perrin. 'A New Drawing by Jean Cousin the Elder for the Saint Mamas Tapestries', *Metropolitan Museum Journal* 37 (2002), pp.63–76.

——. 'Trésors Cachés. Chefs-d'Oeuvre du Cabinet d'Arts Graphiques du Château de Versailles, and François Lemoyne à Versailles', exhibition catalogues by Xavier Salmon', *Master Drawings*, vol.41, no.1 (Spring 2003), pp.69–73.

Steinitz, Wolfgang. 'Les Cris de Paris' und die Kaufrufdarstellung in der Druckgraphik bis 1800, Salzburg, 1971.

Stuffman, Margret. 'Charles de La Fosse et sa position dans la peinture française a la fin du XVIIᵉ siècle', *Gazette des Beaux-Arts*, LXIV (July–August 1964), pp.1–121.

Ternois, Daniel. *Jacques Callot, Catalogue complet de son oeuvre dessiné*, Paris, 1962a.

——. *L'art de Jacques Callot*, Paris, 1962b.

——. 'Callot et son temps; dix ans de recherches (1962–1972)', *Le Pays Lorrain*, vol.54 (1973, no.4), pp.211–48.

——, ed. *Jacques Callot (1592–1635), Actes du colloque organisé par le Service culturel du Musée du Louvre et la ville de Nancy à Paris et à Nancy les 25, 26 et 27 juin 1992*, Paris, 1993.

——. *Jacques Callot, Catalogue de son oeuvre dessiné, Supplément (1962–1998)*, Paris, 1999.

Thomas, T.H. 'The Drawings and Pastels of Nanteuil', *The Print-Collector's Quarterly* (December 1914), pp.326–61.

Thomson. Richard. *Seurat*, Oxford, 1985.

Tinterow, Gary. 'Gericault's Heroic Landscapes, The Times of Day', *The Metropolitan Museum of Art Bulletin*, vol.XLVIII, no.3 (Winter 1990/91).

Turner, Nicholas. *Italian Baroque Drawings, British Museum Prints and Drawings Series*, London, 1980.

Uzanne, Octave. *Drawings of Watteau*, London and New York, 1908.

Vallery-Radot, Jean. *Le Dessin français au XVII^e siècle*, Lausanne, 1953.

Venturi, Lionello. *Cézanne, Son art–son oeuvre*, 2 vols, Paris, 1936.

Vidal, Mary. *Watteau's Painted Conversations: Art, Literature, and Talk in Seventeenth- and Eighteenth-Century France*, New Haven and London, 1992.

Vigne, Georges. *Dessins d'Ingres, Catalogue raisonné des dessins du musée de Montauban*, Paris, 1995.

Whiteley, Jon. *Ashmolean Museum Oxford, Catalogue of the Collection of Drawings, VII: French School*, 2 vols, Oxford, 2000.

Whitman, Nathan T. *The Drawings of Raymond Lafage*, The Hague, 1963.

Whitney, Wheelock. *Gericault in Italy*, New Haven and London, 1997.

Wildenstein, Alec. *Odilon Redon, Catalogue raisonné de l'oeuvre peint et dessiné*, 4 vols, Paris, 1992–8.

Wilhelm, Jacques. 'François Le Moyne and Antoine Watteau', *Art Quarterly*, XIV (1951), pp.216–30.

Wollin, Nils G. *Desprez en Italie, Dessins topographiques et d'architecture, décors de théatre et compositions romantiques, Exécutés 1777–1784*, Malmö, 1935.

Zerner, Henri. *The School of Fontainebleau: Etchings and Engravings*, New York, 1969.

——. *L'Art de la renaissance en France, l'invention du classicisme*, Paris, 1996.

Zolotov, Youri. *Antoine Watteau*, Leningrad, 1973.

——. *Antoine Watteau, Gemälde und Zeichnungen in Sowjetischen Museen*, Leningrad, 1986.

EXHIBITIONS AND EXHIBITION CATALOGUES

Amsterdam and Paris, 2003. *De Watteau à Ingres, Dessins français du XVIII^e siècle du Rijksmuseum Amsterdam*, catalogue by R.J.A. te Rijdt, Rijksmuseum, Amsterdam, 2 November 2002–2 February 2003; and Institut Néerlandais, Paris, 20 March–18 May 2003, French edn.

Atlanta, 1983. *The Rococo Age: French Masterpieces of the Eighteenth Century*, catalogue by Eric M. Zafran, High Museum of Art, Atlanta, 1983.

Boston, Ottawa and Paris, 1998. *French Prints from the Age of the Musketeers*, Sue Welsh Reed, ed., Museum of Fine Arts, Boston, 21 October 1998–10 January 1999, National Gallery of Canada, Ottawa, 5 February–2 May 1999; and The Mona Bismarck Foundation, Paris, 1 June–15 July 1999.

Cambridge, Toronto, Paris, Edinburgh, New York and Los Angeles, 1998–2000. *Mastery & Elegance: Two Centuries of French Drawings from the Collection of Jeffrey E. Horvitz*, ed. Alvin L. Clark, Jr., Harvard University Art Museums, Cambridge, 5 December 1998–31 January 1999, Art Gallery of Ontario, Toronto, 20 February–18 April 1999; Musée Jacquemart-André, Paris, 1 May–25 June 1999; National Gallery of Scotland, Edinburgh, 9 July–5 September 1999; National Academy Museum and School of Fine Arts, New York, 8 October–12 December 1999; Los Angeles County Museum of Art, Los Angeles, 24 February–24 April 2000.

Chantilly, 2002. *Les Clouet de Catherine de Médicis, Chefs-d'oeuvre graphiques du Musée Condé*, catalogue by Alexandra Zvereva, Musée Condé, Château de Chantilly, 25 September 2002–3 February, 2003.

Chicago, 2004. *Seurat and the Making of 'La Grande Jatte'*, catalogue by Robert L. Herbert et al., Art Institute of Chicago, 16 June–19 September 2004.

Chicago, Amsterdam and London, 1994. *Odilon Redon: Prince of Dreams, 1840–1916*, catalogue by Douglas W. Druick et al., Art Institute of Chicago, 2 July–18 September 1994; Van Gogh Museum, Amsterdam, 20 October 1994–15 January 1995; and Royal Academy of Arts, London, 16 February–21 May 1995.

Cleveland, Cambridge and Ottawa, 1989. *From Fontainebleau to the Louvre: French Drawing from the Seventeenth Century*, catalogue by Hilliard T. Goldfarb, Cleveland Museum of Art, Fogg Art Museum, Cambridge; and National Gallery of Canada, Ottawa, 1989.

Detroit and Philadelphia, 2002. *Degas and the Dance*, catalogue by Jill De Vonyar and Richard Kendall, Detroit Institute of Arts, 20 October 2002–12 January 2003; and Philadelphia Museum of Art, 12 February–11 May 2003.

Edinburgh, 1979. *Degas 1879*, catalogue by Ronald Pickvance, National Gallery of Scotland, Edinburgh, 13 August–30 September 1979.

Fort Worth and Kansas City, 1983. *J.-B. Oudry, 1686–1755*, Kimbell Art Museum, Fort Worth, 26 February–5 June 1983; and Nelson Atkins Museum of Art, Kansas City, 15 July–4 September 1983.

Frankfurt and New York, 1992. *Daumier Drawings*, catalogue by Colta Ives, Margret Stuffman and Martin Sonnabend, Städelsche Kunstinstitut and Städtische Galerie, Frankfurt, 17 November 1992–17 January 1993; and Metropolitan Museum of Art, New York, 26 February–2 May 1993 (English edn, New York, 1993).

Geneva, 1979. *Hubert Robert (1733–1808), Dessins et peintures*, Galerie Cailleux, Geneva, 30 October–15 December 1979.

Geneva, 1980. *Fantin-Latour, lithographies*, catalogue by Rainer Michael Mason, Musée d'art et d'histoire, Geneva, 19 December 1980–22 February 1981.

Grenoble, Rennes and Bordeaux, 1989. *Laurent de La Hyre, 1606–1656, L'homme et l'oeuvre*, catalogue by Pierre Rosenberg and Jacques Thuillier, Musée de Grenoble, 14 January–10 April 1989; Musée des Beaux-Arts et d'Archéologie, Rennes, 9 May–31 August 1989; and Musée de Bordeaux, 6 October 1989–6 January 1990.

Hartford, San Francisco and Dijon, 1976. *Jean-Baptiste Greuze, 1725–1805*, catalogue by Edgar Munhall, Wadsworth Atheneum, Hartford, 1 December 1976–23 January 1977; The California Palace of the Legion of Honor, San Francisco, 5 March–1 May 1977; and Musée des Beaux-Arts, Dijon, 4 June–31 July 1977.

Karlsruhe, 2003. *Eugène Delacroix*, Staatliche Kunsthalle, Karlsruhe, 1 November 2003–1 February 2004.

King's Lynn, 1985. *French Drawings of the 17th and 18th Century*, Fermoy Gallery, King's Lynn, 26 July–10 August 1985.

London, 1895. *Guide to an Exhibition of Drawings and Engravings by the Old Masters, principally from the Malcolm Collection*, catalogue by Sidney Colvin, British Museum, London, 1895.

London, 1906. *Catalogue of an Exhibition of the Staats Forbes Collection of One Hundred Drawings by Jean François Millet*, Leicester Galleries, London, January–February 1906.

London, 1917. *Catalogue of a Collection of Drawings by Deceased Masters*, Burlington Fine Arts Club, London, 1917.

London, 1932. *Exhibition of French Art, 1200–1900*, Royal Academy of Arts, London, 4 January–5 March 1932.

London, 1950. *Catalogue of an Exhibition of French Master Drawings of the 18th Century*, Matthiesen Gallery, London, October, 1950.

London, 1951. *Emilian Drawings of the XVI Century*, British Museum, London, 1951.

London, 1956. *Drawings by Jean-François Millet*, Moot Hall, Aldeburgh, 16–24 June 1956; National Museum of Wales, Cardiff, 7–28 July 1956; and Arts Council Gallery, London, 17 August–15 September 1956.

London, 1958. *Old Master Drawings*, H.M. Calmann, London, 1958.

London, 1961. *Daumier: Paintings and Drawings*, Tate Gallery, London, 14 June–30 July 1961.

London, 1968a. *France in the Eighteenth Century*, Royal Academy of Arts, London, 6 January–3 March 1968.

London, 1968b. *The César Mange de Hauke Bequest*, catalogue by Paul Hulton, British Museum, London, 1968.

London, 1969. *Berlioz and the Romantic Imagination*, Arts Council and Victoria and Albert Museum, London, 17 October–14 December, 1969.

London, 1972a. *The Art of Drawing (11000 BC–AD 1900)*, catalogue by Edward Croft-Murray, British Museum, London, November 1972–February 1973.

London, 1972b. *The Age of Neoclassicism*, Royal Academy and the Victoria and Albert Museum, London, 9 September–19 November 1972.

London, 1973. *Old Master Drawings from Chatsworth*, catalogue by James Byam Shaw, Victoria and Albert Museum, London, 1973.

London, 1974a. *Portrait Drawings: XV–XX Centuries*, British Museum, London, 2 August–31 December 1974.

London, 1974b. *Drawings by Victor Hugo*, catalogue by Pierre Georgel, Victoria and Albert Museum, London, 1974.

London, 1978. *Gainsborough and Reynolds in the British Museum*, catalogue by Timothy Clifford, Antony Griffiths and Martin Royalton-Kisch, British Museum, London, 1978.

London, 1980. *Watteau: Drawings in the British Museum*, catalogue by Paul Hulton, British Museum, London, 1980.

London, 1981. *Drawing: Technique and Purpose*, catalogue by Susan Lambert, Victoria and Albert Museum, 28 January–26 April 1981.

London, 1984a. *Landscape in Italy: Drawings of the 16th & 17th Centuries*, British Museum, 9 February–29 April 1984.

London, 1984b. *Master Drawings and Watercolours in the British Museum*, ed. John Rowlands, British Museum, London, 1984.

London, 1985. *Old Master Drawings and Sculpture*, Thos. Agnew & Sons Ltd, London, 13 November–20 December 1985.

London, 1991. *French Drawings: XVI–XIX Centuries*, catalogue by Gillian Kennedy and Anne Thackray, Courtauld Institute Galleries, London, 4 July–6 October 1991.

London, 1994. *Claude: The Poetic Landscape*, catalogue by Humphrey Wine, National Gallery, London, 26 January–10 April 1994.

London, 1997. *Seurat and the Bathers*, catalogue by John Leighton et al., National Gallery, London, 2 July–28 September 1997.

London and Antwerp, 1999. *The Light of Nature: Landscape Drawings and Watercolours by Van Dyck and his Contemporaries*, catalogue by Martin Royalton-Kisch, Rubenshuis, Antwerp, 15 May–15 August 1999; British Museum, London, 18 September–5 December 1999.

London, Houston, Cleveland and New York, 1995. *Poussin, Works on Paper: Drawings from the Collection of Her Majesty Queen Elizabeth II*, catalogue by Martin Clayton, Dulwich Picture Gallery, London, 16 February–30 April 1995; Museum of Fine Arts, Houston, 27 August–12 November 1995; Cleveland Museum of Art, 22 November 1995–24 January 1996; and Metropolitan Museum of Art, New York, 6 February–31 March 1996.

London, Paris and Boston, 1980. *Camille Pissarro, 1830–1903*, Hayward Gallery, London, 30 October 1980–11 January 1981; Grand Palais, Paris, 30 January–27 April 1981; and Museum of Fine Arts, Boston, 19 May–9 August, 1981.

London, Washington and New York, 1999. *Portraits by Ingres: Image of an Epoch*, ed. Gary Tinterow and Philip Conisbee, National Gallery, London, 27 January–25 April 1999; National Gallery of Art, Washington, DC, 23 May–22 August 1999; and Metropolitan Museum of Art, New York, 5 October 1999–2 January 2000.

Los Angeles, 2004. *Cézanne in the Studio: Still Life in Watercolors*, catalogue by Carol Armstrong, J. Paul Getty Museum, Los Angeles, 12 October 2004–2 January 2005.

Los Angeles, New York and Paris, 1994. *The French Renaissance in Prints from the Bibliothèque Nationale de France*, Armand Hammer Museum of Art, Los Angeles, 1 November 1994–1 January 1995; Metropolitan Museum of Art, New York, 12 January–19 March 1995; and the Bibliothèque Nationale de France, Paris, 20 April–10 July 1995.

Lyons, London and New York, 2003. *Ingres, Burne-Jones, Whistler, Renoir . . . , La Collection Grenville L. Winthrop, Chefs-d'oeuvre du Fogg Art Museum, Université de Harvard*, Musée des Beaux-Arts, Lyons, 11 March–26 May 2003; National Gallery, London, 25 June–14 September 2003; and Metropolitan Museum of Art, New York, 20 October 2003–25 January 2004 (French edn).

Manchester and Cambridge, 1987. *The Private Degas*, catalogue by Richard Thomson, Whitworth Art Gallery, Manchester, 20 January–28 February 1987; and Fitzwilliam Museum, Cambridge, 17 March–3 May 1987.

Manchester and Norwich, 1991. *Corot*, Manchester City Art Gallery, 18 May–30 June 1991; and Norwich Castle Museum, 6 July–18 August 1991.

Middletown and Baltimore, 1975. *Prints and Drawings by Gabriel de Saint-Aubin, 1724–1780*, catalogue by Victor Carlson, Ellen D'Oench and Richard S. Field, Davison Art Center, Wesleyan University, Middletown, Connecticut, 7 March–13 April 1975, and Baltimore Museum of Art, 25 April–8 June 1975.

Milan, 1985. *Fogli di Antichi Maestri, Disegni dal XVI al XIX secolo*, catalogue by Silvana Bareggi, Stanza del Borgo Gallery, Milan, 1985.

Minneapolis, 1978. *Millet's 'Gleaners'*, Minneapolis Institute of Arts, Minneapolis, 2 April–4 June 1978.

Modena, 2005. *Nicolò dell'Abate, Storie dipinte nella pittura del Cinquecento tra Modena e Fontainebleau*, catalogue by Sylvie Béguin and Francesca Piccinini, Foro Boaria, Modena, 20 March–19 June 2005.

Munich, 1987. *Gemälde und Zeichnungen, 1490–1918*, Galerie Arnoldi-Livie, Munich, summer 1987.

Nagoya and Tokyo, 2002. *French Drawings from the British Museum: From Fontainebleau to Versailles*, catalogue by Hidenori Kurita, Michiaki Koshikawa and Hidenobu Kujirai, Aichi Prefectural Museum of Art, Nagoya, 26 April–30 June 2002; and National Museum of Western Art, Tokyo, 9 July–1 September 2002 (also, published separately, English Text Supplement, 2002).

Nancy, 1992a. *L'art en Lorraine au temps de Jacques Callot*, Musée des Beaux-Arts, Nancy, 13 June–14 September 1992.

Nancy, 1992b. *Jacques Callot, 1592–1635*, Musée Historique Lorrain, Nancy, 13 June–14 September 1992.

New York, 1959a. *French Drawings from American Collections: Clouet to Matisse*, Metropolitan Museum of Art, New York, 3 February–15 March 1959.

New York, 1959b. *A Choice Collection of Important Engravings, Etchings, and Woodcuts by the Old Masters from the XVth to the XVIIth Century in Impressions of the Highest Quality, Drawings and Watercolors by Old and Modern Masters*, catalogue no.26, William H. Schab Gallery, New York, 1959.

New York, 1968. *Old Master Drawings*, H. Shickman Gallery, New York, 1968.

New York, 1997. *The Private Collection of Edgar Degas*, 2 vols, catalogue by Ann Dumas et al., Metropolitan Museum of Art, New York, 1 October 1997–11 January 1998.

New York, 1998. *Master Drawings from the Hermitage and Pushkin Museums*, Pierpont Morgan Library, New York, 25 September 1998–10 January 1999.

New York, 1999. *Eighteenth-Century French Drawings in New York Collections*, catalogue by Perrin Stein and Mary Tavener Holmes, Metropolitan Museum of Art, New York, 2 February–25 April 1999.

New York, Detroit and Paris, 1986. *François Boucher, 1703–1770*, catalogue by Alastair Laing et al., Metropolitan Museum of Art, New York, 17 February–4 May 1986; Detroit Institute of Arts, 27 May–17 August 1986; and Grand Palais, Paris, 19 September 1986–5 January 1987.

New York and Fort Worth, 2003. *The Drawings of François Boucher*, catalogue by Alastair Laing, The Frick Collection, New York, 8 October– 14 December 2003; and Kimbell Art Museum, Fort Worth, 18 January–18 April 2004.

New York, Fort Worth and Ottawa, 1990. *Masterful Studies: Three Centuries of French Drawings from the Prat Collection*, catalogue by Pierre Rosenberg, National Academy of Design, New York, 13 November 1990–20 January 1991; Kimbell Art Museum, Fort Worth, 11 February–21 April 1991; and National Gallery of Canada, Ottawa, 1 July–25 August 1991.

New York, New Orleans and Columbus, 1985. *The First Painters of the King: French Royal Taste from Louis XIV to the Revolution*, catalogue by Colin B. Bailey, Stair Sainty Matthiesen Gallery, New York, 16 October–22 November 1985; New Orleans Museum of Art, 10 December 1985– 19 January 1986; and Columbus Museum of Art, 8 February–26 March 1986.

New York and Ottawa, 1999. *Watteau and His World: French Drawing from 1700–1750*, ed. Alan Wintermute, The Frick Collection, New York, 19 October 1999–9 January 2000; and National Gallery of Canada, Ottawa, 11 February–8 May 2000.

Newcastle upon Tyne and London, 1973. *Watercolour and Pencil Drawings by Cézanne*, Laing Art Gallery, Newcastle upon Tyne, 19 September–4 November 1973; and Hayward Gallery, London, 13 November–30 December 1973.

Norwich and Manchester, 1987. *The Art of Watercolour*, Norwich Castle Museum, 4 April–17 May, 1987, and Manchester City Art Gallery, 23 May–28 June 1987.

Orléans, 1984. *Peintures françaises du Museum of Art de la Nouvelle Orléans*, catalogue by Edward P. Caraco, Musée des Beaux-Arts, Orléans, 9 May–15 September 1984.

Ottawa, Paris and Washington, 1999. *Daumier, 1808–1879*, National Gallery of Canada, Ottawa, 11 June–6 September 1999; Galeries Nationales du Grand Palais, Paris, 5 October 1999–3 January 2000; and The Phillips Collection, Washington, 19 February–14 May 2000 (French edn, 1999).

Oxford, 1990. *A Loan Exhibition of Drawings by Nicolas Poussin from British Collections*, catalogue by Hugh Brigstocke, Ashmolean Museum, Oxford, 4 December 1990–17 February 1991.

Oxford and London, 1998. *Claude Lorrain: Drawings from the Collections of the British Museum and the Ashmolean Museum*, catalogue by J.J.L. Whiteley, Ashmolean Museum, Oxford, 30 June–13 September 1998; and British Museum, London, 9 October 1998–10 January 1999.

Paris, 1861. *Exposition de Ingres au Salon des Arts-Unis*, Paris, March, 1861.

Paris, 1867. *Catalogue des tableaux, Etudes peintes, dessins et croquis de J.-A.-D. Ingres*, École des Beaux-Arts, Paris, 1867.

Paris, 1874. *Exposition des oeuvres de Prud'hon, Au profit de sa fille*, École des Beaux-Arts, Paris, 4 May–4 July 1874.

Paris, 1879. *Catalogue descriptif des dessins de maîtres anciens*, École des Beaux-Arts, Paris, May–June 1879.

Paris, 1900a. *Catalogue général officiel, Oeuvres d'art, Exposition Centennale de l'art français (1800–1889)*, Grand Palais, Paris, 1900.

Paris 1900b. *Exposition universelle de 1900, Exposition rétrospective de la ville de Paris*, Paris, 1900.

Paris, 1934. *Daumier, Peintures, Aquarelles, Dessins*, catalogue by Charles Sterling, Musée de l'Orangerie, Paris, 1934.

Paris, 1951. *Le Dessin français de Watteau à Prud'hon*, Galerie Cailleux, Paris, April 1951.

Paris, 1967a. *Le Cabinet d'un grand amateur, P.-J. Mariette, 1694–1774*, Musée du Louvre, Paris, 1967.

Paris, 1967b. *Ingres*, Petit Palais, Paris, 27 October 1967–29 January 1968.

Paris, 1972. *L'École de Fontainebleau*, Grand Palais, Paris, 17 October 1972–15 January 1973.

Paris, 1973. *Autoportraits de Courbet*, catalogue by Marie-Thérèse de Forges, Musée du Louvre, Paris, 1973.

Paris, 1975. *Jean-François Millet*, catalogue by Robert Herbert, Grand Palais, Paris, 17 October 1975–5 January 1976.

Paris, 1978. *Claude Lorrain, Dessins du British Museum*, Musée du Louvre, Paris, 19 October 1978–15 January 1979.

Paris, 1981. *De Michel-Ange à Géricault: dessins de la donation Armand-Valton*, École Nationale Supérieure des Beaux-Arts, Paris, 19 May– 12 July 1981.

Paris, 1982. *J.-B. Oudry, 1686–1755*, Galeries Nationales du Grand Palais, Paris, 1 October 1982–3 January 1983.

Paris, 1984. *Dessin et Sciences, XVIIᵉ–XVIIIᵉ siècles*, catalogue by Madeleine Pinault, Musée du Louvre, Paris, 22 June–24 September 1984.

Paris, 1985. *Soleil d'encre, Manuscrits et dessins de Victor Hugo*, Musée du Petit Palais, Paris, 3 October 1985–5 January 1986.

Paris, 1989. *Maîtres français 1550–1800, Dessins de la donation Mathias Polakovits à l'École des Beaux-Arts*, École Nationale Supérieure des Beaux-Arts, Paris, 19 April–25 June 1989.

Paris, 1993. *Dessins français du XVIIᵉ dans les collections publiques françaises*, Musée du Louvre, Paris, 28 January–26 April 1993.

Paris, 1994a. *Nicolas Poussin, 1594–1665*, catalogue by Pierre Rosenberg and Louis-Antoine Prat, Grand Palais, Paris, 27 September 1994– 2 January 1995.

Paris, 1994b. *Delacroix: Le voyage au Maroc*, Institut du Monde Arabe, Paris, 27 September 1994– 15 January 1995.

Paris, 1995. *Manet, Gauguin, Rodin . . ., Chefs-d'oeuvre de la Ny Carlsberg Glyptotek de Copenhague*, Musée d'Orsay, Paris, 9 October 1995–28 January 1996.

Paris, 2002. *La passion du dessin, Collection Jan et Marie-Anne Krugier-Poniatowski*, Musée Jacquemart-André, Paris, 19 March–30 June 2002.

Paris, 2003. *François Boucher, Hier et aujourd'hui*, catalogue by Françoise Joulie and Jean-François Méjanès, Musée du Louvre, Paris, 17 October 2003–19 January 2004.

Paris, 2004. *Primatice, Maître de Fontainebleau*, catalogue by Dominique Cordelier et al., Musée du Louvre, Paris, 22 September 2004–3 January 2005.

Paris, Cambridge and New York, 1994. *The Renaissance in France: Drawings from the École des Beaux-Arts, Paris*, catalogue by Emmanuelle Brugerolles and David Guillet, École Nationale Supérieure des Beaux-Arts, Paris, 23 September–6 November 1994; Fogg Art Museum, Harvard University Art Museums, Cambridge, 4 February–9 April 1995; and Metropolitan Museum of Art, New York, 12 September–12 November 1995.

Paris and Geneva, 1986. *Artistes en voyage au XVIIIᵉ siècle*, Galerie Cailleux, Paris, 20 May–5 July 1986; and Galerie Cailleux, Geneva, October–November 1986.

Paris, Geneva and New York, 2001. *Le Dessin en France au XVIIᵉ siècle dans les collections de l'École des Beaux-Arts*, catalogue by Emmanuelle Brugerolles, École Nationale Supérieure des Beaux-Arts, Paris, 12 January–31 March 2001; Musée d'Art et d'Histoire, Geneva, 20 September–18 November 2001; and The Frick Collection, New York, 17 September– 1 December 2002 (French edn).

Paris, London and Philadelphia, 1995. *Cézanne*, catalogue by Françoise Cachin et al., Galeries Nationales du Grand Palais, Paris, 25 September 1995–7 January 1996; Tate Gallery, London, 8 February–28 April 1996; and Philadelphia Museum of Art, 30 May–1 September 1996.

Paris and New York, 1987. *Fragonard*, catalogue by Pierre Rosenberg, Galeries Nationales du Grand Palais, Paris, 24 September 1987–4 January 1988; and Metropolitan Museum of Art, New York, 2 February–8 May 1988.

Paris and New York, 1991. *Georges Seurat, 1859–1891*, catalogue by Robert L. Herbert et al., Galeries Nationales du Grand Palais, Paris, 9 April–12 August 1991; and Metropolitan Museum of Art, New York, 24 September 1991–12 January 1992.

Paris and New York, 1993. *French Master Drawings from the Pierpont Morgan Library*, catalogue by Cara Dufour Denison, Musée du Louvre, Paris, 1 June–30 August 1993; and The Pierpont Morgan Library, New York, 15 September 1993–2 January 1994.

Paris and New York, 1997. *Pierre-Paul Prud'hon*, catalogue by Sylvain Laveissière, Galeries Nationales du Grand Palais, Paris, 23 September 1997–5 January 1998; and Metropolitan Museum of Art, New York, 10 March–7 June 1998.

Paris, Ottawa and New York, 1988. *Degas*, catalogue by Jean Sutherland Boggs et al., Galeries Nationales du Grand Palais, Paris, 9 February–16 May 1988; National Gallery of Canada, Ottawa, 16 June–28 August 1988; and Metropolitan Museum of Art, New York, 27 September 1988–8 January 1989.

Paris, Ottawa and New York, 1996. *Corot*, catalogue by Gary Tinterow, Michael Pantazzi and Vincent Pomarède, Galeries Nationales du Grand Palais, Paris, 27 February–27 May 1996; National Gallery of Canada, Ottawa, 21 June–22 September 1996; and Metropolitan Museum of Art, New York, 29 October 1996–19 January 1997.

Paris, Philadelphia and Fort Worth, 1991. *The Loves of the Gods: Mythological Painting from Watteau to David*, catalogue by Colin B. Bailey, with the assistance of Carrie A. Hamilton, Galeries Nationales de Grand Palais, Paris, 15 October 1991–6 January 1992; Philadelphia Museum of Art, 23 February–26 April 1992; and Kimbell Art Museum, Fort Worth, 23 May–2 August 1992.

Paris and Versailles, 1989. *Jacques-Louis David, 1748–1825*, Musée du Louvre, Paris and Musée National du Château, Versailles, 26 October 1989–12 February 1990.

Rennes, 2001. *Jacques de Bellange*, catalogue by Jacques Thuillier, Musée des Beaux-Arts, Rennes, 16 February–14 May 2001.

Rome, 1972. *Il paesaggio nel del cinquecento europeo*, Villa Medici, Rome, 20 November 1972–31 January 1973.

Rome, 1990. *J.H. Fragonard e H. Robert a Roma*, Accademia di Francia a Roma, Villa Medici, 6 December 1990–24 February 1991.

Rome, Dijon and Paris, 1976. *Piranèse et les français, 1740–1790*, Villa Medici, Rome, Palais des États de Bourgogne, Dijon, and Hôtel de Sully, Paris, May–November, 1976.

Rome, New York and St Louis, 2002. *Orazio and Artemisia Gentileschi*, catalogue by Keith Chistiansen and Judith W. Mann, Museo del Palazzo di Venezia, Rome, 15 October 2001–6 January 2002; Metropolitan Museum of Art, New York, 14 February–12 May 2002; and St Louis Art Museum, 15 June–15 September 2002 (English edn, 2002).

Stockholm, 1917. *Fransk Konst i Nationalmuseum våren 1917*, catalogue by Richard Bergh, Nationalmuseum, Stockholm, March–April 1917.

Stockholm, 1992. *Louis Jean Desprez, Tecknare, Teaterkonstnär, Arkitekt*, Nationalmuseum, Stockholm, 3 June–4 October 1992.

Stockholm, 1997. *Cézanne I blickpunkten*, catalogue by Görel Cavalli Björkman, Nationalmuseum, Stockholm, 17 October 1997–11 January 1998.

Tokyo and Kumamoto, 1982. *François Boucher*, catalogue by Denys Sutton, Tokyo Metropolitan Art Museum, 24 April–23 June 1982; and Kumamoto Prefectural Museum of Art, 3 July–22 August 1982.

Tokyo and Kyoto, 1980. *Fragonard*, catalogue by Denys Sutton, National Museum of Western Art, Tokyo, 18 March–11 May 1980; and Kyoto Municipal Museum, 24 May–29 June 1980.

Tokyo and Nagoya, 1996. *Italian 16th and 17th Century Drawings from the British Museum*, catalogue by Michiaki Koshikawa and Hidenori Kurii, National Museum of Western Art, Tokyo, 6 February–7 April 1996; and Aichi Prefectural Museum of Art, Nagoya, 19 April–26 May 1996.

Toledo, Chicago and Ottawa, 1975. *The Age of Louis XV: French Painting 1710–1774*, catalogue by Pierre Rosenberg, Toledo Museum of Art, 26 October–7 December 1975; Art Institute of Chicago, 10 January–22 February 1976; and National Gallery of Canada, Ottawa, 21 March–2 May 1976.

Toronto, Ottawa, San Francisco and New York, 1972. *French Master Drawings of the 17th & 18th Centuries in North American Collections*, catalogue by Pierre Rosenberg, Art Gallery of Ontario, Toronto, 2 September–15 October 1972; National Gallery of Canada, Ottawa, 3 November–17 December 1972; California Palace of the Legion of Honor, San Francisco, 12 January–11 March 1973; and New York Cultural Center, New York (in association with the Fairleigh Dickinson University of New Jersey), 4 April–6 May 1973.

Toulouse, 1962. *Les Dessins de Raymond La Fage*, Musée Paul Dupuy, Toulouse, 1962.

Tübingen, 1978. *Paul Cézanne: Zeichnungen*, catalogue by Götz Adriani, Kunsthalle, Tübingen, 21 October–31 December 1978.

Tübingen and Berlin, 1984. *Edgar Degas. Pastelle, Ölskizzen, Zeichnungen*, catalogue by Götz Adriani, Kunsthalle, Tübingen, 14 January–25 March 1984; and Nationalgalerie, Berlin, 5 April–20 May 1984.

Versailles, 2001. *François Lemoyne à Versailles*, catalogue by Xavier Salmon, Château de Versailles, 14 May–12 August 2001.

Villequier and Paris, 1971. *Dessins de Victor Hugo*, catalogue by Pierre Georgel, Musée Victor Hugo, Villequier, June–October 1971; and Maison de Victor Hugo, Paris, November 1971–January 1972.

Washington, 1975. *Jacques Callot: Prints & Related Drawings*, catalogue by H. Diane Russell, National Gallery of Art, Washington, DC, 29 June–14 September 1975.

Washington, 1978. *Hubert Robert: Drawings and Watercolors*, catalogue by Victor Carlson, National Gallery of Art, Washington, DC, 19 November, 1978–21 January 1979.

Washington, 1998. *Degas at the Races*, catalogue by Jean Sutherland Boggs, National Gallery of Art, Washington, DC, 12 April–12 July 1998.

Washington, Cambridge and New York, 1978. *Drawings by Fragonard in North American Collections*, catalogue by Eunice Williams, National Gallery of Art, Washington, DC, 19 November 1978–21 January 1979; Fogg Art Museum, Cambridge, Mass., 16 February–1 April 1979; and The Frick Collection, New York, 20 April–3 June 1979.

Washington and Chicago, 1973. *François Boucher in North American Collections: 100 Drawings*, catalogue by Regina Shoolman Slatkin, National Gallery of Art, Washington, DC, 23 December 1973–17 March 1974; and Art Institute of Chicago, 4 April–12 May 1974.

Washington and Paris, 1982. *Claude Lorrain, 1600–1682*, catalogue by H. Diane Russell, National Gallery of Art, Washington, DC, 17 October 1982–2 January 1983; and Grand Palais, Paris, 15 February–16 May 1983 (English edn).

Washington, Paris and Berlin, 1984. *Watteau, 1684–1721*, catalogue by Margaret Morgan Grasselli and Pierre Rosenberg, National Gallery of Art, Washington, 17 June–23 September 1984; Galeries Nationales du Grand Palais, Paris, 23 October 1984–28 January 1985; and Schloss Charlottenburg, Berlin, 22 February–26 May 1985 (English edn).

Winterthur, 1955. *Europäische Meister, 1790–1910*, Kunstmuseum, Winterthur, 12 June–24 July 1955.

Yamanashi, 1998. *Return to Nature: J.F. Millet, The Barbizon Artists and the Renewal of the Rural Tradition*, Yamanashi Prefectural Museum of Art, 26 September–6 December 1998.

INDEX OF ARTISTS

General Index